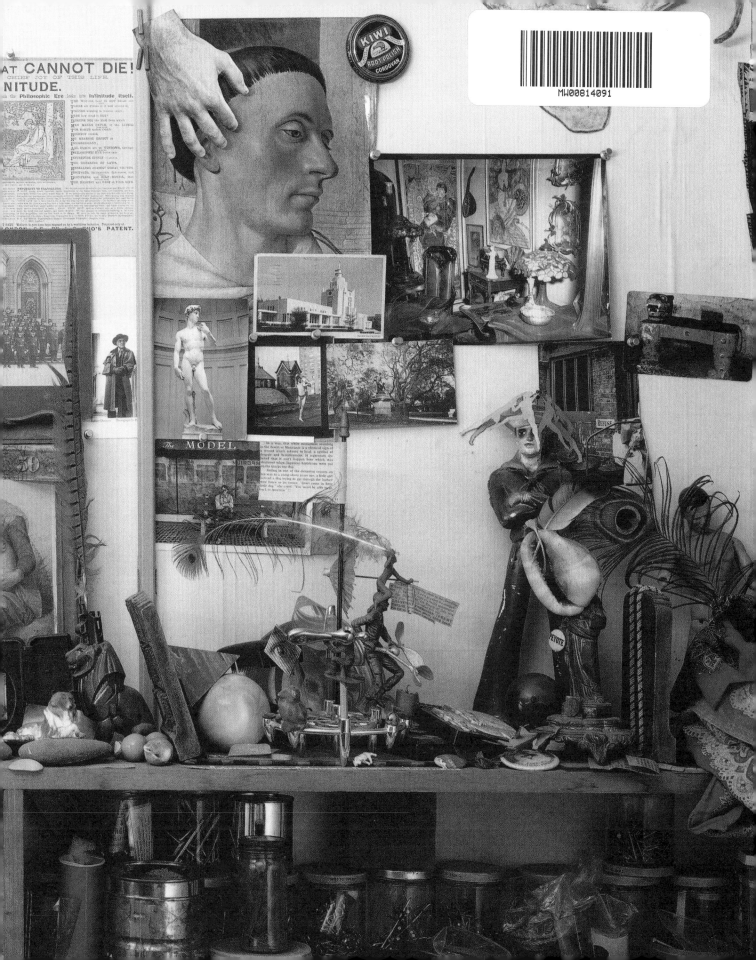

AN OPENING OF THE FIELD

Jess, Robert Duncan, and Their Circle

Michael Duncan
and Christopher Wagstaff

With additional essays by
William Breazeale
and James Maynard

CROCKER
art museum

Pomegranate
PORTLAND, OREGON

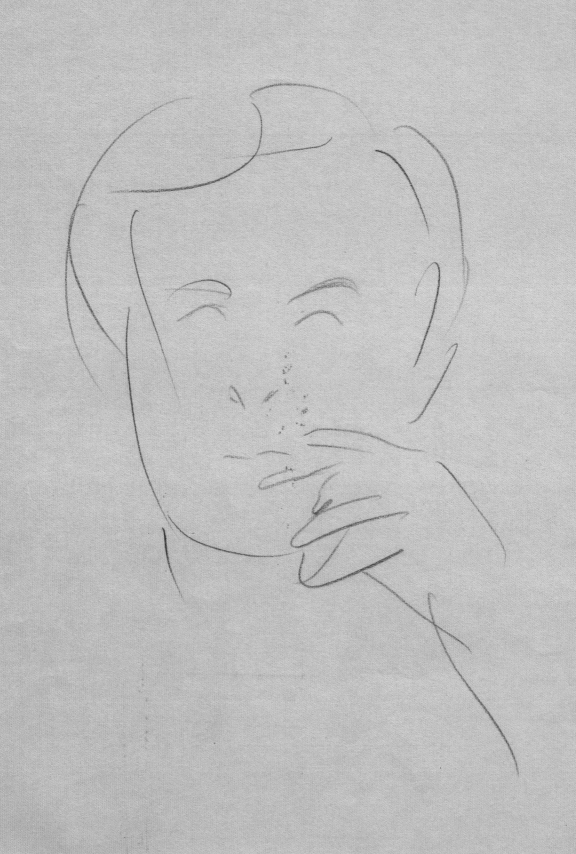

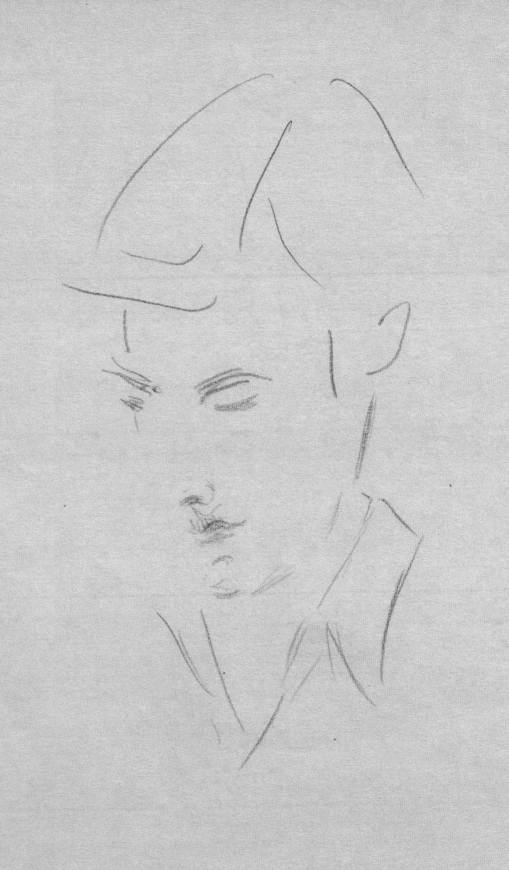

Published by Pomegranate Communications, Inc.
19018 NE Portal Way, Portland OR 97230
800 227 1428; www.pomegranate.com

To learn about new releases and special offers from Pomegranate, please visit
www.pomegranate.com and sign up for our e-mail newsletter. For all other queries, see "Contact Us" on our home page.

Pomegranate Europe Ltd.
Unit 1, Heathcote Business Centre, Hurlbutt Road
Warwick, Warwickshire CV34 6TD, UK
[+44] 0 1926 430111; sales@pomeurope.co.uk

Published on the occasion of the exhibition "An Opening of the Field: Jess, Robert Duncan, and Their Circle,"
organized by the Crocker Art Museum, Sacramento, and curated by Michael Duncan and Christopher Wagstaff:

Crocker Art Museum, Sacramento	June 9 – September 1, 2013
Grey Art Gallery, New York University	January 14 – March 29, 2014
Katzen Arts Center, American University, Washington DC	April 26 – August 17, 2014
Pasadena Museum of California Art	September 14, 2014 – January 11, 2015

This exhibition and catalogue supported by a grant from the National Endowment for the Arts.

NATIONAL ENDOWMENT FOR THE ARTS

Photographs, as well as artworks not included in the exhibition, are courtesy of the following individuals and institutions:
Harry W. & Mary Margaret Anderson, 186; Becky Brockway, 176; Don Buhlman, 226; Robert DeNiro Jr., 156; Ernesto Edwards, 188, 202; Estate of Norris
Embry, 194; Lilly Fenichel, 198, 258, 274 (upper left); Llyn Foulkes, 206; Linda Hawkins, 274 (lower left); George Herms, 218 (lower left); Fran Herndon, 220;
Harry Jacobus, 230; The Jess Collins Trust, 2, 3, 53, 59, 71, 76, 146, 187 (left and right), 245 (left and right), 268, 272 (upper left and lower left), 273 (center left),
274 (center left), 275 (center left), 276 (lower left); Lorna Anthea Star Jordan, 40, 238; Estate of Pauline Kael, 242; Joanne Kyger, 133 (left), 160, 172, 174, 274
(lower right); Kristine McKenna / Michael Kohn Gallery, 262; Don Mixon, 254; Nora Eccles Harrison Museum of Art, Utah State University, Logan, 216; The
Poetry Collection of the University Libraries, University at Buffalo, The State University of New York, 8, 82, 86, 107, 113, 114 (upper left), 116, 117, 118, 130, 133
(right), 138, 142 (upper), 144, 147, 150, 164, 180, 184, 208, 212, 234, 246, 250, 266, 272 (upper right), 273 (upper left and upper right), 275 (upper left), 275 (upper
right and lower right), 276 (upper left, upper right, and lower right); Violet Redl, 150, 180; San Francisco Museum of Modern Art, 19.

Front cover:	Back cover:	Overleaf:
Jess, *The Enamord Mage: Translation #6,* 1965	Pauline Kael residence with 1956 mural by Jess	Left: Elmer Bischoff, *Portrait Sketch of Robert*
Oil on canvas over wood, 24½ x 30 in.	Photograph by Ben Blackwell	*Duncan,* 1953. Right: Elmer Bischoff, *Portrait*
Collection of The M. H. de Young Memorial	Endpapers:	*Sketch of Jess,* 1953
Museum, Fine Arts Museums of San Francisco	Jess's studio, 2004	Both pencil on paper, 11 x 8½ in.
	Photographs by Ben Blackwell	Courtesy of the Jess Collins Trust and Adelie Bischoff

Library of Congress Cataloging-in-Publication Data

An opening of the field : Jess, Robert Duncan, and their circle / Michael Duncan and Christopher Wagstaff ; with additional essays by William Breazeale and
James Maynard. — First, hardcover [edition].
 pages cm
 Includes index.
 ISBN 978-0-7649-6582-1 (alk. paper)
 1. Arts—California—San Francisco Bay Area—History—20th century—Exhibitions. 2. Jess, 1923–2004—Exhibitions. 3. Duncan, Robert, 1919–1988—
Exhibitions. 4. Jess, 1923–2004—Friends and associates—Exhibitions. 5. Duncan, Robert, 1919–1988—Friends and associates—Exhibitions. I. Duncan,
Michael, 1953– Opening of the field. II. Wagstaff, Christopher, 1943– "This here other world."
 NX511.S36O64 2013
 709.2—dc23 2013001403

Pomegranate Catalog No. A220
Designed by Patrice Morris
Printed in China

22 21 20 19 18 17 16 15 14 13 10 9 8 7 6 5 4 3 2 1

Contents

Acknowledgments

The curators would like to thank the following supporters for their assistance in preparing this exhibition and catalogue:

Altman Siegel Gallery, San Francisco (Claudia Altman Siegel); Anita Noennig Paper Conservation, Oakland; Atthowe Fine Arts Services, Oakland; Michael Auping; Robert J. Bertholf; the late Robin Blaser; Estate of Jack Boyce (Jane Slack); Becky Brockway; Estate of James Broughton (Joel Singer); Gerald Buck; Don Buhman; Timothy Burgard; the late Hilde and David Burton; Sandra B. and Stephen D. Burton; Cantor Arts Center at Stanford University; Charles, Barbara, and Courtney Collins; Crocker Art Museum, Sacramento (John Caswell, Matt Isble, Lial Jones, Scott Shields); Ernesto Edwards; Estate of Norris Embry (Warren Wilmot Williams); David Farwell; Lilly Fenichel; Adrienne Fish; Llyn Foulkes; Nemi Frost; Colin Gardner; Bert Golding; Linda Hawkins; Fran Herndon; Loretta Howard; Harry Jacobus; Gina James; Jeffrey Maser, Bookseller, Berkeley; The Jess Collins Trust (Mary Margaret Sloan); Lawrence Jordan; Lorna Anthea Star Jordan; Megan Fox Kelly; Joanne Kyger; Estate of Denise Levertov; Joanna McClure; Michael McClure; Tara McDowell; Kristine McKenna; Karin McPhail; Michael Kohn Gallery, Los Angeles; Don Mixon; William Brodecky Moore; Morris and Helen Belkin Art Gallery, Vancouver, BC; Mythos Gallery, Berkeley (Susan Steel); The National Endowment for the Arts; Dr. John Hallmark Neff; Margaret Nielsen; Estate of Charles Olson (Melissa Watterworth Batt, University of Connecticut Libraries, Storrs, CT); Paule Anglim Gallery (Paule Anglim, Ed Gilbert); Pauline Mohr Art Conservation, Oakland; The Poetry Collection and the Charles D. Abbott Library Fellowship of The University Libraries, University at Buffalo, State University of New York (Michael Basinski and James Maynard); Janet Prill; Ann Reynolds; Ingrid Schaffner; Odyssia Skouras; Barry Sloane; Estate of Jack Spicer (Peter Gizzi and Kevin Killian); Robert Dean Stockwell; Studio Frameworks, Oakland (Aletha Worrall); Tibor de Nagy Gallery, New York (Andrew Arnot, Eric Brown, and Andrea Wells); Barbara O'Brien Wagstaff; Valerie Warren; and Wilfred J. Jones Photography, San Francisco.

Special appreciation goes to Tibor de Nagy Gallery, New York, for its multifaceted support of this exhibition. Tibor de Nagy is the exclusive representative of Jess's estate.

Director's Foreword

Jess, Robert Duncan, and their richly imaginative works became a catalyst for an entire generation of poets and artists who gathered at the couple's San Francisco home from the 1950s onwards. Their circle included artists such as R. B. Kitaj, Edward Corbett, Wallace Berman, Lawrence Jordan, and George Herms, as well as the poets Jack Spicer, Robin Blaser, and Michael McClure. In this rich cultural mélange, experimentation, such as the coupling of poetry and artwork, became the norm. The Bay Area world that surrounded the couple is now emerging in the history of art. Focusing on an artist, a poet, their relationship, and their influence, the exhibition "An Opening of the Field: Jess, Robert Duncan, and Their Circle" provides a view into a multilayered world resonant with new and appropriated images and text. In addition, Jess and Robert Duncan's relationship as it developed over the years has special pertinence today, a time of widespread reassessment of issues surrounding homosexual relationships.

The themes of myth, humor, and transformation underlie the entire exhibition, from Jess's famous paste-ups to George Herms's sculptures. The first exhibition to examine the relationships that developed among the couple and their artistic circle, it is a collaboration between the independent curator Michael Duncan and the writer Christopher Wagstaff, coordinated with the Crocker's curator William Breazeale. I am grateful for their efforts, and those of Crocker Chief Curator and Associate Director Scott A. Shields, in bringing this project to fruition. The participation of the Jess Collins Trust means that we will bring an entire new body of work to public view; a large number of the works exhibited were originally in Duncan and Jess's own art collection. Other lenders to the exhibition, both private individuals and public institutions, have been extremely generous in sharing their works with us. Finally, I am grateful to the staff of the Crocker Art Museum and our partners Lynn Gumpert, director of the Grey Art Gallery at New York University; Jack Rasmussen, director and curator at the Katzen Art Center at American University; and Jenkins Shannon, executive director at the Pasadena Museum of California Art, for helping us to share this exhibition with a broad public.

Lial A. Jones
Mort and Marcy Friedman Director
Crocker Art Museum

Robert Duncan and Jess, c. 1965
Photograph by Helen Adam

An Opening of the Field

Jess, Robert Duncan, and Their Circle

Michael Duncan

For lucky visitors who frequented it, 3267 Twentieth Street in San Francisco's Mission District was an extraordinary place, a realm of art and literature shaped by two complementary sensibilities bent on vitalizing and reinhabiting culture at large. One of the most productive artistic couples of the twentieth century, artist/poet Jess (1923–2004) and poet/artist Robert Duncan (1919–1988) established a domestic space that fostered their practices and inspired a generation of Bay Area artists and poets. The couple nearly filled all four floors of their rambling Victorian house with libraries—mythology and reference on the ground floor, Oz books and fairy-tale editions in the bedroom, French literature and an exhaustive modernist collection upstairs. All remaining walls were covered with the visionary art of friends such as Helen Adam, Wallace Berman, Edward Corbett, Lilly Fenichel, Tom Field, George Herms, Harry Jacobus, R. B. Kitaj, and Philip Roeber.

Like 27 rue de Fleurus—the Paris apartment where Gertrude and Leo Stein amassed their early collection of Matisse, Gris, and Picasso—the house embodied a distinctive cultural moment. While certainly not as well known as that of the Steins, the alternative aesthetic that Duncan and Jess espoused had a remarkable impact on their peer group and has

vital significance for artists and writers today. Their symbiotic relationship and the cultural view it generated are showcased in this exhibition, evidenced through their work and that of their immediate friends and colleagues. Centered on Jess and Duncan's own collection, "An Opening of the Field" presents art with a refreshingly different set of values from mainstream museum fare.

* * *

Reexamining myths through a broad synthesis of cultural references, Jess and Robert Duncan's deeply interrelated works stand as crucial assemblages of the meaning of our time. Jess's art was about the retrieval of images from a culture overflowing with them. In his collages—or, as he called them, "paste-ups"—he created mind-bending interminglings and fantastic juxtapositions, using images taken from sources ranging from Dick Tracy to Dürer, from *Life* magazine ads to medical-textbook drawings, from classical engravings to beefcake photos from *Physique Pictorial.* Jess filtered these far-flung references through a self-described Romantic sensibility, one that valued the transforming power of the imagination above all else.

A key progenitor of postmodernism, Jess has for decades been known mostly to cognoscenti as an inventive and sophisticated master of the collage aesthetic. Both his paste-ups and paintings are now receiving fresh attention from a younger generation attuned to his interests in myth, narrative, and appropriation. Jess's conceptually rigorous works are important touchstones for a wide range of contemporary artists, including Sherrie Levine, Mike Bidlo, Duncan Hannah, Matthew Benedict, Jane Hammond, Wangechi Mutu, Elliot Hundley, and Marco Brambilla. His radical explorations of gender and gay identity are crucial antecedents for works by Felix Gonzalez Torres, Arch Connelly, Thomas Woodruff, Nayland Blake, and Glenn Ligon.

Jess's unusual background helps to account for the intensity and ambition of his work. The youngest son of a Long Beach civil engineer, Jess was an introverted, asthmatic child with strong enthusiasms for L. Frank Baum's Oz books and classical music. His cousin Valerie remembered Jess while in high school introducing her to Beethoven, Mahler, and Bruckner, as well as showing her constellations in the night sky.[1] He read widely—including Poe and Proust. His best friend in school, Bert Golding, remembers him being "an interested reader of literature and literary history" as well as being fascinated by "behavioral or ethical problems."[2] The Depression hit the Collins family hard, and, under his parents' guidance, Jess took a practical path by majoring in chemistry at Cal Tech. His schooling was interrupted by World War II; drafted into the army, he was assigned to work in various labs on the production of plutonium for the Manhattan Project. Experiencing extreme anxiety over the ramifications of his atomic-energy work, Jess in 1948 had a dream that prophesied the devastation of the world in 1975. Eight weeks after the dream, he abandoned science, moved to San Francisco, dropped his surname, and decided to study art. The burning intensity of his life-work substantiates this radical change.

The threat of nuclear apocalypse is a recurring motif in Jess's work, often symbolized by the mushroom-cloud shape of the omega symbol. Duncan wrote of the air of "nightmare gravity" found in Jess's art (and in that of early de Chirico and Max Ernst). He found its roots in the reality of "the grown-up nightmare which the workers in chemistry and physics have brooded in our time. Xibalba, the land of violent death [the Mayan setting for Jess's *Translation #2*], whose Lords cause bleeding in the road, vomiting of blood, running of pus from open sores, the terrors of revolution and of war, has been known by the artist not only in dreams but in actuality."[3]

Just as so much of surrealism can be seen as a response to the horrors of World War I, Jess's work can be read as a reaction to the nuclear threat. Rejecting the world of twisted science, Jess sought a kind of redemption by entering the realm of myth and the imagination. The fact that a dream spawned Jess's art is crucial to his work, demonstrating the importance of the unconscious in his imagery. Jess's only published volume of original writings is *Critical Dreams* (Poltroon Press, 1986), a small-press edition of dream descriptions from the 1950s and 1960s. Following a skewed logic, these dreams involve psychosexual encounters with family members and mythic characters. Loaded with particularized detail and incident, they mirror the collages' multileveled, shape-shifting approaches to narrative and structure.

Jess attended the California School of Fine Arts in San Francisco (CSFA) from 1949 to 1951 during the legendary administration of Douglas MacAgy, studying painting under Clyfford Still, Hassel Smith, and Edward Corbett. Although swept up in the abstract expressionist zeitgeist, the school surprisingly welcomed all kinds of art. In an interview, Jess described the extreme open-mindedness of Still, who taught his students a respect for European art history, an abhorrence of "style," and the poetry of materials.[4] Jess also credited the "dark and moody

poetics" of Corbett as providing a lasting influence. The two untitled Corbett works from 1950 in this exhibition (both formerly in Jess and Duncan's collection) portray atmospheric realms through delicate brushwork and layered undercoating. In the introspective abstraction *Secret Compartments* (1952) (p. 12), Jess amalgamated the jagged forms of Still with the revelatory moodiness of Corbett, endowing the work's ochre and khaki crags and cavities with allegorical meaning.

In a letter, Jess described his first years with Duncan as "a crash course in every aspect of Western art, of course including the Surrealist and Dada workings. Freud in the foreground."[5] His interests in narrative, fantasy, and mythology, fostered by his readings with Duncan, soon surfaced in paintings. In

The One Central Spot of Red (1958) (p. 73), symbols from George MacDonald's magical Victorian-era tale *The Princess and the Goblin*—a pair of scissors, a cavelike mouth, a white rose, a trailing piece of string—appear in an expressionistic landscape of dense, cloudy greens. As Jess moved away from abstraction toward symbolism, he sought formal ways to convey in paint a symbol's heightened state of being. In the queasy pastels of *Feignting Spell* (1954) (p. 14), he depicts a room of discomforted, darting-eyed figures, seemingly pressed into the space by a low pink ceiling and yellow floor. Prompted by Jess and Duncan's troubled friendship with an overstaying houseguest (the painter Norris Embry), the painting exudes a feeling of psychosexual angst.[6] The figures seem oppressed by Embry's ominous profile

Edward Corbett, *Untitled*, 1950
Oil on canvas

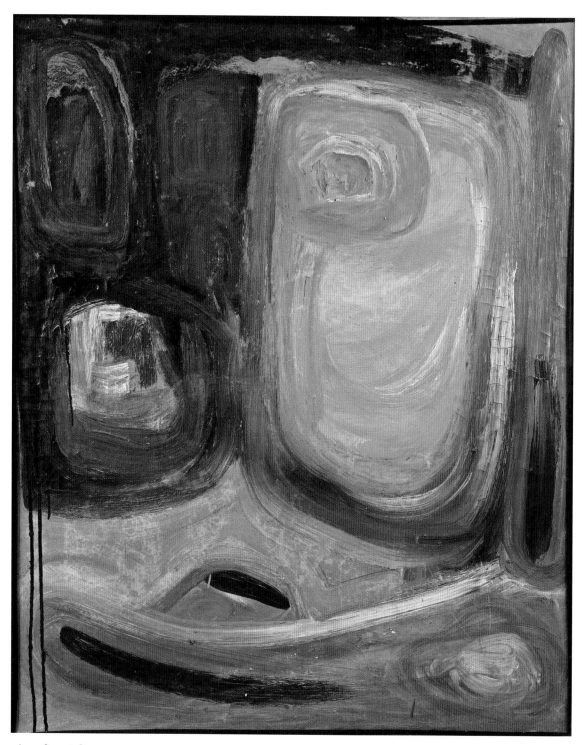

Jess, *Secret Compartments*, 1952
Oil on canvas

in the foreground, their only proffered exit a back-stage passageway curtained with ominous drips. The painting's claustrophobic interior is mottled with several impasto globs of paint that scar its drippy surface like aberrant growths; their extraneous presence pushes the composition into a new, more visceral realm. Similar globs of pigment crop up in unpredictable places throughout Jess's paintings, creating strange textures that stand for the time-consuming act of painting itself. As Duncan put it, "Everywhere in the layers of illusion and illustration arising from the visual syntax of color and mass, of boundary and reference, the painter pictures the painting itself."[7]

The same self-reflexive process is crucial in the Translations, Jess's series of paintings depicting found images. These works began in 1959, after Jess took up the idea of creating a complex painting on the myth of Narcissus, classical mythology's embodiment of the self-reflective nature of art-making. Daunted by the prospect of incorporating a vast number of figurative elements within a single work, Jess decided first to embark on a project that would teach him more about the craft of figurative art. The result was the Translations, a group of paintings based on selective photographs, prints, and drawings, rendered by Jess in the manner of schematically outlined and colored paint-by-number canvases. Over the next seventeen years, as the series grew to include thirty-two pieces, it became less a learning tool than a multifaceted demonstration of Jess's evolving aesthetic. In reworking the black-and-white source images, he employed his odd abstract expressionist palette, giving the paintings a color scheme that doesn't necessarily coincide with their graphic images and that often yields an abstract visual effect. Jess also correlated each found image with a pertinent text—from Plato, William Blake, Gertrude Stein, and others—which he inscribed on the back of the canvas. Through the slow, elaborate layering of pigment, the images were gradually imbued with

Jess's sensibility. As he stated: "I wanted to make myself aware of what I felt about this image. And this intense meditative process that I had undertaken allowed those feelings to come forth."[8]

The existential intensity of Jess's enterprise can be felt in *Montana Xibalba: Translation #2* (1963) (p. 15), taken from a 1944 University of Montana yearbook photograph of soccer players. Each section of the image is overpainted in multiple layers of gobbed-on pigment, building to an overall thickness of nearly three-quarters of an inch. The picture's (literal) weight is explained by a quotation from the Popul Vuh, a Mayan sacred text, which ties the image to a cosmological myth in which the gods play a ball game to determine the movements and fates of the planets. This metaphor crystallizes around the figure 8 on the central player's jersey—for Jess a symbol of infinity, as well as a representation of the paradoxical, endless motion of the Möbius strip. Sections of the playing field are bizarrely colored in flesh tones, lavender, and off-white; graphic lines are signified by deeply carved, relief-like incisions. The built-up paint gives the work an air of sheer obsessiveness, one rivaling on a smaller scale that of the Bay Area's other grand impasto, Jay DeFeo's eight-inch-thick *The Rose* (1958–1964).

The Enamord Mage: Translation #6 (1965) (p. 16) re-creates the image of a photograph of Duncan taken by Jess in 1958 at their house in Stinson Beach. A related quotation from Duncan's poem "The Ballad of the Enamord Mage" ("I have seen green Globes of Water/ Enter the Fire. In my Sight/ Tears have drownd the Flames of Animal Delight") associates the poem's alchemist narrator with Duncan, whose image looms between two burning candles, above a mysterious bowl of peacock feathers and an array of religious (the Zohar) and mythological (*Thrice-Greatest Hermes*) texts. Seemingly ready to conjure a magical transformation, Duncan takes the role as the instigator of Jess's grand Translation project.

Jess, *Feignting Spell*, 1954
Oil on canvas

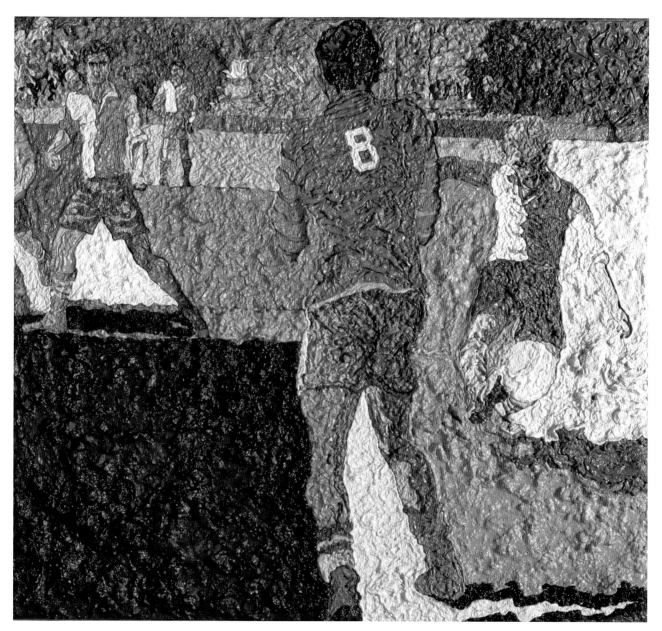

Jess, *Montana Xibalba: Translation #2*, 1963
Oil on canvas mounted on wood

Other Translations are distinctly lighter in tone. For Jess, fantasy illustrations, fairy tales, and nonsense verse are vehicles to heightened states of awareness and the archetypes of myth. As Ingrid Schaffner observed, "The archetypal story for Jess was one of an innocent's wanderings, or fall, into realms of the imagination, the metaphysical, outer space, or the unconscious."[9] *In Praise of Sir Edward: Translation #7* (1965) re-creates part of a playful letter and sketch by the Pre-Raphaelite painter Edward Burne-Jones, sent to the precocious daughter of a family friend. In the full correspondence, noted on the back of the painting, Burne-Jones joked to his young friend in a mock childish voice that he had abandoned drawing in favor of copying—itself a daunting act that he couldn't properly accomplish "if I live 1000 years." The image that the artist—and Jess—"copy" is a charming drawing of a naked toddler riding

on the back of a giant cat. By obsessively copying Burne-Jones's so-called copy, Jess channels this fanciful rapport with a child, creating in the process an emblem of the transformative powers of fantasy and appropriation. He presents as well a compelling advocation of his grand enterprise.

As in the best children's literature, a sense of play both grounds and elevates Jess's work. In 1951 he began translating from the original German a volume of fantastical poems by Christian Morgenstern, a great turn-of-the-twentieth-century creator of improbable animals (the Moonsheep, the Offbeatowl) and absurd objects. Called *Galgenlieder (Gallowsongs)* (p. 18), these gothic reveries, with their eerie transformations and transmogrifications, lurk behind the effusive mélanges of dream and reality found in many of Jess's collages.[10] Jess's original poetry similarly engages wordplay, fantastical

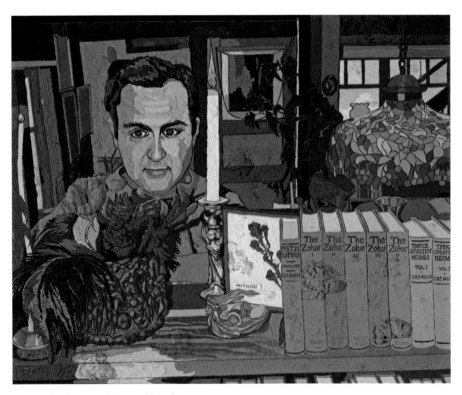

Jess, *The Enamord Mage: Translation #6*, 1965
Oil on canvas over wood

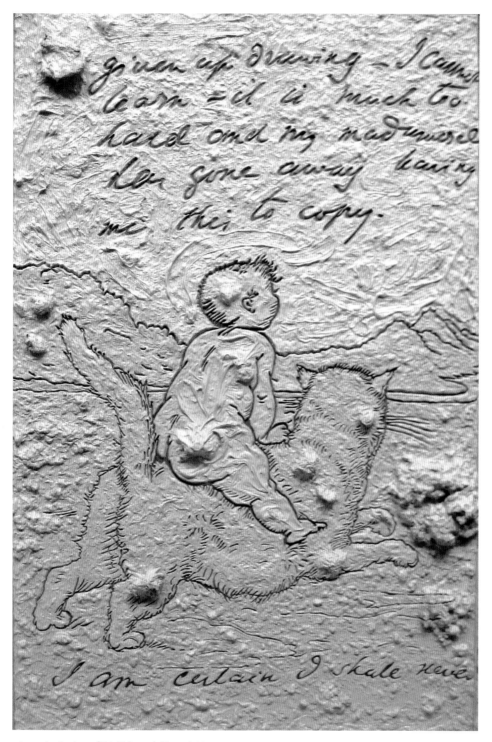

Jess, *In Praise of Sir Edward: Translation #7*, 1965
Oil on canvas mounted on wood

animals, and fairy-tale narratives.[11] In his lively illustrations for children's stories by Duncan (*The Cat and the Blackbird* [1967] [p. 58]) and Michael McClure (*The Boobus and the Bunnyduck* [1957] [pp. 140–41]), Jess also evoked fanciful alternate worlds not unlike those of the fairy tales and Oz books he so admired.

Intended as the culminating work in the Translations series, Jess's extravagant six-by-five-foot drawing *Narkissos* (1976–1991) traces the Narcissus myth through the entire history of art and literature. The complex imagery ranges from the mirror of Dionysus to a Berenice Abbott parabolic mirror reflecting an eye; from a Dürer owl to a Sendak frog; from a Pontormo figure to a crowd scene from Fritz Lang's *Metropolis*. On a mountainous hillside, with a blind Eros standing behind him, the drawing's central figure, Narcissus, kneels by a dark pool. He is transfixed by his mirror reflection, which appears

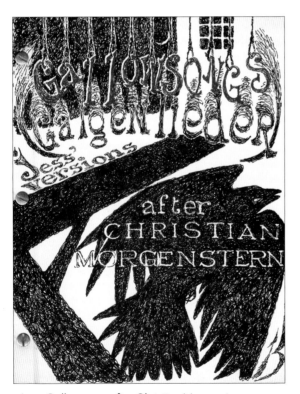

Jess, *Gallowsongs after Christian Morgenstern*
(Los Angeles: Black Sparrow Press, 1970), versions and illustrations by Jess (drawings c. 1959)

here in the guise of Brancusi's sculpted Narcissus head of 1914, a lost modernist work that—significantly—exists only in photographic reproduction. Throughout the drawing, dozens of analogous mirror images and visual doubles reflect Narcissus's fixation; his self-love connotes desire for a facsimile of himself, a copy, a work of art. Jess's Translations—his grand project of copying—folds into the all-encompassing presentation of the myth. Around this mind-bending tableau of self-reflection, Jess creates a wildly vertiginous landscape where multiple versions of Echo take suicidal leaps, and where rivers seem to flow both uphill and down.

During the work's long making, Jess kept a notebook of transcribed texts and clipped images relating to the Narcissus myth, charting his determination "finally to maintain intense homoeros unprofaned, sensuous, joyful-fearful."[12] In its "Image Reservoir," the notebook included wide-ranging lists of paintings and drawings to use as potential sources for "Landscape," "Water," "Symbols," "Youths," and various mythological characters. The *Narkissos* project stands as an unparalleled compendium of ideas and attitudes about masculinity and homoerotic desire tracked through mythology, literature, and psychological analysis.[13] Like, say, Duchamp's *Large Glass* with its accompanying *Green Box* notes, *Narkissos* is a vastly complex artwork that rewards scholarly study.

In contrast to the formal control of the Translations and *Narkissos,* the paste-ups are sprawling, extravagantly chatty massings of images. Inspired by Max Ernst's *Une semaine de bonté*—a birthday gift from Duncan in 1952—Jess's earliest collages reshuffle magazine advertisements and captions. The tone of Jess's early collages is light, extending to campy in-jokes; a fractured headline in *Boob #3* (1954) announces "The story of how we once pleased women by being forgetful—but only once." In *Untitled (Eros)* (c. 1956) (p. 20), the word "sticky" in a drippy font appears amid a homoerotic mélange of images;

a matador, sailors, and Jack Kerouac spice a stew of strutting and stretching beefcake clipped from physique magazines.

As Jess grew obsessed with myth and archetype, the collages became intricate fields of clotted and amalgamated images that convey what he called "a network of stories." By tracing the logic of Jess's visual decisions, the viewer is brought inside the artist's protean, image-happy world. Increasing to sizes of up to four by six feet, the collages often take the form of giant landscapes or seascapes, sometimes with posters of mountains or oceans serving as backdrops. With Brueghel-like exuberance, Jess fills his landscapes with a host of symbolic images that are all spun out of the natural world. Here, metaphors are literalized and glued in place: swimmers are clouds, red kittens are autumn leaves, Michelangelo's Sistine Chapel ceiling is the bark of a very well decorated tree. The paste-ups are imaginative worlds to get lost in; they are Jess's visual translation of fiction's narrative spell. At the same time, Jess presents not one but many stories simultaneously, again in the fashion of Brueghel or Bosch.

In the paste-ups, Jess often uses an arcane mythological reference as a springboard. The flux of sea creatures, detritus, and sexual spume tossed up by

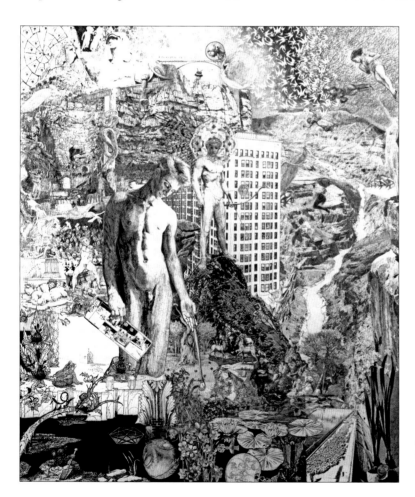

Jess, *Narkissos*, 1976–1991
Graphite on paper and
collage, 70 x 60 in.

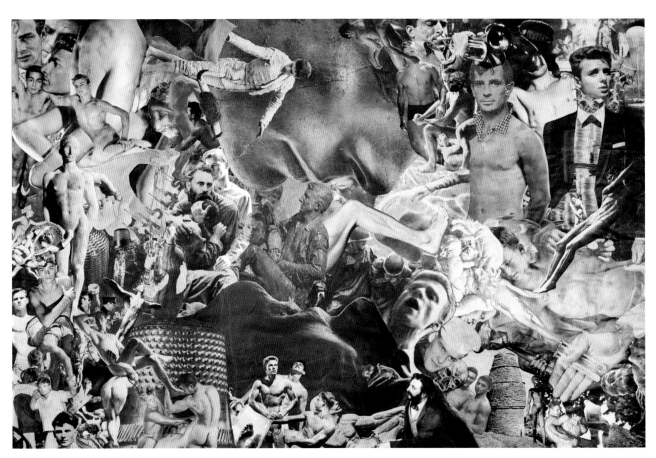

Jess, *Untitled (Eros)*, c. 1956
Collage

the ridge of the tsunami in *Sent On The VIIth Wave* (1979) (p. 22) refers both to the mother-wave that Australian surfers anticipate (the largest in each cycle of seven) and to the birthplace in Welsh Celtic mythology of the goddess Bloddwynn, the Goddess of the Western Isles of Paradise. Jess presents a huge crest of sensual images riding a "pipeline" with risky abandon. Developed in the 1960s, a branch of higher mathematics called catastrophe theory described how sudden shifts in geometric behavior arise from small changes in circumstances, visualized graphically in the form of a wave. Typically including an allusion to such *Scientific American* lore, Jess presents a "catastrophic paradise" of interactions and transformations that gather force to climax and hit the shore.

Jess originally intended to create paste-ups for all twenty-two major arcana of the tarot but completed only five (the Fool, the Hanged Man, the Sun, the Chariot, and the Hermit).[14] *The Chariot: Tarot VII* (1962) (p. 23) conveys the paradoxical stasis and motion symbolized by its card, presenting an imposing pile of images including a train, chess-set knight, winding staircase, classical statuary, several jalopies, bumper cars, flocks of birds, and disembodied eyes. Other paste-ups address personal and political concerns. Jess's outrage against the Vietnam War and the militaristic expansion of the Johnson era exploded in *The Napoleonic Geometry of Art— Given: The Pentagon in the Square; Demonstrate: The Hyperbolic Swastika* (1968) (p. 24), one of Jess's most sardonic works and a masterpiece of political satire. Including a large swastika lightly incised on its Plexiglas covering, the paste-up parodies the proof of a geometric theory, punning on the dubious associations of the US Pentagon at that time. Here, an abstract warrior-denizen of the "UNTIED SSTATE OF CIA-MARE" composed of fragments of maps leads the charge on a central target surrounded by a devilish array of weapons and relics of imperialism.

In the Salvages, a series of paintings made in the 1970s and 1980s, Jess personalized the accumulation aesthetic of the collages, using the figurative skills he acquired in making the Translations. Most of the Salvages started from abstract paintings of the 1950s—either his own abandoned works or canvases bought in thrift shops—to which he added new figurative imagery. The resulting themes are appropriately self-reflective. The Salvages are Jess's most subtle and personal works, filled with passages of intricately painted beauty. In *Signd and Resignd: Salvages VII* (1965/1987) (p. 26), Jess depicts, over a spooky expressionist townscape, scenes of rock-throwing rowdies and a street artist making a chalk drawing. A man in the foreground with a yawning kitten in his lap gazes into space, "resigned" to brutality and the ephemeral. In Jess's last work, *"Danger Don't Advance," Salvages IX* (c. 1995) (p. 84), a drawing of the railroad construction crew who linked the eastern and western United States at the turn of the twentieth century is applied over a standing male nude. The work's title warns of the ominous nature of America's destiny and serves also as a kind of "noli me tangere" tattoo for the central figure; any "advance" casts this naked Adam out of Eden.

With his strategies of appropriation, Jess reanimates allegory and symbolism, modes that have lost favor in our literal-minded, ahistorical era. In reexamining myths through a synthesis of art and literature, Jess invigorates modernist formal structures and shows how postmodernism might acquire a surprising historical weightiness. His achievement goes hand in hand with that of his remarkable partner.

* * *

Robert Duncan is a uniquely towering figure in American poetry, offering in his writings a myth-obsessed appreciation for all forms of the poetic imagination. A voracious reader of everything from

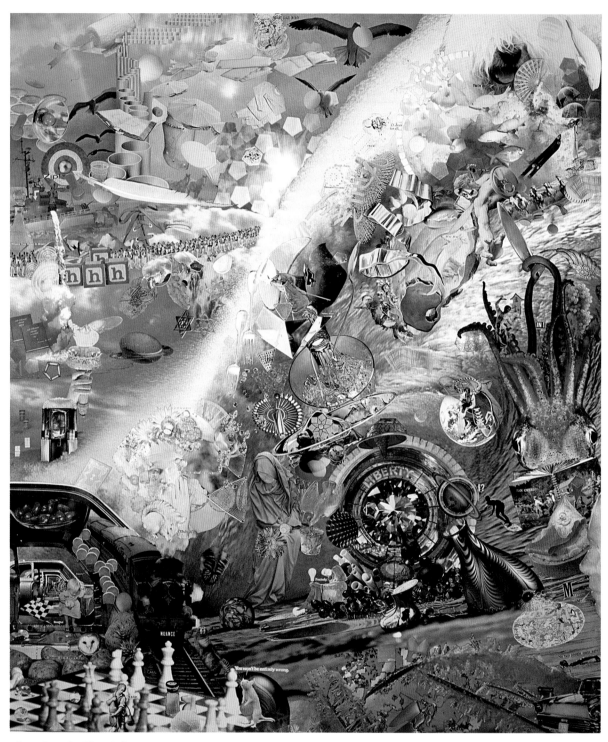

Jess, *Sent On The VIIth Wave*, 1979
Collage and mixed media

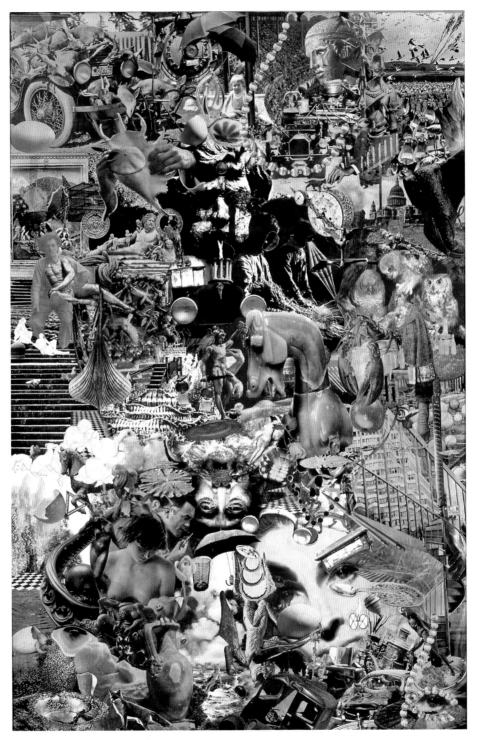

Jess, *The Chariot: Tarot VII,* 1962
Collage

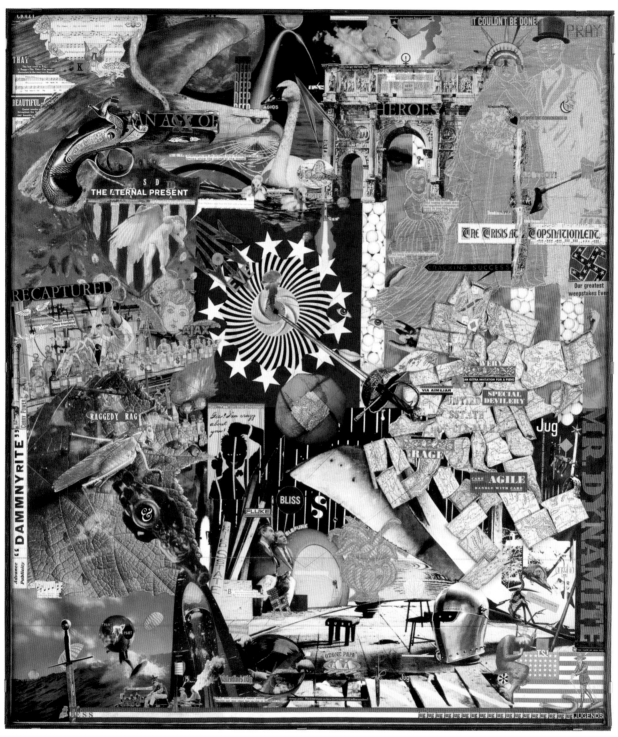

Jess, *The Napoleonic Geometry of Art—Given: The Pentagon in the Square; Demonstrate: The Hyperbolic Swastika*, 1968
Collage and diverse materials

Jess, *"Rintrah Roars . . .": Salvages VI*, 1965/1981
Oil on canvas

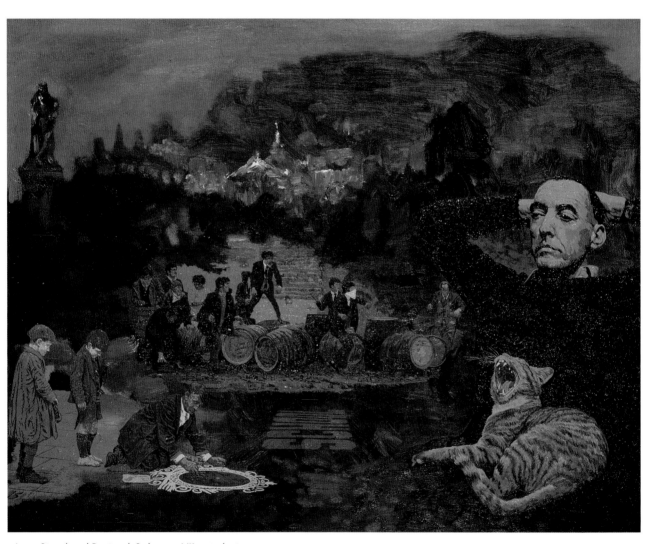

Jess, *Signd and Resignd: Salvages VII*, 1965/1987
Oil on canvas

Paracelsus to the Oz books, Duncan published over forty volumes and has been acknowledged as one of the most erudite poets of his time. In his eclectic myth-laden verse, he took as his program "to emulate, imitate, reconstrue, approximate, duplicate."[15] Spinning off from the modernist practices of Ezra Pound, H.D., and William Carlos Williams, Duncan melded images and ideas from art and life in order to tap what he called "a community of feeling."[16] He embraced an "open field" poetics derived from the projective verse of Charles Olson, transfiguring autobiographical incidents and confessional details into communal experience. With a proto-postmodern breadth of referents, Duncan set the stage for a refreshed poetic engagement in society, human psychology, and the spirit. James Broughton wrote of his breadth of learning and love for ideas:

> I delight in the verbal playground of his mind wherein ideas trip over one another, slide off in lost directions or incomplete somersaults, dig tunnels, make faces, stand on their heads squealing. His conversation was a bewildering tour of hermetic philosophy, astrology, linguistics, Blavatsky, Celtic myth, the Zohar, Whitehead, medieval history, family history, and many other resonant zones freely retranslated by his mental hopscotch. Even when I had no clear notion of what Robert was talking about, I relished every moment of hearing him speak it.[17]

Although Duncan's writings have for the most part been out of wide circulation, the publication of a six-volume edition of collected works is now under way. Contributing as well to the revival of interest in his work are a new biography and a volume of collected interviews.[18]

Adopted as an infant by a Bakersfield couple who were followers of theosophy and hermetic thought, Duncan was from his youth steeped in myth and allegorical interpretation. He attended the University of California, Berkeley, for two years before heading to Woodstock and then Manhattan in 1938, where he fell under the spell of writer Anaïs Nin and her friends Henry Miller, Lawrence Durrell, and Kenneth Patchen. He was drafted in 1941 but obtained a psychological discharge by openly announcing his homosexuality. In 1944 he published a controversial essay in *Politics* magazine, "The Homosexual in Society," that forever marked him as an outsider from the East Coast mainstream literati. His writings of the 1940s reflected his discovery of writers who would prove to be lifelong influences: Gertrude Stein, H.D., Pound, and James Joyce. Duncan also became extremely well versed in art history, having sought out museums in his travels and avidly followed the art scene of the 1930s and 1940s. In a 1939 letter to friends Lili Fabilli and Cecily Kramer he cited images that he pinned on his wall by Rouault, Matisse, Picasso, Virginia Admiral, Dufy, Kandinsky, Miró, Rousseau, Giotto, Braque, and himself.[19]

Duncan returned to Berkeley in 1946, taking classes in medieval and Renaissance studies and connecting with a circle of poets associated with Kenneth Rexroth that included Jack Spicer and Robin Blaser. His experiences as part of the so-called Berkeley Renaissance provided the subtext for *The Venice Poem* (1948), a richly allusive investigation of the poetic spirit. When Jess heard Duncan read the poem publicly in Berkeley, its raw sexual energy and intellectual breadth made a tremendous impact on him. His meeting with the poet shortly thereafter led to a lifetime association. Duncan brought to the relationship a sophisticated knowledge of Western literature and philosophy as well as a lifetime of exposure to the arcane esoteric lore of his theosophist parents.

Duncan and Jess's relationship thrived on a remarkable mix of complementary and contrasting factors. They shared a sense of independence nurtured in reaction to controlling families.[20] Duncan

had endured a bizarre set of parental expectations. His adoptive theosophist parents raised him with an awareness of the astrological significance of his birth date and his presumed past-life as no less than a denizen of Atlantis. This parental notion of him being distinctive was both burdensome and liberating, endowing him with a sense of difference and entitlement from an early age.[21] He described himself as having an "overwhelming centeredness of self—a self so confident it's barely about to experience its risks."[22] With a matter-of-fact acceptance of his homosexuality and identity as a poet, Duncan was a precocious independent spirit from an early age. He was a ringleader advocate of left-wing politics and cutting-edge literature at Berkeley, where he socialized with a tight-knit group composed mostly of women. Duncan, Virginia Admiral, Pauline Kael, and the sisters Lili and Mary Fabilli were politically active, free-spirited bohemians whose nervous pre-war energies were focused on socialist rallies and a series of fledgling literary journals.

Duncan's interests were not confined to literature but included art, music, and film as well. Although not widely known, his crayon drawings and set designs provide a fascinating backdrop to his writing. In his college years, he was interested in the automatic drawings of the surrealists. Inspired by the activities of his painter friends Virginia Admiral and Lili Fabilli, he made spontaneous, colorful crayon designs, many on unpainted wood furniture. As Admiral stated, these designs were made "without hesitation, self-doubt, theorizing, speculating or calling it art."[23] His notebooks from the early 1940s include elaborately composed abstract drawings that toy with the idea of patterning, varying regularity of shape and color with improvisatory flair. In 1941 Duncan had met Hans Hofmann in Provincetown and was clearly drawn to his use of bright colors. Fanciful line drawings in the mode of those by Cocteau often accompanied manuscript

poems and books given to friends. In 1952 Duncan made fifty copies of his poetry pamphlet *Fragments of a Disorderd Devotion* to give as Christmas greetings, each featuring a different hand-drawn crayon cover. Duncan's illustrated booklet *The Return* (1957) and several other decorated books were made as gifts for Helen Adam, partly in response to her numerous gifts of poems, collages, and photographs.

Created in a style derived from Picasso, Matisse, and Miró, Duncan's colorful abstract works confirm his belief in the protean nature of form. Like Jess, Duncan believed in imagination and metamorphosis as aesthetic prompts. The playful nature of Duncan's poetics seems carried over into the drawings' use of

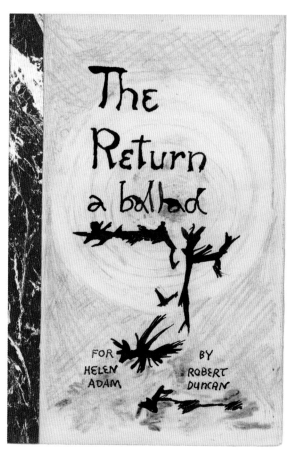

Robert Duncan, *The Return: A Ballad (for Helen Adam),* 1957
Handmade book with wax crayon drawings

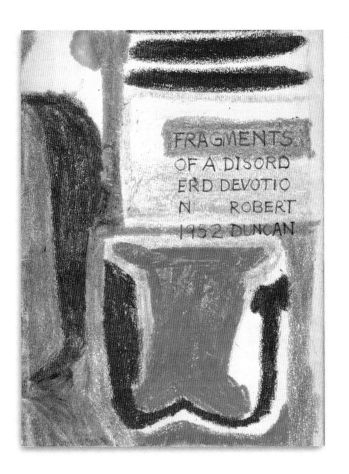

Robert Duncan, *Fragments of a Disorderd Devotion* (San Francisco: privately printed, 1952) Book with cover hand-decorated in wax crayon and ink (two copies)

visual rhymes, repetitions, and organic and erotic shapes.[24] In 1951 he began using a special crayon made of beeswax and oil that resisted fading from sunlight. Christopher Wagstaff has noted the special properties of crayon as a medium: "Less fluid than oils, crayons require a sense of working into and with a form rather than working out a predetermined form, a very important distinction for Duncan."[25] Describing Duncan's drawings, Jess wrote to friends that they were "brilliant as butterflies alight on the walls."[26]

Duncan's productions of plays used larger-scaled theatrical drawings as set decorations. In 1955 a staged reading at the Six Gallery of Duncan's verse play *Faust Foutu* featured a cast of Duncan, Michael McClure, Helen Adam, Jack Spicer, Lawrence Jordan, and Jess, as Faust's mother. A published version of the play included Duncan's stylized line drawings.[27] Duncan's crayon and collage portrait for *Faust Foutu* was used on stage, signaling the ripe sensuality and comic plaintiveness of the title character, an absurdly all-suffering painter who blusters through a bevy of imploring lovers and self-reflexive melodramatic gambits. Duncan stated that the play was dedicated to his incorrigible friend, the painter Norris Embry, and that the Faust character was "compounded of Norris, Brock [Brockway] and Myself."[28] In Duncan's drawing, Faust's hairy nude body is adorned with loose scribbles and tattooed with the names of Norris Embry and Robert Duncan; "Love" is scrawled on each of Faust's meaty thighs. For a summer 1953 performance at King Ubu Gallery of Gertrude Stein's *The Five Georges,* Duncan produced a large drawing depicting one of the Georges in eighteenth-century wig and Roman toga (p. 78). The mock seriousness of the figure's regal stance reflects Stein's typically elliptical entertainment, whose lineup included George Washington as well as her friends George Platt Lynes, Georges Hugnet, and Georges Maratier.

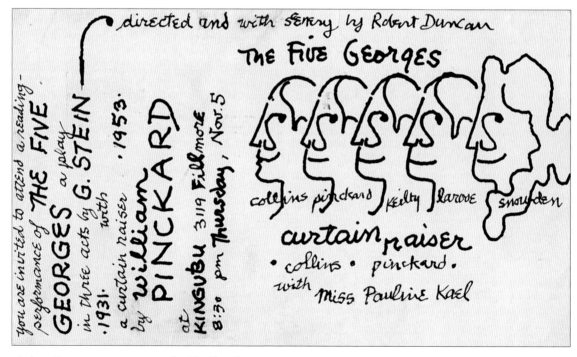

Robert Duncan, announcement for *The Five Georges,* 1953

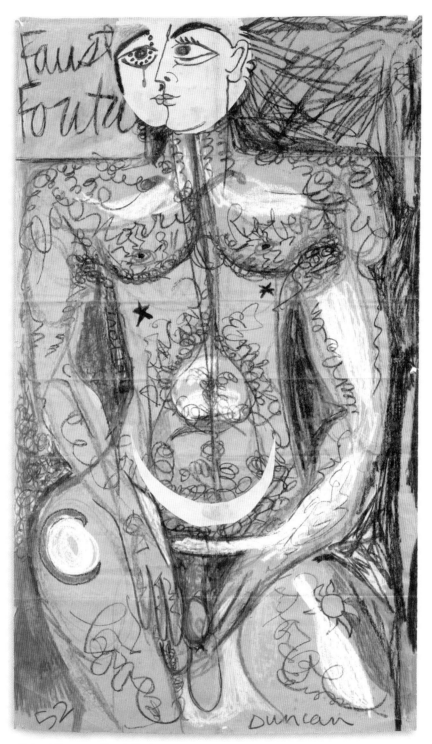

Robert Duncan, *Faust Foutu*, 1953
Wax crayon with collage on butcher paper

Just as Duncan came to the relationship well versed in the history of art, Jess had a deep ongoing interest in literature. While in the army in 1944, Jess sent off for a signed copy of Joyce's *Finnegans Wake,* the book that became the key text in his development as an artist and thinker. After he left the army and returned to Cal Tech, he stumbled across Joseph Campbell and Henry Robinson's *A Skeleton Key to Finnegans Wake* (1947) and became "utterly entranced" by the allusive reading of Joyce's pun-filled, myth-tipsy text.[29] Campbell and Robinson described the intentions behind Joyce's dense, hyperliterate novel:

> Amid trivia and tumult, by prodigious symbol and mystic sign, obliquely and obscurely (because these manifestations are both oblique and obscure), James Joyce presents, develops, amplifies, and recondenses nothing more nor less than the eternal dynamic implicit in birth, conflict, death, and resurrection.[30]

Jess's own practice was to be built upon a similarly ambitious simulation of the processes of life. Joyce's epic remained Jess's touchstone, inspiring his etymological-based wordplay and transformative visual notions.

While working at rural Washington's Hanford Engineering Works, Jess took up painting in his spare time. After first enrolling at the University of California, Berkeley, to pursue a master's degree in chemistry, he made the switch to art and was lucky to have been guided to CSFA, where he blossomed under the stimulus of its amazing faculty. After an argument with his father, he decided to cut off all relations with his past. Nothing is known of the specific content of this quarrel.[31] Jess's papers include no letters and very few documents from his life before meeting Duncan.[32]

The severance from his past seemed to liberate Jess to pursue his desire to become an artist and to live openly as a gay man. Jess's new life included a frankness about homosexuality that was unusual for the time. In a 1950 CSFA class taught by Hassel Smith, Roy DeForest remembered striking up a friendship with Jess: "After about the whole quarter, he said, 'Roy, a friend of mine and I are having a party. Why don't you come over?' So I came over. It was the first time I ever saw guys dancing with each other and I was right off the farm."[33]

The relationship with Duncan sparked Jess's exploration of sexual imagery, both in paste-ups and the remarkable *A Thin Veneer of Civility (Self-Portrait)* (1954). In this painting, Jess depicts himself nude with hands at crotch level, dangling string to play with his cat. Above him, the face of his beloved shimmers with the luminosity of the head of Holophernes in Gustave Moreau's *The Apparition* (1876).[34] Tender, tongue-in-cheek, and pointedly sexual, the painting blithely breaks nearly every taboo of its time. In *Lovers III: Erotic Triptych,* (1969) (p. 34), a gift to Duncan, Jess presents fellatio as a romantic trope. In its bucolic forest setting, blithe gay sex is the centerpiece of a Renaissance-style triptych.

Just before he met Jess, Duncan had been introduced by his friend Brock Brockway to the explosion of activity at CSFA. At the time, he wrote a friend that he had "pursued almost to exhaustion the adventure of seeing what is going on; Bischoff, Still, Edward Corbett, Hassel Smith, and Brockway—all demand one's eye."[35] His interest in the new scene peaked with Clyfford Still's 1950 exhibition of paintings at the alternative Metart Galleries in San Francisco:

> My mother had already given me money to go back to school where she thought I was going to get a degree. I was going to go to Europe; in fact, the trip had already been paid for. Then I saw this Still show and that changed my mind . . . I realized when I got home that I'd seen something absolutely stupendous. Stupendous is the right word, because it

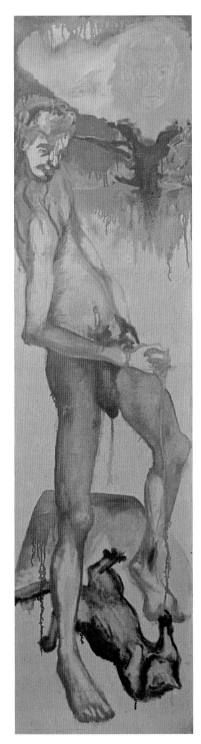

Jess, *A Thin Veneer of Civility
(Self-Portrait)*, 1954
Oil wash on canvas

knocks you . . . [He] was a mixture of inside feelings and grand proportions of form . . . They offered an experience of a contradiction of an aesthetic which immediately made it appealing."[36]

Still's mix of the personal and the monumental proved to be a kind of model for Duncan's poetics. Duncan's decision to move in with Jess was both a personal and aesthetic commitment:

> We are so close, very cooperative in temperament. We had that point of decision: I was able to move in with him only by realizing that I felt as enthusiastic about his painting as I did about my own poetry, that it was a "thing," a process of art taking place, and I would not worry about whether we would be successful or not . . . In 1950 to 1952, the period when I came to know Jess, I went way beyond where I'd been before, absorbing being a "poet."[37]

Both their practices sharpened and focused after the partnering. In several key early collaborative projects, Jess made collages and drawings to accompany Duncan's writings.[38] Some Jess works served further as springboards or counterpoints for specific Duncan poems and essays. Language and poetry were integral to Jess's visual practice. In his subtle, conceptually rich illustration for Duncan's poem "An Imaginary War Elegy" (p. 35), for example, the rhyming Chinese characters for "blood" and "snow" flank a diagram depicting the alchemical distillation of a contained scene of warfare into another held in a beaker; as Duncan relates in his poem, war is an inexorable, unalterable part of nature.[39]

In the early years of their relationship, Jess's purview expanded radically to include an ever-wider range of mythological and literary references. In the mid-1950s he used as springboards for paintings quotations from Dostoyevsky (*Feignting Spell*) (p. 14),

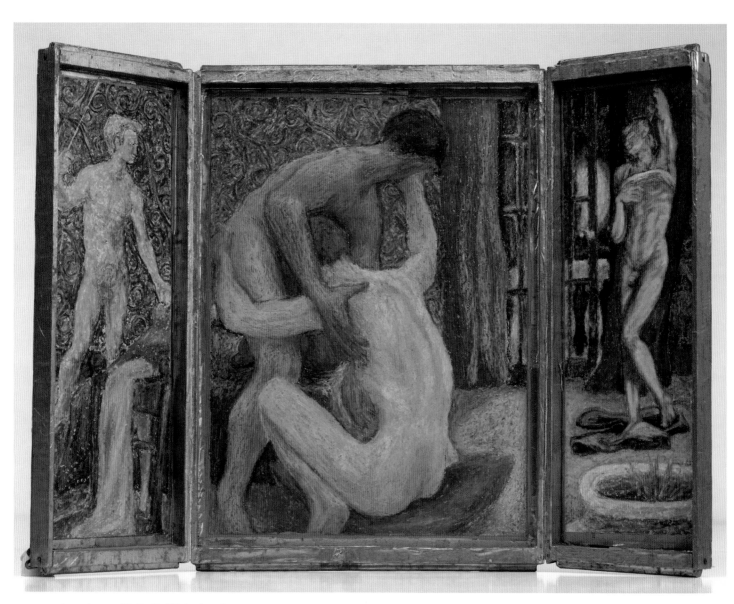

Jess, *Lovers III: Erotic Triptych*, 1969
Wax crayon on paper, mounted in cabinet

Ovid (*An Antinous*), and Cervantes (*Don Quixote's Dream of the Fair Dulcinea*) (p. 72), inscribing them on the backs of the canvases and including them on exhibition wall labels.[40] Throughout their thirty-seven years together, Duncan's poetics continued to inspire and deepen Jess's conceptual approach to the appropriation of images. The Translations series was conceived like a complex volume of poetry with interrelated motifs and themes.

The couple made one extended trip together in 1955—a yearlong stint in Europe, visiting London, Paris, and Barcelona but spending most of their time in the Mallorcan village of Bañalbufar. The quiet atmosphere of Mallorca proved immensely productive for Jess, while Duncan struggled at times with the isolation. At a down moment well into the trip, he wrote to Robin Blaser, "I pine for diversions, of talk, of personalities, or of American movies . . . I want to go to Paris and there wont ever be enuf money for it. Famished anyway for city life."[41] In later years together, Jess's stay-at-home routine wildly contrasted with Duncan's life on the road in the public sphere; starting in the late 1960s, Duncan spent much of each year traveling, teaching and reading at colleges and universities.

During that time, the couple's correspondence sustained and nurtured the relationship. On visits to museum and gallery shows across the country and in Europe, Duncan acted as Jess's eyes, re-creating the artgoing experience for him. A 1960 letter provides a good example of one of his reports from the field:

Dearest—
Back from Middletown where this morning I saw a small show of "paintings of other worlds" that included a masterpiece of a portrait by Francis Bacon where the hands were single bold twisted globby brushes of mixed paints—achieved somehow in the midst of calculated draftsmanship—with a brow of

another fluid blob; and a Delvaux of skeletons that would have delighted Helen [Adam], gloating over a new grave; a beautiful Magritte of a human chair in the seat of a giant stone chair in a deserted seashore scape.

These were the striking things. There was a Dubuffet—but now I find there is less and less to look at or to look into in a Dubuffet.

Then when I got to New York between 4 and 5 I had an hour at the Guggenheim where there were so many immortal paintings—Kandinsky, Bonnard, a Cezanne, Braque, Leger—even a shining Hélion—Delaunay (five at least), Gleises, Metzinger, Modigliani: but here, the beautiful verification was Tapiés—he is a wonderful painter. A rough quiet of spirit? A massive tranquility. And there was a ten foot ceramic gate (at least ten) by Miró . . . Every ass though who objected to

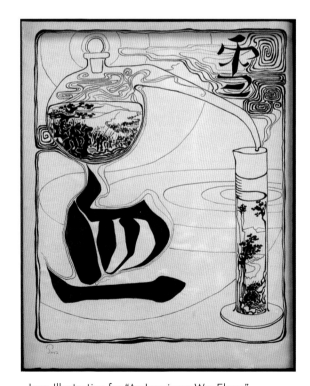

Jess, Illustration for "An Imaginary War Elegy," c. 1962–1964 (with Robert Duncan)
Ink on paper

the size of the exhibition rooms was not looking: there are ample spaces for big paintings. Picasso (two paintings) was disappointing, and DeKooning (so that he leaves me after this canvas unsure). O Jess! The fairy tale Kandinskys! A room of them![42]

While Duncan toured Paris's Gustave Moreau Museum in 1979, he scribbled a letter while he walked through the gallery:

In the Great Hall of his mansion—where immediately, tremendously—as somehow not in exhibitions selected to show him as symbolist or as decadent—his genius is present and awesome indeed. The mural size of the paintings larger than their actual dimensions, the strength throughout of a commanding realization I had not thought to come into. He evokes rightly his co-existence in vision with Leonardo. And on hinged leaved-panels there is a magnificent testimony of his mastery in drawing: the male nude, the beauty of the facial structure, animals: elephant, cat, horse, rhinoceros (in which painting does the rhino come into his language), birds—pelican, ibis, eagle, vulture; snakes and always structural drawings from skeleton, as well as drawings from life. O, yes, monkeys (I write here minutes in my first viewing: I am at section 3: trees, plants, fruits, flowers noted in botanical detail, here too he lays open for himself the structure—just what the hostile and careless critics would maintain he lacks.

So one has absolute evidence in depth that though he inherits and mines his inheritance in the art of Leonardo and of Ingres, he draws from life and from a biological structure. After which he invents/projects/creates (even as I see the later Renoir doing) the living bodies of his own inner need of a world to speak.

I have just come upon drawings of a lion or of lions in action as thrilling as Delacroix. Now skeletons of lions or large cats. And of cat or lion skulls. More of the vulture's head, neck and wings, detailed analyses of how the articulation goes in movement. Then flowers botanical, decorative, architectural.

Now, Section 4—drawings done from the drawings and paintings of others, rehearsing the language of Art itself in its metamorphosis landscapes—that even come into the realm of Caspar David Friedrich—and that rehearse also the passages of Lorrain.

I will return to these drawings tomorrow. They number 2037![43]

Jess was a huge fan of Moreau's work and undoubtedly relished every word. In a 1973 letter Jess showed his appreciation for Duncan's communiqués and summed up his psychological need to stay grounded:

Your beautiful accounts of wonders are better to me than if I had to travel. It was, remember, mostly my inertia that kept us immured in Paris—the hunger, cold, etc was nothing to my inability to tour. I can't assimilate rapidly & so much history, art, strangeness, at every turn of the eye, requires that I live for years in a place in order to see it bit by bit—probably why I'm such a slow painter. And, a tourist just cannot avoid the continual concourse of people, services are indispensible to him . . . for me, no, I unravel.[44]

In turn, Jess's letters gave Duncan solace on the road, reminding him of the domestic comforts of home. Jess's letters relate in detail immediate household dramas: the anticipation and birth of a litter of kittens, the trauma of a rainstorm that flooded Duncan's upstairs office, the blossoming and pruning

of the backyard garden.[45] Duncan relished these reports from the home front, writing back:

> My readings are I find akin to your strata of the painting, strata of my own language that have built up in me, not in notebooks only, strata of a poetic mind; as your presence of the body of Narcissus builds up from lookings; well, as you must know, not a new feeling of my reality but here—a verified feeling. And away from home, my thought ever returning there pictures and re-pictures its terms there. You suffer the burdens and bindings I acquiesce to, and what makes every time freedom a joy, dearest, is that it is a life more "ours" than it was before . . . And here, as I find my intellectual relations more confident and directly what they are, I find myself "closer to home." The Garden, the Library, the Household from which my imagination opens up and the layers of voice and image build. Inhabiting the thought of them, I move here as I will . . . a lovely feeling of it; but not without its contradictions.[46]

The establishment of a household for both Jess and Duncan was a metaphor for the way they constructed art out of the writings, pictures, stories, and accomplishments of the past. Duncan's parents had groomed him to follow in his father's footsteps and become an architect. In an interview he compared the poetic practice he chose to that alternate career path:

> I'm making buildings and architectures frequently. So I go back to build something, and my intuition of when it's time for me to work is when the whole language proposition appears to me as intuitions of building a building. A poem to me is a building of this kind: it's got very specific properties and it can be intricate; but it always has a suite or a number of rooms.[47]

In the midst of a collage poster for a 1971 exhibition of paste-ups, Jess presented a floor plan (p. 125). A cutout image of a griffon filled the living room; a Grecian urn had the terrace; Medusa was in the kitchen, the Eye of Horus ensconced in the pantry. Upstairs, Athena is off the master suite and an Aeolian harp and American flag took separate bedrooms. For this couple, myth and art were alive and ready for occupancy. Informal and abuzz, with rooms always available, Jess's paste-ups lodge life and propagate myth. Playing with seemingly unlikely juxtapositions determined by visual and verbal puns, Jess domesticates disparate elements of culture. His bricolage world of cutout pictures is an intimate one, predicated on affectionate attention to the forms, sounds, textures, and meanings of individual elements. Filled with cross-cultural nectar, Jess's hives of activity house components that together breed new meanings and forms.

Michael Auping described studio visits that demonstrated the integration of myth into the couple's household routine:

> Jess would always make a healthy breakfast which Duncan and I were obliged to eat, and we would talk for an hour or two about images from books or paintings or street signs, anything that happened to come up that morning. Sometimes I would pick out one of the thousands of old books that seemed to line the interior of the house and ask them to recount the story of why they had collected it. Following a synopsis of the story, Jess would say, "It's here because that story isn't over yet. It's still unfolding." And then Jess might notice the image of a sports figure on the Wheaties box and go on about its mythological origin. It's like the house was a transmitter for wandering myths . . . Jess had a special talent for getting time to slow

down so that fantasy, which in the end is what creative thinking is, seemed as natural as breathing.[48]

Jess and Duncan's "house of myth" represents a departure from the institutional status quo. As a kind of symbiotic team, the couple upheld an alternate aesthetic, one far from "mid-century modern" notions of Bauhaus clean lines and functional form. Ignoring the mainstream, they relished the organic ornament of art nouveau and heartfelt sentiment of Victoriana, furnishing their house with antique Tiffany lamps and vintage nineteenth-century decorations. At the heart of their aesthetic was a renewed sense of the Romantic tradition, one that Jess tracked through Blake, Palmer, Moreau, the Pre-Raphaelites, Redon, and Bonnard. A statement for an early exhibition, most likely written by Jess and Duncan, spells out his mode of operation:

> Romanticism is an ever present and recurring aspect of all periods of art. The coldness of the nineteenth century's neoclassic school gave way to a romanticism. In the work of the American realists of two decades ago, romanticism was an unmistakable undercurrent. Even in abstract expressionism there is seen a romanticism. Romanticism is not a style, but a state of mind. Underlying the paintings of Jess Collins, as he himself says, is a "balance wheel whose spokesmen are Redon, Goya, Blake, Ryder, Bosch, Turner, etc. . . ." "I draw from the well of man's spirit already manifest in his works, as if they themselves were paint-pots of metaphysical color, employing not the iconoclastic acerbity of the Dadaists whom I admire, but asserting the image as the spirit's track recorded."[49]

According to Duncan, the imagery of Jess's early Romantic paintings, evidenced here by *Don Quixote's*

Dream of the Fair Dulcinea (1954) (p. 72) and *The One Central Spot of Red* (1958) (p. 73), rose out of the painter's roots in the nonobjective painting of Still, Smith, and Corbett: "Even as the inkblots of Rorschach stirred the phantasy and in their very non-representational formation gave rise to significant figures in the mind, so the masses of the drip and blob school . . . became generative of inner vision."[50] Duncan acknowledged as well the influence of Vuillard, Bonnard, the Nabis, and Munch, enabling Jess to bypass "the dominant aesthetic of the first half of the century—the grand chic parisien establisht by Picasso and Matisse" in order to embark on "the life-stream of a romantic visionary art."[51]

In his writings, Duncan embraced a Romantic heritage sourced in Dante and the troubadour poets and infused with the sentiment of traditional folklore. He acknowledged the taboo nature of this trajectory:

> The very word "Romantic" is, in literary and social criticism today, pejorative. But it is in the Romantic vein—to which I see my own work as clearly belonging—that the two worlds, the lordly and the humble, that seemed to scholars irreconcilably at odds, mythological vision and folklorish phantasy, are wedded in a phantasmagoria . . . the spiritual romance.[52]

Duncan's more cosmopolitan approach expands the perimeters of modernism to tap the cosmic consciousness of a thinker-poet like Dante, who pursued a "polysemous" meaning including the literal, the allegorical, the moral, and the anagogical (mystical).[53]

Michael Davidson described Duncan's all-embracing aesthetic:

> For Duncan, romanticism involves "powers of love" that are primordial, locked in the forms of biological and psychological life but

intuited in the narratives and images of certain intellectual traditions. Because of their potency, these ideas are deemed spiritually dangerous in times of religious orthodoxy or artistically inferior in times of cultural orthodoxy. They cannot appear except in veiled or occult forms, or else they manifest themselves in despised "naive" or sentimental genres like children's stories or fables. What Duncan calls "permission" refers to the poet's ability to participate (not control) these "potencies in common things" and release them, beyond all reference to literature, to a swirling, changing universe.[54]

Weaving sentiment and romance into the mix, Duncan seeks liberation from the constraints of formalism and the egocentricity of confessional, gut-spilling verse.

In his revisionist modernism, the realms of imagination and the spirit are undeniable, vital aspects of the "thingness" or "objecthood" of the poem. In the opening work of his first major book of poetry, "Often I Am Permitted to Return to a Meadow," in *The Opening of the Field* (1960), Duncan gives "permission" for poets and readers alike to dwell in scenes "made-up by the mind." The meadow of the poem's title is a locus for transformative games, mythic appearances, and "free permission." Characteristically interested in the mythic and connotative, Duncan explicated the poem by referring to the enchantments of Morgan Le Fay and the narrative in the Zohar of Abraham discovering the cave where Adam had been buried.[55] For Duncan, the "field" of poetry is open to such allusions while being infused from within by personal history and feeling. His series of poems titled The Structure of Rime grappled with the infusion of life and myth in the mechanics of the poem itself:

O Lasting Sentence,
sentence after sentence I make in your image. In the feet that
measure the dance of my pages I hear cosmic intoxications of the
man I will be.[56]

Poetic and personal measure are one.

* * *

The Jess/Duncan households were models of social conviviality and domestic tranquility.[57] Although Jess grew reclusive and very selective of guests in later years, in the first decade of the relationship, dinners, music-listening parties, and group sessions of art-making were commonplace events at the house. Lawrence Jordan described the infectious nature of the household: "They had a very delicate . . . very powerful magic in their house that could turn a young artist completely on to the world of the magic of art."[58] Eloise Mixon, who met the couple at Black Mountain College in 1954, remarked in a letter to Jess on the impact of their personal bond:

> Your union, Robert & you, gave me the first indications I had ever had of a relationship that worked . . . During our Stinson Beach days when for a time we lived in the house with you and afterward saw you frequently, I got my first indications of what a marriage could be. You, the two of you, were my model for what was possible. You were so different and yet you didn't try to change each other! What a miracle! You didn't score points at the expense of each other.[59]

Fresh from Wichita, Michael McClure had enrolled in Duncan's 1954 class at San Francisco State; he found the couple's way of life a revelation: "Robert Duncan and Jess Collins, in their household

filled with sculptures, collages, paintings, sounds of Webern and Lou Harrison, and their attention to the arts and biological sciences made an example for me of one of the ways in which life might be lived."[60] R. B. Kitaj was similarly struck by the house as an embodiment of their individualistic aesthetic:

> The Duncan/Jess house is a retreat in which to re-live some of the life of that town . . . Down every alleyway, pictures, out of post-war, westcoast, Balearic, neo-surrealist, early and more heroic modernist days and years and ever on . . . leading to more libraries and more unorthodox art.[61]

For younger gay friends like Tom Field, who—like most of their circle—had never before encountered an openly gay couple, the relationship served as an eye-opener.[62] Jess and Duncan's matter-of-fact commitment and elegant lifestyle radically overthrew clichéd notions about gender roles, conventional marriage, and bourgeois routine. They enjoyed an existence that broke the rules of both Eisenhower Republicans and beatnik bohemians. Jess and Duncan offered a melding of the traditional and the avant-garde that represented something distinctive, both in their personal and artistic lives.

To varying degrees, the visual artists and poets who were intimates in their circle shared their penchant for romanticism, appreciation of myth, and sense of joyful play. For the most part, these figures operated outside the marketplace, making lyrical, intimate, and humorous works for their own edification and enjoyment. Art was often a gift or a trade. After Jess began to receive attention from galleries and museums, he continually promoted the works of his friends, lobbying on their behalf for exhibitions and curator attention. Duncan wrote catalogue essays and letters of recommendation on behalf of Jacobus,

Jess and Robert Duncan
at Stinson Beach, c. 1959

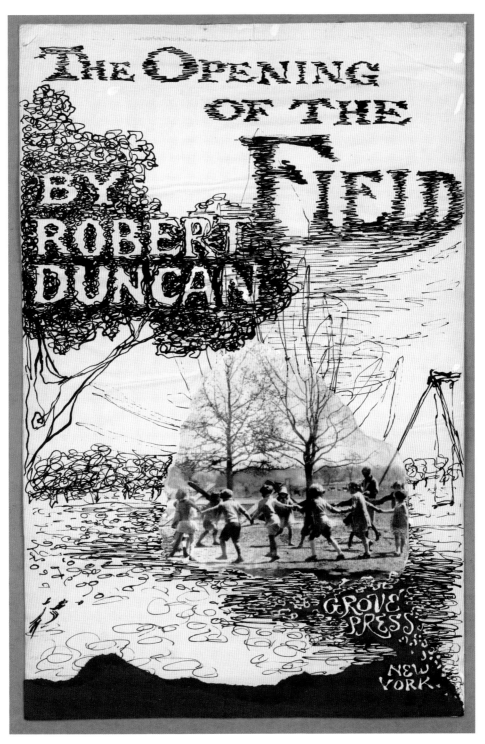

Jess, illustration for title page of Robert Duncan's *The Opening of the Field* (New York: Grove Press, 1960)
Ink drawing with collage

Fenichel, Herms, Kitaj, and Berman, advocating their works as alternatives to the mainstream.[63]

Their works in this exhibition collectively demonstrate both the heritage and legacy of Jess and Duncan's radical experimentation.[64] Jess's lyrical, often Romantic style of nonobjective painting is contextualized and complemented by the lushly painted abstract expressionist works of his CSFA teacher Edward Corbett and fellow students Ronald Bladen, Philip Roeber, Lilly Fenichel, Harry Jacobus, and Tom Field. While those artists' styles vary, they share Jess's interest in the craggy forms of Clyfford Still and lyrical tones of Corbett. Early works by Jess, Brockway, and Jacobus share an appreciation for fanciful colors, domestic scenes, and unabashed lyricism. Jess's *A Mile to the Busstop* (1955) has a forthright fairy-tale narrative directly reminiscent of Brockway's childlike paintings. In turn, the multicolored patchwork elements of Brockway's *Wild Flowers* (1962) share a stylistic similarity to Jacobus's abstractions.

Jess's work had an immediate impact on many of the visual artists around him. The collages of Adam, Berman, Blaser, Edwards, and Herms share his penchant for humor, mythological references, and incorporation of absurdist texts. When asked about early influences on his collage-making, Ernesto Edwards answered with a single name: "Jess."[65] Edwards's accomplished works spin off from Jess's works like *The Mouse's Tale* and *Eros* (p. 20), mixing images of male nudes in a maelstrom of cutout religious symbols, animals, and politicians. Helen Adam's collages emulated Jess's love for unlikely juxtapositions and tersely comic captions. Paul Alexander's series of painted appropriations from the works of Thomas Eakins was a conceptual project clearly akin to Jess's Translations.

Based largely in California, but with significant ties to the East Coast, the artists and poets of this exhibition are connected to crucial nexuses and cadres of American avant-garde production in the 1950s and 1960s. Operating from 1933 to 1957, Black Mountain College counted an astounding number of creative talents among its faculty and students, including John Cage, Robert Rauschenberg, Peter Voulkos, Franz Kline, Harry Partch, Buckminster Fuller, and Willem de Kooning. In the school's final year of operation, Charles Olson invited Robert Duncan to teach several courses there. Duncan's close-knit group of students included exhibition artists Eloise Mixon, Tom Field, and Paul Alexander.

Postwar San Francisco was the site of several artistic and literary revolutions, most famously the one generated around the so-called Beat poetry of Allen Ginsberg. Wallace Berman, George Herms, and Michael McClure became associated with the Beat movement while pursuing their individualistic careers. Directly preceding the Beat explosion, the "Berkeley Renaissance" group of poets—Duncan, Spicer, and Blaser—attracted the poets and artists Adam, Broughton, Herndon, McClure, and Boyce. Exhibition artists James Broughton, Lawrence Jordan, Helen Adam, and William McNeill worked in avant-garde cinema, which also flourished during this era.

The wider circle of artists emerging in the Bay Area in the 1950s and 1960s included such figures as Joan Brown, Bruce Conner, Jay DeFeo, Wally Hedrick, and Deborah Remington, all of whom deeply respected Jess and Duncan's world. King Ubu Gallery (which exhibited works by Jess, Brockway, Duncan, Jacobus, Roeber, and Field) and Buzz Gallery (which exhibited works by Jess, Adam, Alexander, Frost, Edwards, and Herndon) were important early grassroots showcases for Bay Area art. All these sites and groups were crucial breeding grounds for the extraordinary blossoming of art and poetry in midcentury America.

* * *

Jess, *A Mile to the Busstop*, 1955
Oil on canvas

Lyn Brockway, *Wild Flowers*, 1962
Oil crayon on board

Harry Jacobus, *Unsettled*, 1985
Acrylic on canvas

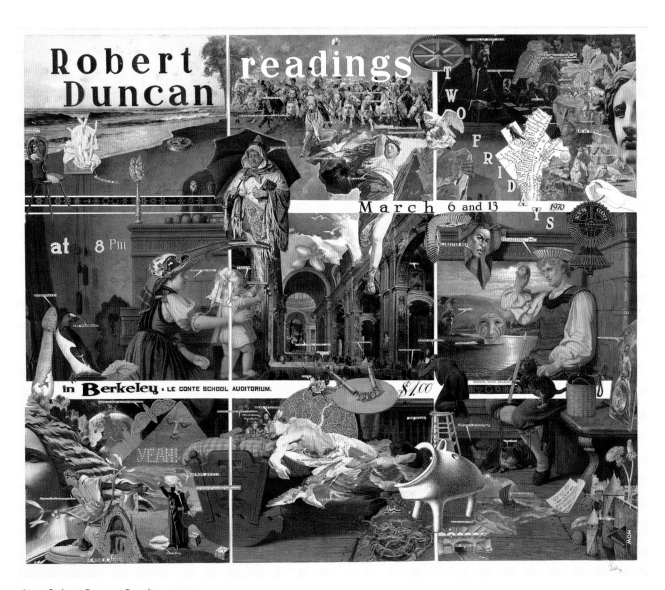

Jess, *Robert Duncan Readings*, 1970
Collage

As the new century progresses, it becomes more and more evident that the 1950s and 1960s were the golden age of American culture, unlikely to be surpassed in creative energy. "An Opening of the Field" presents a lesser-celebrated but significant segment of that zeitgeist. Duncan once stated, "San Francisco is for me . . . a household. Beyond that I don't have much of a picture of the rest of the country; it's almost as vague as living in the rest of history or all of time."[66] It is the specific values and tastes of his immediate San Franciscan community that Duncan appreciated and that emboldened the artists and poets surveyed here to step further outside the mainstream. Michael Davidson has described the "almost medieval sense of poetic coterie" that sustained Duncan's writing, referring to Duncan's devotion to texts by his peers and by literary heroes.[67]

The members of Jess and Duncan's circle drew energy and inspiration from each other in big and small ways. For example, Helen Adam—whose unique and quirky spirit was itself a major influence—surprised Duncan in Mallorca with a copy of John Livingston Lowes's *The Road to Xanadu,* a book that Jess and Duncan read aloud to each other and that Duncan reportedly soon claimed as "his bible."[68] As detailed in the biographical essays of this volume, the artists of "An Opening of the Field" interacted with each other in myriad such ways. Duncan characterized his poetics as "a process of participation in a reality larger than my own—the reality of man's experience in the terms of language and literature—a community of meanings and forms in which my

work would be at once derivative and creative."[69] The artists here were similarly formed from the remarkable sensibilities around them.

As major generators of their immediate scene, Duncan and Jess built an art home that was familiar yet strange, classic yet idiosyncratic. On Twentieth Street, their neo-Romantic sensibilities flourished, enabling them to transform the whole of culture into a vast resource and locus for living, a place to thrive. For friends like Kitaj, their historically conscious aesthetic pointed not backward but forward:

> One day in Duncan's kitchen, I was drawing his profile on a copper etching plate while he read to me from Lady Gregory. It could seem so wrong, as if there are newer things to do in an age when men fly faster than sound. But they still pour out of their churches and kill each other in the streets like they always did so I supposed it's something else, like they say, to draw from the face and read aloud. Eliot said Pound was full of "grand stuff." Duncan says in my own grand copy of *Heavenly City, Earthly City*:
> And we go on, borrowing and borrowing from each other.[70]

For a new generation, the works of Jess, Duncan, and their circle offer ways out of contemporary art's insularity and triviality. Unleashing the metamorphosing powers of the historical imagination, this art can serve as a nurturing haven for future understanding, pleasure, and transformation.

1 Valerie June Warren, letter to author, April 5, 2012; and letter to Jess, July 18, 1995, Jess Papers, The Bancroft Library, University of California, Berkeley. One of Warren's reminiscences evokes Jess's later interests in translation and appropriation: "Do you recall our controversy as to whether we would rather hear a piece of piano music played with notes correct, or with mistakes but with good interpretation?" She also remembered attending opera and a performance of the dance troupe of Devi Ja with Jess.

2 "In literature and history classes he was essentially the only person who would add information by reporting on supplemental material in class. He had a sharp wit, and was able to make even sarcastic comments in a way which was not offensive." Bert Golding, e-mail correspondence with author, March 24, 2012.

3 Robert Duncan, "Iconographical Extensions," introduction to *Translations,* by Jess (Los Angeles: Black Sparrow Press, in association with Odyssia Gallery, New York, 1971), viii.

4 "I remember Still doing a fabulous lecture on Antonin Artaud's van Gogh text . . . It was very moving in terms of my understanding of the passion of the immediate image and the difficulty an artist has in arousing a sense of spirit in a societal structure that tends to suppress it." Jess, quoted in Michael Auping, "Jess: Scientific American," in Auping, ed., *30 Years: Interviews and Outtakes* (Fort Worth, TX: Modern Art Museum of Fort Worth; Munich: Prestel, 2007), 169–71.

5 Letter from Jess to Gerd Hennum, July 4, 1996. Jess Papers.

6 Michael Auping, *Jess: A Grand Collage, 1951–1993* (Buffalo, NY: Albright-Knox Art Gallery, 1993), 36.

7 Duncan, "Iconographical Extensions," iii.

8 Auping, *Jess: A Grand Collage,* 57.

9 Ingrid Schaffner, "Found in Translation," in Schaffner et al., *Jess: To and From the Printed Page,* exh. cat. (New York: Independent Curators International, 2007), 57.

10 Jess's translation, *Gallowsongs,* was published by Black Sparrow Press (Los Angeles) in 1970.

11 Jess regularly published his poems in little magazines. In 1968 he collected them in an as-yet-unpublished volume titled *This Here Other World,* currently located in the Jess Papers.

12 Jess, *Narkissos,* unpublished loose-leaf notebook, 1976–1991, Odyssia Gallery, New York.

13 For overviews of the issues raised by *Narkissos* see: Michael Palmer, "On Jess's *Narkissos,*" in Auping, *Jess: The Grand Collage*; and David Lomas, *Narkissos Reflected: The Myth of Narcissus in Surrealist and Contemporary Art* (Edinburgh: Fruitmarket Gallery, 2011).

14 In a January 1, 1989, letter to John Neff, Jess described his interest in the tarot: "It is for me an extended and therapeutic metaphor, taking its place alongside others, like Eastern philosophies, world religions of all sorts - to counteract - & balance my early training in natural science." Courtesy of John Neff.

15 Robert Duncan, "Pages from a Notebook," *Artist's View,* no. 5, July 1953, 3.

16 Robert Duncan, *The H.D. Book* (Berkeley: University of California Press, 2012), 310.

17 James Broughton, "Homage to the Great Bear," *Credences* 8/9, March 1980.

18 See *The Collected Writings of Robert Duncan* (Berkeley: University of California Press, 2011–), including *The H.D. Book* (2011), *The Collected Early Poems and Plays* (2012), and other volumes forthcoming; Lisa Jarnot, *Robert Duncan: The Ambassador from Venus* (Berkeley: University of California Press, 2012); and Christopher Wagstaff, ed., *A Poet's Mind: Collected Interviews with Robert Duncan, 1960–1985* (Berkeley: North Atlantic Books, 2012).

19 Jarnot, *Ambassador from Venus,* 58.

20 Duncan stated, "Jess and I both had similar parents, ones we wanted to get away from and households we wanted to leave, because in both cases they were coercive towards their children." From Wagstaff, "A Conversation with Robert Duncan," in Wagstaff, *A Poet's Mind,* 205.

21 For a detailed account of Duncan's background and upbringing, see Jarnot, *Ambassador from Venus.*

22 Wagstaff, *A Poet's Mind,* 206.

23 Virginia Admiral, "Remembering Robert Duncan," in Christopher Wagstaff, *Robert Duncan: Drawings and Decorated Books,* exh. cat. (Berkeley: Rose Books, 1992), 9–11.

24 See Wagstaff, *Drawings and Decorated Books;* and Robert Bertholf and Robin Blaser, *A Symposium of the Imagination: Robert Duncan in Word and Image* (Buffalo, NY: Poetry/Rare Books Collection, University at Buffalo, The State University of New York, 1993).

25 Wagstaff, "An Interior Light: A Note on Robert Duncan's Crayon Drawings," in Wagstaff, *Drawings and Decorated Books,* 14.

26 Jess, letter to Eloise and Don Mixon, July 13, 1992. Mixon archive.

27 The third edition of the play was published by Duncan's own imprint, Enkidu Surrogate (Stinson Beach, CA) in 1959.

28 Duncan, letter to James Broughton, fall 1952, James Broughton Papers, Kent State University, Ohio.

29 Auping, *Jess: A Grand Collage,* 33.

30 Joseph Campbell and Henry Morton Robinson, *A Skeleton Key to Finnegans Wake* (Novato, CA: New World Library, 2004), 13.

31 Bert Golding recalled, "It must have been '49 when Burgess [Jess] made a special trip to visit with me and told me that he had decided to start a new life in San Francisco. He said he was going to cut all his existing connections and just start over. I was shocked, and sorry to hear that, but wished him well. I guess it was stupid, but I didn't realize he was also talking about me—I just assumed that after he was settled he would establish some type of contact. After a few years with no contact, I became worried about him, wanted to be certain he was OK, and maybe establish contact. I hired a San Francisco service to track him and got an address for him. I sent him a post card and a short note, but these were neither returned nor answered." E-mail correspondence with author, March 13, 2012. In a November 30, 1998, postcard, Golding made one more attempt at reestablishing communication (Jess Papers). That card went unanswered.

32 In a May 8, 2012, interview with the author, Jess's brother, James Collins Jr., stated that in early 1951 when he and his wife were visiting his parents in Sacramento, Jess came up from San Francisco for a family dinner. He brought Duncan to the event, which proceeded without conflict or major incident. This dinner was the last time Jess saw his family.

33 DeForest oral history, interview by Paul Karlstrom, April 7–June 30, 2004, Archives of American Art, Smithsonian Institution. In reference to ideas about surrealism, DeForest recalls of Jess in 1950, "It was obvious he was really interested in Clyfford Still, but he started to cut up old phone books and do those collages, which were out of surrealism." DeForest was invited to show at King Ubu Gallery in 1953.

34 Moreau's work was a major influence on Jess. The size of *Narkissos* was chosen to emulate that of Moreau's *Hercules and the Lernaean Hydra* (1875–1876).

35 Duncan, letter to Josephine Fredman, November 9, 1950, cited in Jarnot, *Ambassador from Venus,* 125.

36 Interview with Duncan, "A Conversation about Poetry and Painting (with Kevin Power, 1976)," in Wagstaff, *A Poet's Mind,* 297–99.

37 "A Conversation with Robert Duncan (with Robert Peters and Paul Trachtenberg, 1976)" in Wagstaff, *A Poet's Mind,* 200–201.

38 Jess and Duncan's major collaborations were *Caesar's Gate: Poems 1949–50* (Palma de Mallorca: Divers Press, 1955), *A Book of Resemblances; Poems: 1950–1953* (New Haven, CT: Henry Wenning, 1966), and *Names of People* (Los Angeles: Black Sparrow Press, 1968).

39 "An Imaginary War Elegy" is from Duncan and Jess's most accomplished collaboration, *A Book of Resemblances,* featuring Jess's illustrations for Duncan's poems written during the first years of their relationship.

40 The idea of associating the written word with his paintings had occurred to Jess as early as 1949 in the work *Conversation with Roses.*

41 Duncan, letter to Robin Blaser, undated, Robin Blaser Collection, Special Collections, Simon Fraser University Libraries.

42 Duncan, letter to Jess, April 14, 1960, Robert Duncan Collection, The Poetry Collection of the University Libraries, University at Buffalo, The State University of New York.

43 Duncan, letter to Jess, June 21, 1979, Robert Duncan Collection.

44 Jess, letter to Duncan, May 21, 1973, Robert Duncan Collection.

45 Jess's selected letters are being prepared for publication by the author.

46 Duncan, letter to Jess, May 5, 1969, Robert Duncan Collection.

47 Duncan, interview with Jack R. Cohn and Thomas J. O'Donnell, "Flooded by the World" (1980), in Wagstaff, *A Poet's Mind,* 120.

48 Michael Auping, *Speaking at Jess' Memorial Service, April 2004;* published on a brochure for a Jess exhibition, Gallery Paule Anglim, San Francisco, 2005.

49 Press release for Jess exhibition, Gump's Department Store, December 22, 1958, Jess Papers.

50 Robert Duncan, *A Book of Resemblances,* ix.

51 Ibid.

52 Robert Duncan, "The Truth and Life of Myth," in *Fictive Certainties* (New York: New Directions, 1985), 27.

53 Robert Duncan, *The Sweetness and Greatness of Dante's Divine Comedy* (San Francisco: Open Space, 1965), n.p.

54 Michael Davidson, *The San Francisco Renaissance: Poetics and Community in Mid-Century* (Cambridge, UK: Cambridge University Press, 1989), 127.

55 Robert Duncan lecture at the Poetry Center, San Francisco State University, May 18, 1959. Online audiocast at https://diva.sfsu.edu/collections/poetrycenter/bundles/191230.

56 Robert Duncan, "The Structure of Rime I," in *The Opening of the Field* (New York: New Directions, 1973), 12.

57 Jess and Duncan lived at 1350 Franklin Street (the "Ghost House"; 1951), 1724 Baker Street (1952–1954), De Haro Street (1956–1958), Stinson Beach (1958–1961), 3735 Twentieth Street (1961–1967), and 3267 Twentieth Street (1967 onward).

58 Lawrence Jordan, oral history interview by Paul Karlstrom, December 19, 1995–July 30, 1996, Archives of American Art, Smithsonian Institution.

59 Eloise Mixon, letter to Jess, January 28, 1983, Jess Papers.

60 Michael McClure, interview by Anis Shivani, *Huffington Post,* March 3, 2011, http://www.huffingtonpost.com/anis-shivani/exclusive-beat-poet-mcclure_b_823425.html.

61 R. B. Kitaj, "[Untitled]," in *Robert Duncan: Scales of the Marvelous,* ed. Robert Bertholf and Ian Reid (New York: New Directions, 1979), 206.

62 Field was just out of the army when he met Jess and Duncan at Black Mountain College. "I had only been to bed with one guy, and I didn't know much about it, and it was a big hang-up. I was sort of observing these two people and their lifestyle, because one knew they were gay and a married couple. My sexual experience had been jacking off with a guy once in high school, and I thought that was all there was." Interview with Field, March 18, 1986, in *Tom Field: On Painting at Black Mountain and in San Francisco: An Interview,* ed. Christopher Wagstaff (Berkeley: Rose Books, 2006), 3.

63 See the various biographical essays in this catalogue for individual references.

64 Given the broad scope and limited space of this exhibition, there are many artists and poets whose works might also have been included. These figures include David Young Allen, Kenneth Anger, Martin Baer, Kit Barker, David and Lloyd Bary, Betty Berenson, Ebbe Borregaard, Stan Brakhage, Brock Brockway, John Button, Norma Cole, Gui de Angulo, Joe Dunn, Lili and Mary Fabilli, Lou Harrison, Bobbie Louise Hawkins, Ida Hodes, Joanne Kyger, Philip Lamantia, Claire Mahl, Joanna McClure, Marjorie McKee, Bill Brodecky Moore, Liam O'Gallagher, Pauline Oliveros, Ariel Parkinson, Harry Partch, Irving Petlin, and Nata Piaskowski.

65 Ernesto Edwards, interview with the author, March 24, 2010.

66 Robert Duncan, "The Psyche Myth and the Moment of Truth," 1965 lecture, cited in Jarnot, *Ambassador from Venus,* 261.

67 Jarnot, *Ambassador from Venus,* xvi.

68 Ibid., 139. Lowes's book sparked Duncan's renewed enthusiasm for the Romantic poet Samuel Coleridge, evidenced in "Homage to Coleridge" (1955–1956), an unpublished volume of Duncan's ballads heavily influenced by Adam's poetry.

69 Robert Duncan, "A Footnote, April 1966," *Audit* 4, no. 3 (1967): 48.

70 Kitaj, "[Untitled]," 206.

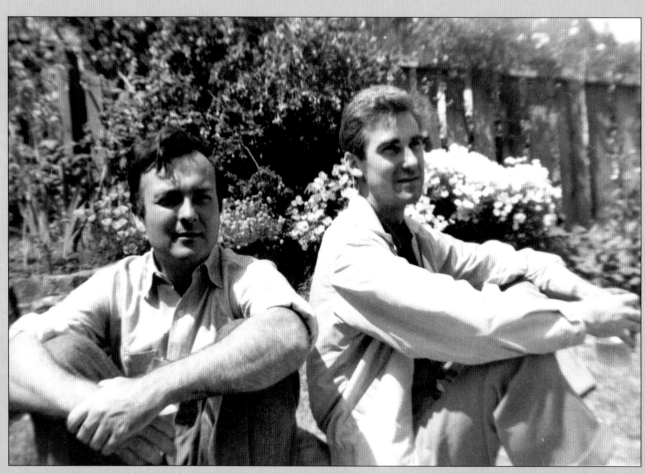

Robert Duncan and Jess, c. 1959

"THIS HERE OTHER WORLD"

The Art of Robert Duncan and Jess

Christopher Wagstaff

Poet Kenneth Rexroth, who played a seminal role in the early-1950s arts revival in the San Francisco Bay Area, declared: "The widely publicized San Francisco Renaissance owes more to [Robert] Duncan than to any other person."[1] Noting Duncan's distinguishing characteristic to be "the depth and humanness of his heart," Rexroth goes on to observe the seriousness and devotion of Duncan's poetry in "seeking the communication of an organic wisdom, as in the act of love. This is poetry which transcends the existentialist dilemma, a gift of the self to the other." These remarks sum up the spirit of that renaissance as it found embodiment in the art of Robert Duncan, Jess, and their circle, which would not have developed to the remarkable degree it did—or perhaps even have survived to be known to the limited extent it is today—without the love and interchange of energies at the heart of the extraordinary household this poet and this painter established and lived in together for thirty-seven years. Indeed, this creative couple epitomizes that close relation between poetry and painting at the core of this so-called Renaissance, which Jess noted in his "Pillowbook" with a text by Giordano Bruno: "True poets and true painters choose one another out and admire one another."[2] Mutual admiration and a shared vision

sustained and stimulated Duncan and Jess so that individually each did more and perhaps greater work than either could have done alone, and the significance of their collaborations has yet to be fathomed. In addition, their commitment to living a life in art inspired many fellow artists, touching in one way or another every one whose work is in this show. George Herms, for example, commented that "the way they lived was so the muses could live in our atmosphere."[3]

* * *

When they met in San Francisco in the summer of 1950, Duncan was thirty-one and Jess twenty-seven. Duncan had grown up in Bakersfield, California, where he first read D. H. Lawrence, Virginia Woolf, H.D., and other modern writers in a high school English class. He began composing poetry at that time. Early exposure to visual arts also influenced him; after a trip with his mother to see French art and Picasso's work at the Legion of Honor in San Francisco, he came to feel some secret of life was shown forth in painting. He soon abandoned the idea of becoming an architect like his father and decided to become a poet instead.

After leaving the University of California, Berkeley, midcourse in 1938, he lived on the East Coast, where he met Yves Tanguy, André Masson, Anaïs Nin and her friends, and some of the surrealists. He also knew Hans Hofmann, who was interested in the young poet's oil crayons. These years of wandering, which included intense sexual activity, sometimes with committed lovers but mostly not, may account for his mother's concern in a letter to him in 1941: "Certainly if I were the mother of some other clean-minded young man—who was looking forward to a *home* and *children*—I would not want him subjected to the daily influences of anyone with your ideas re sex." He returned to California in 1946 and settled for a while in Berkeley, where he studied medieval history with Ernst Kantorowicz and became part of a small group of poets who believed in an imminent artistic rebirth based on "a lore of the spirit." One of the group recalled that they wanted to "build something; we wanted an Athens and a culture to appear here. Something that was planetary and had scope and significance for everywhere."[4]

Only a few years later and not so very many miles from Bakersfield, Jess grew up in Long Beach, California. Feeling isolated in a conventional family and a success-driven culture, he found refuge in the music of Sibelius, Mahler, and Brahms (his favorite composer), which he first heard on the radio and at Hollywood Bowl concerts he attended with his brother, James. Shortly after being drafted in 1943, he was assigned as a lab technician (or in his words, a "flunky chemist in the control labs") to help develop plutonium at Oak Ridge, Tennessee. Horrified by the newsreels of the A-bomb Edward Teller proudly showed those at the lab, he later remarked to filmmaker Lawrence Jordan: "When they dropped the bomb I knew science was made by black magicians."[5]

After leaving the army Jess was a serious Sunday painter, but he soon turned his full attention to art, enrolling in the California School of Fine Arts in San Francisco in 1949. There he took classes from Elmer Bischoff, Edward Corbett, David Park, Hassel Smith, and Clyfford Still, the latter encouraging students to accept an image that appeared on the canvas—what the paint itself would do—rather than follow a style. Duncan later said in an interview that Still and others at the school were keeping alive a mode of being essential to the spirit of man, and that although "the conquistador was ever present in Still [and that] he proposed mastery . . . even in that proposition there emerged canvases that could be seen also as creational fields, as *other* worlds."[6]

It's worth noting that Still was interested in all periods of art and saw modern art not as a radical break from the past but as a continuing and broadening out of it. Duncan and Jess shared this view, as well as the attitude of engaged attention rather than of criticism, which Robert's teacher Ernst Kantorowicz also fostered in his students, cautioning them to be "detectives" rather than "judges" or "real estate certified clerks." In a notebook he kept at this time Duncan wrote: "Whether a painting is 'good' or 'bad,' a masterpiece or an apprentice piece is not of interest if one's interest is painting—what is of interest there is whether a painting speaks or is mute."[7]

Jess first encountered the name Robert Duncan when he stumbled upon a copy of Duncan's *Medieval Scenes* (1950) in a bookstore on Market Street.[8] The poems moved him deeply. The two eventually met at a party, and shortly thereafter Jess asked Duncan, over lunch, what he meant by the line in another early book, "Among my friends love is a great sorrow." Thus began a long, rich, creative conversation and partnership.

Jess took Duncan to see the first exhibit of his work at the Helvie Makela Gallery, which filled one of Helvie's small rooms; Duncan bought a moody blue and green poster-paint portrait that would always hang in the couple's home. Jess later wrote on the back: "Painted in Bischoff's class, '49, among my first sales—to Robert D. for $5.00." It was in this period

that Jess dropped his last name (Collins) and broke ties with his family, who could not accept his homosexual relationship with Duncan.

It must have been a wonderment to Jess and to Duncan to find out how much they had in common, above all a love for L. Frank Baum's Oz books and James Joyce's *Finnegans Wake,* which each had read at about the same time. Duncan felt Jess was someone he had been "appointed" to find, and each believed their being together was destiny rather than accident. At the time Robert met Jess, he had the funds and a ticket to go to Germany to pursue a degree in medieval history. Then, one day, he went to see Clyfford Still's solo exhibit at the cooperative Metart Galleries at 527 Bush Street in San Francisco. He was so disturbed, even shocked, by the paintings—which he found decidedly *un*beautiful—that he later realized he "had seen something absolutely stupendous."[9] Here were discontinuities and dispersions of paint he had never seen before and which he intuited might be applicable to poetry as well as to painting. Between meeting Jess and seeing Still's paintings, Duncan decided to give up his academic ambitions, cancel his travel plans, and stay in San Francisco.

On January 1, 1951, Duncan moved in with Jess where he was living in the old Spreckels mansion, nicknamed "The Ghost House," at 1350 Franklin Street, which housed poets, musicians, and painters, many from the School of Fine Arts. At the time, Jess lived in an upstairs room. When a few weeks later a local commercial artist vacated the downstairs ballroom, the couple moved their belongings into that larger space, which had stained-glass windows and a parquet floor. Duncan hung works of art on the walls—*The Red Table* by college friend Virginia Admiral (p. 159) and *Orpheus* by Marjorie McKee—and Jess set up his studio at one end. A photograph taken in 1951 by Nata Piaskowski (p. 54) shows the area outside the ballroom, complete with a door's bubbling paint and a grey cat given to them by Nancy de Angulo, wife of shaman-anthropologist Jaime de Angulo.

Parties, poetry readings, and art sales abounded at the Ghost House. One of the most memorable gatherings was a celebration for the birthday of their filmmaker friend James Broughton on April 1, 1951. For that event, Jess made a handbill with black lettering and pieces of orange, red, violet, and green paper in the style of Jean Arp (p. 183), while Duncan designed a makeshift throne for Broughton, "the King of Fools," to sit on. Though the two soon tired of the parties and sales—they cured Jess forever of socializing, Harry Jacobus has noted—conviviality overall characterized this period. Around this time Duncan and Jess began their habit of reading aloud to each other every day; some of their earliest readings together were of works by Scottish author George MacDonald, including his poetry. Among Jess's papers is a black binder with many typed excerpts from MacDonald's poetry, for example, "Kneel down and pray/ To the God of

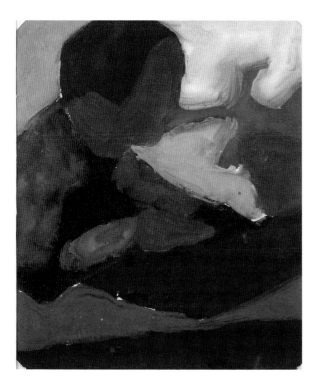

Jess, *Untitled (Blue Shirt),* 1949
Poster paint on paper, 9 x 7¼ in.

sparrows and rabbits and men/ Who never let anyone out of his ken."

Beginning at the Ghost House, the idea of a "household" emerged in the individual as well as the collaborative work of Jess and Duncan. As they conceived it, the term referred to much more than a physical place or a relationship between two people; it was a place of habitation ultimately independent of time and space, where the flow of ideas and the conjunction of poetry and painting fed them daily. The household provided a haven for each, a secure place to work, to reflect in solitude and grow, and it also offered a hearth for others seeking encouragement and relief from what Baudelaire called "the hopeless darkness of ordinary daily existence." Friends and visitors couldn't help but hear the vibrant "contrapuntal communion of all things"[10] and feel and see it in this far-from-chic, fantastical, magical confluence of creativity, where the hallways and rooms were filled with paintings and drawings (their own and those of their friends); prints by Parrish, Picasso, and Blake; thrift-store Victorian glass and furniture; children's books; records (both seventy-eights and LPs); and other assorted objects of inspiration.

"Household" had a poetic and almost mythic reality for each, as their correspondence illustrates. Their letters to one another when Duncan was away reading and teaching often refer to the spirit of their home having an ability to sustain them in these periods of separation, providing a centering where the sympathies and enlarged consciousness of art were appreciated before all else. In one letter Jess writes: "Your little gray home in the West awaits."[11] Robert writes to Jess that their "Garden, the Library, and the Household open up my imagination," and notes in a singular letter to Robin Blaser from Black Mountain College in 1956:

In the daily living one loses track of actually being in love, the loving takes over which is in the fullness of living. But here I am now with the strongest pangs of being in love, reading again and again [Jess's] letters, just for his handwriting to bring him close; and with all the delights of him, I have come back to seeing this or that expression, gasps of dearness that are delicious. There's no deprivation when he is there, for he withholds nothing of himself.[12]

Often struggling with isolation during Duncan's absences, Jess tells his partner that "the spirit that informs our home, a medium of love" nourishes him. Occasionally one senses a strain arising from their differing responses to the outside world, which Jess felt at times bore down on Robert and sucked him into its fissioning maelstrom. In April of 1967 he writes that he must try to "withstand the whirlwind pressure I feel from your own great ability to keep in motion aloft dozens of activities and keep them suspended there as well." In 1969 when a young man

"The Ghost House," 1350 Franklin Street, San Francisco, 1951. Photograph by Nata Piaskowski

named Sparrow arrived on the doorstep of 3267 Twentieth Street (the home they purchased in 1967), demanding entry and saying that Duncan had told him to drop by, Jess right away wrote to Robert, who was traveling, that "formality in some degree must obtain, for you tend to put off work with distractions." And some of Duncan's reply to Sparrow is worth quoting for what it says about home's being a sanctuary that he and Jess strove to keep intact. He wrote to the young poet that he welcomed the emergence of a new generation of troubadour poets, but said: "I am not a troubadour. The sarodguitar and the gaelic table harp belong to the bardic tradition, where my work—a work of the study and the lamp as disapproving critics have remarked—is that of the maker or poet proper . . . And firmly neither my person nor my household are communal or public."

Robert was an extrovert, Jess indrawn, and their being together undoubtedly helped each to find a completeness and grounding they might not have developed as readily individually. Duncan enjoyed people and was a prolific, often eloquent talker, whereas Jess was shy and found lengthy exchanges trying. Jess's sense of isolation probably can be traced back to his childhood, when he felt terribly alone, almost like a "freak of nature," in his words. His later sense of reclusiveness perhaps came from his living so intensively within his own imagination for long periods of time while he was working on his complex paintings and meticulously built-up collages.

Due to Jess's influence, Duncan came to appreciate the need for stillness, and Jess drew strength from Duncan's energy and drive. When asked if he ever stood up to Robert and disputed what he said, Jess replied: "Early on I tried to argue with him but it didn't work out very well and I saw that was not the way to approach Robert. Thereafter, I just mostly listened. Invariably one would later find that Robert was usually right."[13] Jess mentioned too that he and Duncan agreed never to criticize each other's work,

and either to encourage the other or simply say nothing if they had no immediate response to what the other was doing. Each produced art and poetry of great beauty and depth that sometimes showed the influence but never the directing control of the other.

Years and years later, if the subject of their household and relationship came up, the enthusiasm and gratitude each felt for their life and work together could be discerned in the warm tones of Duncan's fast-paced speech, and in Jess's lower-pitched, quieter voice. The painter once described himself as "Turneresque," introspective in temperament, and it is possible that without Duncan he could have become a hermit, while Duncan without Jess—as a number of close friends and even the poet himself felt—might have remained in despair as he says he was at the time they met, without a home and center. Duncan said his own work and thought grew intimately with Jess's, and in 1978 Jess wrote him while he was on a reading tour that he was proud they both continually shared their inspiration with each other, adding, "I can't take originating credit for the method of deliberation in our ways of working, for as I remember it arose in my consciousness thru a contemplation of your immediate and comprehensive action in art." Duncan described their dynamic as "that union of opposites . . . of contending forces united in their contention by love."[14]

At the time of their first meeting and getting to know each other, Duncan composed one of his greatest poems, "The Song of the Borderguard," the writing of which he says made him realize he was in love with Jess.[15] The poem tells about a lonely, sleeping lion and a watchful poet with a guitar who sings to the lion, repeating "Believe, believe, believe." In Jess's drawing (p. 56), which later accompanied the poem, the naked poet and the recumbent lion gaze intently at each other. Diminutive houses and a winding road are sketched in the background. In a 1976 interview Duncan said that at the time of

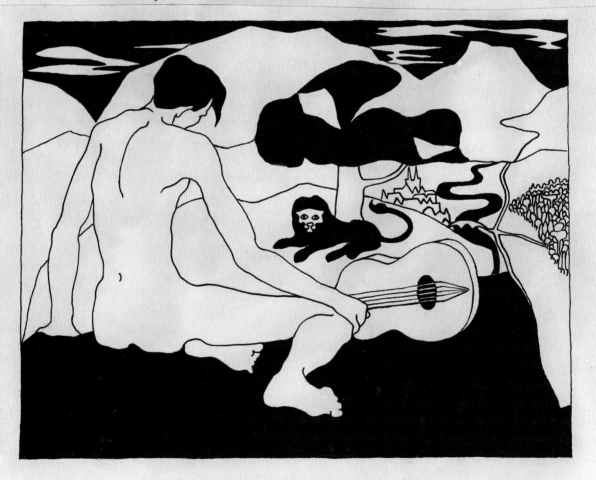

The Song of the Borderguard

The man with his lion under the shed of wars
sheds his belief as if he shed tears.
The sound of words waits —
a barbarian host at the borderline of sense.

The enamord guards desert their posts
harkening to the lion-smell of a poem
that rings in their ears.

Jess, illustration for Robert Duncan's "The Song of the Borderguard," c. 1955
Ink on paper

the poem's composition, he had become haunted by Greek poet Constantine Cavafy's verses about a military guard on the borders of the Roman empire "being invaded, and losing his Roman identity."[16] The "believe" line he said refers to the question, "Do I believe in love?"[17] His mother once told him that he was incapable of love, and Duncan says the essence of this poem was the realization that he was being flooded with another identity, "the living *me* who is in love, something I'd not yet admitted. I am a *barbarian* who is in love."[18] Seeing himself as a protector of the lion, the "Poet on Guard" reiterates "believe," a basic need in a relationship. The singer says he is "certain of the Beloved" and of the Empire—which might be the imagination—as being greater than the individuals in the relationship and uniting them.

* * *

In the fall of 1952 Jess, Duncan, and the painter Harry Jacobus opened a gallery called King Ubu in a converted garage on Fillmore Street in San Francisco. It kept alive with even more exuberance the approach of the experimental Metart Galleries begun by Clyfford Still and twelve students a few years before, which had vowed to "remain free from any school of painting and unincorporated by any commercial interest."[19] Ubu was less worshipful of art than Metart had been. The gallery's iconoclastic spirit was summed up by Duncan when he wrote on a drawing, "King Ubu—the Vanguard of Uncivilization," and by Jacobus when he jotted, "Eye don't giv a fok abot tast." Before the opening, Jess painted on the walls of the entranceway a startling mural featuring dozens of large eyes—a motif that would appear in various guises in his later paintings and collages. Lasting only a year, the gallery featured work by teachers at the California School of Fine Arts and their students and was open two evenings a week and briefly on weekends. An announcement

for one show had written on it an amplification of Pascal, "The eye sees more than the heart knows," and a collaborative drawing by the three founders included an Ubu-speak maxim, "de goostybooze est dispewtandam"—a playful corruption of the Latin phrase *De gustibus non est disputandum* (In matters of taste there can be no dispute) that changes the meaning to "Taste is disputed."

This zanily intelligent, good-willed cooperation at King Ubu was also evident in Jess and Duncan's other collaborations, including one of their first books, *The Cat and the Blackbird* (White Rabbit Press, 1967) (p. 58), which is composed of Duncan's Oz-like children's story and Jess's densely drawn illustrations and lettering. It tells about a cat who lives alone in a house and a blackbird, "a traveling bird," who visits him and who has never had a home before and has been naughty. The blackbird proposes they set up house together, after which the two have a series of adventures, including meeting a little girl, Susan, hearing about a busy man who eventually loses all sense of being busy, and taking a ride on

King Ubu Gallery, 1952
Photograph by Nata Piaskowski

the Merry Go Around at Sunday Beach. Duncan was perhaps reminding himself and Jess not to become so preoccupied with projects that they forget the ongoing work of the imagination and the sheer delight and pleasure of the journey. Throughout, there is no competition or conflict between the cat and the bird, just a joyous being together. Duncan said that he and Jess talked all the time "of this imagination and what it was going to be," and the painter remarked in a letter that the story was important in clarifying the deeper aspects of their relationship at that stage.

Max Ernst once called collaboration a form of collage, and other early works that Duncan and Jess created were essentially shared or joint collages. One of the first was the series of household art scrapbooks the two made at their flat at 1724 Baker Street. These were composed of 18-by-24-inch pieces of cardboard

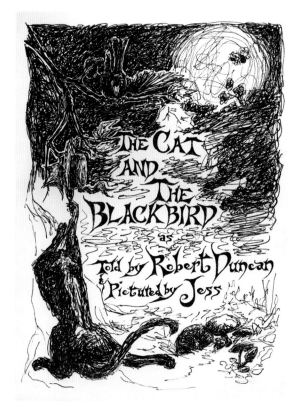

Robert Duncan and Jess, *The Cat and the Blackbird*
(San Francisco: White Rabbit Press, 1967)
Text by Duncan, illustrations by Jess

on which Jess and Duncan took turns gluing reproductions of art from issues of *Life* magazine and from a cache of tipped-in plates from Skira art books given to them by Harry Jacobus.

They created approximately seventy such pages, often displaying them on an easel in their living room. It is hard to tell who did which pages, although the nine or ten densest ones are undoubtedly Jess's, and most likely those devoted to Picasso and Braque are Duncan's, as are the pages of Edouard Vuillard's work, made as an homage to the artist after Jess told Robert that Vuillard's work looked to him like magazine illustrations. Duncan would sometimes create a special spread that would shift Jess's view of art. "I'd make a remark which showed how little I knew about art," said Jess, "and Robert would make a page which would help me see something I hadn't known before . . . Robert swallowed all of Western culture whole."[20]

The pages featured art of many cultures and periods, including Islamic, Romanesque, Byzantine, Renaissance, and impressionist. The exuberant, free-for-all spirit of these scrapbooks shows Duncan and Jess exploring the development of an artistic culture transcending museum walls and academic genres.

Another collaborative venture took place over about three weeks, again at the Baker Street flat. At Robert's suggestion, he, Jess, and Harry Jacobus—who was sleeping in their dining room at the time—made a series of drawings using the *cadavre exquis* ("exquisite corpse") method, in which multiple individuals contribute to a single work without seeing the contributions of the others. This exercise—first used by surrealists Louis Aragon and André Breton in 1925—was a means of temporarily dismissing the critical mind and of undermining the notion of personal authorship.

According to Jess, he, Duncan, and Jacobus did several dozen *cadavre exquis* drawings for the fun of it, usually after dinner. One of them would suggest a subject, such as "Any Old Thing," "Woman Cellist,"

Robert Duncan and Jess, pages from household art scrapbooks, c. 1952
Collage, 18 x 24 in.

Robert Duncan, Harry Jacobus, and Jess,
"Man Woman Cat in a Room," page from
"A Book of Exquisite Corpses," 1952–1953
Book of drawings on paper

Jess, cover for "A Book of Exquisite Corpses"
Plastic letters glued to binder

"Gorgeous Chapeau," or "Berkeley Psychiatrist and Friend." Then on a piece of paper folded in thirds, one of the three of them would do a sketch of the subject on one of these thirds, not showing it to others and leaving small pencil marks extending over the edge at the fold. He would then pass the page along to the next person to continue the drawing from these marks and add their rendition of the subject. The three found the results were often surprisingly "psychic." Later, Jess pasted all the drawings into a binder called "A Book of Exquisite Corpses," noting in pencil on each page the subject of the sketch and the initials of who did which section.

Also in 1953, Duncan and Jess began their most subtle and perhaps most beautiful collaboration, *A Book of Resemblances; Poems: 1950–1953* (Henry Wenning, 1966), which they finished in the mid-1960s. In a letter, Jess writes that in this book he "hoped the wedding of text & drawing would be Poetry."[21] His ink drawings and sinuous designs and Duncan's holograph poems blend dazzlingly together throughout the volume.

One of the major poems in this collection, "An Essay at War" (p. 63), begins with Duncan describing being in the dining room in the house of some friends in Treesbank, California, and fearing for the troops in Korea, who know hellfire rather than the comforts of the hearth he is enjoying. In Part II of the poem, the poet realizes that "the passion for the beauty of passion/ is not love" (*BR,* 31–32), for love is a more enduring dimension surrounding the passionate. He adds that in spite of the fanatical mind conceiving wars, "Truths of the imagination,/ lofty sleights of macrocosmic mind, up-/ lift us" (*BR,* 35). One of Jess's illustrations for Part V of the poem shows a GI stripped to the waist carrying a wounded comrade in his arms, which resembles a Pietà. On his right is a fallen soldier with his shield and sword. The image of comradeship remained an important one for Jess, and it appears again in photographic form in

one of the delicate "paste-ups" (his term for collages) in his *Emblems for Robert Duncan.*[22]

Following this poem comes one called "Of the Art," which describes a child painting a rose. Duncan writes that the little girl's "skill is not a thing learned/ but a thing loved" (*BR,* 45) and adds that she is free from all others' will but that of the rose itself, which moves her hand. The poem "Unkingd by Affection?" (p. 62) speaks of the upheaval occurring within when one loves and commits one's life to another, because affection demands relinquishing kingly attitudes about oneself. It mentions the warmth of a household that includes "an *unam sanctum,* a papal conceit over all beloved things" (*BR,* 59), which is the opposite of "the empire of one's desires" (*BR,* 59).

The most revealing statements of Duncan's and Jess's aesthetics in the 1950s appeared in the *Artist's View* (pp. 64–65), a series of pamphlets edited and printed by the painter Claire Mahl at her own expense. In issue no. 5 (July 1953), Duncan presents some of his most profound remarks on poetics and on such subjects as "On The Secret Doctrine," "On Children Art and Love," "Muse Amused," and "On Suffering." He agrees with Jean Cocteau that artists should proceed into areas where they are unsure of what they are doing, and in fact should only undertake what is *beyond* their talents, thus avoiding the comfortable and easy. He asks, "Why should one's art then be an achievement? Why not more an adventure?"

In issue no. 8 (1954), which was never distributed, Jess discusses art via many humorous and sententious sayings (e.g., "If she had any talent it was utter incapacity" and "Don't go away mad"), reproductions of his early works, and some intriguing black-and-white images from books and magazines. This densely collaged two-sided sheet tells much about his view of art as a state of "unknowing," which can be presented "without stricture." He asserts that "the secret lies/ in never knowing, knowing/ never tells the truth,

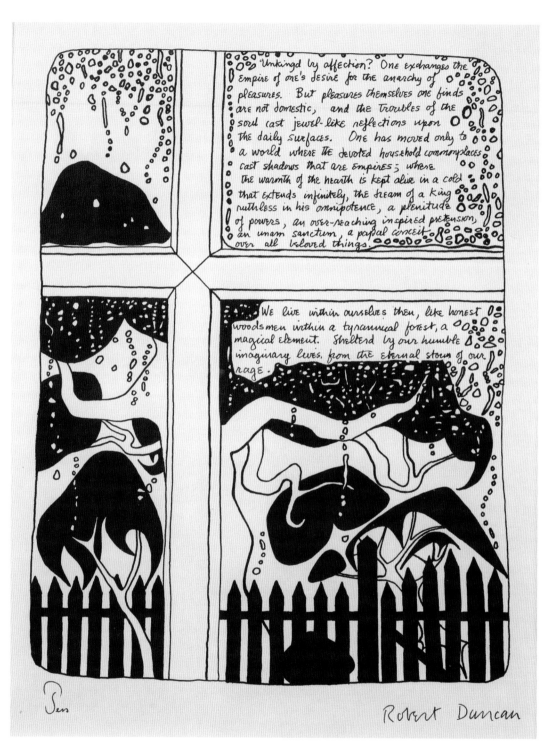

Robert Duncan and Jess, "Unkingd by Affection?" in *A Book of Resemblances; Poems: 1950–1953*
Holograph poem by Duncan; illustration in ink on paper by Jess

for truth/ is inscrutable/ may be/ telling not told." "Told," or what one can put into words, brings an end to "eyeing," or looking without a motive to gain some benefit.

The literary text from which Duncan and Jess drew most deeply for their intuitions about art was James Joyce's *Finnegans Wake* (Viking Press, 1939).[23] Jess first read it in 1944 when he was in the army, and about the same time, Duncan wrote Pauline Kael that he was reading *Finnegan* night and day, telling her "there's a terrific excitement as what he was trying to say comes clear."[24] And he comments elsewhere that a few books, including *Finnegan,* are "reinventions of soul," and that in them one begins to find the gnosis of the modern world.

Duncan's poetry and Jess's art, like *Finnegans Wake,* move toward a "Disconnection of the succeeding" (*FW, 228*) rather than a conclusion. The "tales within tales" (*FW, 522*) Joyce tells certainly

also describe Duncan's poetry and the forms within forms noticeable in Jess's work. Joyce's primary principle in *Finnegans Wake* that "Close only knows" (*FW, 201*) undoubtedly resonated with the couple too. In 1971 Jess writes he has just reread the 628-page novel to find on page 587 the magic title for a painting he knew was lurking there—"Only Our Hazelight to See By." And a few years later he declares in a letter, "My love for Joyce abounds."[25]

It was in *Finnegans Wake* that Jess found the word "indwellingness" (*FW, 488*), which he often used in discussing the gestation of his works. Letting oneself become part of what is not yet fully known or acceptable to the mind can enable one's current knowledge to expand. By dwelling in a subject matter, one becomes absorbed in and possibly a part of it. One's personality can diminish and even be somewhat remade in the image of that which one dwells in. Such "participation," to borrow Duncan's term, requires a

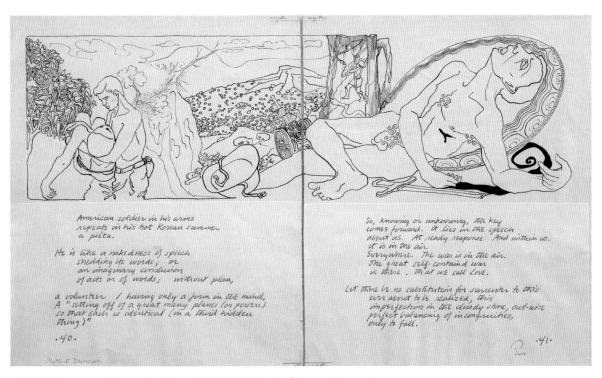

Robert Duncan and Jess, "An Essay at War" in *A Book of Resemblances; Poems: 1950–1953*
Holograph poem by Duncan; illustration in ink on paper by Jess

Robert Duncan, *The Artist's View*, no. 5, 1953
Cover illustration

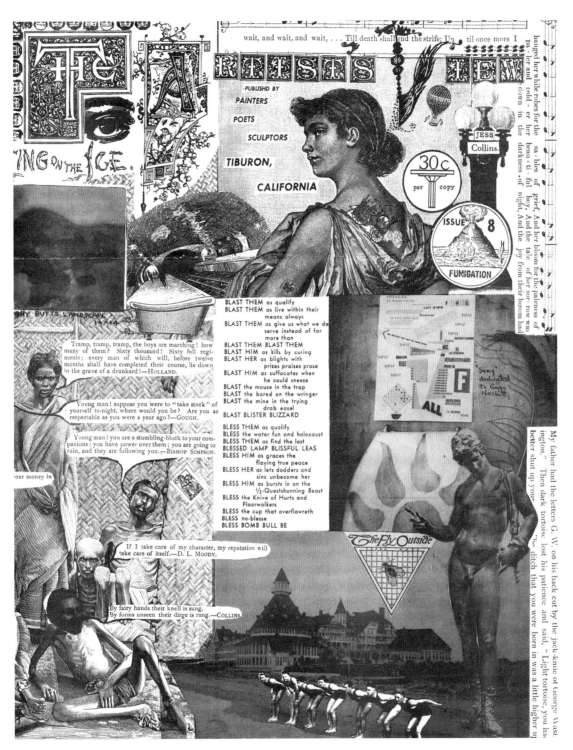

Jess, *The Artist's View*, no. 8, 1954
Collages and writings

degree of solitude, time, and a willingness to move past personality to a greater attentiveness to the present. Duncan and Jess saw personality coming to the fore in our age to the detriment of art and artists, because it takes the place of the soul and the mysteries enveloping it. Jess wrote his art dealer Federico Quadrani that most writing on art "usually applies to the personality . . . [and] I feel that personality has been the poison of Western art."

Connected to this type of participation is the value of anonymity, the view that art is what Jess called an "incalculable enigma" rather than a form of self-expression, and it requires ceasing to see oneself as an important "somebody" and instead to let what is beyond oneself emerge in the fabric of what one writes or paints. Jess wrote to Quadrani in 1968, "My own individual way in painting has been . . . precariously keyd to the Ineluctable," thus summing up his effort to "evoke presences, not persons, and present them as paint."[26] Fame for Jess and Duncan was a negative because it placed some people in a prominent position above others. Stephen Burton has recalled, "Jess felt notoriety and fame were actually a kind of evil or malignancy."[27] Like fame, the concept of "genius," which in the early 1940s Duncan railed against, also assumes only certain people can have inner vision and discourages so-called ordinary folk from seeking any views apart from the norm. In a long interview with Eloyde Tovey in 1978, Duncan clarifies the term "bohemian" as an approach opposite to that of genius and acclaim:

Today Bohemia tends to disappear because if you paint anything it's worth money. That's the death of Bohemia . . . Your art has to be posed with no guarantee and actually look like a very remote unreal activity to be in. Something that nobody values, and you couldn't explain why you're doing it—in order for it to be

Bohemia . . . Bohemian poetry means risk. But it means something more than risk. It means poetry that no one is sure what it is.[28]

In their own domestic bohemia, the two for years scrimped and did without to make ends meet. To augment a small monthly sum he received from his mother, Duncan typed dissertations, as did Jess for a period. Stephen Burton has said, "They were both masters of frugality," and has described the many postcards that went back and forth between Duncan and Jess and Burton's parents to set up lunch and dinner dates until the mid-sixties, when the couple finally got a telephone.[29]

* * *

The first Duncan and Jess collaboration to be published as a full-length book was *Caesar's Gate* (Divers Press, 1955), a collection of Duncan's poems for which Jess created collages. Duncan's poems were from the period of 1949 to 1950, a time of desolation for him. All the images Jess used in the collages came from issues of *Life* magazine he was given in Bañalbufar, Mallorca, where he and Duncan were living in 1955. One or more of the magazines were devoted to the world's religions, and Duncan said that Jess used every image from the sixteen copies of *Life* in creating the collages for *Caesar's Gate* and the nearly 150 other collages he produced in Bañalbufar.

Challenging the conventional concept of talent and authorship, collage—in the words of Max Ernst, Jess's master in this genre—presents the unexpected juxtaposition of two or more apparently disconnected realities, which transforms the meaning of the images themselves and can produce in the viewer "a sudden intensification of the visionary faculties."[30] A number of Jess's collages, or "paste-ups," in *Caesar's Gate* suggest the presence of the sacred in

the inferno of contemporary life. For instance, in his collage accompanying the poem "Aurora Rose," Jess has pasted in small images of seven ancient figures, including an African mask, Mayan and Egyptian statues, a dancing Shiva, and a Buddha; these figures float in and around an image of the Prudential Insurance Building being constructed in Chicago, where a crowd stands on the structure to celebrate its reaching the fortieth floor.

In his paste-up for another poem, "Processionals II," Jess reversed the relationship of the eternal and the quotidian evident in "Aurora Rose." This work includes a faint image of electric wires strung between poles, a coffee cup with a spoon in it on the floor of a shrine, and, dominating the picture, a large sleeping Buddha carved in stone. In an interview Robert Duncan has said, "There can be a war between the spirit and the psyche, but there shouldn't be at all; in fact they really should be together,"[31] and Jess once told Michael Auping, "Everything in the world has a certain quality or spiritual presence, any simple object or image."[32] Jess's paste-ups, like his paintings, are "a dialogue of presences,"[33] with himself functioning more as an instrument and mediator than a creator of the images, which he felt directed him where they needed to go.

Jess and Duncan made thirteen special copies of *Caesar's Gate* for the two of them, the publisher, and friends, each having an original holograph poem accompanying, and written in response to, a color paste-up by Jess. Two of these copies are in this exhibition. In the one with the poem "Shadows of the Smoke," Jess's facing paste-up, slightly Boschean with a strange fish flying in the sky, semi-industrial wheels, a death's head, and a goddesslike or royal seated figure floating in a pastoral landscape, corresponds to the "intimations of a real poetry" residing in the flowers, stars, beautiful women, and other "gliding hallucinations" mentioned in the poem. *Caesar's Gate* stimulated many artists to try collage;

for example, when George Herms saw the book at Wallace Berman's house he was moved tremendously and inspired to make collages of his own.[34]

While living in Mallorca, Duncan and Jess immersed themselves in the poetry and prose of Samuel Taylor Coleridge (1772–1834), whose vision and wide-ranging intellect and experiments in many genres no doubt inspired Duncan.[35] This reading resulted in their sketching out another collaboration, "Homage to Coleridge," which remained unfinished. The small portion of this volume that exists includes Jess's title page drawing of an interior (a book lies open on a table with an inkwell and pen next to it, and a crescent moon over trees is visible through a window), two pages of a typed preface Duncan probably wrote when he returned to San Francisco, and a handful of poems, including one called "A Song, in the style of Blake."[36] In the preface he responds to a comment by Denise Levertov that his writing of ballads in a Coleridgian mode was backward and a poor use of his talent by saying that such imitations took him back to his solitary adolescence, where "Story Book"—fairy tales and myths and such—saw him through many of his fears and terrors.

Perhaps in response to Jess's paste-ups for *Caesar's Gate*, Duncan began writing a book of poems called *Letters* (Jargon Society, 1958), which, like Jess's work, shows an appetite for the sacred within what Yeats called the "'desolation of reality'" (*L, 1*). The poet is in a universe that speaks to him through tables, rooms, rivers, and the most commonplace objects occupying his world—being in effect the Holy Word rising "'from the slumberous mass'" (*L, 13*). One of Robert Duncan's most revelatory volumes, *Letters* describes in part his discovery of a *Thou* or wholeness within which, as a poet and person, he was beginning to find himself. He recognizes that we all dwell within such "an otherness awake," although most of the time we live as if such a connection doesn't exist.

SHADOWS OF THE SMOKE

In Time in those gardens wraiths
descend. Infestations of restless desire.
Corruptions, abstract and sentimental,
of the clear images.

What intimations of a real poetry
conveyed by conjunctions of those
presences — flowers, stars, sheets of
water, beautiful women, engraved
letters — in time. Outline upon
outline. Lineaments cut in the stone.

Now clouds of the clouty eye.

Exhalations of the earth ascend
as if there were necessary ladders,
hairy aspirations toward the
atmosphere.

Gliding hallucinations, thrones,
wheels, seraphim, appear from
all vague passages. From the
hierarchies of our solitude.

SOURCE MAGIC

Recesses of light are fire first.

This light casts the world's darkness
like a flower casting its seed. This
roar of flame is son, sun of
night's little universe. By
photosynthesis the plants —
shadowy demons — make their
green.

The lord of this world coils in
the first spurt, licks the fastnesses
of being like a candle flame
licking the borders of untamed
night.

I am the light of the fire.

And below his triumphal figure
the globe of green things hums
with inspirations.

Robert Duncan (with Jess), *Caesar's Gate* (Palma de Mallorca: Divers Press, 1955)
Two copies of the special edition, each with an original holograph poem by Duncan
and an original paste-up by Jess

In "xxvi: Source," the poet writes, "In this I am not a maker of things, but, if maker, a maker of a way. For the way in itself" (*L*, 38, 40), or a process that exists independently of what one might think it is or want it to be. Like Jess's idea of "a canvas coming into itself,"[37] a poem has its own volition, the forms moving as they will without being forced in this direction or that.

Duncan mentions an experience he had of falling in love with a mountain stream when he was about twelve, saying he knew the fullest pain of longing for it: "To be of it, entirely, to be out of my being and enter the Other clear impossible element" (*L*, 40). Leaving behind almost all traces of the despair and inward grief he experienced in the late 1940s, the poems in *Letters* are permeated with a Blakean ecstasy, which probably derives from the poet's being jarred free from himself and contacting persons and presences of the poem, which speak to him and through him. One poem refers to an owl who hoots for joy as he flies: "This is an owl as he flies out of himself/ into the heart that reflects all owl" (*L*, 44).

In *Letters,* Duncan sees that everything one's own is usually a burden preventing such a release, but a person can lay down such freight. In "Changing Trains," for example, referring to the couple's European travels, he writes of a customs official checking their baggage for contraband and notes, "But our declaration is true: we have come thru with nothing" (*L*, 46). Throughout the book Duncan refers to anti-poets who scorn the effluvia of mistake, misuse, and misunderstanding, which are often gateways to discoveries and meaning. Favoring "insensitive right words" (*L*, 47), they are guardians of correctness, of approved usage, quite unlike the phrases on Duncan's pages floating loose from the fixed structure of the sentence or Jess's images suspended in time and space.

* * *

In a letter of 1955 Jess mentions that when Robert's mother saw one of Jess's paintings at the home of William and Joan Roth she noted, "There is something spiritual in his work." Jess has described himself as at bottom a Romantic painter, one who sees the world and the imagination as potentially at one and who believes there is an invisible connection between things one observes and what lies beyond the transient. In another letter in 1968, he speaks of an author of a *Scientific American* article who has "the boringly usual bias against what he thinks uselessly visionary or mystic." Adhering to logic alone, "'then, indeed, the labor of thought is wonderfully diminished,'" Jess quotes Leibnitz. He felt a kinship with the great symbolist painters who believed in such an undetected identity of objects, creatures, and people. Like both Odilon Redon and Gustave Moreau, Jess appears more and more a *peintre penseur* (thinking painter). Moreau stood out in his time against what he called a "savage love of coarse reality,"[38] and the same might be said of Jess, who, like Moreau, lived in a transfigured world of the imagination, where history and myth take on larger than legendary, anthropological, social, and political dimensions—though they retain these—to reveal their personal and universal relevance.

One of Jess's early major paintings, *Don Quixote's Dream of the Fair Dulcinea* (1954) (p. 72), is both abstract and representational, which are not opposites for Jess because for him the subjective and the objective can meet and blend. He puts Quixote in surroundings where a castle merges with mountains, a fountain can become a unicorn, and what may be a rock discloses a brown rabbit. The tiny Don Quixote, on horseback, rides through a dreamlike blue, green, and beige landscape toward the prominent figure of Dulcinea, flanked by the unicorn and rabbit—perhaps guarding her until Quixote arrives. Quixote's diminutive size may indicate his own unimportance relative to his vision.

Despite his love for times not his own, which he shared with the symbolists and Pre-Raphaelites, Jess would not concur with Samuel Palmer's declaration in a letter, "The Present is not."[39] No matter how ghastly it seemed, Jess didn't believe in nullifying or escaping from the present. Despite the increasing dehumanization he saw everywhere around him, he was interested in the relation of the empirical, day-to-day world to a larger, less-obvious one, as another major early work, *The One Central Spot of Red* (1958) (p. 73), suggests. It depicts an amorphous, murky landscape with a figure approaching a vibrant rose growing in a space surrounded by shadowy, changing shapes.

The late poet Robin Blaser owned this painting for many years, and his partner, David Farwell, described it in a letter: "For me it depicts a marvelous voyage of discovery through the Underworld. The nude male figure striding through the mists holds aloft a torch that seems to overcome the darkness and perils ahead. Even the skulls light up as he passes. Whether it is Orpheus is open to question. He doesn't seem to have his musical instrument, the lyre, with which to serenade Hades. But what of the white rose? . . . For me the painting is full of mystery."[40] Perhaps the flower evokes or symbolizes the *anima mundi,* a presence that must be recovered so the gloomy atmosphere might be transformed and the power of death subdued. Unlike Quixote, who has some soldiers by his side, this figure is alone, holding a sparkling source of illumination in his hands and moving forward as the hero must, whether through the external wastelands or the internal dark woods of doubt and fear, if there is to be any individual or communal redemption. On the back of this canvas Jess has written out a passage by George MacDonald, which says that "one central spot of red" needs to be present in art and life, "the wonderful thing which, whether in a fairy story or a word or a human being . . . shows the unshowable." Jess has painted a red speck in the middle of his painting to acknowledge this "unshowable."

This same interweaving of visible and invisible worlds and forces also shows in the handful of self-portraits Jess did. For example, in *A Thin Veneer of Civility (Self-Portrait)* (1954) (p. 33), a dreamlike yellow head is barely perceptible amid the softly colored abstract shapes behind and to the right of the naked, possibly ejaculating artist and above the cat playing with some dangling yarn. Perhaps representing a second self, this head may belong to the treelike body beneath it.[41] *Selfsketch* (1959), one of his smallest paintings, surprises the viewer with its reversal of figure and ground, the figure being in a thinly painted space surrounded by thick swaths of orange paint, as if to make clear that the paint rather than the painter is the principal thing. The oil crayon *Qui Auget Scientiam Auget Dolorem* (Who augments knowledge augments sorrow) (1959) (p. 74), portrays

Jess, *Selfsketch,* 1959
Oil on canvas

Jess, perhaps in a laboratory coat, looking intently at a disc of light and being partly permeated and affected by it, as may be inferred from the white, radiant particles on his head and brown coat. At the top right in the distance is a white mushroom cloud from which the painter has turned away, as if to show his abandonment of what Jean Arp called "the absolute madness and logic of progress" that "will blow up the earth."[42]

Duncan's several portraits of himself, including *Gorgeous Self-Portrait* (p. 76) and *Faust Foutu* (p. 31), suggest a similar blend of self-criticism and idealization. Jess said Robert had toyed with the idea of becoming a painter in college, but this impulse was supplanted by poetry and his love of ideas.[43] A close painter friend, Lyn Brockway, felt Duncan had an amazing color sense and would have been a first-rate painter had he chosen that field, and painter Marjorie McKee noted that he used every crayon in the box. He liked to work in crayons because they were inexpensive, mostly used by children, and not associated with high or "serious" art. The ones he used in many of his best drawings—and the ones Jess used after he met Robert—were handmade by a friend on her stove top.[44] Large and soft, they were richer and more lustrous than store-bought crayons, and they didn't fade as easily in sunlight. A few of these sticks still exist in Duncan and Jess's crayon box.

Duncan did hundreds of sketches in pen, pencil, and crayon from the late 1930s through the 1950s. Also in the 1950s he wove three wool rugs in bright colors and made several stained-glass windows, including one in their Stinson Beach house having twelve panes. Jess observed that Picasso was the primary influence on Robert's art all the way through, although the presence of Klee and Cocteau is noticeable as well.[45] One of Duncan's largest and most striking crayon works is *Wallpaper Design* (p. 77), which he worked on intermittently from 1952 to 1954, planning to cover a whole wall of their apartment with it. "He pinned up each section as he did it," Jess said. "He built it up like a mosaic; it was not preplanned but an evolutionary or organic design."[46]

On butcher paper, *Faust Foutu* (p. 31) depicts the hero of Duncan's play of that name. The hairy nude has a male and female side, one eye of the Picassoesque face exuding strength and confidence, the other eye shedding tears. The word "Love" is

Jess and Duncan's crayon box, c. 1953

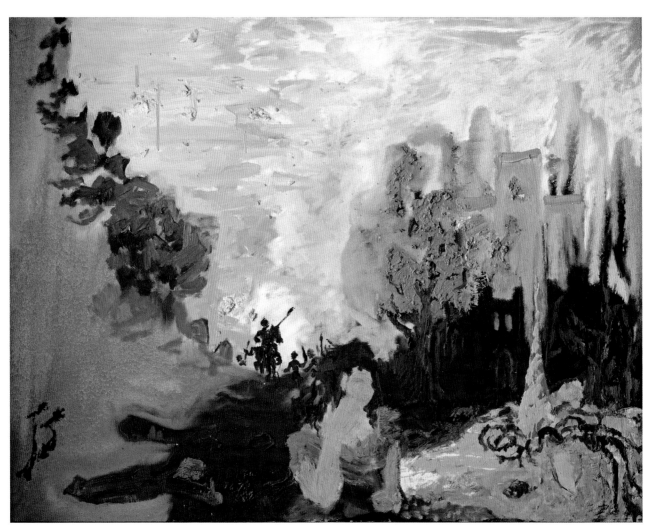

Jess, *Don Quixote's Dream of the Fair Dulcinea*, 1954
Oil on canvas

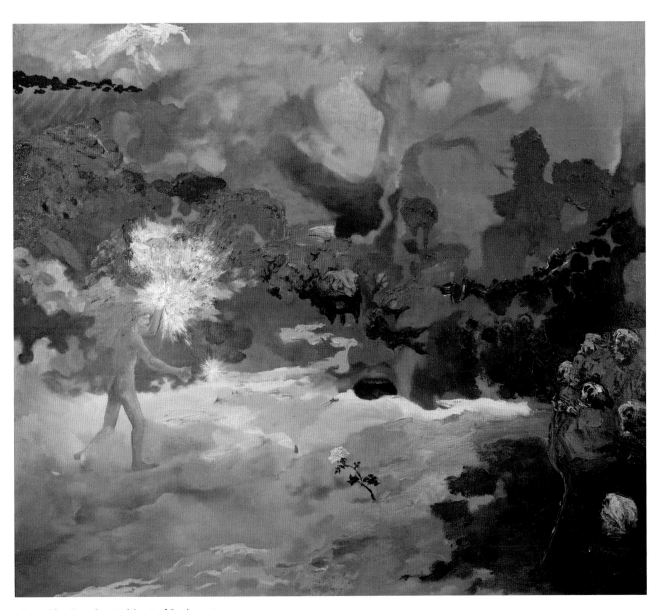

Jess, *The One Central Spot of Red*, 1958
Oil on canvas

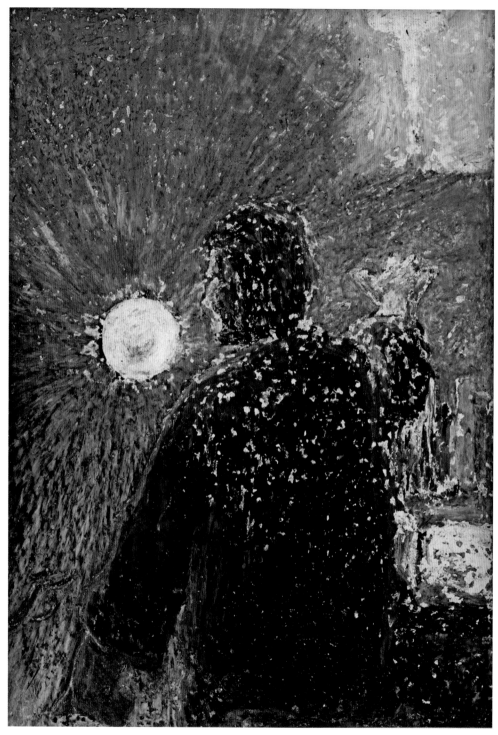

Jess, *Qui Auget Scientiam Auget Dolorem*, 1959
Wax crayon on paper

written four times on the body, and the names "Robert" and "Norris" appear on the right and left of the upper torso ("Norris" referring to Norris Embry, a talented young painter friend). For Gertrude Stein's *The Five Georges,* which Duncan directed at the King Ubu Gallery in 1953, five actors, including Jess and James Keilty, read the parts in a concert-recital format, as it was difficult to get the performers to arrive for rehearsals. *George III* (p. 78), the life-size crayon tableau made for the play, portrays a haughty, slightly dazed king in a large, curly wig holding a scepter in one hand and a cloak or train in the other. He appears to be standing on a stage in stocking feet, and the panel may correspond to Stein's lines, "A fan is a man made merry/ By a cloak./ Who can always be/ Just as they think."[47] One of those in the audience for this production was the young filmmaker Stan Brakhage, who for a while did housecleaning for Jess and Robert in exchange for room and board. He recalled, "Robert sent me a copy of the brown edition of Stein's *Operas and Plays* as a gift while I was in Denver. He was determined to stage her work, which had had so little attention. Because of Charles Laughton's success with staged readings, it was fashionable to do performances just by reading the script, and this was how *The Five Georges* was done."[48]

One of Duncan's major plays, *Faust Foutu* (Enkidu Surrogate, 1959), written between 1952 and 1954, owes a debt to Gertrude Stein, T. S. Eliot, and Jean Cocteau, among others, and is a sort of declaration of independence from what he elsewhere called "uptight aesthetics." It embodies the irreverent spirit of the King Ubu Gallery, where it was first performed after the gallery closed its doors, and is a kind of "Kelticdada." Like Allen Ginsberg's "Howl," written a few years later, Duncan's play exalts the liberty of the individual soul, which was being strangled by consensus and complacency in the early 1950s. In Act II, Faust, a painter, on boarding a ship with a number of painters and society

people bound for the Venice Biennale, declares, "I work that I may come to no fulfillment" (*FF,* 26). Professor Abgrund-Nachmacher, who sounds like a parody of an art critic, says: "[Faust] has the will to creation and what I call the anxiety of the realism of the essential . . . [a] will to the concrete of the abstract," and "the effort to be deep is not the penetration of depths" (*FF,* 48). Near the end of the play, tremblingly disrobing and referring to "the otherness reveald when I lay bare the poor spectacle of my body" (*FF,* 63), the Poet states that "the mind has been schooI'd to master each saving disgrace" (*FF,* 64), rather than stumble into, onto, something fresh by way of mistakes and perceived failures. One line in italics sums up the spirit of Duncan's *Faust*: *"All That Is Not Imagination Is a Time Payment Plan Calld A Useful Life"* (*FF,* 64). To a degree, *Faust Foutu* prefigured the so-called San Francisco Renaissance in its affirmation of an art serving the imagination rather than utilitarian ends. Many years later, Jess observed, "Robert wanted to sweep all of this old 'art thinking' out of his system and the best way to do this he thought was to laugh at all the pretentiousness of art,"[49] as he does in this play.

Duncan's other key play, the tragedy *Medea at Kolchis: The Maiden Head* (Oyez, 1965), also based on a mythical personage, was written and performed at Black Mountain College in August 1956 and again in San Francisco a few years later. The play's subject is love and betrayal and the supplanting of a mythic past by a demythologized present. The major character has an angry, "terrible" side, suggested in Duncan's drawing for the cover of the Black Mountain program. The young, inexperienced Medea falls in love with a poet, Jason, who is intent on stealing the magic fleece Medea's poet father, Arthur, has been guarding for what seems like centuries. Jess's painting *Moonset at Sunrise* (1963) (p. 80), which relates to Duncan's play, shows the young Medea holding back a drapery or curtain to observe her soon-to-be lover.

1942 gorgeous self-Portrait RD

Robert Duncan, *Gorgeous Self-Portrait*, 1942
Wax crayon on paper, 19 x 15 in.

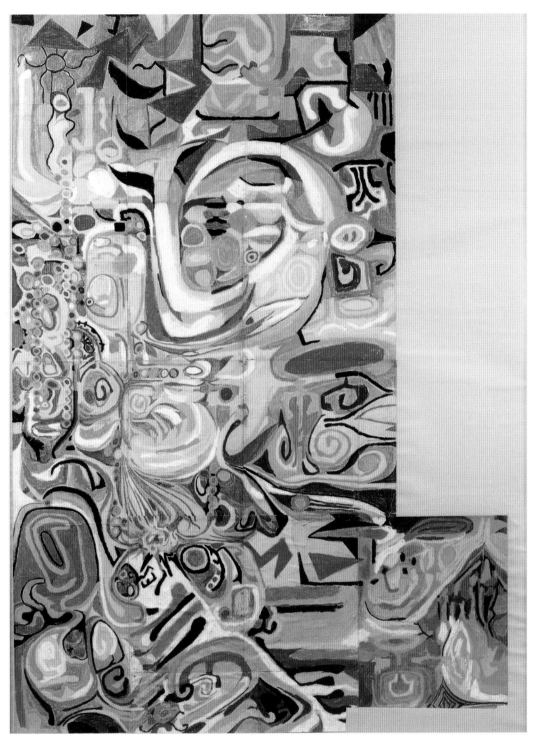

Robert Duncan, *Wallpaper Design*, c. 1952–1954
Wax crayon on paper, mounted on canvas

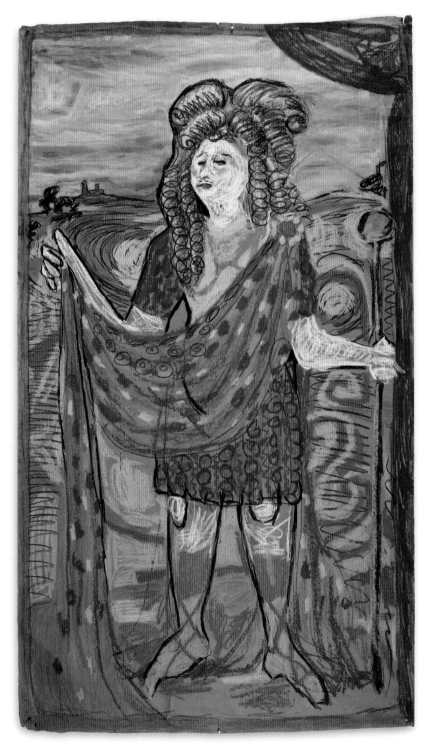

Robert Duncan, *George III*, 1953
Wax crayon on brown butcher paper

She faces away from the rising sun and the illumination behind her, and to her right is a large crescent moon. The moon and sun may suggest she is between the states of clarity and confusion. After her father's stroke, which she has been instrumental in bringing on, she cries, "O/ bloody Moon hide me!" (*MK,* 29). Her father speaks earlier of "this stupid obstruction calld 'Arthur'" and adds he has come to loathe the personality, which, as "the crawling place of the *you,* the *me*" (*MK,* 28), narrows vision so one cannot see life's "luminous uncertainty."

Recognizing the centrality of myth for Duncan and Jess helps to throw light on their paintings, paste-ups, and poetry. Rather than being only about peculiar ancient persons and practices, myth for these two artists involves the disclosure in time of what is primordial and time-free. From their childhood reading they were both steeped in the world of stories—Germanic fairy tales, nursery rhymes, Greek myths, Olive Beaupré Miller's *My Book House,*

Program for *Medea* (Black Mountain College production), 1956. Cover illustration by Robert Duncan

and the Bible. Duncan's book *The Truth and Life of Myth: An Essay in Essential Autobiography* (House of Books, 1968) is a long meditation on the meanings of the literature he and Jess grew up with and continued to love all their lives. The essence of myth for him is found in Heraclitus's fragment about the Logos, or Law: "Though men associate with it most closely, yet they are separated from it and those things which they encounter daily seem to them strange" (*TLM,* 22). He believes that since the seventeenth century we have experienced "a retraction of sympathies" and have been losing a sense of fellow-creatureliness with the sensible universe, including trees, stones, birds, animals, and plants, for we mainly take our identity in what we can "command." Myths offer the possibility of increasing our sympathies, as in them things often become other things, suggesting that we, too, can become closer to the world around us. As we begin to live within the spirit of the stories evoked in myth and in poetry, we can slowly intuit that "the actual and the spiritual are revealed, one in the other" (*TLM,* 42), and that we all have within us Faust and Medea, and much more besides.

* * *

Robert Duncan's single most important volume, *The Opening of the Field* (Grove Press, 1960) (p. 41), is the full fruition of his dedication to the joining in poetry of what is heavenly and what is earthly,[50] and shows his own immersion in the symbols embedded in the old stories told and retold. It is the first volume he fully shaped as a book during the course of its writing, each poem speaking to the others and contributing to a composed whole. It is a volume of cosmology, with "a spiritual urgency" (*OF,* 50) moving in and through events and the world. It is a book of the "intimations of the secret Mover" (*OF,* 42), or a never absent Law, informing the poet and the poem which nothing finite can fully annul: "The

Jess, *Moonset at Sunrise*, 1963
Oil on canvas

force that words obey in song/ the rose and artichoke obey/ in their unfolding towards their form" (*OF*, 60). "A Poem Slow Beginning" alludes to the small community of poets—not more than four or five—in Berkeley in the late 1940s who nurtured a belief that a committed, communal faith might produce a transformation in the surrounding society and culture: "the Berkeley we believed/ grove of Arcady—/ that there might be/ potencies in common things" (*OF*, 14). Mentioning that this force is an "indwelling" which moves himself and others in its harmony, "the witness [that] brings self up before the Law" (*OF*, 10), Duncan writes that without these orders of music hidden, "we should all be claimd by the preponderant void" (*OF*, 39). The primary concern of this volume is the "field," whose nature is to *open* and reveal more of itself. The field is a metaphor for the cosmos or an expanding state of awareness, which the personality of the poet no longer controls but seeks to attend. *The Opening of the Field* makes clear that the field is folded into time.

Like this breakthrough volume of Duncan's, Jess's "Translations" were an opening of the field for him. A series of thirty-two pivotal paintings done between 1959 and 1972, they constitute for the artist "a total spell" and "a Push to Adore,"[51] which recalls Duncan's arresting declaration that he wanted to write "as the universe sings . . . not *for* appreciation, but *in* appreciation."[52] These oils are based on found or preexisting images, including photographs, bubblegum cards, Egyptian wall paintings, comic strips, and five illustrations from an 1887 volume of *Scientific American*. In each painting, Jess takes an image from its original context and renders it in a new, unusual one, thus carrying it out of the world of common sense perception toward what Duncan calls "the field of the visionary and creative Imagination."[53] Taken together, these paintings are like a large pictorial storybook with thirty-two interconnected chapters. In the Translations, the paint is built up layer upon layer so it has a rare thickness and the colors an uncommon brightness, suggesting not only a heightened state of consciousness but also the very presence of a numinousness pulsating within and behind the phenomenal.

The Enamord Mage: Translation #6 (1965) (p. 16) shows Robert Duncan in the couple's Stinson Beach cottage next to books on a shelf, including G. R. S. Mead's *Pistis Sophia* and *Thrice-Greatest Hermes,* and the five volumes of the Soncino edition of the Zohar, thus relating the present world to what is evoked in Hermetic lore and in the pages of the thirteenth-century "Book of Splendor," which explains how an understanding of the Torah can fill the earth and heaven with the radiance of God's glory. In Duncan's "The Ballad of the Enamord Mage," written prior to Jess's painting, the speaker in the poem says, "*I, late at night, facing the page/ writing my fancies in a literal age*" (*OF*, 24), and "These things I know./ Worlds out of Worlds in Magic grow" (*OF*, 24). The Zohar functions in Jess's painting like the old dame mentioned in Duncan's "Structure of Rime XXIV," who "works transitory hints of the eternal" (*BB*, 36), and like poetry that awakes "in the Real new impossibilities of harmonic conclusions" (*BB*, 36). One thinks, too, of Proust's reference to a writer's books watching over him "like angels with outspread wings."[54]

Duncan's favorite in this series, *A ? year's Darling of a pig my size!: Translation #20* (1968) is based on a photograph of Jess taken by his father in the summer of 1926 or 1927 by a lake in Northern California. It shows the boy at three or four years of age standing motionless and by himself on the shore, looking out. He may be in a state of awe. One senses his absorption in the surroundings by his clothes being the same coloration as the landscape and his stillness mirroring that of the lake, grasses, and shoreline, while the bright colors of his hat suggest something unusual may be happening within the child himself. Jess's "Pillowbook" includes a quotation from the novelist

A SHEAF OF POEMS

Restore the hair of the gods! Where
shaggy Christ upon the shaggy wood
is crossed. Divine red Esau kneels
as John the Baptist. Addresses
the Fleece from which the blood
will flow...

In the dark of the moon the hair rules.
The hairy nest emits the moon
which floats upward
into a clean stillness.
The tears become half-men
freakd by the light which returns
into its nest.

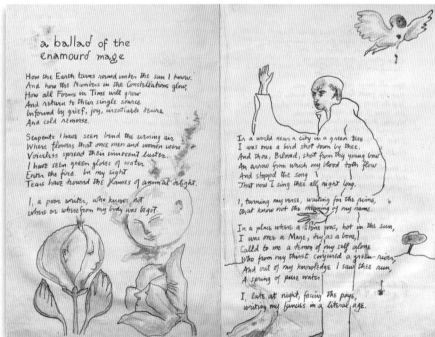

a ballad of the
enamourd mage

How the Earth turns round under the sun I know.
And how the Numbers in the Constellations glow,
How all Forms in Time will grow
And return to their single source
Informd by grief, joy, insatiable desire
And cold remorse.

Serpents I have seen bend the evening air
Where flowers that once men and women were
Voiceless spread their innocent luster.
I have seen green globes of water
Enter the fire. In my sight
Tears have around the flames of animal delight.

I, a poor writer, who knows not
where or whose from my body was begot.

In a world near a city in a green tree
I was once a bird shot down by thee.
And thou, Biloved, shot from thy young bow
An arrow from which my blood doth flow
And stoppd the song
That now I sing thee all night long.

I, turning my verse, waiting for the rime,
that know not the meaning of my name.

In a place where a stone was, hot in the sun,
I was once a Mage, dry as a bone,
Calld to me a demon of my self alone
Who from my thirst conjured a green river,
And out of my knowledge I saw thee run,
A spring of pure water.

I, late at night, facing the page,
writing my fancies in a literal age.

Robert Duncan, pages from *Untitled (A Sheaf of Poems)*, 1957
Artist book with holograph text and drawings by Duncan

Algernon Blackwood that could describe this painting: "The beginning of wisdom is surely—Wonder."[55]

Carefully chosen words and texts often play an important role in Jess's works, notably within some of the paste-ups and on the backs of many of his paintings, including all of the Translations. Just as drawings and paintings compose a significant part of Duncan's output, so the many poems Jess wrote, and those by Christian Morgenstern he translated, can contribute to our understanding of his oeuvre. Duncan did the majority of his crayons in the 1940s and 1950s, and Jess, likewise, wrote most of his poetry in this period. His poems are themselves like complex collages, though easier than they look at first glance. Perhaps his earliest is the 1944 tribute to James Joyce written on the back flyleaf of his signed copy of *Finnegans Wake,* which begins: "Howth wishipeth a mannakin his Mastur?" He says that Joyce "woold frowen at my fruitile posturlating . . . mellowdyrama/ for psychologos." Duncan called Jess an irrepressible punster (like his Mastur), and almost every word in his poems has at least two meanings. One poem mentions a "dithyramble," bringing out that poetry can help one wander about and explore. Others refer to insects and creatures who can comfort and instruct: "Be wary beleery be humble a bee/ alone atone o when agone are we." To a degree summing up his work and that of his partner's is the title Jess gave to his still unpublished volume of poetry, *This Here Other World.*

Jess called his last major series of paintings "Salvages" and has said these nine works are in part devoted to clouds becoming mountains and visible things becoming less objective and vice versa. Refashioned from previously laid-aside work, these paintings, with their brilliant, creamy coloration and multiple images, seem to express the impulse that first turned Jess from worldly pursuits to art: to save what has value from loss and destruction. The last, unfinished, work in the series, *"Danger Don't Advance," Salvages IX* (c. 1995) (p. 84), shows a figure whose physical features are not clearly defined, standing in "this here other world." Jess has sketched on the man's body numerous figures, bareheaded or with bowler hats, who were part of a crew putting through the first Continental Railroad. In a letter to Don Mixon in October 1995, he writes: "The image is from a turn of the century posing by the construction crew, in Sunday clothes, ranged along a hillside where the final linkage in the Sierras foothills was in readiness to hook up East and West." That this large Albion-like figure carries such images on his body may suggest his capacity to absorb others' identities as well as to unite opposite halves of a continent and of himself. The sign held by one man in the crew, "Danger Don't Advance," indicating the hazards of a construction site, could allude to the peril of such endeavors. Joyce calls his hero in *Finnegans Wake* HCE, or Here Comes Everybody. One also thinks of Walt Whitman's line "I am large, I contain multitudes," and despite the apparent physical isolation of Jess's Narkissos-like, alchemical man, the lustrous and thickly painted paradisial landscape surrounding him may indicate an "other" world supporting him.

Solitary figures recur in Jess's works, and this one hauntingly recalls the huge, crouching man in Jess's first collage, *The Mouse's Tale* (1951), whose entire body is made up of black-and-white photos of nude or nearly nude bodybuilders lying about, running, or jumping, which Jess cut out of magazines. Thus, the artist begins and ends his career with a depiction of what could be an Everyman—a one containing the many, and embodying a communal life like that alluded to often in Duncan's later poetry, for example, "There is no/ good a man has in his own things except/ it be in the community of every thing" (*BB,* 79), and "Where there is no commune,/ the individual volition has no ground" (*BB,* 71).

* * *

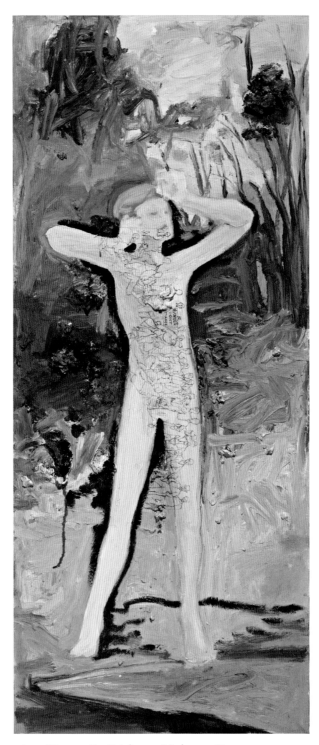

Jess, *"Danger Don't Advance," Salvages IX*, c. 1995
Oil on canvas

Duncan told acquaintances that he and Jess experienced the same joys and faced all the same struggles that heterosexual couples do. One of their closest friends, Harry Jacobus, remembered that their first years together contained some shaky times, and Duncan once implied in an interview that one reason for going with Jess to Mallorca in 1955 was to escape the snares of a past attraction for someone in San Francisco.[56] In his words, he was at heart "fanatically monogamous" and felt extreme guilt whenever he was unfaithful to Jess.[57] His final and most emotionally challenging and exalted book of poetry, *Ground Work II: In the Dark* (New Directions, 1987), published just before his death, records some of his most difficult personal struggles with physicality and how he tried to resolve them. In the first third of the volume he anguishes over a brief affair with a young poet during a reading-teaching tour in Australia in 1976, the poems revealing a darkness and despair unlike anything he had experienced before. He speaks of "la/ limitation de la lumière" (*GW,* 207) and a "loss of the essential in the/ shadows and undertow" (*GW,* 193). However, just as Ezra Pound transmuted his hardness and selfishness into a greater humanity and humility in *The Pisan Cantos* (1948), so Robert Duncan in his last volume faces vanity and other unattractive traits in himself and seeks to free himself from them through belief in the luminousness of "a shining realm above" (*GW,* 202). From the grief of encroaching age and personal inadequacy, he moves into a larger area of consciousness presided over by such Dantescan virtues as "Bonitas," "Veritas," "Magnitudo," and "Sapientia" (*GW,* 239), and comes to see "in this world the other world attending" (*GW,* 231). It is notable, too, that in the depths of the sorrow opening this volume he undergoes a significant shift in his view of sexuality:

Now truly the sexual Eros will have
 left me and gone on his way.
It is a superstition of our time that
 this sexuality is all, is
lock and key, the body's
deepest sleep and waking (*GW,* 186).

Although neither Jess nor Robert was comfortable with physical demonstrativeness in public, a sweetness of affection was ever obvious in their relationship. Jess was never far from Duncan's mind, nor Duncan from Jess's. There are many references to Jess throughout Duncan's poetry, and of course numerous signs of Robert's presence in Jess's work. In "Epilogos," the poet writes, "For I have filld my solitude with your being,/ my essence dwells in your love" (*BB,* 137), and in his "Dante Études" he refers to Jess as "my blessing near/ reminder of my dear humanity" (*GW,* 97). In his great "Circulations of the Song," he affirms, "How happy I am in your care, my old companion of the way!" (*GW,* 171), and finally sees they are "one/ in the immortal ellipse" (*GW,* 173–74). It was apparent that theirs was a profound and lasting bond, far stronger than anything physical.

* * *

Robin Blaser, who became a close friend of Robert Duncan in the 1940s and later of Jess, and who owned works by many of the artists in this circle as well as by these two dear associates, would take time every morning to look at each painting and drawing, and these words by his partner, David Farwell, offer hints for our own viewing:

During our time together, almost every morning Robin did a tour of our home "to say good morning to everybody," as he put it. If

you weren't aware of what he was doing, you probably wouldn't catch it, but it was a very important part of his day. I frequently came upon him in the living-room or his study standing quietly in front of some painting, just looking.[58]

To "just look" at a work of art in this manner, to let it say its message, is perhaps the secret or main requirement for our enjoyment of it, especially if the work seems different or difficult to appreciate.

Blaser noted that Jess's paste-ups are packed with more than one can grasp: "His collages say, 'Try to pay attention and stop at all the places in which you begin to catch a whiff of meaning.' The collages are full of transformations, which take one back to a world of the imagination."[59] Jess once told R. B. Kitaj he was "down and down in Jesstation," and that being "a poor loust hastehater of the first degree" (*Finnegans Wake*, 408), in the words of his favorite novel, helped him become, like his master James Joyce, a "Muster of the Hidden Life" (*FW*, 499). He had periods of producing a large number of works, but more often the process went "likity millimeter," which gives a good idea of how to catch that "whiff" Blaser mentions, and thus, possibly, to enter meaning's realm.

* * *

In Duncan's play *Adam's Way*, one character asks the heartfelt question many of us do, from childhood to old age, "How may I grow into what I do not know?" (*RB*, 156). Indirectly responding to this query, another character states: "When from your own self you are undone/ What thou truly art will be begun" (*RB*, 144). This question and response confront us again and again in Robert Duncan's and Jess's work, and just as they themselves are part of a larger story that can't be told at one sitting, as Jess once noted, so

their works cannot be grasped at one reading or viewing. Part of a galaxy, or an open, inclusive household and field that speak to the heart, Duncan's writing, as he said, was "derivative,"[60] and Jess said his art was not "mine" but "mined."[61] Thus, they suggest to us that our lives, as well, are part of a larger, untold story; and, by taking time to carefully read and look with quiet attention, as Jess advised one young inquirer to do in relation to his work, we can find the meanings according to our own perceptions and discover that "this here other world" ultimately lies within and around us.

Jess and Robert Duncan, 1969

At the time of the writing of this essay, I had not yet seen Lisa Jarnot's *Robert Duncan: The Ambassador from Venus, A Biography* (Berkeley: University of California Press, 2012), an invaluable and eloquent account of the poet's life. Equally valuable is the superlative *Robert Duncan: The Collected Early Poems and Plays,* edited by Peter Quartermain (Berkeley: University of California Press, 2012), which also appeared while this catalogue was being prepared.

—CW

1 Kenneth Rexroth, *Assays* (New York: New Directions, 1961), 192, 239.

2 "A Tread By A Thread: A Pillowbook," Jess Papers, The Bancroft Library, University of California, Berkeley.

3 Tara McDowell, unpublished interview with George Herms, Newport Beach, CA, October 23, 2010. Courtesy of McDowell.

4 Author's unpublished interview with Ariel Parkinson, Berkeley, November 15, 1991.

5 Tara McDowell, unpublished interview with Lawrence Jordan, Petaluma, CA, March 21, 2011. Courtesy of McDowell.

6 Robert Duncan, Notebook #66, The Poetry Collection of the University Libraries, University at Buffalo, The State University of New York.

7 Robert Duncan, Notebook #11, The Poetry Collection.

8 Author's conversations with Jess, 1991–2004. Subsequent remarks of Jess's from such conversations will be noted "Conversations with Jess."

9 Kevin Power, "A Conversation about Poetry and Painting," in *A Poet's Mind: Collected Interviews with Robert Duncan, 1960–1985,* ed. Christopher Wagstaff (Berkeley: North Atlantic Books, 2012), 297.

10 From Robert Duncan, "Orders, *Passages 24*" in *Bending the Bow* (New York: New Directions, 1968), 78. Subsequent citations to Duncan's volumes will be noted in the text parenthetically, using the following abbreviations: (*BR*)—*A Book of Resemblances; Poems: 1950–1953* (New Haven, CT: Henry Wenning, 1966); (*FF*)—*Faust Foutu* (Stinson Beach, CA: Enkidu Surrogate, 1959); (*L*)—*Letters* (Chicago: Flood Editions, 2003); (*OF*)—*The Opening of the Field* (New York: Grove Press, 1960); (*MK*)—*Medea at Kolchis: The Maiden Head* (Berkeley: Oyez, 1965); (*BB*)—*Bending the Bow* (New York: New Directions, 1968); (*TLM*)—*The Truth and Life of Myth: An Essay in Essential Autobiography* (New York: House of Books, 1968); (*GW*)—*Ground Work* (New York: New Directions, 2006); and (*RB*)—*Roots and Branches* (New York: Charles Scribner's Sons, 1964). The 2006 edition of *Ground Work,* ed. Robert J. Bertholf and James Maynard, includes the previously published volumes *Ground Work: Before the War* (1984) and *Ground Work II: In the Dark* (1987). Page numbers refer to this 2006 edition.

11 Letters between Duncan and Jess are in The Poetry Collection, and letters to Jess's dealers Federico and Odyssia Quadrani, along with correspondence from his friends, are in the Jess Papers. Jess's letters are currently being collected and edited for publication by Michael Duncan, who has generously shared some of the fruits of his labors for use in this essay.

12 Robert Duncan, letter to Robin Blaser, Robin Blaser Papers, The Bancroft Library.

13 Conversations with Jess.

14 Steve Abbot and Aaron Shurin, "*Gay Sunshine* Interview," in Wagstaff, *A Poet's Mind*, 180. In a 2006 interview with the author, the late Hilde Burton, one of Duncan's closest friends and confidantes, commented: "Jess became the quieting influence. Robert began to calm down some after they met, but he always carried the involvement with the outer world, while Jess remained committed to the inner one, But, of course, Robert's poetry is of the inside landscape and not the outer world. Jess's is a kind of inner development that we don't know much about actually. I thought it was wonderful how they played off against each other, how they inspired one another constantly."

15 Robert Peters and Paul Trachtenberg, "A Conversation with Robert Duncan," in Wagstaff, *A Poet's Mind,* 209.

16 Ibid.

17 Ibid.

18 Ibid., 210.

19 Thomas Albright, *Art in the San Francisco Bay Area, 1945–1980* (Berkeley: University of California Press, 1985), 32.

20 Conversations with Jess.

21 Jess, letter to Henry Wenning, January 24, 1966, Henry Wenning Papers, Special Collections, Washington University, St. Louis, MO.

22 Jess made this set of black-and-white ovals in 1988–1989 for the covers of *The Collected Writings of Robert Duncan*, a multivolume series first envisioned in 1987 but not published at that time; the first volume in the series, *The H.D. Book* (Berkeley: University of California Press), was released in 2011. The ovals were first published in the exhibition catalogue *Jess: Emblems for Robert Duncan* (San Jose: San Jose Museum of Art, 1989).

23 Subsequent page references to *Finnegans Wake (FW)* are to this 1939 edition.

24 Robert Duncan, in the collection "Letters to Pauline Kael (1940–1946)," The Bancroft Library.

25 Jess, letter to Federico Quadrani, December 18, 1971, Jess Papers; Jess, letter to Robert Duncan, September 19, 1976, Jess Papers.

26 Jess, letter to Federico Quadrani, February 27, 1968, Jess Papers; Jess, "I Ups to Myself And," *J,* no. 2 (October 1959).

27 Author's conversation with Stephen Burton, December 31, 2011. Concerning fame, Duncan writes in an April

30, 1957, letter to Robin Blaser: "The utter corruption of the scene now is 'career,' is the lurking opportunity . . . Performance, entertainment, effect are paramount. And process, source, necessity unimportant." (Robin Blaser Papers, 1955–1971, The Bancroft Library.) He observes elsewhere that Rimbaud was saved because he had never heard of Rimbaud.

28 Eloyde Tovey, unpublished interview with Robert Duncan, 1978, The Bancroft Library, 154.

29 Author's conversation with Stephen Burton, February 23, 2012.

30 Max Ernst, *Beyond Painting* (New York: Wittenborn, Schultz, 1948; reprint, Washington, DC: Solar Books, 2009), 25. Page citation is to the reprint.

31 Kevin Power, "A Conversation about Poetry and Painting," 311.

32 Michael Auping, "An Interview with Jess," in *Jess: A Grand Collage, 1951–1993,* ed. Michael Auping, with essays by Auping, Robert J. Bertholf, and Michael Palmer, exh. cat. (Buffalo, NY: Albright-Knox Gallery, 1993), 19. This volume is indispensable to all students of Jess's work, for Auping's superbly written and comprehensive essay on all phases of Jess's oeuvre, for Palmer's penetrating study of Jess's *Narkissos,* and for Robert Bertholf's illuminating and pathbreaking discussion of the creative relationship of Duncan and Jess, "The Concert: Robert Duncan Writing Out of Painting."

33 Ibid.

34 Herms, interview with Tara McDowell, October 23, 2010.

35 The many correspondences between Robert Duncan and S. T. Coleridge are becoming more apparent. Kathleen Raine's words about the great Romantic poet could well describe Duncan: "No one will deny that Coleridge is a most difficult, not to say formidable writer . . . [He was] spiritually a giant and an adventurer in all the countries of the imagination." From Raine, ed., *The Letters of Samuel Taylor Coleridge* (London: Grey Walls Press, 1950), v, ix. Even as a young man, Coleridge declared he was "a great reader, and read almost everything." He added in a letter that "from my early reading of fairy tales and genii . . . my mind had habituated to the Vast, and I never regarded my senses in any way as the criteria of my belief." Coleridge, *Select Poetry and Prose,* ed. Stephen Potter (London: Nonesuch Press, 1933), 566, 532.

36 Robert Duncan, manuscript for "Homage to Coleridge," The Poetry Collection.

37 This phrase is from the title of a poem in Duncan's *Writing Writing: A Composition Book; Stein Imitations* (Albuquerque, NM: Sumbooks, 1964), n.p.

38 Geneviève Lacambre, *Gustave Moreau: Between Epic and Dream* (Princeton, NJ: Princeton University Press, 1998), 34. Lacambre quotes Moreau as saying the painter must develop the "eyes of his soul and spirit as well as of the body" and that he himself was less interested in conveying "the passions of man" than in "render[ing] visible, so to speak, the flashes of illumination" (ibid., 35).

39 *The Life and Letters of Samuel Palmer, Painter & Etcher,* ed. A. H. Palmer (London: Eric and Joan Stevens, 1972), 249. Original edition published in 1892. Jess and Duncan both revered Palmer (British, 1805–1881). For many years Jess had on a wall outside of his studio a color print of Palmer's *Coming from Evening Church.*

40 David Farwell, letter to the author, February 12, 2012.

41 Jess related to the author that during his visit to 1724 Baker Street, W. H. Auden, misreading this painting, asked, "Why is that man peeing on the cat?"

42 *Arp on Arp: Poems, Essays, Memories,* ed. Marcel Jean (New York: Viking Press, 1972), 364.

43 Conversations with Jess.

44 The crayons were made by photographer and artist Gui de Angulo, the daughter of Jaime de Angulo.

45 Conversations with Jess.

46 Ibid.

47 Gertrude Stein, *Operas and Plays* (Paris: Plain Edition, 1932), 313.

48 Stan Brakhage, telephone interview with the author, September 25, 1988.

49 Conversations with Jess.

50 Duncan's first book was *Heavenly City, Earthly City* (Berkeley: Bern Porter, 1947).

51 Jess, typed note, n.d., Jess Papers.

52 Robert Duncan, letter to Robin Blaser, April 30, 1957, Blaser Papers, The Bancroft Library.

53 Robert Duncan, "Iconographical Extensions," in *Translations by Jess* (New York: Odyssia Gallery, 1971), ix. The most penetrating discussions of the Translations series include this one by Duncan and another by Michael Auping in Auping et al., *Jess: A Grand Collage.* Other valuable treatments of these paintings are found in an untitled essay by Madeleine Burnside in *Jess,* exh. cat. (New York: Odyssia Gallery, in association with John Berggruen Gallery, San Francisco, 1989) and in Tara McDowell's doctoral dissertation, "Image Nations: The Art of Jess, 1951–1991," being completed at the University of California, Berkeley.

54 André Maurois, *Proust: Portrait of a Genius* (New York: Carroll & Graf, 1984), 314.

55 Jess, "A Tread By A Thread," Jess Papers.

56 Peters and Trachtenberg, "A Conversation with Robert Duncan," 199.

57 David Quarles, "Poet of Light and Dark," in Wagstaff, *A Poet's Mind,* 178.

58 David Farwell, letter to the author, February 12, 2012.

59 Robin Blaser, taped interview with the author, San Francisco, June 19, 1986.

60 "Meeting with a College Student" (an interview with Deborah Digges, 1974), in Wagstaff, *A Poet's Mind,* 4.

61 Jess, letter to *Open Space,* January 12, 1964, Jess Papers.

A Gallery of Images

Works by
Robert Duncan
and Jess

Jess, *To Corbett*, 1951
Oil on canvas

Jess, *Now Roll Over And Play Dead: imaginary portraits #2: self-*, 1952
Oil on canvas

Jess, *The Visitation (I)*, 1954
Oil on canvas

Jess, *Untitled (Man under tree)*, c. 1960
Ink on paper

Jess, *Robert Bee Rose: imaginary
portraits #16: Robert Duncan*, 1955
Oil on canvas

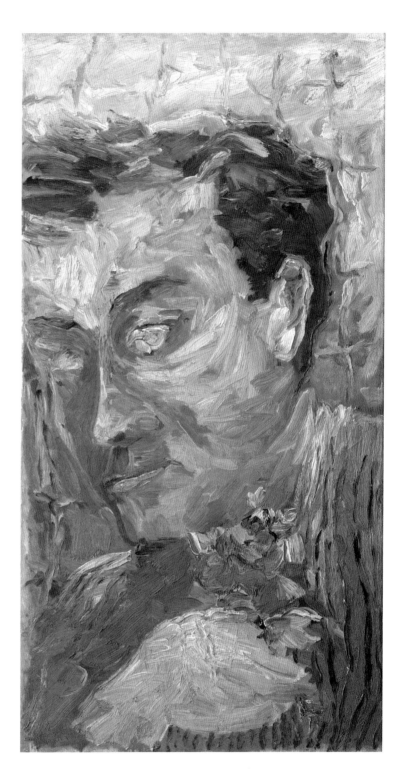

Jess, *One Way*, 1955
Collage

Jess, *Untitled (IF, To D.)*, 1962
Collage

Jess, *Section Through Hairy Skin*, c. 1956
Collage

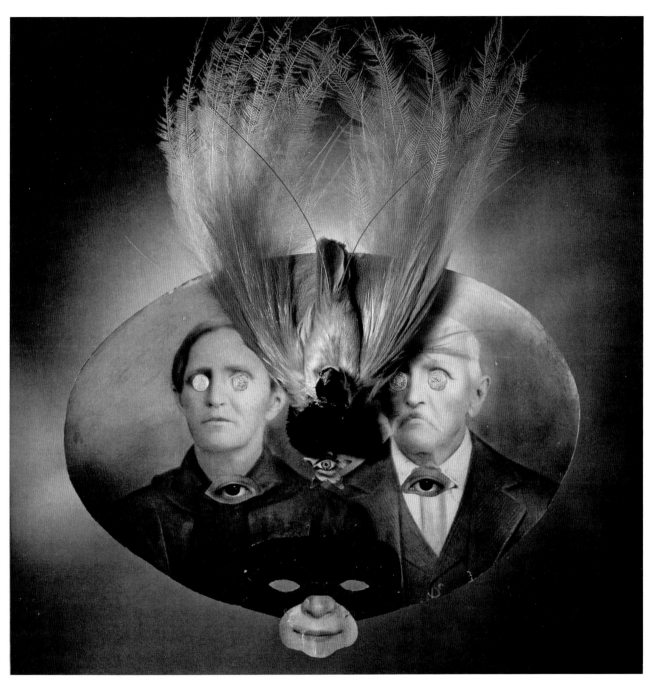

Jess, *A Mask for All Souls*, 1969/1992
Paper collage, stuffed bird mounted on vintage photograph attached to cap

Jess, illustrations for Helen Adam's
San Francisco's Burning, c. 1961–1963
Ink on paper

Helen Adam, *Ballads* (New York: Acadia Press, 1964), illustrations by Jess; limited edition with hand-colored cover and two additional pages

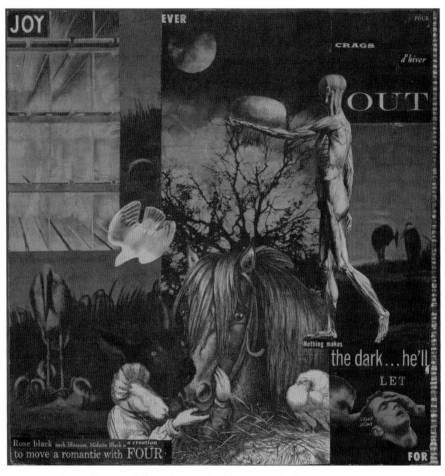

Jess, untitled collage for *Robert Duncan Reading* record album, 1957

Jess, *The Seven Deadly Virtues of Contemporary Art*, 1954
Crayon on board in standing frame

Jess, intertitles for *Finds of the Fortnight*, 1960
Thirty-five collages on paper used in Lawrence
Jordan's 1980 film

The lady says "Yes... neither of us could have done it WITHOUT THE OTHER"

THE POOR GIRL THAT HID IN THE POLAR SEA ASKS — 'HAS THE SUN STOPPED RISING?' — CHIEF RISING SUN KEEPS THE LOST SKIES FIVE TIMES HOTTER THAN ALL THE QUEEN'S HORSES' GLASSES WITH NOTHING BUT A NAME, YOUTH, BRAINS AND IMPROVEMENT. HAPPY BURGLAR SAM GAMBLES AN ARCTIC GRIN FOR THE AIR OF A TAILORED CAMERA. THEY ARE NOT PEOPLE PICKING OUT A RARE HOT PLATTER OF FESTIVE VANITY.

ALAS, IT'S NEEDED FOR A THREE-WAY AIR OF PROPRIETY—

WINK

AFTER THE SHOW PLEASE! LADIES! NO GAMBLING TOO FAR IN THE CENTER AISLES!

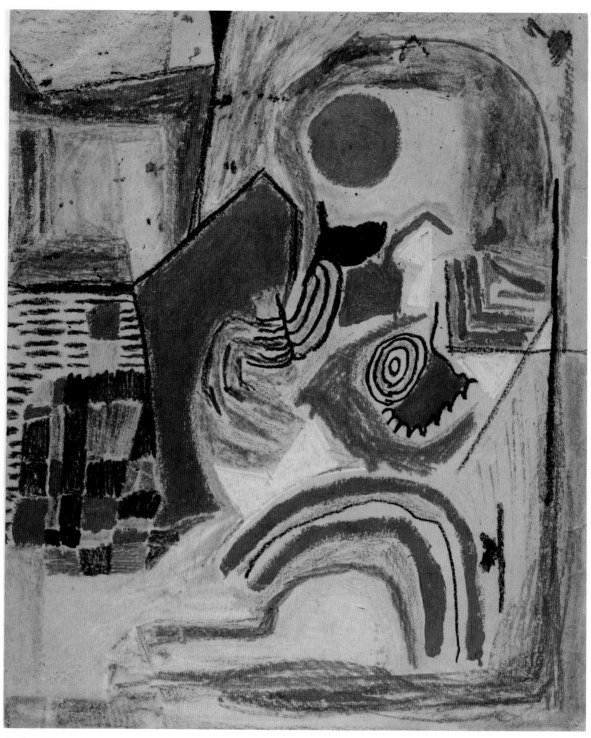

Robert Duncan, *A Winter Sun Yet Dark*, 1950
Wax crayon and gold paint on paper

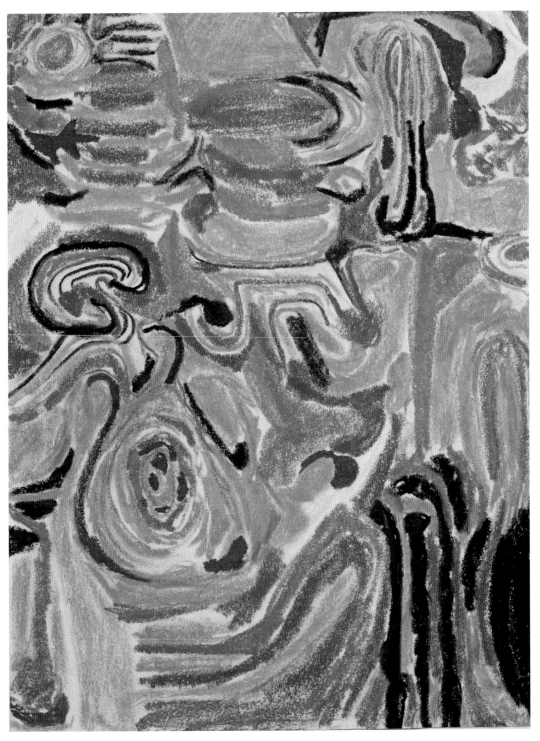

Robert Duncan, *Dancing Salamanders*, c. 1953
Wax and oil crayon on paper

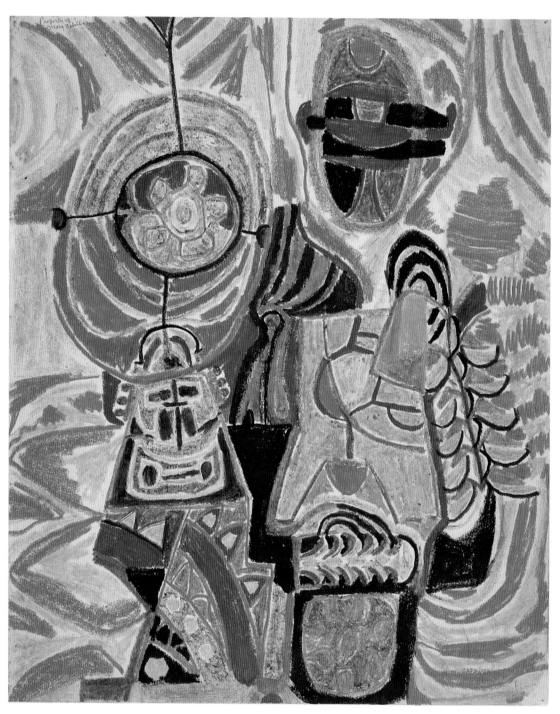

Robert Duncan, *Untitled*, 1947
Wax crayon on paper

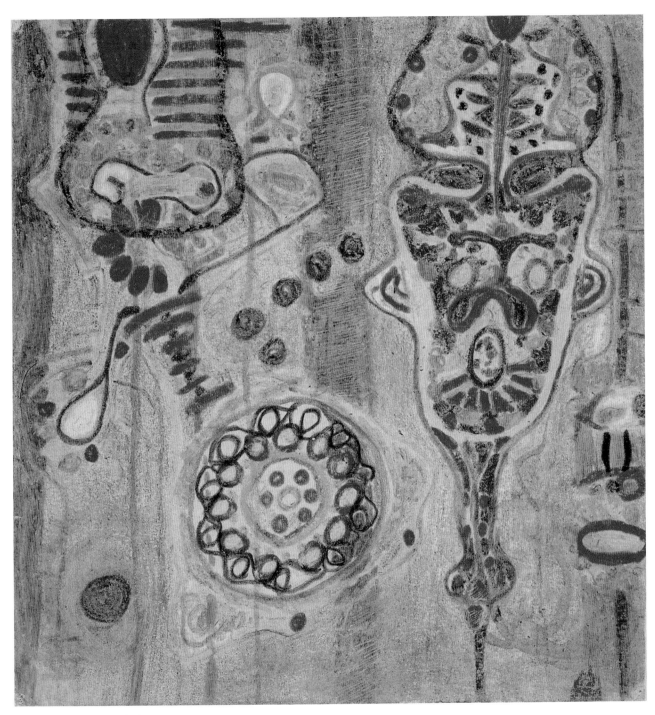

Robert Duncan, *Untitled*, 1943
Wax crayon on paper, 11 x 10½ in.

Robert Duncan, *Odalisque*, c. 1953–1954
Wax crayon on paper

Robert Duncan, *Self Portrait with Shadow*, 1946
Wax crayon on paper

Robert Duncan, *Flight of the Grecian Babes*
and *girl fairy*, from *A selection of 65 drawings
from one drawing-book 1952–1956* (Los Angeles:
Black Sparrow Press, 1970)

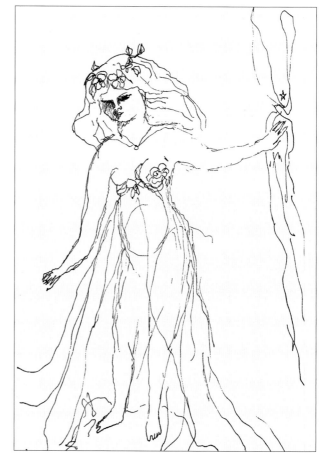

Robert Duncan, *Achilles' Song*
(New York: Phoenix Bookshop, 1969),
cover illustration by Duncan

Robert Duncan, "Yahveh noticing,"
from *A selection of 65 drawings*, 1970

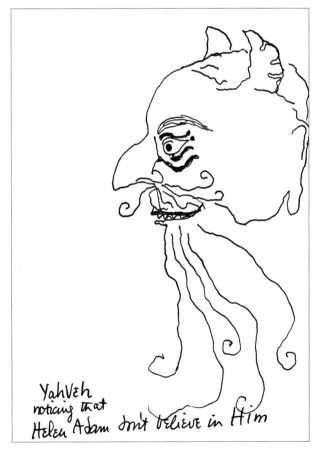

Robert Duncan, *Homage to Jack Spicer*, 1947
Wax crayon on paper

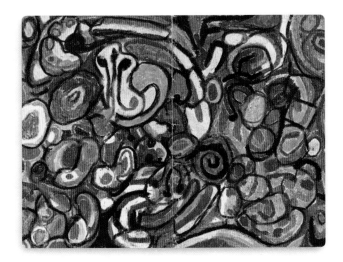

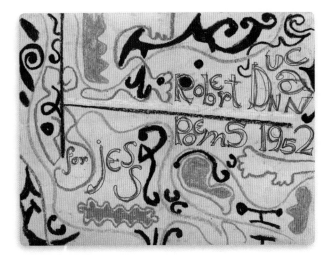

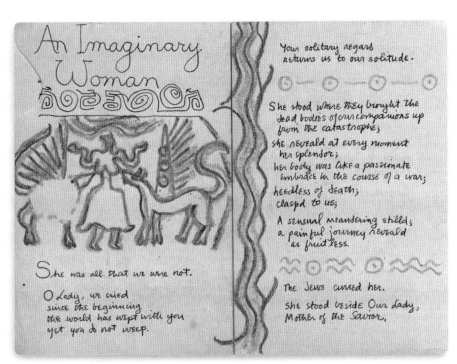

Robert Duncan, cover, title page, and poem from *Poems, 1952: for Jess*, illustrated artist's book, 1952
Wax crayon and ink on paper

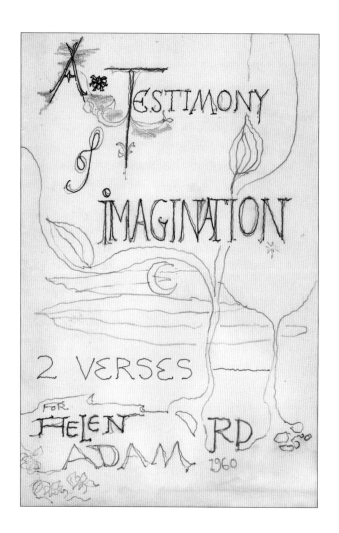

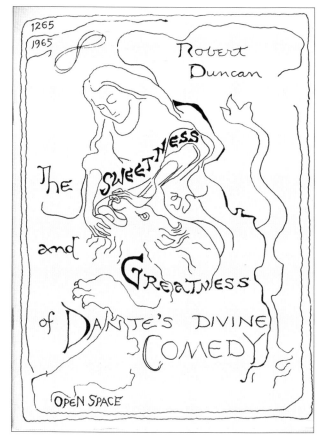

Robert Duncan, *A Testimony of Imagination:
2 Verses for Helen Adam*, 1960
Illustrated artist's book, pen and pencil on paper

Robert Duncan, *The Sweetness & Greatness of
Dante's Divine Comedy* (San Francisco: Open
Space, 1965), cover illustration by Duncan

Robert Duncan, *Untitled (Greek god)*, c. 1955–1956
Wax crayon on paper

Robert Duncan, *Untitled* (male figure), c. 1960
Ink on paper, 10½ x 9¼ in.

Robert Duncan, Christmas card to Virginia Admiral, 1953
Wax crayon on paper, 5½ x 3½ in.

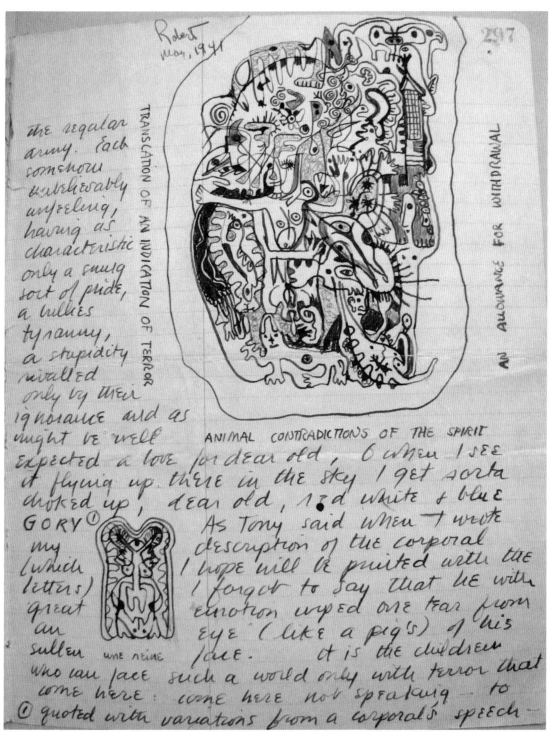

TRANSLATION OF AN INDICATION OF TERROR

AN ALLOWANCE FOR WITHDRAWAL

the regular army. Each somehow unbelievably unfeeling, having as characteristic only a smug sort of pride, a bullies tyranny, a stupidity rivalled only by their ignorance and as might be well expected a love for dear old,

ANIMAL CONTRADICTIONS OF THE SPIRIT

O when I see it flying up there in the sky I get sorta choked up, dear old, red white & blue GORY①

my (which letters) great an sullen

UNE REINE

As Tony said when I wrote description of the corporal I hope will be printed with the I forgot to say that he with emotion wiped one tear from eye (like a pig's) of his face. It is the children who can face such a world only with terror that come here: come here not speaking — to

① quoted with variations from a corporal's speech —

Robert Duncan, page from notebook, 1941

Jess, c. 1965
Photograph by Fran Herndon

Paste-Ups by Jess
A Reading in the Labyrinth

William Breazeale

In describing his work, Jess preferred the term "paste-up" to "collage," emphasizing the casual nature of juxtaposing images and distancing his works from the history of collage, from Braque to the surrealists. Paste-ups in Jess's formulation are less about revolutionary technique—by his time the medium of collage was well integrated into modern art—and more about revolutionary content: an array of images that interact and resonate in a variety of open-ended ways.

The origins of the paste-up lie as much in Jess's personal experience as in the art world. For example, according to Michael Auping, Jess had a great-aunt whose habit of scrapbooking led her to create collages out of magazine images—collages she shared with her young great-nephew. Another catalyst to Jess's work came in 1952, when he and Robert Duncan purchased a copy of Max Ernst's 1934 collage novel *Une semaine de bonté.*

Jess's approach to his medium is much different from Ernst's. Where Ernst focuses on a series of simple scenes, each with similar prints seamlessly integrated by scale to create a disturbing whole, Jess creates an entire world where size, period, and source are less important than his playful, highly individual vision. This joyful jumble of photographs, prints, and even advertising images is a labyrinth of visual contrasts, resonances, and often humorous juxtapositions. Like medieval church labyrinths, the paste-ups are about contemplative journeying—in this case pleasurable visual wandering—rather than about reaching an end goal.

One work that epitomizes Jess's style is *Paste-Ups by Jess,* which he made as an announcement for his 1971 exhibition at the Odyssia Gallery. Since Jess created this work to show the public what they would see at the gallery, it can be regarded as representing the essential elements of his approach. Humor comes to the fore even as we read the title, the snail oozing past the artist's name like marginalia in a medieval manuscript. The same visual play continues throughout, from brains with eyes and ears to bird-headed men to a man walking on water holding a moon.

Some of Jess's sources can be identified. The paste-up itself is made on the surface of an eighteenth-century British print by Samuel Middiman (based on a design by Joseph Wright of Derby) illustrating act 3, scene 3 from Shakespeare's *A Winter's Tale.* The scene is famous for its seemingly nonsensical setting (Bohemia, a desert country near the sea) and stage direction ("Exit, pursued by a bear"). Jess subverts the literary by covering the main figures

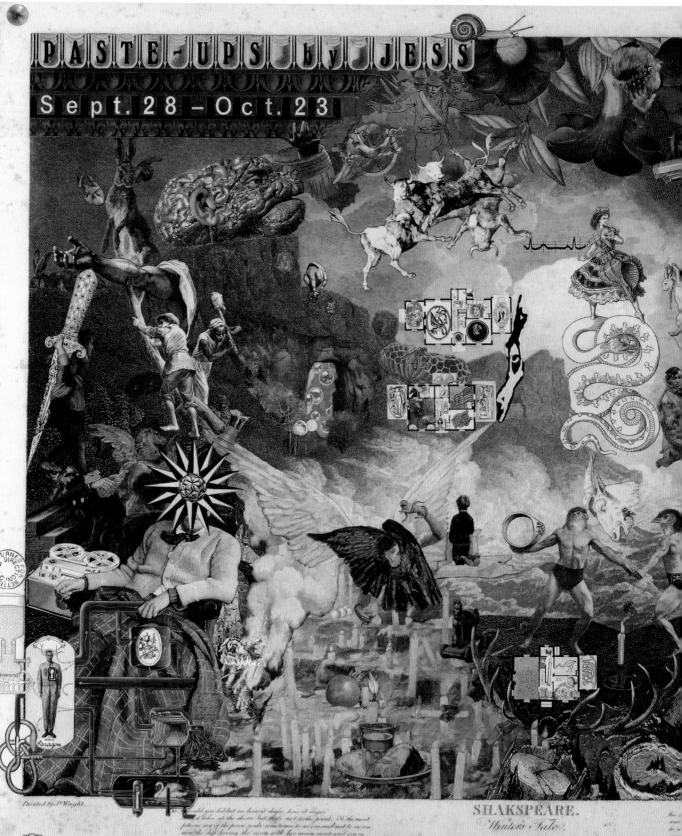

PASTE-UPS by JESS

Sept. 28 – Oct. 23

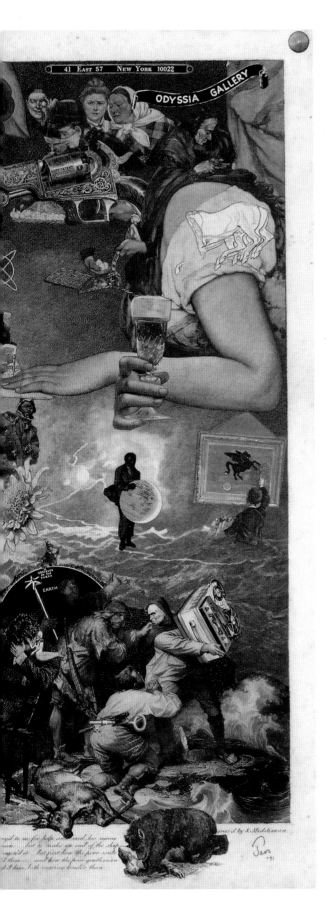

Jess, *Paste-Ups by Jess,* 1971
Collage

of Antigonus fleeing and the chasing animal, leaving only the highly dramatic rocky coastline and sea lit by heavy but thinning clouds. However, he does retain the setting on a typewritten scrap added to the original caption.

Other source images include a large variety of nineteenth-century engravings, wood-engravings, and lithographs, drawn from advertising, genre prints, and fine art—for example, the tangle of bulls floating below Jess's name are from Goya's *Disparate de tontos* (also known as *Disparate de toritos*) in the Disparates (Follies of Mankind) series. The few "modern" images are taken from advertising and science (e.g., the reel-to-reel tape players and the surface of the moon) and are placed for maximum effect, injecting jarring temporal reminders. Several mid-twentieth-century photographs complete the bank of source images.

Let us enter the labyrinth together. Among the infinite number of entry points is the area cleared around the two bird-headed men at lower center-right. Toned and athletic, they mirror each other's stance like the figures in a fifteenth-century altarpiece. But

their bird heads make them hybrids—supernatural figures that simultaneously evoke the Egyptian sky- and war-god Horus and the humanized animals of nineteenth-century French printmaker J. J. Grandville. Almost grasping hands, they are ready to throw ring and globe in a mystic ritual as they circle the lit candle below. The only observer is the disembodied ram's head, a grinning relic of the ancient world. Above the ram is another ancient icon, the hissing snake, a multivalent symbol of vitality. The snake is coiled both in front of and beyond the cliff, giving it enormous scale. Perched on the snake is a suddenly modern image of a nineteenth-century ballet dancer. Pointing her toe in a pert sixth position, she seems unconcerned at the transformation that has turned her dress into a shell. This column of images moving upward from ancient to modern, from male to female, from ritual to ballet, gives a sense of the themes that may govern Jess's seemingly chaotic juxtapositions.

As in a labyrinth, the viewer is repeatedly presented with a choice of visual path in the paste-ups. Here we can follow either the ballet dancer's glance

downward to the prancing cat or the heartbeat chart that enters her back. If we follow the latter, a literal counterpart to the snake's symbolism of vitality, we end at the tangle of bulls from Goya's Disparates. Without reference to the source, the bulls are the embodiment of chaotic strength, bucking and weaving while suspended in midair. Knowledge of Disparates, however, adds another level of meaning, since that series is about human folly and its consequences. Such a theme is supported by the militaristic group above and the figure being broken on the wheel, a medieval form of torture and the way Saint Catherine of Alexandria was martyred. These last two images, along with the barrel sprouting a hand supporting the title, seem to emanate from the curiously expressive, humanized brain at left, as if to say the human brain is the source of senseless violence and folly.

Directly left of the brain, forming the summit of a hollow visual pyramid that extends nearly to the paste-up's bottom margin, is a standing rabbit. He looks ready to fall down this rabbit hole—not the only *Alice* reference in Jess's wonderland—while disembodied hands and arms grasp at him and his shyer companion beyond. As in *Alice,* disparity of scale provides humor in a mock-serious world; to prop up the arm, one figure uses an enormous Victorian paper knife while the other uses a giant log. The latter figure and his companion, a black girl whose pose mirrors his as she carries her burden, are especially reminiscent of Winslow Homer's illustrations for *Harper's Weekly* in the 1860s. In this area as nowhere else the disembodied predominates; in addition to the brain, hands, and arms already mentioned, eyes stare out from a black velvet mask in the shadows. Here also correspondences with the right-hand images begin:

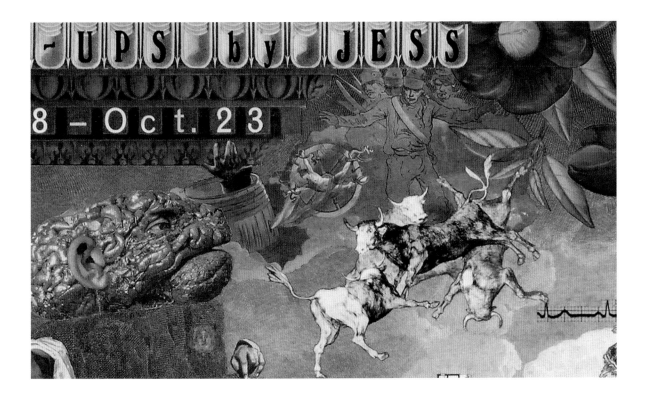

the enormous disembodied arm opposite, the paired Pegasuses, and the two tape players below. With Pegasus, the winged horse piloted by Bellerophon to slay the Chimera, Jess introduces the classical Greek world of gods and heroes. Pegasus's own wings are echoed visually by white and black pairs connecting him to the Egyptian myths of the Horus-men.

Pairs and dualities, whether visual or thematic, recur in the whole of Jess's work, not just in the paste-ups, and deserve special attention in the search for resonance. The mirrored Horus-men, the symmetrical placement of Pegasus and tape recorders, the relation between spirituality and domesticity we will see in the house plans, and the themes of body and disembodied all provide paths to meaning.

Within, or in front of, the pyramid the atmosphere suddenly turns inward and domestic. Though his face is hidden by a compass rose and polyhedron, a man sits peacefully in his chair, a plaid quilt drawn up to his lap as he listens to the tape player beside him. Almost woven into the plaid is the gnomon magic number square from Albrecht Dürer's *Melancolia I*. The tube he grasps in his left hand leads to an organized tangle of boilers and pipes, the interconnected chambers inhabited by mystic symbols, a swan, and a man. The keyhole over the latter's heart may provide a clue, an analogy between the body's internal workings and this mystical heating system.

The imagery of heat and fire continues to the right, connecting body and the spirit. Before a

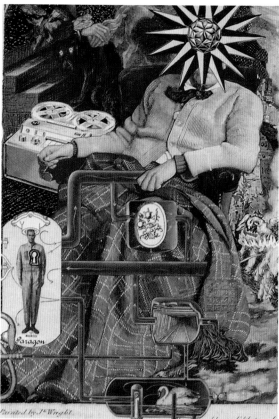

cloud of smoke is a burning phoenix, the mythical bird whose rise from its own ashes symbolizes regeneration. Fire also is the flame of many candles, their votive wax flowing down the steps as after a Church festival. Lit and extinguished by unknown hands, they embrace a plate of bread and glass of water placed as if they were the bread and wine of the Eucharist. Myth and ritual connect again as we move past the steps, with the floating image of a little boy kneeling in prayer, placed as if riding the waves, his shape echoed by the land-bound Trojan horse rolling along like a child's pull-toy below. Whether or not these juxtapositions comment on the efficacy of Church ritual and prayer, the importance of the spiritual life—or lives—is clear.

That Jess proposes equal-opportunity spirituality is clear as well and made manifest in another element of the paste-up. Seemingly independent of their surroundings, and seeming to float in front of all else, are three house plans. The lowest of the three—filled with spiderwebs, candles, butterflies, Egyptian ibises, the Madonna and Child, and the word *Ka'aba* for the holiest place in Mecca—connects the domestic and the universal through major religious traditions as well as symbols that appear in many cultures. In those above, Greco-Roman myth predominates in images of Medusas, griffins, winged horses, goddesses, and Orpheus's harp, though Egypt and the Church are represented with Horus's eye and a bishop's miter. Here as well, more down-to-earth

symbols—the flag, the chess pieces, the train and snail, and the mechanical mouse—are present in all their ambiguity. But the world of home and the world of the spirit are linked in Jess's vision.

With this counterclockwise circle we have returned to the Horus-men's clearing and their myth-bound choreographed ritual. The only difference between the two men is the Jolly Roger that forms part of the fabric of the right-hand man's garment, introducing a sinister note into otherwise symmetrical form and action. These sinister overtones continue in the group of figures at lower right. The man in the chair, his gesture one of despair as he grasps his forehead, listens to the seductive whispers of a fish-tailed spirit. Beside him is a scene of drama and theft, with figures begging and remonstrating

as another carries off his prize—the second modern reel-to-reel tape player. The context for the two tape players, placed at opposite ends of the paste-up, could not be more different: one is domestic and peaceful; the other is wild and dramatic. These opposites are strengthened by the key hanging from the supplicant's belt at lower right, which fits the keyhole in the man's heart at lower left exactly. Behind and below the supplicant, a fallen deer and a bear attacking a man bring out the violence and drama of the natural world as well as the human one. Ironically, the scene must represent the end of the chase begun in Shakespeare's famous stage direction for the scene from *A Winter's Tale*: "Exit, pursued by a bear." Enveloping all of the activity in this bottom-right corner are two opposing images of the cosmos: in

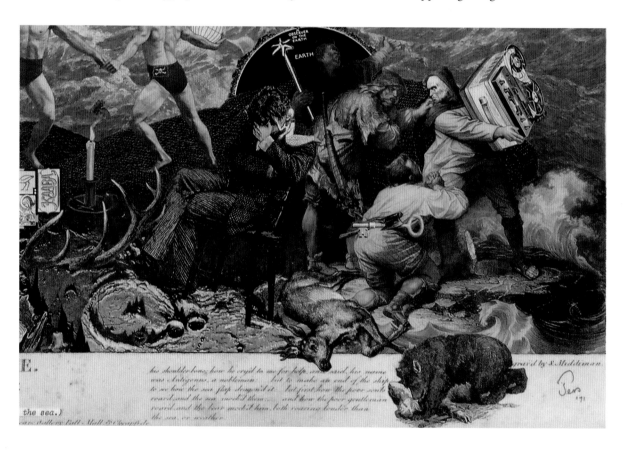

the foreground the lunar surface (referencing the 1969 *Apollo* moon landing—still a relatively recent event when Jess created the work); and in the background a solar eclipse complete with placement of the viewer on Earth.

With his early interest in science and the cosmos, Jess is especially adept at creating worlds. He does not limit himself to the kind of cosmic reference we have just seen, however. The world of letters, the world of art, and the world of the imagination coincide and contrast here and in the artist's work in general. References to each world abound not only in the paste-ups but also in paintings, with various inflections throughout his career.

Let us continue the journey. At this point we leave the realm of earth and enter sea and sky. Curiously isolated against the clouds on the bright horizon is a

black man holding a moon, which is shaded except for a bright fingernail of light. The moon echoes not only the cosmic symbolism of the foreground craters and eclipse diagram but also the sun at his back, peeking through clouds. The man rides the waves, literally walking on water, while to the right a schoolboy wades instead. The painting the boy retouches contains two elements: a black Pegasus and another fingernail moon. Perhaps a thematic link is intended, since just as the man defies water, the horse defies air. At left, even though they rest on a rock, two seamen, one white and one black, pilot their wheel, its spokes echoed by the floating flower beside it. The black seaman's hat just brushes a letter floating in midair. The letter, paradoxically illegible, both communicates and hides information, becoming a metaphor for the paste-up itself.

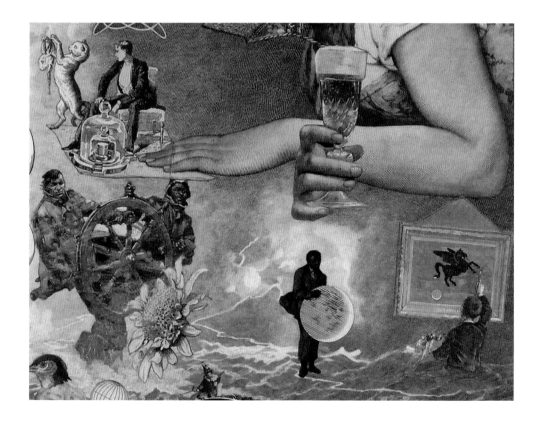

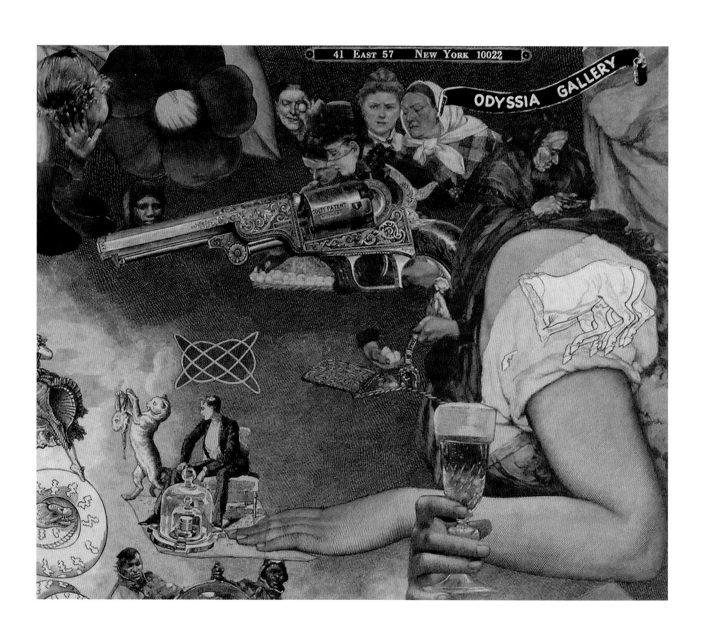

The letter also serves as a sort of flying carpet where a man in white tie sits, eyes downcast. He turns away from a double-domed tray, perhaps an electrical apparatus or a stock ticker, preferring to gaze at the tail of a prancing cat. The most formal and the least accessible of the figures in the paste-up, this man exhibits an apathy contrasting with the cat's liveliness as it parades its prey—a dripping rabbit's head—for the shell-dressed ballet dancer. The animal instincts of the business world find their counterpart in feline pursuits, it seems.

Such is the power of the flying-carpet letter that it lifts an enormous disembodied arm like the one the giantess Alice sticks out the window of the White Rabbit's wonderland house. The arm supports nearly all the images in this upper corner, literally or figuratively. A second hand sprouts from the wrist, hospitably offering the viewer a glass of beer in a gesture of welcome. The shoulder is emblazoned with a broken sculptural relief of ancient horses, relating the arm to the world of myth as well as wonder. From it a third smaller hand sprouts to hold a ghostly hamper. Above the latter leans a peasant woman, her own disembodied hand placing eggs into the hamper. Other peasant women populate the upper corner, their homely, curious glances joining those of their middle-class sisters to gaze down the barrel of a giant pistol pointed, like one of the tubular blooms above, at the flying, fighting bulls. A girl shields herself from its report. From wonder to weaponry, from earthiness to myth, from guns to flowers, from nonsense to senseless violence, the thought-provoking contrasts in this upper corner typify Jess's labyrinth of images.

This preliminary journey through the labyrinth, like any interpretive journey, can follow only one path at a time. But the paste-ups are networks of images, with sources that resonate across the entire structure as well as with the images closest to them, and in multivalent ways. Each journey, each resonance, is particular to the individual viewer, a function of what both Robert Duncan and Jess called "indwelling." By their very nature as a network of images, the paste-ups rebel against universal meaning and purposefully defy the kind of analysis that seeks one-to-one correspondence.

In *Paste-Ups by Jess,* themes such as flames and firearms, hands and arms, gestures and glances are all scattered throughout to provide directions, detours, and shortcuts in the journey to meaning. The journey we have taken is part of an individual experience and is descriptive rather than definitive—part of a number of visual experiences that can change over time. The images that I have not brought forward in my path—a tree stump, bees, bubbles, and Harriet Tubman among them—may serve as new entry points and as an invitation to other viewers to make their own journeys.

Such journeys can only reveal more. Jess's enigmatic, changeable juxtapositions correspond to the inner world, where the kaleidoscope of visual and emotional fragments is rearranged daily. Part of Jess's brilliance is to bring the inner world, its enigmas and its contrasts, its journeys and transformations, to the fore. It is not his own inner world he creates, but rather a many-layered vehicle for exploring our own shifting imagination.

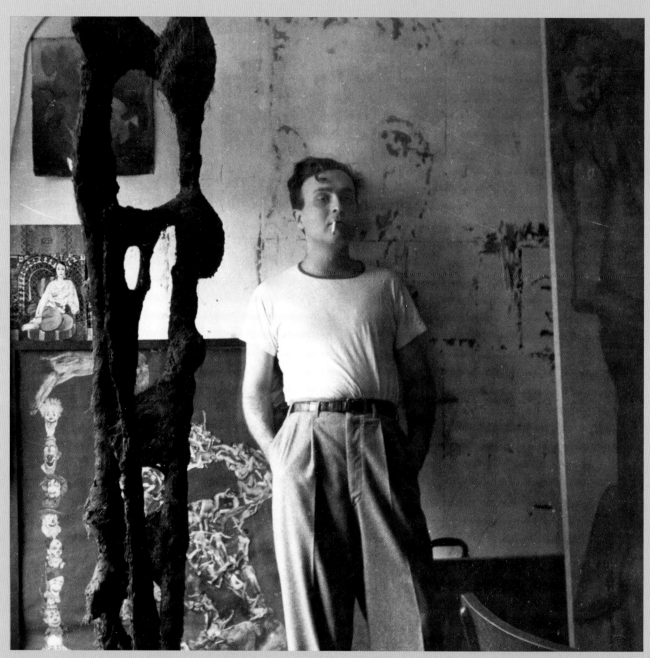

Robert Duncan, with artworks by Jess, 1953
Photograph by Wallace Berman

Poetry as Primary Community

Duncan, Spicer, Blaser, McClure, Olson, Levertov, and Creeley

James Maynard

In his preface to a bibliography of Robert Duncan's many publications, Robert Creeley writes that "Poetry is primary community, primarily communal" and identifies Duncan as "that poet of my generation who brought the communal world of this art forward again."[1] Being a poet was an incredibly social activity for Duncan, who, having chosen early on to dedicate his life to poetry, interacted with a large and diverse group of writers, artists, and others. For "An Opening of the Field: Jess, Robert Duncan, and Their Circle," six poets in particular have been identified as key members of Duncan's community: Jack Spicer, Robin Blaser, Michael McClure, Charles Olson, Denise Levertov, and Robert Creeley. They are represented in the exhibition checklist by their publications and, in some cases, their paintings and drawings, as well as by a few of the other associational items that they exchanged in friendship.

From Berkeley to Black Mountain

Historically and geographically, these six relationships fall roughly into two periods of Duncan's writing life: first, the Berkeley and San Francisco Renaissances of the 1940s and '50s, respectively, and then the Black Mountain years of the 1950s and '60s.

All seven poets were included in Donald Allen's landmark anthology *The New American Poetry, 1945–1960* (1960), a collection of third-generation modernists from aesthetic communities around the United States who were loosely united in their practice of formal experimentation and their rejection of academic verse. Spicer and Blaser were part of Duncan's poetry circle in Berkeley, California. The younger McClure was originally a student of Duncan's in a poetry workshop sponsored by the Poetry Center in San Francisco, and the two went on to become friends. It was in San Francisco, too, where Jess, whom Duncan first met in 1949, was a student at the California School of Fine Arts. On both sides of the Bay, these literary and artistic groups were part of a shared impetus toward creative expressions unconstrained by convention.

Beginning in the early 1950s, however, Duncan's social and aesthetic affiliations—his self-identification as a poet—began to shift away from the Bay Area toward a group of writers associated with the *Black Mountain Review*. As Duncan writes, "Between 1951 and 1954 with the first issues of *Origin*, edited by Cid Corman, a configuration of new writing appeard which determined my concept of what the tastes of the poet were to be. Charles Olson, Denise Levertov

and Robert Creeley were primaries in that field—they gave directive and challenge."[2]

Having sought each other out and then been published together in the pages of Black Mountain College's literary magazine (which also published a few of Jess's collages), Duncan, Olson, Levertov, and Creeley generally shared the principles of projective energy and organic, improvisational form articulated in Olson's influential essay "Projective Verse" (1950). Otherwise, they were geographically separated. In fact, the only time that all four of them were in the same place together was during the 1963 Vancouver Poetry Conference at the University of British Columbia.

Worlds Made Possible

It is difficult to exaggerate the material and psychological support these six poets lent to Duncan's writing and vice versa. More than just the motivation and encouragement they shared as a group of like-minded writers and thinkers, they were exchanging manuscripts back and forth, providing each other with feedback, working out new ideas together, writing essays and poems for one another, publishing each other, reviewing each other, defending each other, challenging each other, and sometimes even criticizing each other in matters of poetics. "Problems in poetry," Duncan once observed, "project new problems in the emotional life of the community," and often the inverse was equally true.[3]

Inevitably, interpersonal and aesthetic frictions occurred, and sometimes these could be quite serious. Duncan experienced varying degrees of disagreements with all six poets, but he never stopped declaring, both in print and in private, the significance each held for him. Together, they formed around Duncan and Jess a network of overlapping communities in which some of the most important poetry of the second half of the twentieth century took shape.

SPICER & BLASER

Having left the University of California, Berkeley, in December 1938 during his third year of college, Duncan spent the next few years living in the East (staying at times in Philadelphia, Annapolis, New York, Woodstock, and Provincetown) before returning to the Bay Area in 1945. He came back to find an anarchist literary culture gathered around Kenneth Rexroth in San Francisco, where Madeline Gleason had also established a Poetry Guild and, beginning in 1947, a Festival of Contemporary Poetry.

It was at a meeting at Rexroth's home in 1946 that Duncan first met Jack Spicer (1925–1965).[4] Afterward, Spicer showed typescripts of three of Duncan's "Berkeley Poems" to Robin Blaser (1925–2009), and soon the three were living and writing together in Berkeley. These poems were later published in Duncan's first book of poetry, *Heavenly City, Earthly City* (1947), which provides the context

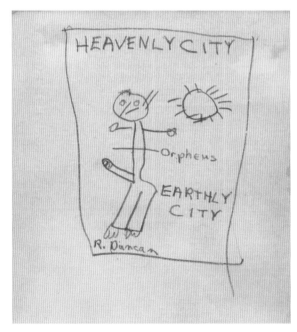

Jack Spicer, *Heavenly City Earthly City,* 1947
Pencil on torn paper

Jack Spicer, Ebbe Borregaard, and
Joanne Kyger, Halloween 1957

Robin Blaser and James Felts, 1953

for Spicer's priapic caricature of Duncan as Orpheus that is part of the exhibition. In an obituary for Spicer, Duncan wrote: "In the late 1940s, Jack Spicer, Robin Blaser and I hoped for what we called a Berkeley Renaissance. We wanted a learned poetry, learned not in terms of the literary world but in the lore of a magic tradition and of a spiritual experience we believed to be the key to the art."[5]

The three poets often met at 2029 Hearst Street, a communal house belonging to Hugh and Janie O'Neill, where in ten nightly sessions in 1947 Duncan composed in the manner of a séance his *Medieval Scenes* (1950), a poem significant for its introduction of seriality to the other Berkeley poets. Duncan, Blaser, and Spicer also studied together at UC Berkeley with the Renaissance and medieval scholar Ernst Kantorowicz, and they participated in off-campus lectures and poetry readings led by Duncan at Throckmorton Manor, a Berkeley boardinghouse. Later, when both Spicer and Blaser were living in Boston in the mid-1950s, Duncan came to visit.

Although Duncan and Spicer in particular were notorious for their quarrels and antagonisms—Blaser once described their collective association as a "dissonant companionship in poetry"—they at times supported each other in equal measure.[6] For instance, Duncan published Spicer in his magazine *Berkeley Miscellany,* typed Spicer's *After Lorca* (1957) for its publication by Joe Dunn's White Rabbit Press (with cover art by Jess), and under his imprint Enkidu Surrogate published Spicer's *Billy the Kid* in 1959 (illustrated by Jess); Spicer published Duncan in his magazine *J*; and Blaser played the role of the dragon Hermes in a 1962 performance of Duncan's play *Adam's Way.*

Spicer died of complications related to his alcoholism shortly after the Berkeley Poetry Conference in 1965, and the following year Duncan precipitated a major falling out with Blaser when he criticized Blaser's translations of Gérard de Nerval's collection of mystical sonnets, *Les Chimères.*

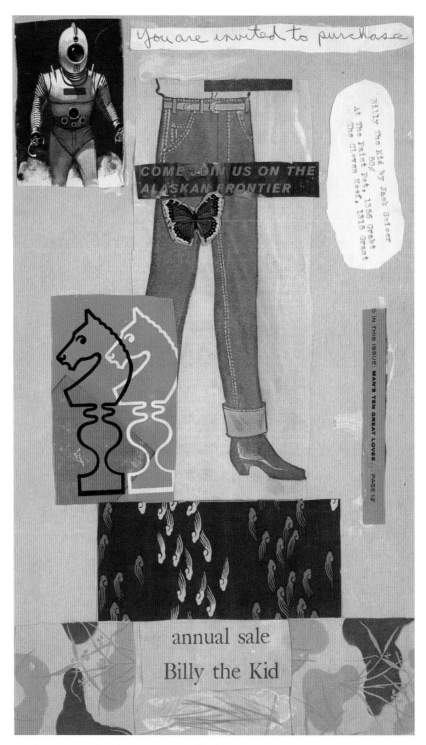

Jack Spicer (with Robert Duncan), *Billy the Kid*, 1959
Collage on cardboard

Jack Spicer, *The Heads of the Town up to the Aether,* 1962
Edition with original crayon drawing by Spicer

Caterpillar 12 (New York: Clayton Eshleman, 1970)
Cover collages by Robin Blaser featuring photographs of Robin Blaser and Jack Spicer

Jack Spicer, *Untitled*, 1957
Pastel on cardboard

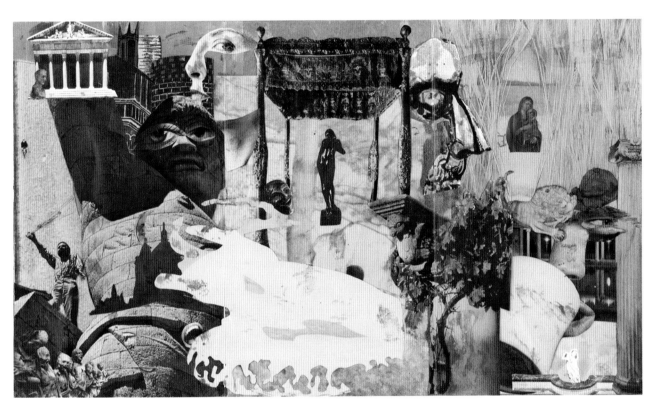

Robin Blaser, *Triptych*, 1960
Collage

One of many younger poets for whom Duncan was an important mentor, Michael McClure (b. 1932) moved to San Francisco from Kansas in the early 1950s and began a lifelong friendship with Duncan and Jess. In 1954 a donation from W. H. Auden helped found the Poetry Center at San Francisco State College (today San Francisco State University), and that same year McClure attended a poetry workshop taught by Duncan and Norman McLeod. After Duncan's death, McClure wrote: "As the students of his first workshop at San Francisco State listened to his insights and projections regarding their poems and looked in wonder at his restructuring of their work on the blackboard, they knew something big was happening."[7] Initially, when McClure came into the workshop writing sonnets and other formal verse patterns, Duncan was skeptical; it was only when McClure returned to writing free verse as he had done in high school that the two became friends.[8]

In October 1955, McClure—who demonstrates the fluidity of interaction between the Bay Area poetry communities—was one of five poets who took part in the famous reading at the Six Gallery in San Francisco, when Allen Ginsberg first read "Howl" in public. (Duncan and Jess missed it as they were then living abroad on the Spanish island of Mallorca.) Today, the event is widely seen as

Michael McClure, with sculptures
by Miriam Hoffman, c. 1955

an inaugural moment of the Beat Generation, a movement whose geographical and chronological proximity to Duncan and the Berkeley Renaissance is indicated by the fact that the Six Gallery was co-organized by Spicer and existed in a former garage previously occupied by the King Ubu Gallery, a collaborative arts space run by Duncan, Jess, and the artist Harry Jacobus.

Following the birth of his daughter, Jane, in 1956, McClure wrote a children's story for her entitled *The Boobus and the Bunnyduck* (Arion Press, 2007), which Jess illustrated in 1957 using wax crayons.

Michael McClure, *Snake Eagle*, 1956
House paint on canvas

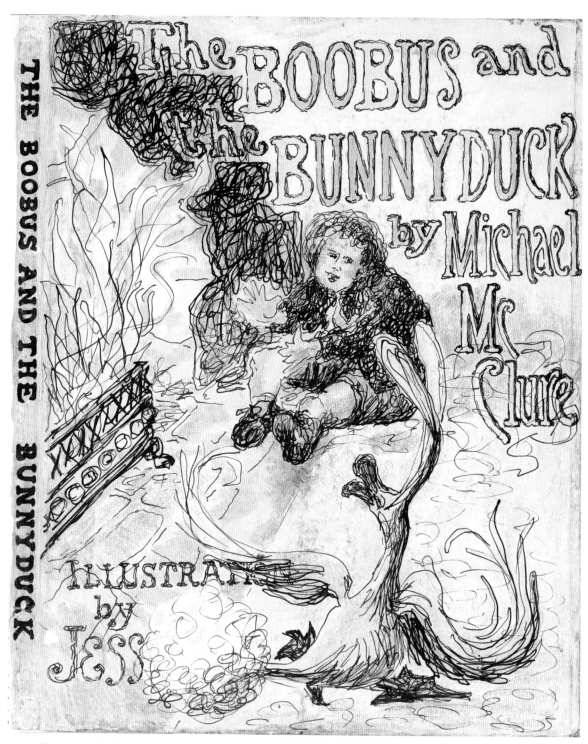

Jess, illustration for *The Boobus and the Bunnyduck* by Michael McClure, 1957
Crayon, ink, and watercolor on paper

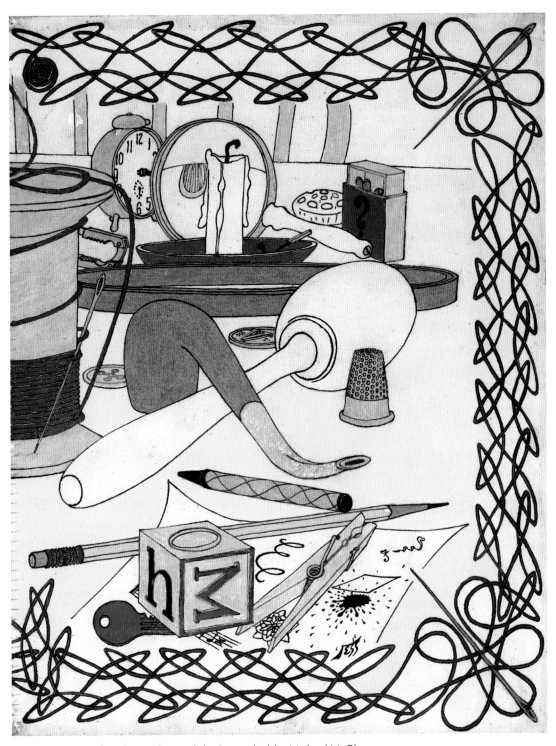

Jess, illustration for *The Boobus and the Bunnyduck* by Michael McClure, 1957
Crayon, ink, and watercolor on paper

Duncan regarded Charles Olson (1910–1970) as the defining poet of his generation, often referring to the 1950s and '60s as "the Age of Olson." The two first met in 1947, when Olson was in California doing research on the Donner Party; at the time, Duncan wasn't aware that Olson was a poet. Duncan then read Olson's "Projective Verse" in 1950, only later grasping its full significance as a new proposition for poetic form.

Early on in their relationship, Olson published in the first issue of the *Black Mountain Review* (Spring 1954) the short essay "Against Wisdom as Such," a warning explicitly addressed to Duncan regarding the threat of poetic sectarianism. In it, Olson argued that the poet should "traffick" in no wisdom or ideology outside or "separable" from the poem, and that true wisdom is ultimately contingent and only ever embodied in "the time of the moment of its creation."[9] This text became one that Duncan returned to many times in the ongoing articulation of his poetics. Five issues later appeared Duncan's "Notes on Poetics Regarding Olson's *Maximus*," in which he places the aesthetics of Olson's *Maximus Poems* in the philosophical tradition of American pragmatism.

In the winter of 1956 Olson wrote to Duncan and asked him to teach that spring and summer at Black Mountain College, where Olson served as rector during the school's final years. It was there at the Asheville, North Carolina, campus that Duncan wrote and produced the play *The Origins of Old Son,* a punning satire written about Olson, and where Olson traded his spring poem beginning "Bud pink enclosing" (included in the exhibition) "in exchange for Jess's gift of a [drawing of a] red cardinal upon his limb 'emblazoned,'" as Duncan described in a letter to Denise Levertov.[10]

Even though he would sometimes delight in playing the heretic to Olson's dogmas, a stance he

Charles Olson with his son, Charles Peter, c. 1957

took with many of his closest friends, Duncan often and consistently emphasized the significance of Olson and his *Maximus Poems.* In the introduction to Olson's lecture at the 1965 Berkeley Poetry Conference, for instance, he names him as one of the seven poets he was called to study, identifying Olson as one of his "superiors" in the art and casting him in Promethean terms: "For all of the poets who matter to me in my generation Charles Olson has been a Big Fire Source."[11] As a fellow poet exploring the possibilities of open-form poetics in the postwar period, Duncan often spoke of having shared with Olson a particular adventure in poetry that came to a decided end with Olson's death in 1970.

Fielding Dawson, flyer for Charles Olson's *Maximus Poems 11–22, Jargon 9* (Highlands, NC: Jargon Press)

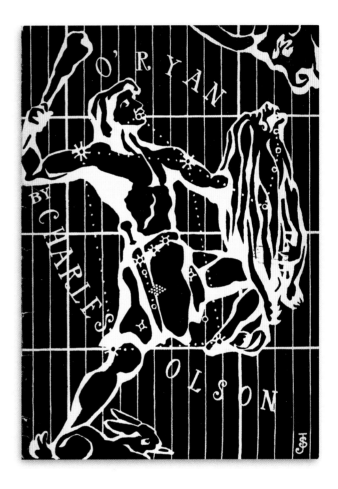

Clockwise from top left:

Charles Olson, "A Litan, for Duncan in January," 1958
Typed postcard

Charles Olson, *O'Ryan 2.4.6.8.10* (San Francisco: White Rabbit Press, 1958)
Cover illustration by Jess

Charles Olson, "Bud pink enclosing" (for Jess), 1956
Card with typed poem

The first personal interaction between Duncan and Denise Levertov (1923–1997) came as a surprise. Having been greatly impressed with Levertov after reading her poem "The Shifting" in *Origin* 6 (Summer 1952), Duncan was so moved that he mailed her a poem titled "Letters for Denise Levertov: An A Muse Meant" (subsequent versions appeared in the *Black Mountain Review* and in Duncan's collection *Letters* [1958]) and signed it only "R.D." Although she tentatively guessed who sent it, Levertov mistakenly read the intended homage as a critique and wrote back to say so. From these inauspicious circumstances began an extremely close—and eventually volatile—literary and personal friendship and a significant correspondence totaling nearly five hundred letters exchanged back and forth over more than three decades.

More so than the other writers of their community, Duncan and Levertov shared an interest in both Jewish and Christian mystical traditions, and Levertov's father, a Russian Jew turned Anglican, had been a translator of the Zohar, a Kabbalistic text important to Duncan. Their first meeting in person occurred in New York in 1955, when Duncan drove across the country with Jess and Harry Jacobus on their way to Mallorca. Five years later they again were in New York together to visit with the poet H.D.

In October 1967, both Duncan and Levertov participated in "A Meeting of Poets and Theologians to discuss Parable, Myth, and Language," a conference held at the College of Preachers in Washington, DC. Duncan's remarks from this event were revised to become the book-length essay *The Truth and Life of Myth,* first published in 1968, in which he ardently defends Levertov's poetry against accusations of sentimentality. Above his writing desk Duncan kept Levertov's drawing (included in the exhibition) of "The bear in the wicked tasman tree," which is most likely an illustration she gave to him of the dream

Denise Levertov, 1961

she recounts in a March 7, 1957, letter written from Guadalajara, Mexico.[12]

As intense and passionate as their friendship was, its disintegration was equally so, ultimately coming to an end in the early 1970s over their differing attitudes toward the relationship between poetry and politics during the Vietnam War. While both poets were staunchly political, Duncan criticized Levertov publicly for what he saw as her poetry's explicit ideology in *To Stay Alive* (1971); instead, he argued, the poem should be free to come to its own ends outside the strictures of partisan thinking (ironically making an argument parallel to Olson's "Against Wisdom as Such"). In response, Levertov accused Duncan of arrogance and elitism, and consequently their relationship was never the same. Writing in 1979, both to give her side of the story and to honor Duncan with a "critical tribute," she nonetheless identified him as her "mentor" in twentieth-century American poetry and "aesthetic ethics," acknowledging the longstanding value of his "messages of love, support, and solidarity in the fellowship of poetry."[13]

Jess, cover illustration for 5 *Poems by Denise Levertov*
(San Francisco: White Rabbit Press, 1956)
Ink on paper

Denise Levertov, *"The bear in the wicked tasman tree,"* 1956
Ink on paper

As the editor of the *Black Mountain Review,* Robert Creeley (1926–2005) began writing to Duncan in earnest in order to solicit work for the magazine. They soon met in 1955 in the town of Bañalbufar on Mallorca, where Creeley and his wife were then living. Recalling their first meeting in a late interview, Creeley remembers that:

> Within ten minutes of meeting Robert I was intrigued by him, and somewhat scared. I was a New England Puritan, straight, and here was West Coast, gay. I didn't know whether I could measure up to his . . . not even to his interests, but to his habit. I knew that he and Olson were close at that point. It was Olson who effectually said Duncan should come into the *Black Mountain Review.*[14]

In Mallorca, Duncan introduced Creeley to the poetry of Louis Zukofsky, and the two spent time with the artist John Altoon. In addition to editing the *Black Mountain Review,* Creeley had established the Divers Press and was publishing books by many of the *Origin* and Black Mountain writers. That same year he published Duncan and Jess's *Caesar's Gate: Poems 1949–1950,* their most extensive collaboration featuring poems by Duncan and collages by Jess. Although of all the Black Mountain poets their writing displays the least resemblance—Creeley often practicing a lyric minimalism and Duncan proposing larger cosmological structures—the two nonetheless shared a great sense of affection toward one another, and each respected the other's writing. Creeley felt equally appreciative of Jess, whom he once described as "one of the most extraordinary and complexly literate people I think I've ever known."[15] Duncan reviewed Creeley's books *For Love* (1962) and *Thirty Things* (1974), and Creeley in turn reviewed Duncan's *Roots and Branches* (1964). The two also

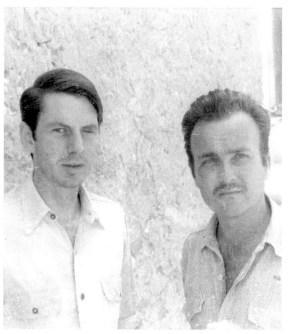

Robert Creeley and Robert Duncan
in Mallorca, 1955–1956

wrote poems in homage and imitation of each other, with Duncan's "Thank You for Love" dedicated "for Robert Creeley" and reading in part:

A friend
's a distant nearness,
as if it were *my* loneliness you have
given song to, given a hand

towards parting without faltering,
lingering in the touch.

. .

Words are friends
and from their distance

will return.[16]

Explaining their more than thirty years of friendship, Creeley once remarked that it was not so much their shared literary values that brought them together as rather a more basic sense of community:

I think both of us were, not to make an easy conjunction, but I think we were each of us in our particular ways trying to both invent and discover a world which would include us.[17]

[W]e were each of us trying to locate and enter a world made possible. Not simply accommodating what we were doing, but in which what we were doing found relationship, place, and company, a companion.[18]

R. B. Kitaj, *For Love (Creeley)*, 1966
Lithograph, 23 x 16 in.

1 Robert Creeley, preface to Robert J. Bertholf, *Robert Duncan: A Descriptive Bibliography* (Santa Rosa, CA: Black Sparrow Press, 1986), 9.

2 Robert Duncan, introduction to Robert Creeley's July 16, 1959, reading at the Poetry Center, San Francisco State College. From the Robert Duncan Collection, The Poetry Collection of the University Libraries, University at Buffalo, The State University of New York.

3 Robert Duncan, "The Poet and Poetry—A Symposium," *The Occident* (Fall 1949), 40.

4 See Lewis Ellingham and Kevin Killian, *Poet Be Like God: Jack Spicer and the San Francisco Renaissance* (Hanover, NH: Wesleyan University Press, 1998), 10.

5 Robert Duncan, "Jack Spicer, Poet: 1925–1965," *California Librarian* 31, no. 4 (October 1970): 250.

6 Robin Blaser, "The Practice of Outside," in Jack Spicer, *The Collected Books of Jack Spicer,* ed. Robin Blaser (Los Angeles: Black Sparrow Press, 1975), 289.

7 Michael McClure, "Robert Duncan: A Modern Romantic," *New Directions* 52 (1988): 1.

8 See Mick McAllister's interview with Michael McClure in *The Beat Journey,* published as *unspeakable visions of the individual* 8 (1978): 101.

9 Charles Olson, *Collected Prose,* ed. Donald Allen and Benjamin Friedlander (Berkeley: University of California Press, 1997), 261.

10 Robert Duncan, letter to Denise Levertov, April 26, 1956, published in *The Letters of Robert Duncan and Denise Levertov,* ed. Robert J. Bertholf and Albert Gelpi (Palo Alto, CA: Stanford University Press, 2004), 38.

11 From Duncan's opening remarks that begin Olson's *Causal Mythology* (San Francisco: Four Seasons Foundation, 1969), 1.

12 In the letter, Levertov writes:
The other morning I woke straight from a dream which I here transcribe, I think in the exact words of the dream, tho' of course the pictures which the narration accompanied I can't reproduce.

"Once there was a bear; and as he went through the woods he saw a tree, and climbed it, its leaves as he thought looking fair and very fine to eat—being like bears, like dogs or the ears of dogs, like gods. But alas it was the wicked tasman tree, & once up in its boughs the bear was captured, finding himself half-bear, half-boughs. 'Ach, how bad it is up here,' he would cry out, 'with the tree's mocking voice calling out *"Dinner? Dinner?"* all day long.' But at nights he would become all bear again, & wander freely in the woods; & that was good." Bertholf and Gelpi, *Letters,* 59.

13 Denise Levertov, "Some Duncan Letters—A Memoir and a Critical Tribute," in *Scales of the Marvelous,* ed. Robert J. Bertholf and Ian W. Reid (New York: New Directions, 1979), 95, 114.

14 Robert Creeley, "Relationship, Place, and Company: A Conversation with Robert Creeley about Robert Duncan," transcribed and annotated by James Maynard, *Journal of American Studies of Turkey* 27 (Spring 2008): 144.

15 Ibid., 155.

16 Robert Duncan, "Thank You for Love," in *Roots and Branches* (New York: Charles Scribner's Sons, 1964), 115–16.

17 Creeley, "Relationship, Place, and Company," 154.

18 Ibid., 153.

Circle of Artists

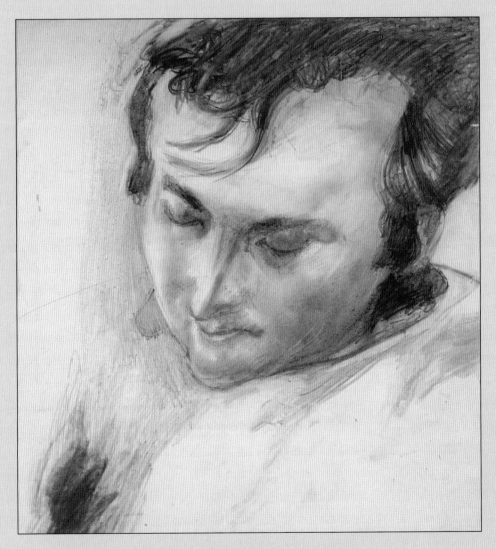

Tom Field, *Portrait of Robert Duncan*, 1956
Pencil on paper

One of the most colorful literary figures of the past century, Helen Adam (1909–1993) blossomed in San Francisco after establishing herself as a child prodigy poet in her native Scotland. A precocious spirit who at age two allegedly spoke in rhyme to her dolls, she published three books of ballads by age twenty and continued writing almost exclusively in the ballad form. Daughter of a country minister, Adam was bred on the fairy tales and fantastical verse of George MacDonald and Andrew Lang. In 1934 her golf-crazed father tragically died after freakishly being hit in the head by a ball, and five years later the family emigrated to the United States, living for a time in New York but eventually settling in San Francisco.

Pushing the boundaries of folk poetry's traditional themes of betrayal and death, Adam's ballads are dark narratives with a shocking toughness and rigor. In 1954 she enrolled in Robert Duncan's class at San Francisco State University's Poetry Center, where she amazed the class with a dramatic reading of one of Blake's *Songs of Experience*. Duncan later commented that her "sublime and visionary" recitation had tapped "the wonder of the world of the poem itself, breaking the husk of my modernist pride and shame, my conviction that what mattered was the literary or artistic achievement."[1] Her devotion to meter and rhyme defied every tenet of contemporary poetry; yet her fantastical subject matter and traditional ballad forms tapped Romantic folkloric roots that Duncan cherished. He began to use the ballad form in his own poems and corresponded with Adam about their structure and narrative flow. Adam quickly entered the social whirl of the San Francisco poetry scene, successfully interacting with often rival camps of poets. She attended Allen Ginsberg's famous first reading of "Howl" at the Six Gallery in 1955 and studied with him briefly that year. She was also an active member of Spicer's "Magic Workshop"

Helen Adam, 1957
Photograph by Harry Redl

at the San Francisco Public Library, as well as of Duncan and Broughton's group "The Brotherhood of the Maiden and its Secret Six."

The Bay Area poetry scene expanded Adam's world beyond the scope of the tiny apartment where she lived with her mother and sister, Pat. Helen became a popular figure at poetry events; acclaimed for her dramatic readings, she chanted and sang in her heavy Scottish brogue as she swayed and gestured. Poet Maureen Owen described her performing skills:

The eerie quality of her verse made the hair on your toes stand stiff. She could scare the pants off God. A simple night nursery rhyme in her hands could stop your heart cold. Each poem beginning with a lilting ballad loveliness and then slowly it starts to take a turn, a dark turn, a chilling turn and the listener or reader is caught in a vortex, spiralling in.[2]

In her lifetime Adam published twelve volumes of poetry and a short-story collection. A selection of her poetry was included in Donald Allen's influential anthology, *The New American Poetry* (Grove Press, 1960). In 1964 Buzz Gallery hosted an exhibition of Adam's photographic portraits using double-exposures intended to reveal their subjects' astral twins. Many of these were accompanied with evocative verse captions intended as tributes. Duncan and Jess held a revered place in Adam's personal pantheon, and she often dedicated poems and photographs in their honor. Scrapbooks of her photographs of group activities at Stinson Beach, Golden Gate Park, and a local graveyard are fanciful records of the time. Made in collaboration with William McNeill and inspired by her poem "Anaid Si Taerg (Great is Diana)," Adam's film *Daydream of Darkness* (1963) is a symbol-laden paean to the mystical qualities of the moon.

While living in San Francisco, Adam also made about seventy-five surreal collages, many featuring glamorous women juxtaposed with insects or reptiles. Clearly inspired by the humor and audacity of Jess's early collages, Adam's marvelously odd works uniquely invoke her particular sense of the bizarre and mystical. Goads for fantasy, they star empowered females able to fend off all kinds of adversity. Captions are used in counterpoint, usually for sardonically humorous effects. Kristin Prevallet observed that Adam's work often describes "forms of *ibbur,* in which there is a sudden inhabitation of the body/mind of a living person by the soul/will and personality of another . . . Like a dancer, when Adam performed her ballads she sought to put her audience under a spell and tell a story that, through the persistence of an ancient rhythm, would 'give them the grue.'"[3] This "spine-tingling shudder" endowed her work with a visceral punch.

Always on the brink of poverty, Helen and Pat had a string of unfortunate secretarial and menial jobs. While working as a bicycle messenger, Adam wrote or memorized poetry on the road. In her papers is a scrawled version of Duncan's poem "Often I Am Permitted to Return to a Meadow" that she used as a pocket crib sheet.[4] Adam's books *Ballads* (Acadia Press, 1964) and *San Francisco's Burning* (Oannes, 1963) featured covers and illustrations by Jess. He wrote of wanting to illustrate her collected verse. A hit production of Adam's verse play *San Francisco's Burning* at James Broughton's theater space, The Playhouse, led to turmoil within her peer group. Duncan and Jess disapproved of Broughton's efforts to make the play more commercial. Music was added, and in 1965 Adam became convinced that she should move with Pat to New York to pursue an off-Broadway production. The upheaval soon proved unfortunate as the play's potential was squelched by a devastating *Village Voice* review. While attracting in the next decades an enthusiastic coterie of New York admirers, Adam and her sister were unable to avoid further dire economic hardship. Despite efforts by Duncan and other friends to win her grants and financial support, Adam fell into depression and ill health after the death of Pat in 1986. She died seven years later, a ward of the state.

—Michael Duncan

1 Robert Duncan, "The Truth and Life of Myth," in *Fictive Certainties* (New York: New Directions, 1985), 30.
2 Maureen Owen, "Helen Adam, 1909–1993," *Poetry Project Newsletter, St. Mark's Church* 152 (December 1993 / January 1994): 5.
3 Kristin Prevallet, ed., *A Helen Adam Reader* (Orono, ME: National Poetry Foundation, 2007), 23.
4 Helen Adam Papers, The Poetry Collection of the University Libraries, University at Buffalo, The State University of New York.

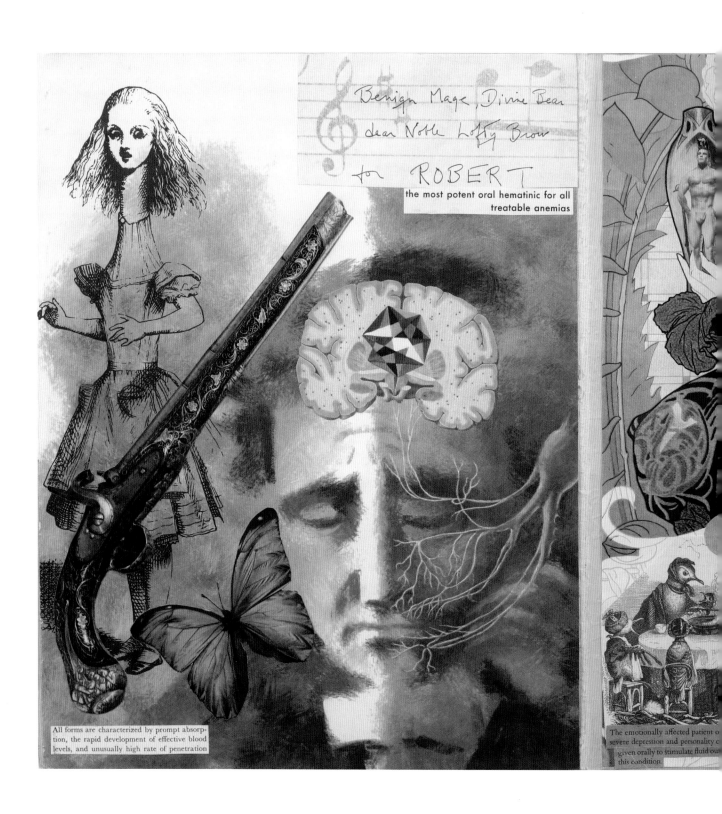

Benign Mage, Divine Bear
dear Noble Lofty Brow

for ROBERT

the most potent oral hematinic for all treatable anemias

All forms are characterized by prompt absorption, the rapid development of effective blood levels, and unusually high rate of penetration

The emotionally affected patient o[...]
severe depression and personality c[...]
given orally to stimulate fluid ou[...]
this condition.

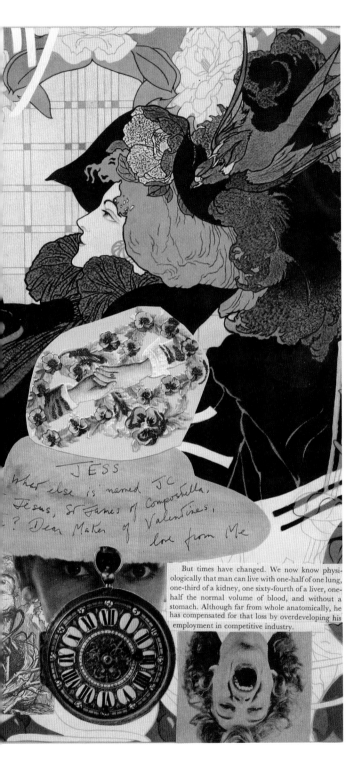

Text within the collage:

JESS

What else is named J.C.
Jesus, St James of Compostella,
...? Dear Maker of Valentines,
love from Me

But times have changed. We now know physi-
ologically that man can live with one-half of one lung,
one-third of a kidney, one sixty-fourth of a liver, one-
half the normal volume of blood, and without a
stomach. Although far from whole anatomically, he
has compensated for that loss by overdeveloping his
employment in competitive industry.

Helen Adam, *Benign Mage, Divine Bear*, c. 1957–1959
Collage

BONNIE CHARLIE'S GONE AWA.

WHERE ARE THE SNOWS

Helen Adam, *Bonnie Charlie's Gone Awa*, c. 1957–1959
Collage

Helen Adam, *Where are the Snows*, c. 1957–1959
Collage

"I BLAME MOTHER."

(PERHAPS NO ONE WILL NOTICE THEM.)

Helen Adam, *I Blame Mother*, c. 1957–1959
Collage

Helen Adam, *Perhaps No One Will Notice Them*, c. 1957–1959
Collage

An accomplished painter, independent publisher, and writer, Virginia Holton Admiral (1915–2000) traveled in several important avant-garde circles of the 1930s and 1940s. While she is known today chiefly as the mother of actor Robert De Niro, her vibrant, lushly colored paintings and sensitive figurative drawings deserve to be better known. Born in rural Oregon to a grain-broker father and schoolteacher mother, Admiral was raised in a variety of small midwestern towns, spending summers in Berkeley. During the Depression she attended Coe College in Iowa and lived for a year in Chicago, where she studied painting at the Art Institute. She moved to Berkeley, where in 1938 she finished her bachelor's degree in English at the University of California.

At Berkeley, Admiral was besotted with left-wing politics and poetry and fell in with a group of students including Robert Duncan and the sisters Mary and Lili Fabilli. Helping publish the mimeographed flyers and pamphlets of the Young People's Socialist League, Admiral hosted poetry readings from her garret apartment, often showcasing Duncan's new works. Admiral remembered that time as an art-filled bohemian idyll:

> Robert and Lili loved to cook. We listened to Robert's records: Stravinsky, Hindemith, Bach cantatas, Edith Sitwell, T. S. Eliot. In the evenings Mary and I would be doing watercolors or drawing, and Lili had developed a way of making crayon designs on cloth, then fixing them with a hot iron. Robert would be typing, listening to music, talking, none of it interfering with the poem he was working on.[1]

While working on the Federal Arts Project in Oakland in the late 1930s, Admiral collaborated with Duncan in the mimeographed production of the short-lived literary magazine *Epitaph* (Spring 1938).

Virginia Admiral, c. 1957

Relocating to New York, she enrolled at the Hans Hofmann School of Fine Arts to study painting. When visiting New York, Duncan spent much time with Admiral, spending extended periods crashing in her loft. In 1939, the two of them approached Anaïs Nin, asking her to contribute to their new magazine *Ritual* (whose cover featured an abstract drawing by Admiral). Nin observed in her diary, "They are both children out of *Les Enfants Terribles*."[2] Nin earned money at the time by cranking out erotic stories commissioned by eccentric Oklahoma millionaire Roy Milisander Johnson; Nin enlisted Duncan and Admiral to keep up with the demand for fresh pulp.

In her diary, Nin described Admiral's cold-water Fourteenth Street studio loft:

> The place is cold, but the hallways and lofts are big and high-ceilinged and the only place possible and available to a painter . . . On weekends the heat is turned off. The enormous windows which give on the deafening traffic noise of Fourteenth Street have to be

kept closed . . . The setting is fit for *Crime and Punishment,* but the buoyancy of Virginia and Janet [Thurman, Admiral's then roommate] and their friends, lovers, is deceptive. It has the semblance of youth and gaiety. They are in their twenties. They joke, laugh, but this hides deep anxieties, deep fears, deep paralysis.[3]

Admiral's active psychoanalysis intrigued Nin, who was always happy to be drawn into her friends' psychodramas. While attending Hofmann's classes, Admiral fell in love with fellow painter Robert De Niro, who thereafter allegedly had a brief affair with Duncan. Nin's diary entries relish reports about the tangled incident and its aftermath.

Admiral and De Niro married in 1942, and their son Robert was born the following year. They divorced three years later but remained on civil terms for the rest of their lives. Admiral supported herself and her son by starting Academy Typing Composition, a successful secretarial and typesetting service she ran from 1956 to 1976. She also pursued occasional journalism gigs, sometimes writing for pulp magazines like *True Crimes.* She also later worked for Maria Ley-Piscator, who ran New York's Dramatic Workshop—where De Niro Jr. took classes from the age of ten.

Duncan wrote in his notebook of a visit to Admiral's studio in 1941, seeing in her work a reflection of the time's troubled state of mind: "We stand in the shadows above the lights of Fourteenth Street. The paintings move back into the walls like mirrors of our dreams—the dark stage of gathering forces."[4] In an elliptical way, the works reflect Admiral's interest in psychological complexity. In her painting *The Red Table* (1944) (p. 159), Admiral employs a Hofmannesque palette of bright colors, setting up compositional tension through the harshly delineated biomorphic shapes, Matisse-like ornaments, and elements of still-life. This masterful work later received pride of place in Duncan's study on Twentieth Street. Similarly drawing on eclectic elements, *Blue Composition* (1943–1944) adds bits of collage text to the abstract depiction of enigmatic aerial apparatuses. Both these paintings were included in Admiral's 1946 exhibition "Art of this Century" at Peggy Guggenheim's gallery. Admiral's works were also included in the gallery's important group show "The Women" (1945).

Admiral was associate editor of *Experimental Review* (1940), another short-lived literary journal organized by Duncan. Two decades later she was involved in several small-press ventures, including Acadia Press, which published Helen Adam's *Ballads* (1964) with illustrations by Jess. Three years of production delays prompted a series of furious letters from Jess. Despite this falling-out, Duncan regularly visited and stayed with Admiral on his frequent later trips to New York. Admiral's other Acadia Press publications included *Poems* by Aram Saroyan, Richard Kolmar, and Jenni Caldwell (1963) and *From Now On* by William Packard (1963). Admiral was active in the antiwar movement and other left-wing causes, as well as in efforts to achieve low-cost housing for artists in Manhattan's Soho district. In 1979 her work was included in the group show "Hans Hofmann as Teacher: Drawings by His Students" at the Metropolitan Museum of Art. Her paintings are in the permanent collections of the Museum of Modern Art, the Metropolitan Museum of Art, and the Peggy Guggenheim Collection in Venice, Italy.

—Michael Duncan

1 Admiral, "Remembering Robert Duncan," in Christopher Wagstaff, *Robert Duncan: Drawings and Illustrated Books* (Berkeley: Rose Books, 1992), 9.

2 Anaïs Nin, *The Diary of Anaïs Nin: Volume III, 1939–1944* (New York: Harcourt Brace Jovanovich, 1969), 18.

3 Ibid., 73.

4 Duncan notebook, 1941, Robert Duncan Collection, The Poetry Collection of the University Libraries, University at Buffalo, The State University of New York, cited in Wagstaff, *Robert Duncan,* 11.

Virginia Admiral, *Blue Composition*, 1943–1944
Oil and collage on canvas

Virginia Admiral, *The Red Table*, 1944
Oil on canvas

PAUL ALEXANDER

Oil painter and watercolorist Paul Alexander (b. 1931) has been revered by many of the artists and poets in this exhibition (including Robert Duncan and Jess, who devotedly collected his work) due to his personal integrity and his thoroughgoing dedication to painting. Born in Fort Wayne, Indiana, Alexander was drawn to art as a young boy and showed a talent for drawing as early as the third grade. As a teenager he made his way to the Art Institute of Chicago to see its peerless collection of impressionism and post-impressionism, including the Cézannes, which have had, along with their creator, the most profound influence on him. Later at the Fort Wayne Art School, he studied with the intuitive teacher Elizabeth Eddy and concurrently began doing studies based on Rubens, Velázquez, Goya, Titian, and Eakins, a practice he would continue for years.

Eddy told Alexander about Black Mountain College, where he went in 1955 after he left the air force. The fabled art school in North Carolina was soon to close and had an abandoned air about it. However, it was surrounded by great natural beauty, and Alexander quickly became part of a lively community of art enthusiasts, most of whom had solid training behind them. He studied primarily with Joseph Fiore, who, though devoted to abstract expressionism, gave students berth to work in their individual ways. With the arrival of Robert Duncan and Jess between terms in 1956, a new element entered the school, bringing a more personal involvement with myth and a more pictorial approach to painting. Alexander has said, "[Charles] Olson was certainly involved with myth and we were all reading [Greek mythology scholar] Jane Harrison, but we were still understanding myth from an outsider's point of view."[1] With Duncan and Jess, myth arose from the latent energies and powers in oneself and in the universe.

Paul Alexander, with his portrait of Tom Field, 1965
Photograph by Joanne Kyger

At Black Mountain, Alexander worked almost exclusively in oil and in a large format. In his words, his paintings were mostly nonrepresentational, the color almost raucous, but because he didn't have a feeling "for that abstract thing," they evolved into pseudo-landscapes in which the color reflected "the green Eastern mountains and forests . . . and streams and silvery skies and mists and clouds."

The college closed before Alexander could graduate, and in the summer of 1956 he came to San Francisco with a list, given him by Robert Duncan, of people to look up. He thought briefly of continuing his education but found that being in the company of the poets and artists gathered at The Place and other North Beach spots offered more intellectual excitement than any art school could. After Alexander came to San Francisco, he was drawn more and more to the figure and to watercolors, which, in Joanne Kyger's words, are "luminous, grounded, grand, and classic."[2] In 1961, he resumed the theatrical work he had begun under Wes Huss at Black Mountain, appearing with Helen Adam in Duncan's *A Play with Masks,* written for him and for which he made masks out of balloons covered with water-soaked papier-mâché. In 1962 he played Bobbin in Duncan's costumed play *Adam's Way,* performed at the Tape Music Center on Nob Hill. In 1964 Alexander and Bill Brodecky

Moore began Buzz, a gallery and meeting place for artists, which showed Jess, Tom Field, Fran Herndon, Lawrence Jordan, and David Young Allen, all of whom were exploring nonvernacular and Romantic approaches to art.

Three of Alexander's major oils are *Eakins as Pan* (1974), *Death of Patroclus* (1964), and *Japanese Iris* (1981). Based on a photograph Thomas Eakins took of himself in 1883 playing a hornpipe in a woodland setting, *Eakins as Pan* (p. 163) was commissioned by poet Robin Blaser while Alexander was living on remote Bowen Island near Vancouver, British Columbia. In the painting, the standing figure is shown in close relationship with the lush environment around him, some of the coloration of the trees and ground reflected on his body. Although the Greeks associated Pan with a presence found in forest sanctuaries and which can be protective, the flute player here may be more the artist who produces his or her melody in rhythm with the natural world and doesn't need an audience to hear or appreciate it.

The main image in *Death of Patroclus* (p. 162) is of "wide-hearted" Patroclus, Achilles's great friend, lunging toward the fierce Trojan warriors described in Book 16 of *The Iliad*. Patroclus is joyously wielding his shining spear, resisting Hector and his men "like something greater than human," as Homer says; behind him are Ensor-like faces, possibly of Achilles, Phoibos Apollo, or some of his fellows. Alexander has said that this work, which took months to finish, began as an abstraction but soon changed course:

> Early on the images began to emerge. I had been reading *The Iliad,* and the images were of Patroclus, Apollo, Hector, the armor of Achilles, ships on fire in a swirl of activity. *The Iliad* was in the air . . . George [poet George Stanley] was talking about Homer. Joanne [poet Joanne Kyger] was writing The Odyssey Poems. I was captivated.

> Even so I tried to wipe out the figures as they appeared. It was a time of dedication to abstraction, and to deviate into pictures was considered wrong. Still the images persisted until I just let them be there, then embraced them and took a new turn in my painting.[3]

Also important in Alexander's body of work are his ink drawings, which he produced over many years. These drawings were done quickly and with an amazing sureness, the images often implied by a minimal number of fine lines; examples include the nine ink sketches of a mysterious rider on a no-less-mysterious horse in George Stanley's *Pony Express Riders* (White Rabbit Press, 1963), whose opening poem ends hauntingly, "Able to forget/ they were the men that fought and loved./ they rode.

During the past thirty years Alexander, perhaps following the example of his master Cézanne, has preferred living close to the land, away from the bustle of metropolitan centers. It is an event when he decides to come to San Francisco and leave his small house on the wild and unspoiled Mendocino coast, where he continues to express his love for nature in radiant watercolors.

—Christopher Wagstaff

1 This and other quotations from Alexander are from a three-part interview with the author in 1986, published as *Paul Alexander: On Black Mountain and the San Francisco Scene* (Berkeley: Rose Books, 2010).

2 From a statement by Kyger on the cover of Wagstaff, *Paul Alexander.*

3 From the article "Buzz Gallery," written by Paul Alexander, July 16, 2002, available online at www.bigbridge.org/issue9/bgpage2.htm.

Paul Alexander, *Death of Patroclus*, 1963
Oil on canvas

Paul Alexander, *Eakins as Pan*, 1974
Oil on board

Paul Alexander, *Japanese Iris*, 1981
Oil on canvas

WALLACE BERMAN

Wallace Berman (1926–1976) was an enigmatic underground figure whose collages and assemblages articulate an important strand of dark mysticism in postwar American culture.[1] Born in Staten Island, New York, Berman was raised in Los Angeles, where he attended Fairfax High. After a brief stint in the navy in 1944, he took classes at Chouinard Art Institute and Jepson Art Institute before pursuing his independent artistic path. After his 1952 marriage to Shirley Morand and the birth of their son, Tosh, three years later, he established a domestic routine that nourished and guided his art-making. The Berman house on Crater Lane was a gathering place for many artists in the burgeoning Los Angeles underground scene.

Berman's wider circle included many San Francisco artists and poets. One afternoon in 1954, on the recommendation of filmmaker Kenneth Anger, Wallace and Shirley Berman visited Duncan and Jess in their San Francisco apartment on Baker Street, resulting in what Duncan later called "an unfolding recognition that we were possibly fellows in our feeling of what art was."[2] The Bermans' 1954 trip also included a visit to King Ubu Gallery. Berman began a correspondence, creating for Duncan and Jess some of his most playful and lyrical collage mailers, most celebrating the absurdities of pop culture. Berman cherished their relationship, on one of the mailers playfully overlaying a photo of Duncan over images of Gertrude Stein and Alice Toklas. In 1963, Duncan sent the Bermans the manuscript of a poem that he had dedicated to them, "Structure of Rime XIX: 'The artists of the survival . . . '," later published in his volume *Roots and Branches.*[3] In their living room, Duncan and Jess prominently displayed a framed copy of Patricia Jordan's portrait photograph of Wallace.

Berman's hand-printed, personally distributed literary journal *Semina* (1955–1964) stands as an

Wallace Berman, c. 1973

iconic document of its time, presaging a variety of cultural and aesthetic developments and providing an outlet for some of the most innovative literary and artistic voices of the 1950s and '60s. *Semina* 8 (1963) included Duncan's short poem "Increasing," accompanied by a nude photo of the poet. In the same issue, Jess contributed an enigmatic collage of a cat leaving a Turkish prison.

Berman thrived on mystery and contradiction. His evocative, oracular artworks often feature hermetic symbols and images referring to jazz music, French poetry, sports, or the Kabbalah. Inside jokes, willful obfuscation, and hermetic systems abound, giving an air of insular impenetrability to the uninitiated. A conviction on charges of public obscenity for his 1957 exhibition at Ferus Gallery in Los Angeles alienated Berman from again exhibiting his work in galleries. The trumped-up charge was not even for a work by Berman, but instigated by a print by his artist friend Cameron depicting the mystical coitus of a woman and an alienlike demon. Disgusted with the experience and seeking a change, he moved to an apartment on Scott Street in San Francisco, near the homes of artist friends Joan Brown, Bruce Conner, Jay DeFeo, and Wally Hedrick. Continuing to work on *Semina,* he shifted base in 1960 to a Marin

County houseboat. He opened the Semina Gallery on a dilapidated houseboat nearby, hosting a few one-day exhibitions of artists such as Edmund Teske and George Herms.

After returning to Los Angeles in 1961, Berman slowly became reengaged with the local art world. He is best known for his Verifax works of the 1960s and 1970s—a series of photo-collage grids of images taken from newspapers and magazines reproduced by means of an early prototype of the Xerox machine. The pictures, each framed by the same image of a handheld transistor radio, feature wildly varied symbols and inspirations that were in the air. The mix of pictures of heavy cultural weight with ones from mass media reflected the reality of American postwar culture—photographs of Lenny Bruce or Bob Dylan might be as symbolically loaded as those of an Isis sculpture or Celtic ornament. Acting as a kind of magic tablet, Berman's transistor radio broadcasts talismanic images that are visual counterparts to the Kabbalistic connotations of the Hebrew alphabet characters that were also often featured in the Verifax works. The single-frame Verifax work *Untitled 112 (Ezra Pound)* (p. 167) is a proposed cover image for an unknown Duncan text on Pound.

In the mid-1960s Berman's work began to reach a larger audience. The January 1966 issue of *Artforum* featured a Verifax work on its cover and a feature on Berman's work.[4] In 1968, Berman was the subject of a solo survey exhibition at the Los Angeles County Museum of Art. In the early 1970s he began painting Hebrew letters on stones that were usually attached to chains or placed in wooden vitrines as if their magical properties needed to be restrained or contained. He also began painting the letters in situ in the landscape. Neatly inscribed on hillside boulders, at the ocean's edge, and along a concrete block wall off Topanga Canyon Road, the mysterious messages bore no author's signature. Over part of one large wall painting, Berman splashed a bucket of black paint, onto which he repainted alephs, beths, and taws in white, as if the characters had magically permeated the attempt to obscure their power.

Like many other 1970s artists, Berman was interested in expanding his practice beyond the confines of museums and gallery walls. But his works transcend the elliptical one-liners, wry philosophical statements, and existential pranks of most conceptual artists. Tapping into ancient methods and rites of transformation, his works have a poetic urgency that has nothing to do with Duchampian gamesmanship or Naumanesque anomie. Jess in 1992 stated about his friend Berman's mysticism, "I believe he wishes to emphasize and attend to the appearance of the Mysteries in every kind of experience, to enforce our awareness of the Unknown in places we've just taken for granted."[5] On Berman's Verifax works, the mysterious handwritten notations that sometimes appear alongside reproductions of Hebrew letters and tarot cards are directions for change, as illegible as the prescriptions of a family doctor but as crucial and necessary for health. Berman's automatic writing invokes art that can tap latent "magnetic memories" and instigate spiritual revolution. His often-repeated refrain "Art is Love is God" was not a platitude but an imperative statement, an alchemical command.

— Michael Duncan

1 Michael Duncan, "Wallace Berman and His Circle: Introduction," in *Semina Culture: Wallace Berman and His Circle*, ed. Michael Duncan and Kristine McKenna (Santa Monica, CA: Santa Monica Museum of Art, 2005).
2 Robert Duncan, "Wallace Berman: The Fashioning Spirit," in *Wallace Berman: Retrospective*, exh. cat. (Los Angeles: Fellows of Contemporary Art, 1978), 19.
3 Robert Duncan, letter to Wallace and Shirley Berman, March 15, 1963, Wallace Berman Archive, Archives of American Art, Smithsonian Institution.
4 "Wallace Berman's Verifax Collages," *Artforum*, January 1966, 39–42.
5 Jess, letter to Colin Gardner, September 28, 1992, archive of Colin Gardner.

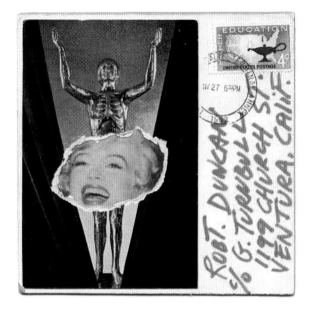

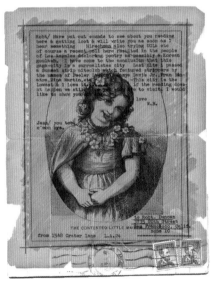

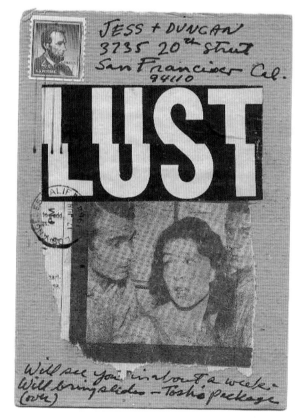

Wallace Berman, mailers to Jess and Robert Duncan, c. 1962
Ink and collage on cards

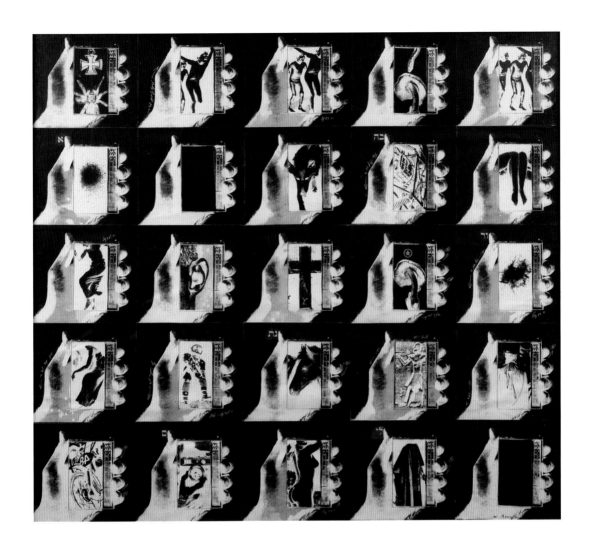

Wallace Berman, *Untitled (Spider)*, c. 1964–1976
Twenty-five-image Verifax collage

Wallace Berman, *Untitled 112 (Ezra Pound)*, c. 1964–1976
Single negative photographic image

RONALD BLADEN

Ronald Bladen (1918–1988) had a poetic sensibility that distinguished his work from that of other sculptors associated with New York minimalism of the 1970s and '80s. His roots in San Francisco help explain that distinction. Born in Vancouver, British Columbia, to British-born parents, Bladen grew up in rural Washington. He had a natural facility for drawing, and at age thirteen he was given a solo show of paintings and watercolors at the University of Oregon.

In 1939 he moved to San Francisco, where he took classes at California School of Fine Arts until 1945, quickly shifting from commercial to fine art and studying with Ralph Stackpole, Clay Spohn, and David Park. While in school, he worked part-time as a welder in shipyards, soon learning to become a toolmaker. Bladen picked up on the city's burgeoning literary scene, becoming interested in myth, symbolist poetry, and theosophical texts. His early works are mystically inflected drawings showing the influence of Blake, Redon, and Albert Pinkham Ryder (also a favored artist of Jess). Bill Berkson described Bladen's early paintings:

> Using a palette knife to layer his colors and occasionally raking them back with a comb or stick, he was then depicting pale angelic figures set flatly on dark patches and played about by flares of light.[1]

Bladen fell in with the city's budding poetry community, meeting Sanders Russell, Kenneth Rexroth, Philip Lamantia, Robert Duncan, and Yvonne Rainer. He regularly attended lectures and meetings of the Libertarian Circle, an anarchist/pacifist group that met in the Fillmore district. As he stated in an interview, the exposure to writers heightened his commitment to painting:

Ronald Bladen, 1946

> I think the poets influenced me in terms of art and the importance of art. We all needed one thing, certainly I did: I needed an audience and I had it. It wasn't special, just very human; nothing to do with whether things were good or bad. Just part of living. Their commitment in relation to a way of life was something I did not meet with in terms of art school or education.[2]

Bladen wrote some poetry himself and regularly attended readings. In 1947 he contributed the atmospheric cover for *The Ark,* a literary magazine that also included four reproductions of his ethereal graphite drawings as well as poems and an essay by Robert Duncan. As Berkson reports, Bladen's self-described "'spiritualized, humanistic non-objectivism' would have appealed to Duncan."[3] Bladen met Jess soon after Jess and Duncan began living together. The couple lived briefly with the Bladens while house-hunting.

In April 1954 Duncan and Jess hosted a one-man show of Bladen's work in their Baker Street house. Duncan particularly admired an untitled work from 1953, and Bladen decided to give it to him. The lower horizontal form of this untitled painting suggests a shadow of the upper blue swath of paint. Several other early works depict shadowed forms, emulating an experience Bladen had in the 1940s at Partington Ridge in Big Sur when he stretched his arms and saw his silhouette appear on the clouds below him. Jess later remarked that Bladen provided him with technical advice, encouraging him to mix his own titanium white pigment. Bladen's rich, thick colors made an impression on Jess, who relished the "tans and rich browns and peanut-butter tones and duns, with thick, often velvety textures."[4] In the mid-1950s at Big Sur, Bladen made works on paper with earth, water, and leaves; two of these "Earth Drawings" were reproduced in *Ark II/Moby I* (1956) directly following the Allen Ginsberg poem, "The Trembling of the Veil." At that time Bladen lived at 707 Scott Street, where a host of other poets also lived, including Michael and Joanna McClure and Lawrence Jordan. In 1955 Bladen's paintings were included in two different group shows at the Six Gallery, alongside works by Richard Diebenkorn, David Park, Wally Hedrick, and Julius Wasserstein. Bladen was also among the 150 people who attended Allen Ginsberg's famous first reading of "Howl" at the Six in 1955.

Late that year, Bladen became friends with the New York painter Al Held, who spoke enthusiastically about the Manhattan art scene. In 1956 Bladen took Held's advice and moved to New York, where he met a new group of artists, including sculptor George Sugarman, and became a founding member of the Brata Gallery, a cooperative space on Tenth Street. Bladen's paintings from this period are thick impastos that contain, as Berkson described them, "broad, buttery hints of landscape: some suggest peninsular outcroppings seen from above, others plunge the eye into the midst of frontally bunched arabesques like undersea growths."[5] *Connie's Painting* (c. 1957–1958) (p. 170), made during this time, features thick daubs of earth-tone color relieved by assertive streaks of sky blue.

Bladen's painting developed into large-sized panels with heavy mounds of paint that protrude from the surface edges. These works led to his breakthrough into sculpture in the mid-1960s. His sculpture gained widespread attention in the Jewish Museum's exhibition "Primary Structures" (1966), a landmark exhibition of reductive sculpture that included works by Donald Judd, Carl Andre, and Robert Morris. In 1964 Bladen met sculptor Connie Reyes, who became his life partner. A longtime jazz enthusiast, he took up tenor saxophone in New York and played regularly with a group of artist friends. His first solo show of sculpture was in 1967 at Hofstra University. Monumental sculptures were made for exhibitions at the Corcoran Gallery of Art, San Francisco Museum of Modern Art, and New York University. After short stints teaching at Hunter College and Columbia University, he settled at Parsons College, where he remained on the faculty from 1976 to 1988, the year of his death from cancer.

—Michael Duncan

1 Bill Berkson, "Bladen: Against Gravity," *Art in America,* January 1992, 82. Biographical material is primarily taken from this important essay.

2 Bladen, interview with Corinne Robins, 1969, Ronald Bladen Papers, Archives of American Art, Smithsonian Institution, cited in Douglas Dreishpoon, "Making the Inside the Outside," in *Ronald Bladen: Drawings and Sculptural Models,* exh. cat., (Greensboro, NC: Weatherspoon Art Gallery, University of North Carolina, 1996), 23.

3 E-mail correspondence with Berkson, May 17, 2012.

4 E-mail correspondence, Berkson citing his interview with Jess, c. 1992.

5 Berkson, "Bladen: Against Gravity," 83.

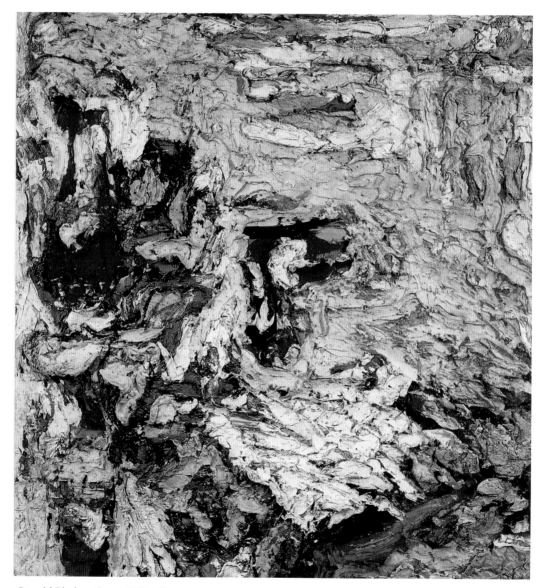

Ronald Bladen, *Connie's Painting*, c. 1957–1958
Oil on canvas

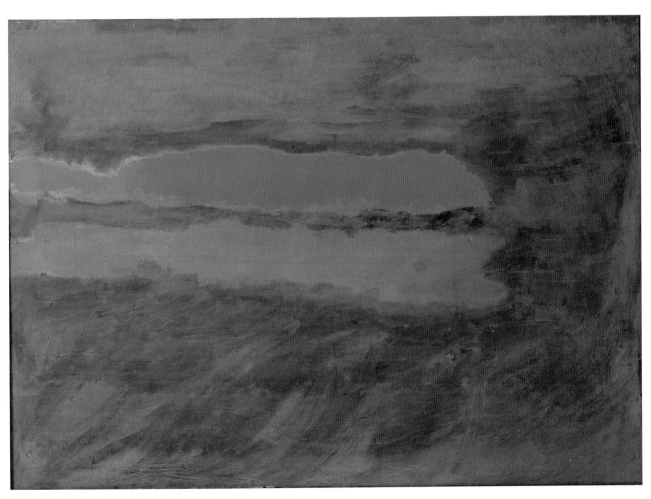

Ronald Bladen, *Untitled (Blue Forms)*, 1953
Oil on canvas

Though few in number, the beautifully lyric abstract expressionist canvases of John Philip "Jack" Boyce (1933–1972) were prized by his peers, and the artist's early, tragic death was a great loss to his circle of friends.

Boyce lived in Farmington, Michigan, in his youth. He hoped to play football for the University of Michigan, but a head injury suffered in high school football kept him from realizing this dream. Additional sadness came when a younger brother died from the effects of an accident when he was seven. After graduating from the University of Michigan, Boyce served two years at an antiaircraft station in Alaska. There he read art history books and became interested in going to art school. Late in 1956 he moved to California, where he met artist and photographer Ken Botto. The two would become lifelong friends. Both attended the California College of Arts and Crafts in Oakland and Claremont Men's College; at the latter, Boyce studied with the painter Richards Ruben, who inspired him and turned him in the direction of abstract painting.[1]

In 1963, unhappy over the political situation in the United States, Boyce went to the Trinity Alps in Northern California to get away and sort things out. At Forks of Salmon he met and became friends with the poet Lew Welch, who, like himself, was living in one of the abandoned shacks that had originally been built by the California Conservation Corps. In a letter to poet Gary Snyder, Welch said he'd met "a fine fellow"[2] named Jack Boyce, a man who spends his time trying not to be a painter "but only needs a small nudge from or into the right direction & he'll blow like crazy."[3] He added that Boyce had seen only the "hate-filled, doped-up unhiply, lack-genius side of this whole generation"[4] and that Lew was going to take him to San Francisco "to see if a tour of our beautiful friends will help."[5] Boyce did soon leave

Jack Boyce, c. 1965

Cecilville near Forks of Salmon with several six-by-six-foot oil paintings and came to San Francisco, where he bought fifteen poetry books and immersed himself in the writings of William Carlos Williams (his favorite), Philip Whalen, and Gertrude Stein.

In 1964 Boyce met poet Joanne Kyger. With Welch's encouragement, Boyce, Kyger, and Robert Duncan met for a number of weeks to read Stein's work aloud. Kyger and Boyce married in 1966, and while they were living on Pine Street in San Francisco, Boyce did a series of exquisite, small oil pastels called Apparitions—dense color-worlds with a few of the shapes suggesting faces and human features. Boyce produced the softness of the surfaces by using his fingers to smear the paint and meld the colors. Kyger wrote a series of twenty-two poems to accompany the pastels, and on the backs of some of them are phrases from her poems, e.g., "I didn't know which direction, she whispered in his ear."

After the Apparitions were shown at the artist-run Buzz Gallery, Boyce and Kyger went to Europe for nine months, primarily to look at paintings and

art. Boyce had saved a detailed mimeographed list of important European art from an "Introduction to Art History" class in 1957, and the couple used it as their guide, checking off each work on the sheets after they found and viewed it. They spent a month in Florence going to the Uffizi every day. In Madrid, at the Prado, Boyce was especially impressed by Goya's black paintings. In February 1966 the couple received a check with this note: "For Joanne and Jack for their first evening out in Madrid from us RD and Jess."[6]

After a year of living in a loft in New York City, the couple returned to San Francisco, where Jack worked on a group of oils and acrylics, among them a few eight-foot-high scroll-like works, one of which is in this exhibition (p. 175). Kyger believes he painted these radiant canvases fairly quickly and probably tacked them to the wall while doing them.[7] After visiting an exhibit Boyce had at his house of these and other works, Jess wrote to Duncan, who was on a reading junket: "Jack Boyce's paintings (calligraphic, on paper, all dimensions tiny to mural size) are joyously beautiful. They bring Earthly Paradise into the room. They are rich and strong, yet simply immediately present—color is from the garden and field in full spring. I didn't ask price, but said when you got home you would make choice—because I wanted them all."[8] At nearly the same time, Boyce helped Bill Brown, a publisher and landscape designer, to refurbish a garden pavilion behind Duncan and Jess's Victorian house.

Boyce had inherited some money from his grandfather, and he started to spend weekends going up and down the coast trying to find some land to buy. He finally chose property in Bolinas, a small seacoast town near San Francisco, where he began building a structure called the Purple Gate House. In 1970 he and Kyger separated and he began living with Magda Cregg, the widow of Lew Welch. One night in 1972, while walking on one of the high beams in the yet-unfinished house, he fell to his death.

Boyce's passing hit the Bolinas poetry community hard; Robert Creeley, in particular, felt deep despair. Lewis McAdams wrote an elegiac poem ending with the words "Whatever the power source is, it burns/ it does not dissolve," and Jess and Robert, too, were saddened to lose their gifted friend.

—Christopher Wagstaff

1 Joanne Kyger, interview with Barbara O'Brien and the author, July 16, 2012. Other details here about Boyce's life are drawn from this interview.
2 Donald Allen, ed., *I Remain, The Letters of Lew Welch and the Correspondence of His Friends, Volume Two: 1960–1971* (Bolinas, CA: Grey Fox Press, 1986), 97.
3 Ibid.
4 Ibid.
5 Ibid.
6 Robert Duncan, handwritten note, Joanne Kyger personal papers.
7 Kyger, interview.
8 Jess, letter to Robert Duncan, July 21, 1968, Robert Duncan Collection, The Poetry Collection of the University Libraries, University at Buffalo, The State University of New York.

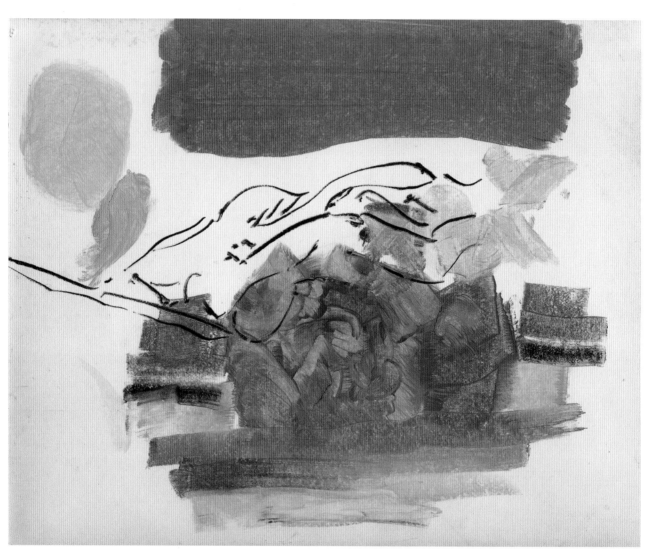

Jack Boyce, *Apparitions III (hand over mouth)*, 1964
Gouache and ink on paper, 6 x 8 in.

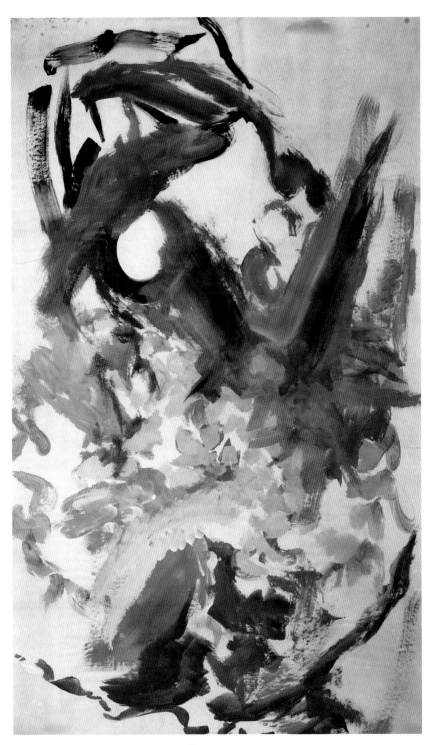

Jack Boyce, *Untitled (hanging scroll)*, 1968
Opaque on paper mounted on cloth

A brilliant painter whose artistic career was far too brief, Lyn Brockway (née Brown, 1929–2002) was born in San Francisco and attended the University of California, Berkeley, from 1948 to 1950. She studied painting at the university, concurrently taking classes from Elmer Bischoff at the California School of Fine Arts, but her undergraduate major was English and she served as an editor of *Occident,* the student literary magazine. In its fall 1949 issue, under her aegis, the magazine presented together for the first time the poetry of Robert Duncan, Robin Blaser, William Everson, and Jack Spicer. She also published in the same issue Duncan's short story "Love—A Story" and a piece by Gertrude Stein.

While a student, Brockway had a studio in Throckmorton Manor, a rundown rooming house on Telegraph Avenue at Oregon Street, south of the Berkeley campus, which was home to many theater-arts students, poets, and painters. Through her work on *Occident,* she met and became friends with Duncan, who held informal classes at Throckmorton and "rounded up people with marvelous reading voices who came and read aloud their favorite poets."[1] He also taught *Finnegans Wake* in his room, with the attendees sitting wherever they could, on the floor and on his bed. When Duncan saw Brockway's paintings and drawings, he responded to them right away; Lyn said Robert would look at her work in her studio several times a week, often reading to her from Ezra Pound's *Cantos* while she painted. She remembered Duncan once dying a pair of her shoes purple and painting white unicorns on them. One day he brought her to the studio of Brock Brockway (her future husband), where they all spent considerable time reviewing Brock's portfolios of charcoals and pen and inks.

When Brockway finished her master's degree in 1950, she left on a trip to Europe with fellow student

Lyn Brockway in Ralph Stackpole's studio and sculpture yard, c. 1948

Jay DeFeo, having saved eight hundred dollars for this purpose from waitressing in a local restaurant and pool hall. For a year and a half she immersed herself in all the art she had previously seen only in reproductions. Both she and DeFeo would paint and draw much of the day in their tiny Paris room—evoked in the painting *Breakfast in a Paris Lodging* (p. 179)—and in 1951 the two women had the first showing of their work in the Galerie Fabre in Paris. At about the same time she met painter Norris Embry, a young, sometimes unbalanced friend of Duncan's, who one night impulsively threw a large amount of her work and his own off a bridge into the Seine. While she was in Paris, her work was also being exhibited in the Bay Area, her *Red Painting* winning an award in an annual exhibition at the Oakland Art Gallery in 1951.

Returning to San Francisco in November 1952, Brockway was just in time to show a selection of her new work at the exuberant King Ubu Gallery, where she was in one exhibit with Harry Jacobus and Jess

and in another called "Large Scale Drawings." She remembered that King Ubu wanted to undermine the artist's sense of self-importance, and that in the space nothing was hung in a straight, horizontal line, recalling, "Paintings crowded on top of each other, and sculptures filled the room." She has also noted that she, Jacobus, Jess, and Brock Brockway didn't use the word "artist" to describe themselves, nor did they see themselves as having "something to say," adding, "How I hated that phrase! Painting a picture was part of the joy of being alive!"

It was probably fortunate that Brockway had absented herself to Paris for two years, because it provided her with a freedom to develop her own individual vision away from the pressures of the California art scene. She was a pioneer of figurative painting in the Bay Area and was unequaled in her use of bright, Fauve-like, almost hallucinatory colors in her depiction of cafés, striped rugs, trees reflected in water, spring flowers, dark trees, and other scenes. She was also different in her application of layer upon layer of paint to her canvases to create as much of a "three-dimensional effect as one gets on a two-dimensional surface." During the early 1950s, she and Jess were close friends and admirers of each other's work, and it is likely that Brockway's use of thick, impasto textures appealed to Jess and to a degree influenced his own rich building-up of the surfaces in his canvases. She also produced attractive works using pastels and bright crayons, for example, *Wild Flowers* (p. 43), in which the two trees look sentient and might be taken for the backs of people's heads.

Due to increasing family responsibilities, Brockway had virtually stopped painting by 1957. However, before that time she had produced a body of at least thirty highly original oil paintings, many of which were exhibited at the Peacock Gallery in San Francisco in 1963. Robin Blaser, who began his art collection by buying one of Lyn's paintings in the late 1940s, has commented: "The first thing that drew attention was the stunning beauty of her canvases, by which I mean a color that literally speaks and literally moves through a room. She used a heavily surfaced, utterly exotic color so that you knew you'd moved into a new landscape unlike any in the history of landscape painting . . . She was after otherness all the time."[2]

In the later 1960s and the 1970s, Brockway devoted herself to raising two daughters, along with spending time with and caring for her husband. For a period she worked with firing clay, and she once gave Duncan and Jess a painted tile that had the same shimmering quality one sees in many of her paintings. She courageously faced the effects of ill health in her final years, all the while maintaining a kindness toward, and an intense interest in, other people, as well as an enthusiasm for the art of the European masters, whose work she revisited on several trips to Europe before her death.

—Christopher Wagstaff

1 Quotations from Lyn Brockway and some factual material here are from several letters she wrote to the author in 1989 and 1990 and from her essay "Reflections" in *Lyn Brockway, Harry Jacobus, and Jess: The Romantic Paintings,* ed. Christopher Wagstaff, catalogue for an exhibition at the Palo Alto Cultural Center and the Wiegand Gallery, Belmont, CA, May 20–June 30, 1990.
2 Robin Blaser, from an unpublished discussion with the author, June 19, 1986.

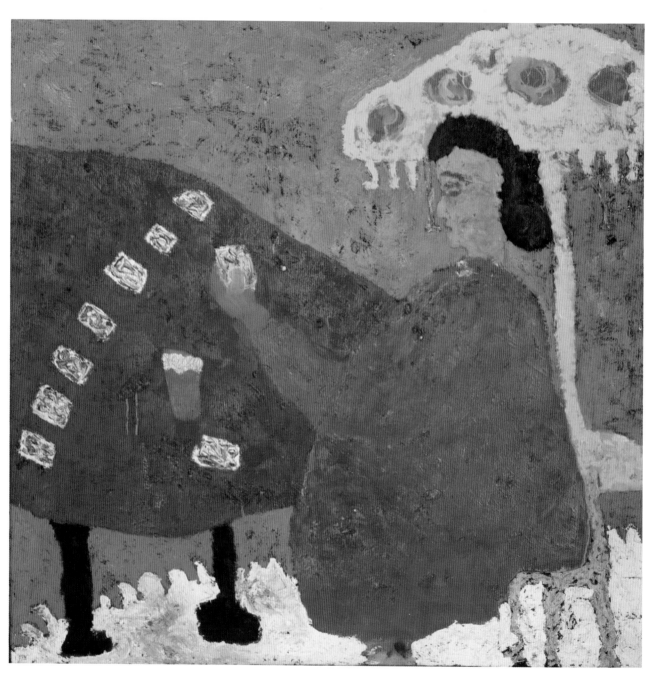

Lyn Brockway, *Aunt at Solitaire*, 1953
Oil on canvas

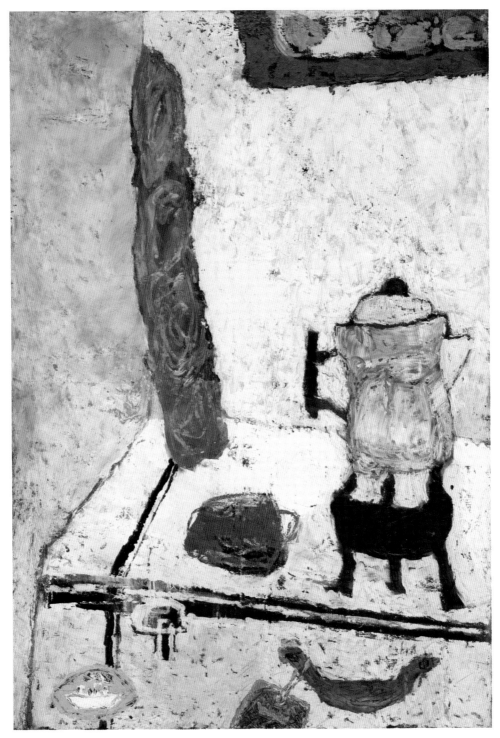

Lyn Brockway, *Breakfast in a Paris Lodging*, 1951
Oil on muslin

Poet and filmmaker James Broughton (1913–1999) stayed true to a spirit of play through the many phases of his long life. As a promoter of sensuality with a light touch, he added an element of cosmopolitan sophistication to midcentury avant-garde cinema. The father of three children and with partners of both genders, he was defiantly bisexual, following his libido where it took him. Jonathan Williams characterized Broughton's unique place in postwar West Coast culture:

> As poet, film-maker, and playwright, he graced the San Francisco scene through its various and countless renaissances since 1946, earning him such labels in its press as "San Francisco's own man for all seasons," its "leprechaun poet laureate," etc. Yet he never was fashionable, nor identified with any school: always the odd bird in the orphic aviary, he remained uniquely true to his own visionary music.[1]

Born in Modesto to a family of bankers, Broughton was an impetuous child known as "Sunny Jim," who claimed to speak with spirits and loved all things theatrical. Military school did not dampen his flair but only sparked a lifetime devotion to poetry and drama. He attended Stanford University, where he was at odds with English professor Yvor Winters and left three months before finishing his degree. Impetuously traveling cross-country, he ended up in New York, where he managed to get a job on a passenger cargo ship headed for the Mediterranean and South America.

Returning to Manhattan, Broughton began writing in earnest, reviewing books for the *New York Herald Tribune*. Brought back to San Francisco in 1939 by his mother's death, he was able to avoid the draft by presenting a psychiatrist's letter stating, as Broughton put it, "that I was unfit to kill Japs and Nazis because I preferred butterflies to bazookas."[2] After another few years in New York pursuing

James Broughton, 1957
Photograph by Harry Redl

playwriting, Broughton settled back in San Francisco, where he met Madeline Gleason, Kenneth Rexroth, and Robert Duncan and fell in with the burgeoning poetry scene of the late 1940s. He developed a close friendship with Pauline Kael, living with her for a brief period and becoming in 1948 the father of her child, Gina James. With his lover Kermit Sheets he founded Centaur Press, which published Broughton's *The Playground* (1949), a verse drama with political overtones. On visits to Duncan and Jess in Stinson Beach, Broughton was part of many group activities and was frequently photographed by Helen Adam. His early poetry often explored childhood, playing off nursery rhymes and the nonsense verse of Lewis Carroll and Edward Lear.

Broughton collaborated with Sidney Peterson on a short experimental film, *The Potted Psalm* (1946), which was premiered in the Art in Cinema series at San Francisco Museum of Art. After making several more short films (including *Mother's Day* [1948] and *Four in the Afternoon* [1951]), Broughton and Sheets went to London in 1952 in hopes of finding more ready acceptance of his avant-garde productions. In Broughton's absence from San Francisco, Duncan and Jess rented his house at 1724 Baker Street.

Broughton soon found funding for his perhaps most accomplished film, *The Pleasure Garden* (1953). Filmed in London's Crystal Palace Gardens, the twenty-two-minute farce is a light satire of society's attempts to repress desire. The film depicts various lovelorn types—a bird-watcher, a cowboy, an ingenue, a sculptor—who find each other only to be separated by a Puritanical Minister of Public Behavior. A dowager fairy godmother finally sets things right. Although the film was well received, its production left Broughton financially depleted. He returned to San Francisco in 1955, falling back into a poetry community appreciative of his brand of fantastical whimsy.

Between 1957 and 1962—partly in reaction to the excessive media hype surrounding the Beats—Broughton organized an informal poetry group called "The Brotherhood of the Maiden and its Secret Six," consisting of Duncan, Jess, Gleason, Eve Triem, Helen Adam, and himself. As Broughton described the group:

> We met not only once a month, but usually on a birthday of one or the other of us, or a feast day, like Easter . . . or Equinox. And they were always joint feasts at one house or another . . . and we always had to write a poem for each occasion, and that was fun, because we knew we'd have a good audience.[3]

In 1957 Jess painted the large work *Angel Captain Hornblower: Imaginary Portrait #17* (now lost), playfully depicting Broughton as a nude warrior angel enthroned next to a gigantic preening peacock. Duncan became critical of the insistent lightheartedness of Broughton's verse, and later both Jess and Duncan had a major falling out with Broughton about his involvement in the production of Helen Adam's play, *San Francisco's Burning*.

Despite these quarrels, Broughton remained a loyal supporter of Duncan throughout his life. A 1976 essay commemorated their friendship:

To me Robert seems more Roman than Venetian: a pleasure-loving laureate of ancient style, wearing almost visible laurel. He was the first poet I had ever met who was totally passionately servant of his muse, the first poet I had ever met who walked as if clad in Apollonic mantle. No professorizing, no part-time prose-itizing, none of the mixed media of my own divagations. Here was a poet who lived poetically because poetry lived him. Whether his poems were "great" matters to me not a whit; he was obviously great at being a poet. My encounter with the assured, quirky and articulate bard set off a bell-clang in my head. I have loved him all the years like my confessor priest of the Faith of Poetry.[4]

In later decades Broughton continued to experiment and change. An interest in Zen sparked a friendship with Alan Watts; he was married for sixteen years to the artist Suzanna Hart and fathered two children; and finally in 1976 he married the cinematographer and artist Joel Singer, with whom he developed a lasting relationship chronicled in several films. In 1989 Broughton received the American Film Institute's Maya Deren Independent Film and Video Artists Award.

—Michael Duncan

1 Jonathan Williams, "James Broughton," on Jargon Society website, http://jargonbooks.com/broughton.html.

2 Broughton, *Coming Unbuttoned* (San Francisco: City Lights, 1993), 53.

3 Broughton, in interview with Lisa Jarnot, September 1998, cited in Jarnot, *Robert Duncan: The Ambassador from Venus* (Berkeley: University of California Press, 2012), 173.

4 Broughton, "Homage to the Great Bear," April 26, 1976, in *Credences* 8/9, March 1980.

James Broughton, *Un Jeu d'Été pour Robert et Jess*, c. 1957
Collage

James Broughton, *The Pleasure Garden*, 1953
Film transferred to DVD

Jess, flyer for James Broughton reading, 1951
Collage with ink and paper

EDWARD CORBETT

One of the West Coast's most significant yet under-recognized postwar painters, Edward Corbett (1919–1971) developed his mature style in the late 1940s after being hired by California School of Fine Arts director Douglas MacAgy to teach alongside Clyfford Still, Elmer Bischoff, David Park, and Hassel Smith. Corbett had attended CSFA as a student from 1936 to 1941. The son of an army officer, he moved frequently as a child but felt most at home in the Southwest. He stated that his "self-awareness of imaginative life" was inspired as a teenager in the Arizona desert landscape: "Something must be said to reveal the secrets, not only of the mountains and the deserts and their distances, but of the senses and the mind discovering them. I was prepared, by a wish at least, to be an artist."[1]

After a stint in the army and merchant marine, Corbett lived briefly in New York, where the Mondrian retrospective at the Museum of Modern Art (MOMA) and friendships with Ad Reinhardt and Jack Levine made big impressions.[2] Returning to teach at San Francisco State College in 1947, he met Clay Spohn, who recommended him to be hired at CSFA; the school had become newly energized under the administration of MacAgy. Corbett attributed the remarkable atmosphere at the school to its generation of returning GIs, in both the faculty and students. He stated, "I'm sure the war had a lot to do with it . . . It deeply rearranged values. The prewar sense of the orderliness or properness (of life) . . . was outmoded. If you have the world blow up in your face, you're bound to have some change of mind."[3]

Under the influence of fellow teachers Clyfford Still and Hassel Smith, Corbett's work shifted from geometric forms into looser "improvisations" involving enamels, Duco (automotive lacquer), sand, and swaths of contrasting color. Corbett was the school's most widely read faculty member, interested in the

Edward Corbett, c. 1958

existentialist writings of Sartre, Kierkegaard, Camus, and Heidegger. He urged his students to have a broad background in the arts, saying "the best preparation for an artist is a classical viewpoint, a universal interest in the humanities . . . And the best possible education is the kind of learning that continues without the school or teacher: private personal learning."[4] Corbett also was unabashed about asserting "human values" in art, beyond formalist composition. His Romantic, more literary-minded approach to visual art particularly appealed to independent-minded CSFA students like Jess, Philip Roeber, and Lilly Fenichel.

Jess and Robert Duncan owned two works by Corbett that were exhibited in Corbett's retrospectives at the San Francisco Museum of Art (1969) and Richmond Art Center (1990). Manny Farber eloquently wrote of the distinctive nature of Corbett's emotionally heightened abstractions from this period:

Ed Corbett . . . make(s) poetic pictures of emptiness; the paintings of this lonely Arizonan catch the bitter gloom of current times. His technique starts with a starved palette (gray, black, red house paint) which

is further simplified into a one-color canvas, enriched by a treacherous texture of varying paint qualities and finishes (enamel, flat, waxy). Corbett not only robs his color of its voice but by glazing and powerful brushing tries to efface rather than build form. This creates a gray, vacant work that bides its time while a tortuous underground life throbs beneath the crust-like surface, occasionally breaking through in a rage of etched lines or splattered cobwebs. The burying, cloaking method permits Corbett to express aspects of life—emptiness, stillness, waiting—never before painted directly. His pursuit of a timeless, spaceless design rejects the flamboyant plasticity of the School of Paris.[5]

Just as Corbett was coming into his own as a painter, a 1950 budget crisis at CSFA caused several faculty members, including Corbett, to lose their jobs. Jess titled two of his early lyrical abstractions *To Corbett* (1951) (p. 90) and *On Corbett's Dismissal* (1950). Corbett moved to Taos, where he wrote Duncan, "I'm surrounded by some of the worst painters in the world, some of the prettiest mountains: together they make for a great solitude & (a kind of) peace of mind."[6] Corbett also sent Jess and Duncan copies of his tersely sardonic prose poems and fables.

In 1952, MOMA curator Dorothy Miller chose Corbett, along with Clyfford Still, Jackson Pollock, and Mark Rothko, for inclusion in "Fifteen Americans," one of her prestigious surveys of contemporary artists at the museum. Corbett's artist statement in the catalogue simply read, "I intend my work as poetry."[7] That same year, he began his association with New York's Grace Borgenicht Gallery, where he showed regularly for the next fifteen years. In 1953, he took a teaching position at Mount Holyoke College, remaining there for ten years. Back

on the West Coast, in 1955 his works were included in "Action I" at Syndell Gallery in Los Angeles, curated by Walter Hopps and Ed Kienholz.

In the 1960s, Corbett's painting continued to develop, despite battles with ill health, the loss of a leg, and alcoholism. The two subtly minimal series both called Paintings for Puritans (1955, 1967–1968) include some of his most masterful works. Today his art is celebrated by cognoscenti, making him one of the quiet heroes of West Coast abstraction. As R. B. Kitaj remarked after seeing Corbett's works in Duncan and Jess's home:

> When I first saw the beautiful Ed Corbett black abstraction at a stair landing I was reminded of the stupid disposition of reputation. Corbett died in agony, maybe greater than Rothko's. He is hardly known in America and unknown here in the rest of the world. He was, in these stunning charcoals, among the most wonderful abstractionists and I am no great protagonist of abstraction.[8]

> — Michael Duncan

1 Draft of Guggenheim Fellowship application, 1951, Papers of Edward Corbett, Archives of American Art, Smithsonian Institution; cited in *Edward Corbett: A Retrospective,* ed. Susan Landauer, exh. cat. (Richmond, CA: Richmond Art Center, 1990), 12.

2 Gerald Nordland, *Edward Corbett,* exh. cat. (San Francisco: San Francisco Museum of Art, 1969), n.p.

3 Ibid., interview with Nordland.

4 Ibid.

5 Manny Farber, "Art," *The Nation,* January 6, 1951, 19.

6 Corbett, postcard to Robert Duncan, undated, Robert Duncan Collection, The Poetry Collection of the University Libraries, University at Buffalo, The State University of New York.

7 Statement from Corbett in Dorothy Miller, *Fifteen Americans,* exh. cat. (New York: Museum of Modern Art, 1952), 7.

8 R. B. Kitaj, "[Untitled]," in *Robert Duncan: Scales of the Marvelous,* ed. Robert Bertholf and Ian Reid (New York: New Directions, 1979), 206.

Edward Corbett, *Untitled,* 1950
Charcoal and pastel on drafting paper

Edward Corbett, *Standing Figure*, c. 1940s
Ink on paper, 10 x 6 in.

Edward Corbett, *Me*, c. 1940s
Maroon pencil on paper, 8½ x 5½ in.

The refined, subtle collages of Ernesto Edwards (b. 1933) were completed by the early 1970s and have rarely been publicly exhibited. Edwards was born in Salt Lake City, Utah, and although he had little exposure to art and culture growing up, his grandmother brought home projects for him from her third-grade classroom and also encouraged him to paste cut-out pictures into scrapbooks. In 1962, a few years after graduating from the University of Utah, he visited San Francisco, where he met the poet Lewis Ellingham and Ellingham's friend Gail Chugg. They took "Ernie" (as Edwards was known in those days) to Katy's Bar in North Beach, where he was introduced to the poets Jack Spicer and George Stanley. After quitting his job in Salt Lake City, Edwards returned to San Francisco, staying again with Ellingham and Chugg in Harwood Alley on Telegraph Hill.

During his first week after returning to the city, Edwards went to the San Francisco Museum of Art and saw an exhibition of works by Jess, Bruce Conner, Lawrence Jordan, and other California "assemblage" artists. He was extremely interested in everything in the show but especially noticed the collages by Jess. "I encountered Jess's work for the first time there, which really inspired me," he said. "I went back to Salt Lake City and started cutting up magazines, *Life,* and anything with pictures in it. Somehow Jess's work made me think that I could do collage too."[1] When he showed his first attempts at collage to Bill McNeill, Tom Field, and other new friends, they urged him to continue his work.

Edwards made collages throughout the 1960s, producing about one hundred. A great resource for him was McDonald's, a huge bookstore on Turk Street, where he found usable old magazines. He brought stacks of them home and immediately began cutting out images and laying them on a long

Ernesto Edwards, c. 1963
Photograph by the artist

table. "I wasn't the least bit intellectual about the material; I just chose pictures which drew me somehow," he said. Edwards accumulated many boxes of images, which he carried with him wherever he moved.

For a time Edwards wrote poetry, which was praised by Robert Duncan but was not liked by Jack Spicer, who told him not to be a poet. A friend of many of the writers in San Francisco in the 1960s and '70s, Ernesto sometimes drove an inebriated Spicer home from North Beach in the early morning hours.

Edwards first showed his work in 1964 in the energetic Buzz Gallery on Buchanan Street, run by Paul Alexander and Bill Brodecky Moore. A year or so later he was in a three-person show at "Mostly Flowers," a gallery managed by David Young Allen in the airport bus terminal downtown. And in the late 1960s Edwards and Bill McNeill presented their works in an in-home exhibit on Natoma Street; Robert Duncan attended and bought pieces by both artists. Although Edwards's collages are mostly in private collections and thus not widely known, they are some of the most visually engaging and appealing works produced in this period.

Edwards's earliest collages are entirely black and white, but later he began to use color, with images of men, bathing beauties, animals, Buddhas, and flashes of lightning in the night sky. One of his first works, *Putting on the Eyes* (p. 190), was purchased by Duncan, who may have been drawn to it for its poetic quality and Jess-like density. The overall scene shows factory workers, large cogs, and machinery from nineteenth-century photographs. Within this environment Edwards placed the head of Sigmund Freud; a man leaning over a book with a giant bird on his shoulder; five helmeted men pointing their rifles at an eye above a vat; and a young man resisting a beating from an individual wearing an overcoat and toting a gun in a holster. A few pivotal images in the work may hint at possible redemption and hope, including an angelic floating figure in a sports uniform, a benign-looking winged lady in the right foreground, and a dancer in the upper left corner. These cream-colored forms stand out in the overall black-and-white setting. On the right is a naked Narkissos-type figure who appears to be surveying what surrounds him. Perhaps everything in the landscape is a portion of this observing individual, open to the heavenly, earthly, and infernal doings around him.

Edwards in a quiet way has been a loyal friend to, and supporter of, a number of the painters in this exhibition. With some of his salary received from his job at San Francisco General Hospital, where he worked for many years, he bought art by Paul Alexander, Tom Field, Bill McNeill, Fran Herndon, Nemi Frost, and others. His kind and modest nature has also helped to keep the lines of communication open between these and other artists. He now lives in Salt Lake City. During an interview in 2010, Edwards commented, "It's exciting to see what happens when you put the images of a collage next to each other. It's a view into another place."

—Christopher Wagstaff

1 Comments by Edwards here and many of the biographical details are from the author's interview with Edwards, June 18, 2010.

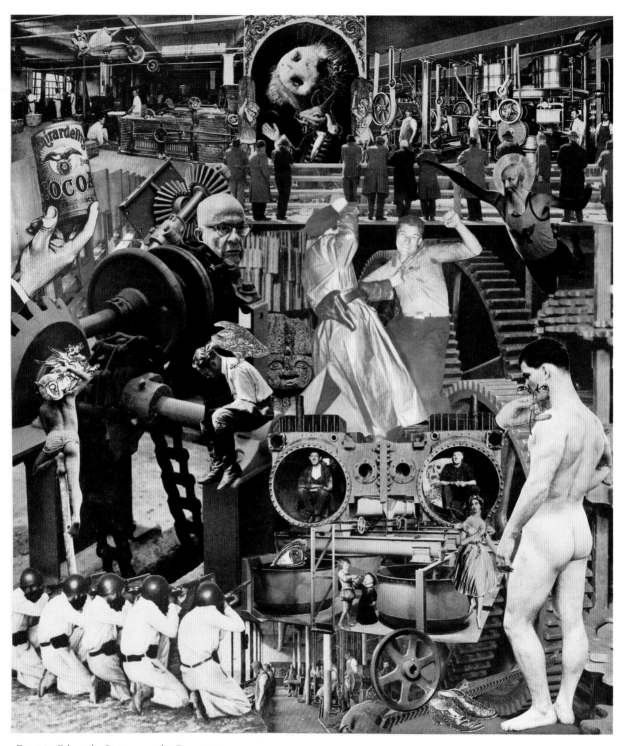

Ernesto Edwards, *Putting on the Eyes*, 1963
Collage

Ernesto Edwards, *Thoughts Have Wings*, 1966
Collage

Ernesto Edwards, *At the Bijou*, 1968
Collage

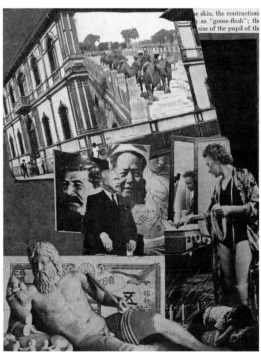

Ernesto Edwards, *Vanishing Men*, 1968
Collage, two of six panels

An ultra "outsider" artist and one whose mesmerizing work is difficult to categorize, Norris Embry (1921–1981) was born in Louisville, Kentucky. He attended the School of the Art Institute of Chicago in 1940 and absorbed its rich collections, especially the German expressionists, who were crucial to him throughout his life. From 1942 to 1944 he lived in New York City, where he met Robert Duncan as well as some of the surrealist painters, and in 1949 he studied with Oscar Kokoshka at his school in Venice. Shortly afterward, at Duncan's suggestion, Embry came to San Francisco, living for about four months with Robert and Jess in their flat at 1724 Baker Street.

Embry and Duncan shared a passion for oil crayons because crayons are often used by children and are not viewed as a medium for "sophisticated" art, from which both sought freedom. Duncan probably also liked Embry's uninhibited lifestyle and the spontaneous, tossed-off look of his work. Harry Jacobus, who was a longtime friend of Embry, has said, "The line quality in his drawings was extraordinary. Having a mind like Rimbaud and the French poets, he was out to destroy everything that referred to the Renaissance."[1] Jacobus added that Embry drew at breakneck speed in order to release the contents he thought were buried in the depths of his unconscious.

During Embry's stay at Baker Street, Duncan and Jess scheduled a one-day sale of his drawings, pinning them to the walls throughout the apartment and offering them for a dollar. In 1953 Norris's portraits and landscapes were shown for the first time in the United States at the eclectic King Ubu Gallery. Embry, who was struggling with alcoholism and manic depression, would often wear out his welcome when he camped out, and such was the case at Baker Street. Once, when Jess complimented him on a stack of drawings Norris had just given him, Embry tore

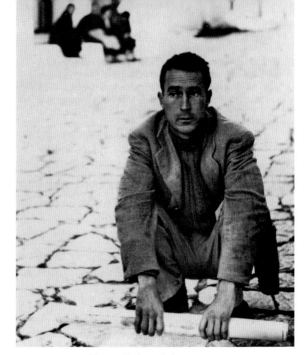

Norris Embry, Athens, 1959

them all up and stomped out the front door.[2] One can sense the strained Baker Street situation in the dreamlike portrayal of Embry with a bandage over his nose in Jess's early painting *Feignting Spell* (p. 14).

Embry was the inspiration for Duncan's character of Faust in his joyous "entertainment" *Faust Foutu* (1953). A sort of declaration of independence from the constraints of a "useful life," this play is a castigation of art as a careerist and self-aggrandizing enterprise. When a painter asks him what he should do, Faust answers, "Nothing. Imitate the dark. Jump into the middle of what you are doing. Attack it." Many years later, Embry wrote Duncan that he'd been offended by the happy ending Duncan had given the play. "Not only did I want a tragedy," he wrote, "I was paying the price for an amazing one."[3]

Embry was prolific almost beyond imagining. He rarely stopped working and would fill random pieces of paper as well as small notebooks with dazzling crayon and ink drawings wherever he was. He usually didn't keep his work but gave it away to whomever showed interest or was nearby. Duncan and Jess saved the many dozens of drawings Embry

gave them, as did Pauline Kael. One large work on paper in Jess and Robert's collection says in one corner, "For Duncan to finish. Norris." Particularly moving is a self-portrait with smudged charcoal writing at the top, "I want to be happy but I can't be," and on another drawing are the words, "Dada alone is indestructible." Sometimes Embry would just sign his name at the bottom "NO," rather than "Norris."

Embry was a world-traveler—an international tramp, in his words. When Jacobus was asked why Embry moved about so much, he said Embry was no doubt trying to escape from himself and find inner peace.[4] His periods of darkness, which involved both himself and his work, led to his being institutionalized several times and making two suicide attempts. In 1979 Embry wrote Duncan that at age eight or nine he had seen a movie called *Suicide Souls,* in which the hero jumps from a skyscraper he'd built. He added that in therapy he was working to undo his childhood decision to become a tragedy, and that his one pleasure was making marks and creating wonder on a flat surface.

Embry was admitted to Baltimore's Sheppard Pratt psychiatric hospital in 1964, where he remained for over a year. His final period in Baltimore involved continued therapy along with the creation of increasingly dense oil paintings and works on paper. Figures, symbols, and words going in every direction fill the pictorial spaces. A good friend in these later years was the painter Grace Hartigan, who described visiting him in a parlor of a townhouse in a once fashionable part of Baltimore. The only furniture she saw was a cot and an electric hot plate. "The rest was a table alive with colors, some I'd never used—fat watercolor sticks." He showed her pages filled with brilliant scarlets and magenta. "Such beauty, oh Norris, dear Norris."[5]

Since his death, Embry's work has been featured in several large exhibitions and been highly praised for its beauty and verve. Like Artaud, Embry pushed beyond the bounds of rationality to see what lay on the other side of those limits. Donald Kuspit has written, "Like the best Expressionist art, [his work] seems involuntarily an art of 'dissemination,' actively subverting 'recuperative gestures of mastery.'"[6] The faces in Embry's drawings and canvases—not detailed or humanistic—convey deep human emotion and a longing for a connection that may be found only in and through love. Norris wrote numerous poems during his life, and on one drawing above a Picassoesque profile he jotted, *"Enfin que vite et mort,/ ton corps ne soit que Roses,"* or "At last that quick and dead,/ Your body be nothing but Roses."

—Christopher Wagstaff

1 Christopher Wagstaff, ed., *Harry Jacobus: An Interview (1985)* (Berkeley: Rose Books, 2004), 116.
2 Author's conversation with Jess, 1989.
3 Embry, letter to Duncan and Jess, n.d., Robert Duncan Collection, The Poetry Collection of the University Libraries, University at Buffalo, The State University of New York. Other remarks from Embry's correspondence with Duncan and Jess are from this collection.
4 Harry Jacobus, in a telephone conversation with the author, n.d.
5 Grace Hartigan, "Remembering Norris Embry," in *Norris Embry: The Final Years, 1978–1980,* ed. Donald Kuspit, exh. cat. (New York: Rosa Esman Gallery, 1987), n.p.
6 Kuspit, *Norris Embry,* n.p.

Norris Embry, *Untitled (garden)*, 1954
Oil crayon on paper

Norris Embry, *Untitled (man and woman)*, c. 1950–1953
Poster paint on torn paper

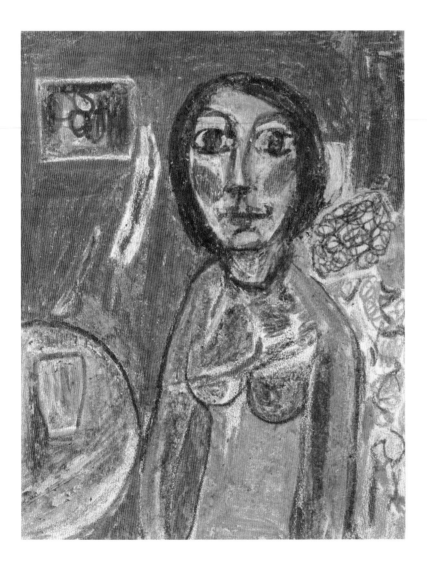

Norris Embry, *Feeding the Cat*, 1951
Monoprint

Norris Embry, *Untitled (woman sitting at table)*, 1951
Oil crayon on paper

One of the most underrated abstract artists who emerged in the West Coast postwar era, Lilly Fenichel (b. 1927) has explored a number of techniques and styles over her long career. Born in Vienna, she and her family fled to Great Britain during the Nazi occupation of Austria in 1939. Her uncle, Otto Fenichel, a renowned Marxist intellectual best known for his book *The Psychoanalytic Theory of Neurosis* (1945), encouraged the family to move to Los Angeles, where he had initiated the city's first psychoanalytic institute. Fenichel claims that "Freud was the church I was raised in," as her family met and socialized with many of the well-known Freudians, including Bruno Bettelheim and Erik Erikson.[1]

During high school and college in Los Angeles she lived with family friends whose son was Rudi Gernreich, later to become the designer of the monokini. Under Rudi's influence, Fenichel studied fashion illustration at the Chouinard Art Institute in Los Angeles and at Los Angeles City College before committing to fine art. She studied privately with the painter Zev in Monterey before moving to San Francisco and winning a scholarship to attend the California School of Fine Arts (CSFA), then under the guidance of Douglas MacAgy. At the school she particularly responded to the classes of Hassel Smith and Edward Corbett. Of Corbett's teaching, she stated, "Ed's approach to teaching drawing was unique. He made it possible for me to deal with areas I was previously afraid of because he was so gentle in his teaching. Ed gave me permission to be soft and feminine when the emphasis was on being tough."[2]

Fenichel was close friends with fellow CSFA students Jess, Philip Roeber, and Deborah Remington, and her experiences at the school shaped her career as a painter. She recently recalled a "not comfortable" dinner party for the somewhat uptight Clyfford Still

Lilly Fenichel, 1950
Photograph by Nata Piaskowski

that Jess gave at the bohemian apartment he shared with Robert Duncan.[3] Roeber remained a supportive friend throughout his life, keeping up correspondence and encouraging her work. In 1951, while still a student, Fenichel exhibited at the Lucien Labaudt Gallery in San Francisco. In a group show at King Ubu Gallery a year later, her works were exhibited alongside those of Hassel Smith, Roy DeForest, James Kelly, Sonia Gechtoff, Seymour Locks, and Madeleine Dimond. Fenichel's early lyrical abstractions employ calligraphic forms that combine the atmospherics of Corbett with the stark drama of Still. The Fenichel paintings owned by Robert Duncan and Jess, *No. 15* (1951) (p. 200) and *Untitled* (1951) (p. 201), both feature craggy and lumbering forms mitigated by subtly delicate layers of color and blossomings of light that suggest natural phenomena.

When MacAgy was pushed out at CSFA, Fenichel left the school, disturbed by the atmosphere of compromise brought in by the school's new

Bauhaus-trained director, Ernest Mundt. She visited Corbett in Taos for a brief time, living in a chicken coop that he had found for her. She was awestruck by the New Mexico landscape and mountains and relished her exposure to Native American culture. Fenichel relocated to New York in 1953 to be near her mother and in 1959 visited New Mexico again, spending time with Clay Spohn, who gave her valuable advice on glazing techniques.

Finding it difficult to support herself by her art, she returned to Los Angeles in 1960, earning a living as a commercial photographers' stylist and an art director for films. Fenichel helped Cheryl Tiegs get her first professional job as a swimsuit model for *Sports Illustrated* and also received art direction credit for the Herbert Ross film *Lucky Lady.* Disenchanted with the movie business, Fenichel left Los Angeles for Taos in 1981 and returned to making art full-time. Over the years, she had established friendships with many artists in New Mexico, including Louis Ribak, Beatrice Mandelman, Oli Sihvonen, and Larry Bell. Her Taos work evolved toward paintings of geometric forms in pale tones, some evoking cloudscapes and evening skies. In the mid-1980s, she branched off with a more minimalist series of sculptural reliefs made from automotive fiberglass.

In 1985 Fenichel relocated to Albuquerque, where she continued to experiment with new mediums and styles. She became interested in the teachings of Wilhelm Reich, particularly, as she put it, his belief "in the connection between man and nature—an organism's connection with nature is the wellspring of human happiness, in the big sense, the connection between the mind and body."[4] Fenichel has frequently acknowledged how her work has alternated between a freedom of imagery and a personal response to nature. A sumptuous series of acrylic paintings on raw canvas, titled Just You Just Me (2003–2004), featured pastel colors dancing into embryonic interwoven forms. While traveling over the years, Robert Duncan met up with Fenichel, both in New Mexico and New York; early on, he wrote of her work:

> To grasp the quality of the painting . . . is to grasp the quality of the woman at work—an extraordinary vitality; a passionate explorative nature; an uncompromising devotion to her craft; and a concept in which intellect and emotion are one of the roles which she plays in shaping and extending the sensual conscious language of art . . . The elegance which Lilly Fenichel achieves, the vast poise in turbulence, is in visual terms what we seek ourselves in the turbulence of city-living or in the vaster field of human pressures and forces in our history.[5]

Fenichel's latest works were exhibited in 2012 at David Richard Gallery in Santa Fe.

—Michael Duncan

1 Nancy Pantaleoni and Stephen Parks, "Lilly Fenichel: 'I Don't Make Hemline Art,'" *ARTlines* 5, no. 3 (March 1984).
2 Susan Landauer, "An Interview with Lilly Fenichel," in *Lilly Fenichel: The Early Paintings,* ed. Fenichel, Landauer, and David J. Carlson, exh. cat. (San Francisco: Carlson Gallery, 1990), 11.
3 Fenichel, telephone conversation with the author, July 5, 2012.
4 Pantaleoni and Parks, "Lilly Fenichel."
5 Robert Duncan, letter to the Albert Bender Award committee, c. 1951, in Fenichel, Landauer, and Carlson, *The Early Paintings,* 7.

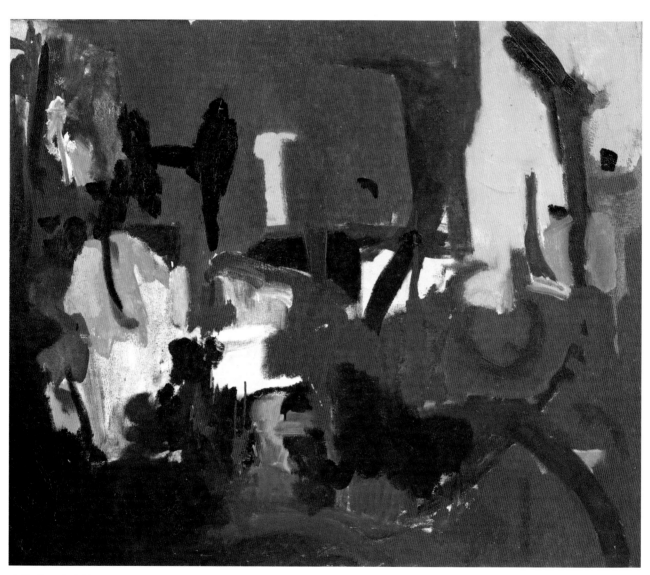

Lilly Fenichel, *No. 15*, 1951
Oil on canvas

Lilly Fenichel, *Untitled*, 1951
Oil on canvas

"His work is full of fire and spirit," said Tom Field's painter friend Bill Brodecky Moore,[1] and the poet Charles Olson believed that Field was perhaps the premier painter to emerge in the last years of Black Mountain College.[2] Ralph T. "Tom" Field (1930–1995) was born and raised in Fort Wayne, Indiana, where he lived with his grandparents from the seventh grade on. Drawn to art at an early age, he said he became known for finger painting and a poster that helped elect a prom queen.[3] After taking two hours of art and drawing classes every day in high school, he attended the Fort Wayne Art School for two years. During that time he saw his first reproductions of works by Franz Kline and Willem de Kooning, which affected him deeply.

Following his service in the army in Korea from 1951 to 1953, Field was encouraged by a sympathetic teacher, Elizabeth Eddy, to apply to Black Mountain College, a small experimental school in the hills of North Carolina where she believed he could more fully develop his rare talent. Asked about his impression of Black Mountain College when he arrived there, he replied that like everyone else he wondered where the students were. The College was in its last but not wholly inglorious years, and only seven had enrolled that fall semester of 1953. He began by studying architecture with Paul Williams, German with Flola Shepard, painting with Joseph Fiore, and sculpture and painting with John Chamberlain. He noted that at first the place was a disappointment, saying, "I had no notion of what a college should be actually, but it wasn't like anything I had seen in the movies."

Joe Fiore helped Field get over a painter's block resulting from his experience in Korea, and the young artist responded to the Diebenkorn-like qualities of Fiore's paintings with their lyrical swaths of color. "You know, we were working from inside," he remarked in 1986. He would do one painting session

Tom Field, 1964
Photograph by Ernesto Edwards

a day and often continue painting and writing at night. When asked about partying, he commented, "There was drinking, but they were not the times I remember. The periods I recall are finally having breakthroughs with paintings. Those seemed the important times for me."

Field also spent some of his days writing poetry, especially for the classes he took with the rector of the school, Charles Olson. One or two of his poems were published in the *Black Mountain Review*, edited by Robert Creeley. He became good friends with Chamberlain as well as Creeley, and he enjoyed taking Olson's courses, the most appealing being "And/Or History," which Field said taught him to think.

When Black Mountain closed for lack of faculty and funds in the summer of 1956, Tom made his way to San Francisco, where he lived with Paul Alexander, a friend since grade school and a fellow alumnus of Black Mountain College. Hearing he could get work as a merchant seaman, he went to seamen's school, and by March 1957 he began shipping out for at least three months each year. When in town,

he became part of the city's vibrant group of Black Mountain refugees, among them Bill McNeill, Ebbe Borregaard, John Wieners, Joe Dunn, Ann Simone, Joy Aiken, Basil King, Knute Stiles, and Robert Duncan and Jess. Field joined a poetry circle of Jack Spicer's, although he found Spicer dogmatic at times. He also attended a writing group organized by Joanne Kyger that met every Sunday in the attic of East-West House, a small Buddhist-oriented community then on California Street.

The first exhibit of Field's work was in 1960 at the Batman Gallery, run by William Jahrmarkt. That was followed by shows at Borregaard's Museum (1961), the Playhouse Theatre (1962–1964), the Peacock Gallery (1963), Buzz Gallery (1964), and other modest art spaces. Field has said he always struggled with self-esteem, which kept him from seeking more preeminent venues for his work. "I never thought I was any good; I just could never push myself." He also struggled with alcohol for some years, which he gave up totally while residing at Synanon from 1974 to 1977. Novelist Michael Rumaker has written of Field: "He was a simple heart, his generosity and good-nature often taken advantage of. He could be quickly hurt, and as quick to forgive."[4]

Possibly the most singularly exciting painter in the circle around Robert Duncan and Jess, Field produced several dozen large-scale oil paintings that sometimes depict a recognizable subject (Ebbe Borregaard in a leather jacket, or the churning, sparkling waves off Ocean Beach) but are more often abstract expressionist in character. One of his most respected works is *Pacific Transport* (1958), which was the first major painting he completed in San Francisco. He has said of it: "I imagined looking out from the wheel house of a white State Line ship with aluminum rigging and seeing all this movement. I used aluminum paint and a lot of blue in the painting and a couple of red spots." *Cluttered Roof* (1959) (p. 205), which received a prize from the San Francisco Art Institute in 1962 and was

in the collection of Duncan and Jess, again shows objects in vigorous interrelation and movement. It was done while Field lived at 509 Buchanan Street, "where I had a view out of a big window, and the neighbors next door had thrown a lot of stuff including an inner tube on their roof. I simply painted the roof in the abstract."

In the fully nonobjective *Kerouac Painting* (1960) (p. 204), the paint—applied in delicate, swirling lines—was well described by poet Robin Blaser in a brochure for Field's 1996 memorial exhibition at 871 Fine Arts in San Francisco: "I watch the colors flash, the vertical and horizontal brush strokes intertwine—not contradict one another, but wind—and flare."[5] This work is so named because Jack Kerouac, while sitting on a couch under it, added a doodle on the canvas in the lower right corner. A recommendation Jess wrote for Field describes well the lasting effect of this and his other works: "I carry indelibly in my memory many of his spontaneous and beautiful images. The immediacy of his paintings brings the viewer into the moment of making."[6]

—Christopher Wagstaff

1 Bill Brodecky Moore, in an unpublished interview with the author on December 1, 1986. In this discussion Moore acutely appraises many aspects of the San Francisco painting renaissance.

2 Christopher Wagstaff, ed., *Paul Alexander: On Black Mountain College and the San Francisco Scene* (Berkeley: Rose Books, 2010), 5.

3 Comments by Field in this biographical sketch are from the interview in Christopher Wagstaff, ed., *Tom Field: On Painting at Black Mountain and in San Francisco* (Berkeley: Rose Books, 2006).

4 Michael Rumaker, *Robert Duncan in San Francisco* (San Francisco: Grey Fox Press, 1996), 23.

5 Brochure for the exhibition "Tom Field: Paintings from Black Mountain College and the Beat Era," organized by Ernesto Edwards for 871 Fine Arts, San Francisco, November–December 1996.

6 Jess, from a letter of June 8, 1988, written in support of Field's Pollock-Krasner grant application, Jess Papers, The Bancroft Library, University of California, Berkeley.

Tom Field, *Kerouac Painting*, 1960
Oil on canvas

Tom Field, *Cluttered Roof*, 1959
Oil on canvas

One of the strongest artistic voices of his generation, Llyn Foulkes (b. 1934) has grappled with the heart and soul of American culture for over fifty years. In his figurative paintings, reliefs, and prints, Foulkes pursues visceral effects and instantly recognizable imagery to convey his dark vision of a spiritually depleted society. Drawing from disparate sources that range from Dalí and Disney to Vermeer and Donatello, he seeks nothing less than to reinvigorate art with the moral seriousness of Renaissance religious art.

After briefly attending the University of Washington, Foulkes joined the army and was posted to Germany, where he witnessed the devastating effects of World War II and became absorbed in European art history, touring museums and making a pilgrimage to Dalí's house in Cadaqués, Spain. After his release from the military in 1957, he moved to Los Angeles to study art at Chouinard Art Institute, which was then firmly entrenched in abstract expressionism. Learning from the sophisticated abstract styles of teachers Richards Ruben and Emerson Woelffer, Foulkes emerged from school fully developed as an artist. Incorporating photographs as well as collaged objects with charred and molten textures, the paintings in his first one-man exhibition, at Ferus Gallery (1961), are remarkably inventive, conceptually varied, and fresh, making use of the painterly qualities of found assemblage elements.

After seeing Jess's work at Rolf Nelson Gallery in 1964, Foulkes and his wife, Kelly, bought on installments Jess's painting *Acteon-Like* (1961) and his paste-up *One Way* (1955) (p. 94). In a letter to Jess apologizing for his late payment, Foulkes wrote:

> I have been very busy trying to stay alive and paint. The months are late but the world is still noon and *One Way* and *Acteon-Like* have not

Llyn Foulkes, c. 1965

fallen into unworthy hands. We have loved them very much and shall not let them go unrepaid . . . Though I know you are more so in need of money shall send you what I can and/ or a painting. The small ones you spoke of are gone (I believe) but will send you something better (for the agony we have caused you).[1]

In a letter to his dealer after his 1965 exhibition of Translations, Jess reported his pleasure in hearing that Foulkes had paid close attention to the work: "I believe Llyn's pleasure and sensitive attention was my greatest delight, as he sought out the paintings' full being thru interest in their process."[2] Foulkes eventually settled with Jess by giving him *This Painting Is Dedicated to Jess* (1966), a desolate yet sensitive landscape whose inscription, repeated like a mantra, indicated his deep heartfelt respect.

Foulkes became well known in the late 1960s for pop paintings structured as large-scale postcards of desert landscapes that conjure an affectless,

existential angst. In 1969, Foulkes repudiated pop art, railing against its flat, thin images and arid planes.[3] Experimenting in his studio in the early 1970s, Foulkes blotted out the face of a self-portrait with an angry swatch of blood-red paint. He became reenergized by the creation of a series of transgressive portraits referred to as Bloody Heads that skewered the sanctity of formal portraiture with a gory Dadaist energy.

In the 1980s Foulkes began exploring larger arenas for social commentary. With sprightly Puritanical fervor, he addressed a national soullessness and capitulation to corporations that for him is epitomized in the squeaky clean corporate symbol of Mickey Mouse. His tableaux feature pop-culture heroes such as the Lone Ranger and Superman pondering their hapless, hopeless roles as moral arbiters in an already blasted world. Although all of Foulkes's portraits have autobiographical elements, self-portraiture directly entered work in which he personally confronted social corruption and corporate greed.

The specific site for Foulkes's messianic mission is Los Angeles—a city perpetually bent on the annihilation of its own history and sense of self-worth. For the past two decades Foulkes has lived and worked in the Brewery Arts Complex in downtown Los Angeles. His works were featured in the 2011 Venice Biennale and Documenta 13 (2012) and is the subject of a 2013 traveling retrospective survey organized by the Hammer Museum in Los Angeles.

—Michael Duncan

1 Llyn Foulkes, letter to Jess, May 3, 1965, Jess Papers, The Bancroft Library, University of California, Berkeley.
2 Jess, letter to Rolf Nelson, January 6, 1966, Rolf Nelson Papers, Special Collections, Getty Research Institute.
3 Foulkes, oral history interview by Paul Karlstrom for the Archives of American Art, Smithsonian Institution, June 25, 1997–December 2, 1998.

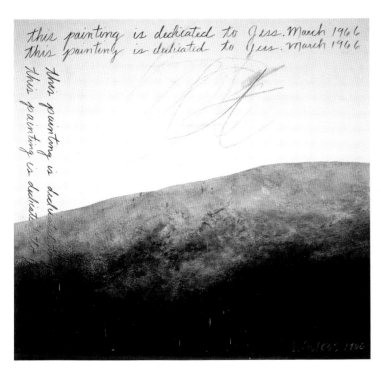

Llyn Foulkes, *This Painting Is Dedicated to Jess,* 1966
Oil on canvas

NEMI FROST

Working independently, Nemi Frost developed her own sophisticated graphic style of figurative painting. Her brightly colored, fantastical works feature bold forms in lush outdoor backgrounds, evoking quirky fairy-tale narratives. In his survey of postwar Bay Area art, Thomas Albright praised Frost's "portraits of many of the local poets in a crisp, Pre-Raphaelite style, against imaginative backdrops that suggested inspiration in Henri Rousseau."[1]

The daughter of a Standard Oil executive, Nemi (Emily) Frost was born in New York and grew up in Palo Alto and Santa Barbara. Just out of high school, she was married for a brief time to Jorgen Hansen, the artist son of artist Ejnar Hansen. She began her career performing as an actress, singer, and dancer, briefly studying drama in Los Angeles. Moving to New York, she worked in off-Broadway, summer stock productions, and traveling road shows. In 1957 her childhood friend Joanne Kyger convinced her to move to San Francisco, where Frost enrolled at the California School of Fine Arts. She took classes there for two years, studying with Frank Lobdell and Richard Diebenkorn.

Through Kyger, Frost fell in with San Francisco's burgeoning poetry and art scene in North Beach. Frost described the rush of excitement she and Kyger experienced at being a part of it: "We couldn't stand to be away from North Beach or each other . . . And we just raced to get back. It was home. It was where everything was happening."[2] Frost's immediate group was centered around Jack Spicer, who held court at The Place or on the lawn and beach of Aquatic Park. With Kyger, Frost and her artist friend Jerome Mallman attended poetry meetings at the apartment of Joe and Carolyn Dunn. These sessions attracted most of Spicer's friends and acolytes, including Robert Duncan and Helen Adam. Most had participated in Spicer's 1957 "Poetry as Magic" class at San Francisco State

Nemi Frost, Stinson Beach, c. 1960
Photograph by Helen Adam

College. Although Frost did not write, she enjoyed being witness to this grassroots poetry movement. The first poem in Spicer's collection *Admonitions* (1958), "For Nemmie," elliptically conjures her fresh energy with its allusions to motion and traffic.[3]

Several of Frost's drawings appeared in *Open Space* 5, including a portrait of John Wieners. The editor of *Open Space,* Stan Persky, was a friend and fellow Spicer follower. Frost was friends also with many other North Beach poets and artists, including George Stanley, Harry Jacobus, Paul Alexander, Dora (FitzGerald) Dull, Tom Field, and William McNeill. While the poetry meetings at the Dunns' were serious events, they sometimes devolved into makeshift happenings. Kyger wrote of one raucous session in her 1958 diary:

> At Joe Dunn's poetry reading yesterday . . . no one came except Nemi, Jerome, Tom Field and I. So we drank ale and used the hoola-hoop, also practiced Zen lotus positions and took Dada photographs. Then we ran to the Bread and Wine Mission, but on passing The Place, Sheila ran out and said, "Leo [Krikorian] will buy a bottle of champagne if you come in."[4]

Continuing to work on her paintings, Frost began exhibiting in local group shows. Through Kyger's connections, she was invited to show at the Rotunda Gallery of City of Paris department store. A *San Francisco Chronicle* reviewer praised her works' "highly entertaining play between silhouette and modeling," remarking that "her line often recalls Aubrey Beardsley and art nouveau."[5] Frost later became an active participant in Buzz Gallery (1964–1965), enjoying a solo exhibition there in May 1965. All the paintings in her show featured titles taken from the writings of Ronald Firbank. In 1977 a private exhibition of her work was held at the home of William McNeill.

Like Rousseau, Frost melds primitivism with a kind of knowing lyricism. *The Mad Hatter's Tea-Party, Starring Dora Dull and Tom Field* (1960) (p. 210) presents her poet and artist friends in fantastical garb, posing outdoors en route to a party, startled yet complaisant like two of Rousseau's contentedly wild beasts. The female's exposed breast and the male's fleshy lower body are slyly sensuous, hinting of revels to come. For her *Portrait of Robert Duncan* (1958) (p. 210), Frost posed the poet in a garden, lying on her sofa nattily dressed, with a lion—Jess's symbol—approaching the dais. For Jess, Frost stepped over the line by depicting Duncan's cross-eyed gaze (Duncan had a lazy eye). Duncan, however, loved the picture and wanted to buy it; Jess forbade the purchase and exiled Nemi from further household interactions.[6] Nevertheless, in 1961 Frost assisted on the production of Duncan's *A Play with Masks,* a Halloween party entertainment staged in Lew Ellingham's apartment, featuring Paul Alexander, Tom Field, Wesley Day, and Duncan.

Frost continued acting in San Francisco, including an appearance with Joanne Kyger in a staged reading of James Keilty's play *Ways of Spending Money.* An illustrated edition of Keilty's plays was planned for White Rabbit Press, but Spicer—due to a private grudge—managed to squelch the publication. Frost later published three illustrations she made for the aborted edition in *Quark,* a paperback anthology of speculative fiction associated with her friend Russell Fitzgerald and edited by Samuel Delany and Marilyn Hacker.[7] Frost remained a loyal friend to Spicer despite his psychological and physical problems in his declining years.

In recent decades Frost has continued to refine her style in decorative, illustrative modes. For the cover illustration for a book by George Souile de Morant and translated by her poet friend Gerald Fabian, *Pei Yu: Boy Actress* (San Francisco: Alamo Square Distributors, 1991), Frost suitably presented a Beardsley-esque drawing of the meticulously dressed performer applying makeup. Works by Frost were featured in a 2012 exhibition at Berkeley's Mythos Gallery. Frost's personal art collection includes works by Field, Alexander, Jacobus, and McNeill.

—Michael Duncan

1 Thomas Albright, *Art in the San Francisco Bay Area: 1945–1980* (Berkeley: University of California Press, 1985), 277.

2 Nemi Frost, interview by Lewis Ellingham, 1987, cited in Ellingham and Kevin Killian, *Poet Be Like God: Jack Spicer and the San Francisco Renaissance* (Hanover: Wesleyan University Press, 1998), 100.

3 Jack Spicer, "For Nemmie," in *The Collected Books of Jack Spicer,* ed. Robin Blaser (Los Angeles: Black Sparrow Press, 1975), 56.

4 Joanne Kyger, "October 13, 1958," in *The Dharma Committee* (Bolinas, CA: Smithereens Press, 1986), 7; cited in Ellingham and Killian, *Poet Be Like God,* 143–44.

5 *San Francisco Chronicle* clipping, not dated, available online at *Big Bridge* webzine, www.bigbridge.org/issue9/bgpage18.htm. Many other photographs and articles related to Buzz Gallery are also available on the *Big Bridge* site; see www.bigbridge.org/issue9/bgtitlepage .htm.

6 Frost, interview by the author, July 12, 2012.

7 *Quark/2* (New York: Paperback Library, 1971), 145–50.

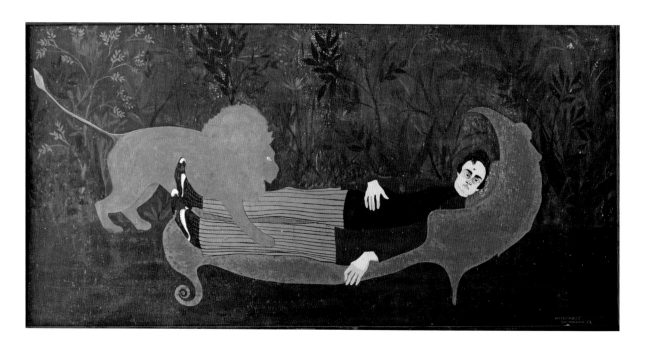

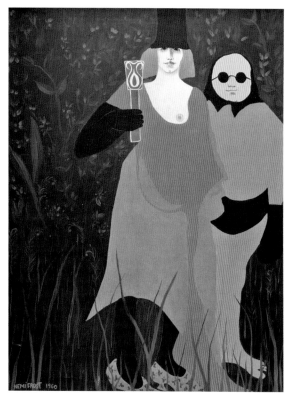

Nemi Frost, *Portrait of Robert Duncan*, 1958
Oil on canvas
Collection of Glenn Todd

Nemi Frost, *The Mad Hatter's Tea-Party, Starring
Dora Dull and Tom Field*, 1960
Oil on canvas

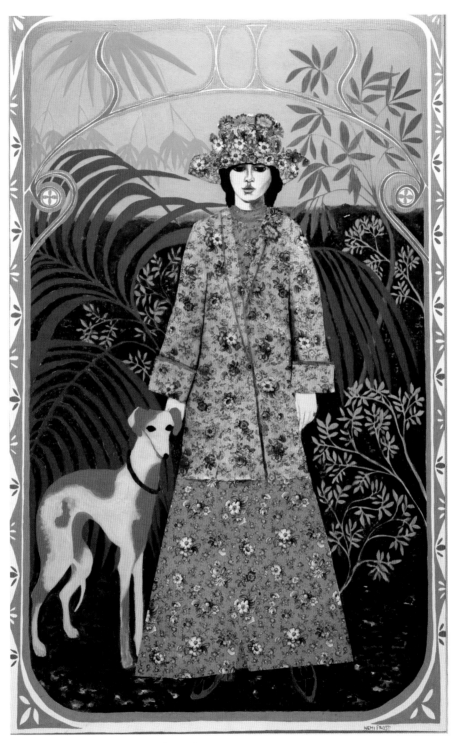

Nemi Frost, *Aunt and Joss (Whippet)*, c. 1961
Oil on canvas and mixed media

A key figure in the San Francisco poetry renaissance, Madeline Gleason (1903–1979) was a major devotional poet of the mid-twentieth century. Associated early in her career with Robert Duncan and James Broughton, she was also admired by the Beats, and she was one of the few women whose work was included in Donald Allen's milestone anthology, *The New American Poetry* (1960). In addition, Gleason is part of the small group of writers and poets, including Lewis Carroll, Kenneth Patchen, Victor Hugo, Jean Cocteau, and Beatrix Potter, who produced a body of drawings and paintings corresponding to the beauty, subtlety, or power found in their literary works.

Born in Fargo, North Dakota, Gleason was raised by Irish Catholic parents and attended parochial schools, where she was introduced to Shakespeare and other great literature. After singing and tap dancing with her cousin in vaudeville shows in the Midwest, she moved in the late 1920s to Portland, Oregon, where she wrote in a newspaper article that a poem makes one feel "some liberation of spirit released in the rhythmical flow of the lines."[1] Relocating to San Francisco in 1934, she translated into English the songs in Bach's Anna Magdalena notebook and organized a series of concerts showcasing lieder by Schubert and Schumann that she had also translated.

A praiseworthy review of her first book, *Poems* (Grabhorn Press, 1944), mentioned Gleason's confronting of evil in the world with the hard sturdiness of Teresa of Avila and John of the Cross.[2] In the mid-1940s Gleason began working at J. Barth and Co., a brokerage firm where for years she was a runner, delivering securities from one brokerage house to another. In 1947 she initiated the Festival of Modern Poetry in the Lucien Labaudt Gallery—likely the first regular poetry-reading series in America. Two years later came her most revelatory book, *The Metaphysical*

Madeline Gleason, c. 1957
Photograph by Helen Adam

Needle (Centaur Press, 1949), which intimates that the author has undergone an interior experience that profoundly affected her values and outlook. In "The Metaphysical Needle's Eye" she says we each have a metaphysical needle within us that has become rusted, for "All the troubles start/ Through some neglect or mistake,/ Fault of ego or of heart."[3] In "The Drudge and the Doppelgänger" Gleason saw the disease of our time as ennui, or the covering of everything "by the dust of inattention" (*Collected Poems,* 59), creating a "dead eye of the soul" (*CP,* 56). Gleason's answer for this dilemma is found in "The unchanging place where love keeps his fixed center" (*CP,* 63).

Sometime while writing the poems in *The Metaphysical Needle,* Gleason began to paint, starting with small, brightly colored works on paper, which she gave to friends. Having no formal training to speak of and not especially responsive to contemporary trends, she chose to paint in a manner that looked "naïve" and "unsophisticated" but was not really so. She usually worked in gouache on heavy paper or boards, shellacking the surfaces afterwards to protect them and give them a sheen. Her paintings, which show the influence of Turner, de Chirico, Rousseau, Moreau, and Rouault, fall into two

distinct styles and periods. Calling her an "original," the critic Alfred Frankenstein said of Gleason's earlier works, exhibited at the Pink House in 1955:

> Miss Gleason takes great pleasure in painting small pictures of carnivals, all glistening and sparkling with their vari-colored lights. Her approach, however, is always on the wistful side; these jewels are delightful, but behind them is always the night.[4]

These first-period works show city streets, buildings, carnivals with tents, and stalls with bright signs: "Katy's Dine and Dance," "Dog Show," "Octavia Palm Reader," "Crasy House," and "Wild West Show." The buildings, often in deserted streets and appearing to lean and be unsteady, are mysteriously lit from within even during daylight. Gleason's colors are often muddy and dark, creating a somber and mysterious mood, and her diminutive figures stand motionless and often alone.

Gleason's later paintings might be termed "mystical" or semireligious. According to her late partner, Mary Clark Greer, Madeline had a deep spiritual faith that she rarely discussed, although she would attend Mass every day at noon. We don't know exactly when Gleason began detecting the eternal in mortal life and believing that the human soul could merge in the absolute, but it's clear that she had intense visions in her mature years which found expression in her art. In her late paintings, it appears one is looking at reality "through a haze, a shimmer of light and color."[5]

The surfaces in these works are amorphous and abstract, and the human forms are faintly delineated and almost indistinguishable from their backgrounds. Her largest and most moving visionary painting, *Untitled (Figures in Desert)* (p. 215), features a group of monks or acolytes in a barren, mountainous region where ahead of them stands a reddish figure with an aureole. The paint is applied thinly with no attempt to embellish or beautify the rugged scene. Another semimystical oil painting, *Assembly of Saints,* depicts five disciples and a teacher who seem to have reached a highly evolved state, having shed their physical characteristics for "the self without name" (*CP,* 62) and perhaps desiring only to "Hymn the joyous praises of/ The resurrection unto love" (*CP,* 227).

In the 1950s and '60s, Gleason remained close to Duncan and Jess, the couple introducing her in 1955 to her lifelong companion, Mary Greer. However, in the stimulating and often tumultuous poetry scene in San Francisco in those years, Madeline was sometimes taken for granted and her voice drowned out by the more charismatic Duncan, Jack Spicer, James Broughton, Allen Ginsberg, and Lawrence Ferlinghetti. However, she continued publishing and painting, reading her poems to large, appreciative audiences, teaching a master workshop in poetry at San Francisco State College, showing her paintings at Wild Side West, and writing a number of remarkable plays. Although Robert Duncan chastised her in 1971 for not becoming more modernist in her poetic practice, Gleason was stalwart in adhering to her lasting loves—Shakespeare, Yeats, and Blake. She continued to write devotional lyrics and paint in a non-twentieth-century mode, and, in the words of a 1974 poem, to "Go the long, lost, lonely road/ And find what is your own" (*CP,* 249).

—Christopher Wagstaff

1 Gleason Poetry Archive, Donohue Rare Book Room, University of San Francisco (CA).

2 Ibid.

3 Reprinted in Madeline Gleason, *Collected Poems 1919–1979,* ed. Christopher Wagstaff (Jersey City: Talisman House, 1999), 85.

4 Quoted in the press release for "Once and Upon," a memorial retrospective of Gleason's paintings, Gallery Become, 1 Haight St., San Francisco, April 24–May 17, 1980.

5 Ibid.

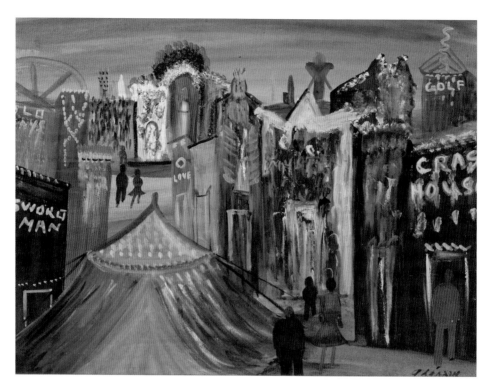

Madeline Gleason, *Untitled (Carnival),* c. 1948. Oil and gouache on board

Madeline Gleason, *Theatre,* 1950. Gouache on paper

Madeline Gleason, *Untitled (Figures in Desert)*, c. 1965
Oil on board

One of the founders of West Coast assemblage art, George Herms (b. 1935) has carried forward the radical, lyrical values of those he calls "the poet heroes of my youth." From the onset of his career, Herms's sculptures, paintings, and drawings have operated on a poetic level, using visual puns, pop-culture references, and time-scarred materials to put an expressive spin on American culture. In assemblages of found objects and richly weathered discards, he seeks to reinterpret and reinvigorate the past, accruing new connotations for detritus. In recent decades, he has become an unofficial historian of the West Coast Beats, carrying on the tradition through works such as his facsimile edition of Wallace Berman's *Semina* (Love Press [George Herms], 1992; distributed by L. A. Louver Gallery). An ongoing series of sculptures commemorating individual poets, artists, and jazz musicians includes the large scrap metal sculptures *Donuts for Duncan* (1989) (p. 218) and *For Jess* (1992).

The son of an agronomist, Herms was born in Woodland, California. While studying engineering at the University of California, Berkeley, Herms became turned on by jazz and literature. He left school in 1954 and moved to Los Angeles, where he got a job as a tabulation operator for Douglas Aircraft and spent his evenings in jazz clubs. On his twentieth birthday, while babysitting for friends in Topanga Canyon, he met Wallace Berman, who would become a lifelong friend and influence. Returning to Berkeley, Herms spent a year taking courses in literature and music appreciation, until dropping out again in 1956 to move to Hermosa Beach. Working at another aircraft parts facility, Herms immersed himself in the Los Angeles jazz and art scenes. He spent much time at the Bermans' house, helping assemble *Semina* and perusing Berman's *View* magazines and books such as Robert Motherwell's *The Dada Painters and Poets*.

George Herms, c. 1957
Photograph by Edmund Teske

Herms began to make assemblage collages from machine parts, punch-card detritus, and beach trash. In 1957, after the obscenity trial involving Berman's Ferus Gallery exhibition, Herms temporarily exchanged houses with the Bermans so that they could avoid the publicity generated by the trial. Later that fall, Herms's first wife, Polly, wanted to return to her studies at Berkeley. Before leaving Hermosa Beach, Herms took all the assemblages he had made to a vacant lot and invited Berman and a few friends to see what he called "The Secret Exhibition." Herms's work reportedly emerged fully developed in this first grouping of assemblages, all of which were abandoned.

In Berkeley, Herms learned painting techniques from artist friend Arthur Richer, but things turned awry when the two were arrested for selling a small amount of marijuana. Richer managed to avoid conviction, but Herms was sentenced to six months at Santa Rita Honor Farm. While he was there, most of his early work was destroyed in a Berkeley fire. Upon his release in 1958, he moved to the mountain

community of Tuolumne, where he painted, took peyote, and studied astrology and esoteric practices.

In the 1960s, Herms continued dividing his time between Northern and Southern California. In the north, he had one-man exhibitions at Berman's Semina Gallery in Larkspur (1960) and at Batman Gallery in San Francisco (1961). The Batman show featured Herms's first tableaux, including *The Meat Market,* made from detritus from the local dump. In the south, he worked on Lawrence Jordan's short film *Jewel Face* (1964) in Topanga Canyon.

Herms met Duncan and Jess in Stinson Beach while working on a film with Jordan. Herms stated, "They took me in as a young practically unformed artist and I began to emulate [them]."[1] In 1962 Duncan and Jess gave Herms their "Servant of Holy Beauty Award," complete with a hand-drawn certificate and twenty-five dollars.[2] Herms's collage *Servant of Holy Beauty Giving Thanks* (1968) (p. 218) commemorates the honor, with its depiction of an oddly shaped face in profile rising above an austere black pedestal. A letter on the back of the work thanks the couple: "Bless you for the light on the path and know that the opening of Caesar's Gate showed this, yr humble servant, the way of beauty." In a letter to Duncan, Jess wrote, "Thinking of George makes me think of natural growing things and how flowers are everywhere spinning their tops."[3] Duncan dedicated the poem "Structure of Rime XXI" to George and his second wife, Louise, celebrating Herms's use of everyday detritus "left in the design of the maze."[4]

In 1964 Herms lived in New York for three months designing sets for Michael McClure's play *The Blossom; or, Billy the Kid.* Then he moved back to Topanga Canyon, where he started his Zodiac Behind Glass series and began publishing books on his handpress under the imprint Love Press. *Box #5 Leo* (1965) (p. 219) honors its sign with found sunburst motifs and a poem in praise of "all feline Hercules." Teaching stints in the 1970s led Herms up and down the West Coast while he produced work for a constant stream of exhibitions. In 1973 Duncan wrote for the catalogue of Herms's retrospective at the University of California, Davis:

> He is one of that little company of Artists of the Reassembly closest to my heart in my own work. Out of the discarded and unrecognized, he has brought up into the light of the Imagination, at once playfully and devoutly,— and out of the Love of the Beautiful, wrought for the Friends of the Earth—a likeness of Earth's humble mysteries. The residues of humanity haunt him.[5]

In 1984 Herms was awarded the Prix de Rome and created *Rome Poem,* a stunning series of assemblages using local detritus. Also in 1984 Herms helped put together an exhibition of Jess's paste-ups at the Newport Harbor Art Museum. In a note from that year, Jess stated, "For me your work has always beamed beauty and love with surety & strength—viz. your ROME POEM!"[6] Retrospectives of Herms's work have been held at Los Angeles Municipal Art Gallery, curated by Edward Leffingwell, in 1992, and at Santa Monica Museum of Art, curated by Walter Hopps, in 2005.

—Michael Duncan

1 Herms, statement, July 20, 2006, cited in Lisa Jarnot, *Robert Duncan: The Ambassador from Venus* (Berkeley: University of California Press, 2012), 475.

2 Ibid.

3 Jess, letter to Robert Duncan, April 10, 1964, Jess Papers, The Bancroft Library, University of California, Berkeley.

4 Robert Duncan, "Structure of Rime XXI (for Louise & George Herms)," *Roots and Branches* (New York: New Directions, 1964), 171.

5 Robert Duncan, "Of George Herms, His Hermes, and His Hermetic Art," in *George Herms: Selected Works 1960–1973,* exh. cat. (Davis, CA: Memorial Union Art Gallery, University of California, Davis, 1973), n.p.

6 Jess, letter to Herms, April 2, 1984. George Herms Papers, Special Collections, Getty Research Center.

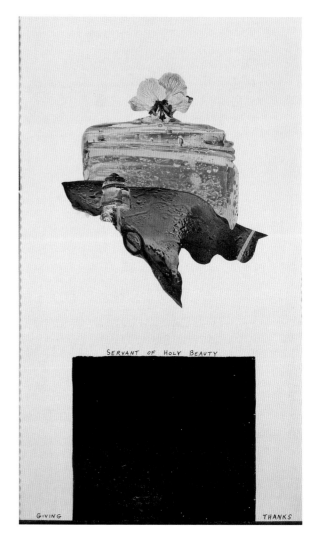

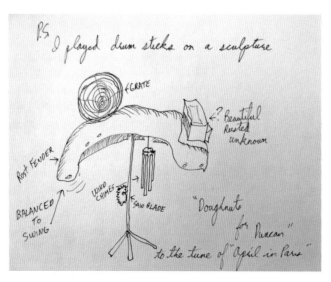

Clockwise from top left:

George Herms, *Donuts for Duncan*, 1989
Mixed media

George Herms, *Servant of Holy Beauty
Giving Thanks*, 1968
Collage

George Herms, drawing for *Donuts
for Duncan*, 1989
Ink on paper, unidentified correspondence

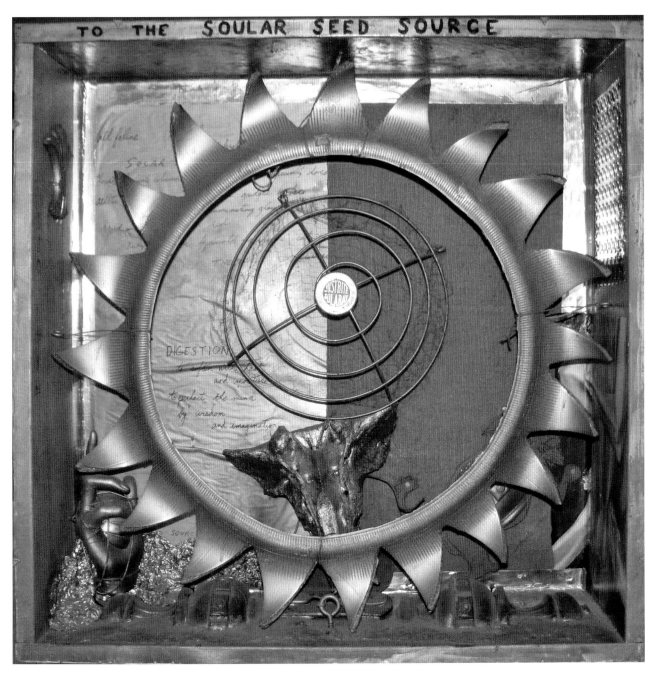

George Herms, *The Zodiac Behind Glass: Box #5 Leo*, 1965
Mixed media

Of all the work by Duncan and Jess's artist friends, Fran Herndon's most obviously embodies the intersecting of the real and the imaginary, the seen and the unseen. One isn't sure if that shape in a painting is a hollow tree or a hooded figure, or if that child holds a stick or a magic wand.

The ninth of ten children, Herndon (b. 1929) grew up on a farm in North Carolina, where she reveled in being outdoors—lying on her back looking at flowers, insects, and clouds, running in the woods, and taking in the heat and the color. Her Native American heritage contributed to the closeness she felt to nature and the nonapparent world, which so features in her art.

Herndon's development as an artist partly results from her association with two of the poets in this exhibition: Jack Spicer and Robin Blaser. Unlike many of the painters in the circle, Herndon did not have an early interest in drawing and painting; according to her, she was not good at it. It was Spicer who quickly recognized her link with what he called "the invisible world." He saw in her work an energy, talent, and "something I didn't know existed,"[1] and he took the time to help bring it out. Herndon met Spicer in San Francisco in 1957 through her husband, Jim, who knew the poet from college. Spicer encouraged her to go to the San Francisco Art Institute, where she had classes from Bruce McGaw—who noticed a charm and innocence in her work—and later from Frank Lobdell and Richard Diebenkorn.

Almost from the start Herndon and Spicer "shared a wonderful communication," each being a muse for the other. Early on the poet gave her a course in art history in her home, and in 1960 while he was writing his *Heads of the Town up to the Aether* and Herndon was learning lithography, the two would meet once a week to share what they were doing. To their amazement, Herndon's lithos would invariably connect in

Fran Herndon, 1958

imagery and spirit to what Spicer was writing in his poems, although neither knew what the other had been thinking about or discovering.[2]

Many of her paintings and collages explore the realm of dreams as well as the world of childhood where things converge in unusual, marvelous ways. In 1961 she began a series of paintings filled with idiosyncratic human and animal figures that blend into their surroundings or move in rhythm with often turbulent, Nolde-like backgrounds. In *Opening Day* (p. 223)—showing her exposure to sports, which both her husband and Spicer followed closely—Willie Mays's gloved hands are reaching skyward and drawing the eye to the nearly invisible white baseball above his head. In front of Mays, another player holds a rabbit in his glove, while more tawny rabbits scamper near the players' feet. These rabbits may be an intrusion of the unexpected province of childhood into the adult, rule-governed sport of baseball, or perhaps they are darting about on the field because it was *their* territory long before the baseball season began. Mays's famous words, "I don't compare 'em, I just catch 'em," appear in gold on the right of the canvas, suggesting not only his lack of

self-importance but his ability to play intensely, and be, in every moment.

In *Jack Spicer and His Radio* (p. 225), another oil from this period, the poet is shown writing in a children's nursery surrounded by stuffed animals, while on his left and above him is a glowing radio to which a young boy points. Spicer occasionally would babysit Herndon's two young sons, and the radio was a crucial poetic metaphor for him, for he felt a poet could conceive of himself or herself as a radio that receives signals and images from a realm outside of what he or she knows. As he said in a lecture to young writers in Vancouver in 1965, "The point is that you're not the thing which is broadcasting. You're the receiver."[3]

In 1962 Herndon exhibited sixteen distinctive sports collages at Borregaard's Museum, a lively alternative gallery space in San Francisco. Although she had seen Jess's collages or "paste-ups" at his cottage in Stinson Beach in 1960, she didn't feel sophisticated enough to respond to them right away. However, becoming friends with him at that time, she soon learned to forgo too much control and "to let things happen more on their own, rather than through my direction." One day an acquaintance of her husband began bringing Herndon issues of *Sports Illustrated.* Intrigued by the images in the magazines, she started cutting and pasting them together on the living room floor. The first and largest of the collages she made was *Collage for Jimmy Brown* (p. 222), which includes not only black-and-white and color cut-out images of the Syracuse running back and other football players, but also lyrical areas of paint that seem to immerse the players in a fluid, buoyant sea of reds, whites, blues, pinks, and blacks. Surprised by the results, Fran thereafter produced about one collage a week. Her last was *White Angel* (p. 224), showing photos of Marilyn Monroe among masks and catlike figures, which the actress herself seems to calmly muse about and look down upon. Having heroic and mythic resonances, other collages show skiers hurtling down slopes, Archie Moore delivering a knockout blow to the devil, Joe Louis wearing a childlike painted crown, a swimmer moving through the water like an angel, and a high jumper vaulting over a high bar surrounded by white birds.

Fran Herndon has always felt a sense of wonder about the world and how it was formed. Though like many in this circle she has struggled with self-consciousness, self-doubt, and a commitment to that side of things (including herself) she doesn't know, she remains moved by what she sees and senses in children, animals, mushrooms, butterflies, trees, and everyday objects, which are so much more than their physicality. Herndon lives in the Richmond District of San Francisco and continues to draw and paint. A major exhibit of her paintings, collages, and lithographs was presented at the Altman Siegel Gallery in San Francisco in 2011. Contemplating her work, one seems in some unexplained way to recognize the places and to feel that one might dwell in their wonder.

—Christopher Wagstaff

1 Biographical material provided in interviews by the author and Harry Jacobus with Herndon on November 9, 1985; December 7, 1985; and March 15, 1986. Also essential have been James Herndon's tribute to the sports collages in his memoir *Everything as Expected* (San Francisco: privately printed, 1973) and Kevin Killian's perceptive essay in the catalogue for the exhibition "Fran Herndon" at Altman Siegel Gallery, San Francisco, 2011.

2 Herndon's evocative lithographs were included in Spicer's seminal book when it was published by the Auerhahn Society in 1962.

3 Peter Gizzi, ed., *The House That Jack Built: The Collected Lectures of Jack Spicer* (Middletown, CT: Wesleyan University Press, 1998), 77.

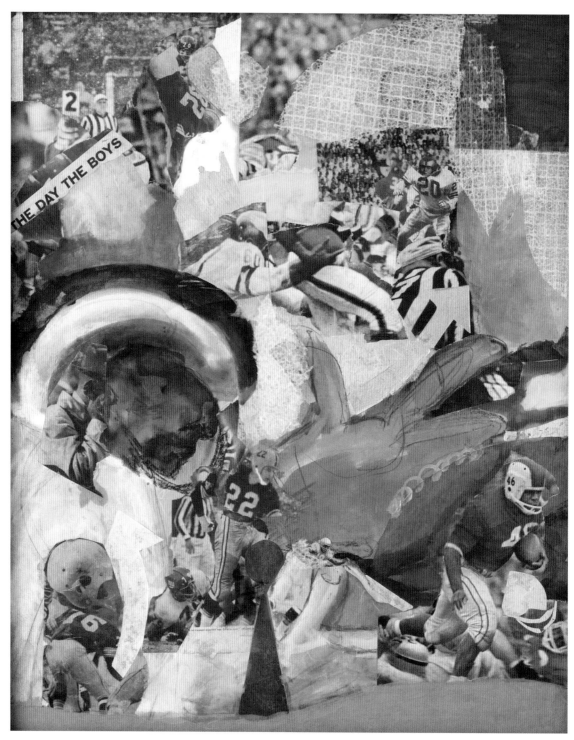

Fran Herndon, *Collage for Jimmy Brown*, c. 1960
Collage on board

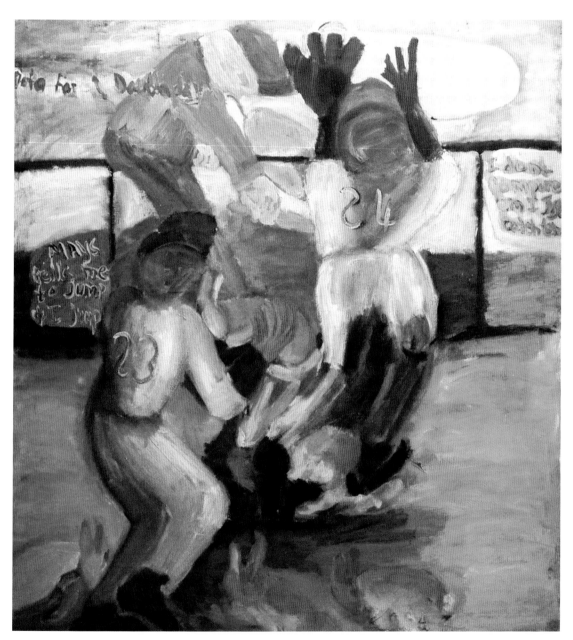

Fran Herndon, *Opening Day*, 1961
Oil on canvas

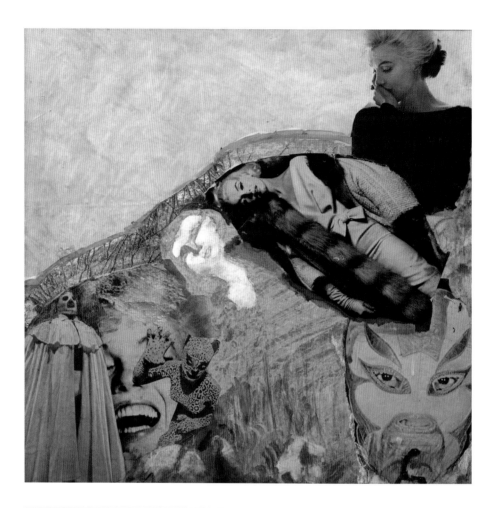

Fran Herndon, *White Angel*, 1962
Collage on Masonite

Fran Herndon, *Fran Herndon at Buzz*, 1965
Silkscreen

Fran Herndon, *Jack Spicer and His Radio*, 1960
Oil on canvas

A fascinating midcentury California sculptor who has slipped from contemporary consciousness, Miriam Hoffman (1911–2005) was once known for plaintive figurative works in terra-cotta and stone that seem like totems from lost ancient civilizations. Born Miriam Kaplan to Turkish immigrant parents, Hoffman was raised in Brooklyn. Precocious and artistic, at age seventeen she left her factory job to hitchhike across country with two friends, ending up in San Francisco, a city that she instinctually loved.

After a short stint at the University of Wisconsin, she was able to transfer on a scholarship to study English literature at Columbia University and City College, eventually receiving a master's degree in art and literature from the New School of Social Research. She moved to San Francisco in 1941 to attend San Francisco State University. A brief marriage led to separation and her return to New York, where she obtained a teaching certificate.

In 1947 she moved to the Southwest to teach in the English department at the University of New Mexico. Two years later she moved back to San Francisco and enrolled in the California School of Fine Arts. At CSFA she met Jess, Harry Jacobus, and Philip Roeber and was soon introduced to Robert Duncan. Duncan and Jess became good friends of Hoffman, buying several of her works (in $10 installments); among them were *Anna* (1950), a large reclining nude in cast stone that was placed in their outdoor garden, and two of the works in this exhibition, *Goblet* (1952) (p. 228) and *Irene* (1952) (p. 229). (They carried another small piece by Hoffman to Mallorca as a talisman from home.) Their collection also included a group of Hoffman's figure drawings from 1952 and 1953. Fran Herndon also has several Hoffman works in her personal collection.

Miriam Hoffman with one of her sculptures, c. 1952

Hoffman's sculptures were included in the opening exhibition of King Ubu Gallery and were regularly chosen throughout the 1950s for the Annual Exhibitions of the San Francisco Art Association. In the catalogue for her first solo exhibition, held at San Francisco's Palace of the Legion of Honor, Hoffman was quoted as being "fascinated by words and shapes," as evident in the etched calligraphic markings on many of her sculptures.[1] In an artist statement submitted to the San Francisco Museum of Art in 1954, she listed the media she worked with as being terra-cotta, cast stone, wood, limestone, and marble, and she described her aesthetic intentions:

One of the characteristics of primitive sculpture is overwhelming immediacy. It might have been yesterday that the sculptor pressed his finger on a shape and there the imprint remains today . . . As a sculptor making clay objects, I should like to shred the separation between spectator and art object. Whether it be a pot, a face, a vessel, a figure, it should retain the "whatness" peculiar to its organization.[2]

Hoffman lived in abject poverty; she refused to capitulate to commercial pressures, pulling out of the art gallery of Gump's after exhibiting there in 1954. She wrote Jess, "Now I have severed from the art merchants—Gump's received my note of 'non servism' with astonishment as if I had raised my 'Medusa Head.' I have nothing but violent distaste for the ivy league gentlemen, now properly costumed for the dance routine of merchandizing sculpture, pulling art down to the mundane sophisticated level of furniture accessories."[3]

In the 1960s she lived and worked in Redondo Beach, and her work became influenced by detritus found on ocean walks. She continued to work primarily in glazed ceramic but expanded her enterprise to more narrative works with individual symbolic components. In the brochure for her 1964 exhibition at the Pasadena Art Museum, Walter Hopps stated, "No dates are given to Miss Hoffman's art or life in respect of her wish that documentation not leave her 'impaled by time.' Indeed haunting evocations of time past, present, and future mingle in the imagery of her art which in some wondrous way seems to reveal directly the artist's inner world."[4] Jess recalled Hoffman telling him how she had been forbidden to play with dolls as a Jewish Orthodox child. According to Jess, this prohibition sparked the "magic intensity" of her work: "You can't appropriate her images. They hold us off."[5]

In the early 1990s, Hoffman's creativity came to a halt when she suffered a broken hip. Largely deaf, she was unable to regain health and was forced to live in a series of retirement communities and homeless shelters. In 1995 gallerist John Natsoulas tracked her down and moved her to Davis, where he showed her work at his gallery. Hoffman contacted Jess at that time asking him to look at some unfired sculptures that she was hoping to be able to finish. She wrote, "If you find in my new work no loss in creative ability, it will lessen somewhat the sense of being in a vacuum-like bell jar."[6]

Late in life she discussed the sources for her work:

Much of my work comes from Greek mythology, Greek tales and Greek society. I attempt creating life in my sculpture. I like the viewer to feel the spiritual external presence as well as the internal presence. Clearly my intention is to transcend time. As I have incorporated many elements that relate to art history, all the art has an individual statement that relates to no one particular being or subject. I have been influenced by no one artist. I have no teachers. Life and what I have learned are my teachers.[7]

Hoffman was using clay as a medium for sculpture several years before Peter Voulkos made his celebrated breakthroughs in the medium. Her works need to be reexamined in that context as well as seen as precursors for contemporary figurative sculpture by artists like Alison Saar, Kiki Smith, and Ruby Neri.

—Michael Duncan

1 Howard Ross Smith, "Miriam Hoffman," *Bulletin of the California Palace of the Legion of Honor* 13, nos. 6 and 7, October and November 1955, n.p.
2 Miriam Hoffman, Artist File, 1954, San Francisco Museum of Modern Art Library.
3 Hoffman, letter to Jess, undated, Robert Duncan Collection, The Poetry Collection of the University Libraries, University at Buffalo, The State University of New York.
4 Walter Hopps, "Sculpture by Miriam Hoffman," in *Miriam Hoffman,* exh. cat. (Pasadena, CA: Pasadena Art Museum, 1964).
5 Jess, interview with Christopher Wagstaff, c. 1989.
6 Hoffman, letter to Jess, May 20, 1995, Jess Papers, The Bancroft Library, University of California, Berkeley.
7 John Natsoulas and Anya Spielman, "What Happened to Miriam Hoffman," in Natsoulas, ed., *The Beat Generation Galleries and Beyond* (Davis, CA: John Natsoulas Press, 1996), 33.

Left: Miriam Hoffman, *Goblet*, 1952
Glazed ceramic

Below: Miriam Hoffman, *Goddess*, 1953
Mixed media

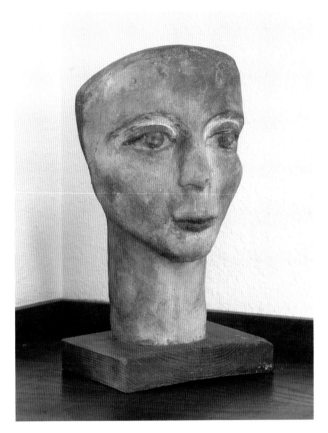

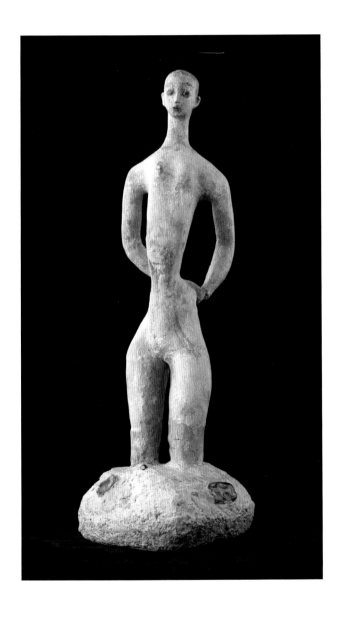

Above: Miriam Hoffman, *Irene*, 1952
Fired ceramic

Left: Miriam Hoffman, *Male Figure*, c. 1952
Ceramic

Harry Jacobus (b. 1927) occupies a special place in the artistic circle around Robert Duncan and Jess. Not only was he the supreme colorist among the painters they knew, but his friendship was one of their best and longest lasting. It began in 1951, when they all lived in a dilapidated mansion in San Francisco; Robert and Jess occupied a ballroom, and Jacobus had a room upstairs. Foremost among their activities together was their opening of the King Ubu Gallery in 1952, which brought together both established and unknown artists who would occupy the stage in the Bay Area art scene for the next thirty years. In mid-1958, when Jacobus stumbled upon the warm light and beauty of Stinson Beach, all three moved there, living across the street from each other for two years.

Jacobus was born in Pana, Illinois, one of six children. After leaving home at a young age and serving in the paratroops, he came to Los Angeles in 1947 and then to San Francisco in 1948. His first major response to painting came in 1949, when he saw an exhibit of abstract canvases by Hassel Smith, Elmer Bischoff, and David Park at the San Francisco Museum of Art. Right away Jacobus knew that nonobjective painting was for him, because it opened up for a viewer many alternative ways of seeing rather than just one.[1] Soon after, he enrolled in the California School of Fine Arts, which in his words was *the* art school in the country at that time. Jacobus's favorite teacher was Clyfford Still, who didn't talk about theories of painting and encouraged his students to follow their inner guides rather than his or anyone else's strictures.

From the beginning, Jacobus's work was distinct from the gestural, more assertive style of the day, leading David Park to comment to him once, "That would be a very nice painting if there weren't so much lace in it." He has said that the more he saw of

Harry Jacobus, Stinson Beach, c. 1960
Photograph by the artist

Bonnard, Vuillard, and Matisse, the more he knew that the paintings he wanted to live with would be like theirs.

In 1952 a friend showed Jacobus a garage near the corner of Fillmore and Filbert Streets that had been a little theater. It looked just right for the gallery Duncan, Jess, and he had talked about opening. After reading Alfred Jarry's *Ubu Roi,* which Duncan loaned him, Jacobus proposed calling the space "King Ubu" to convey the anarchistic and rebellious spirit they hoped the gallery would embody. To make ends meet, he opened a restaurant called Père Ubu; Jess and Robert designed the menus, and Jacobus did the cooking and painted each of the seventeen walls a different color.

In 1954 Harry traveled to Mallorca with Duncan and Jess, and then went on to visit mainland Spain, Germany, France, and Greece, relishing Gaudí's buildings and Art Nouveau architecture and glass. Returning to California in 1956, he contacted Pauline Kael, whom he had met earlier, and began doing posters and projection work for her

Cinema Guild and Studio theaters in Berkeley. He also made several stained-glass windows with sand and other found materials for an upstairs "Braque" room in her home, and he helped lay multicolored floor tiles in the kitchen and on the porch (still in the house today).

By the mid-1960s, Jacobus had stopped painting except sporadically. He was fed up with America's technological, machine-run society and was tired of driving taxicabs. In 1966 he returned to Greece, settling in an eight-room house on Hydra, where there were no cars and where the whiteness of the houses and walls called out for color, stimulating him to produce about fifty Gorkyesque, luminescent oil-crayon works. He melted wax crayons together on the stove so one crayon stick would include many colors, which he could apply to the paper in a chance-like way with a flick of the wrist. He has said that, like Charles Ives's music, these paintings, without a ground and done without revising, "derail logic" and force a viewer to stop and look because the image cannot be taken in at one glance. Jess and Duncan were excited when Jacobus shipped them several of these Greek paintings they had chosen from slides, and Jess wrote right away to his dealer in New York:

> Jacobus is a painter I've known and admired as long as I myself have painted; a friend and fellow artist who is my peer and an influence on what I have done . . . His present paintings seem to me an interweave of landscape expanse and interior space, full of his genius at pattern composition and planar interlock— now in the more dramatic Mediterranean light and color.[2]

After six years in Greece, where his work almost seemed to create itself in a quite joyous way, in 1974 Jacobus moved to Sausalito, California. There he began doing smaller, more contemplative works, including *Untitled (flowers)* (p. 233), where softly radiant areas merge and intermingle with other such shapes near them. He also did a number of abstract expressionist oils and acrylics, including *Unsettled* (p. 44), in which forms simultaneously congeal and float. Robert Duncan published two short essays about the Greek paintings and these later ones, noting in 1983, "He addresses a Mystery in his work and follows through toward the picture, not as a product of craft but as an emergent state of revelation. In the deepest passages of his work I sense a trance, a rapture in the elements of the painting or drawing."[3]

In the past thirty-five years, Jacobus has studied Sufi meditation and practice, composed music, and continued to paint and draw, all the while living simply and frugally. He has recently relocated to Foley, Alabama, and is currently creating bright, arresting digital collages.

—Christopher Wagstaff

1 Christopher Wagstaff, *Harry Jacobus: An Interview* (1985) (Berkeley: Rose Books, 2009), 88. Other quotes from Jacobus in this biography are also taken from this source.
2 Letter to Federico Quadrani, February 12, 1969, Jess Papers, The Bancroft Library, University of California, Berkeley.
3 Robert Duncan, exh. brochure, *Harry Jacobus: Selected Works: 1968–1983,* Memorial Union Art Gallery, University of California, Davis, September 30–November 4, 1983.

Harry Jacobus, *Robert Duncan,
Lyn Brown, and Miriam Hoffman
Playing Strip Poker,* c. 1952
Ink on paper

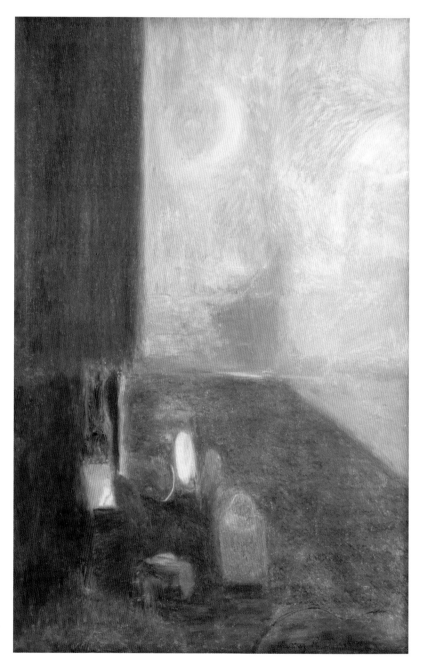

Harry Jacobus, *Ennui,* 1962
Oil pastel on board

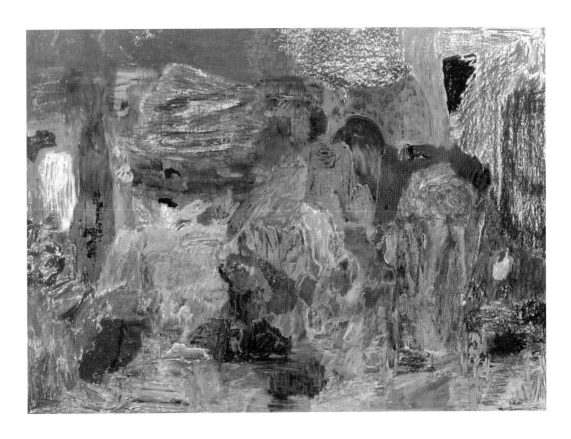

Harry Jacobus, *Last Greek Painting*, 1972
Oil pastel on paper mounted on canvas

Harry Jacobus, *Untitled (flowers)*, c. 1978
Oil pastel on paper

Lawrence Jordan (b. 1934) has been at the forefront of experimental cinema, particularly through his innovative use of animation, for nearly six decades. Born in Denver, Jordan became a film buff early on. In high school he helped form a club called the Gadflies, whose precociousness extended to renting films by D. W. Griffith, Jean Cocteau, and Maya Deren from the Museum of Modern Art in New York. After high school he went off to Harvard, but San Francisco was the place to be in the 1950s, and after a year, Jordan went west.

On his arrival he looked up former high-school classmate Stan Brakhage, who was living in the basement of Robert Duncan and Jess's house at 1724 Baker Street. Jordan recalls that the walls and floors of the house were painted different colors, to optimize the effect of light as it intersected with color.[1] Duncan described the paint scheme as "two walls in a hot tangerine orange, one wall in a soft orange-pink and one in white; ceiling in white; floor in what the paint company with poetic inspiration calls Bermuda blue."[2] For Jordan, this demonstrates the degree to which Jess understood the relationship between constituent parts working together. It also proves how deeply integrated house and work were in both Jess and Duncan's worldview. Jordan has well described how special the Jess and Duncan household was for him: "It's a whole lot more than bourgeois values, it's a magical kingdom and it needs to be protected from all the wayward vibrations that come and go . . . And that taught me a great deal about being civilized, which is hard to find in this American culture."[3]

Jordan and Brakhage spent the summer of 1955 in New York, sleeping on couches in Maya Deren's Greenwich Village studio. Deren introduced the two young men to Joseph Cornell, with whom Jordan began a correspondence that lasted ten years. Jordan worked for Cornell in the summer of 1965 but then

Lawrence Jordan, 1967

returned to the Bay Area, eventually settling in Petaluma, where he has lived and worked since. In 1960 he married Patty Topalian, who was close to Jess and Duncan and in the 1950s documented the San Francisco art scene with hundreds of extraordinary photographs.

Jordan played Faust in Robert Duncan's staging of *Faust Foutu* at the Six Gallery in 1955. With fellow filmmaker Bruce Conner he began the film society Camera Obscura and built San Francisco's first 16 mm experimental theater, the Movie, in North Beach in 1958. He was one of the founding organizers of the film cooperative Canyon Cinema and founded the film department at the San Francisco Art Institute in 1969, where he taught for many years (Bruce Conner learned how to edit film from him). He assisted Wallace Berman with his (only) film, *Aleph*; and he has worked with Michael McClure, Philip Lamantia, John Reed, and Christopher Maclaine, among others.[4]

Jordan has made over sixty experimental films (he prefers 16 mm) as well as numerous collages and

collage boxes. He is especially drawn to Victorian engravings, which he animates. There is often a reciprocal relationship between the films and collages, as when collaged scenes serve as backgrounds for the films. *Hawk Haven* (p. 236), for example, began as a background for the film *Gymnopédies* (1966), in which various objects move and transform across a scrolling scene of castles and verdant foliage, while the eponymous music by Erik Satie plays. The entire film is tinted blue, a Technicolor dream. Later, in the 1990s, Jordan collaged hawks into this Romantic scene, and the piece was reborn as *Hawk Haven.* This technique of reusing material, even one's own earlier work, is especially prevalent among Bay Area artists concerned with scavenging and recuperating old or discarded material. Engraving, Jordan reminds us, was illustration, not fine art.

Jordan's films are wondrous and surreal—alchemical in the manner of George Méliès and Max Ernst. A formative experience for Jordan occurred in Larkspur, California, in 1961, when Jess lent him two of Ernst's collage novels, *La femme 100 têtes* (1929) and *Une semaine de bonté* (1933). Jordan carefully photographed each image, one by one, with a Rolleiflex camera, and realized, as he put it, "I've been seeing a movie in extreme slow motion, one image after another."[5] He began collecting engravings then, and animating them. Ernst's collage novels use engravings, a medium already obsolete by the time he made them, and they are associative rather than didactic: they purport to be novels, and they exploit seriality, but they tell no linear narrative. Considering Jordan's richly multivalent animations to come, one can see how appealing this precedent would be to him. Ernst's collage novels, Jordan's animations, and Jess's paste-ups all are infused with that at times elusive quality which Robert Musil called a "sense of potentialities."

Heavy Water, or The 40 & 1 Nights, or Jess's Didactic Nickelodeon is a collaboration between Jordan and Jess. Collaboration was loose and informal in the 1960s. Jess had some collages made mostly from *Life* magazine, which he wanted to fall into a frame like a nickelodeon. He had picked out a piece of music for each collage, so sound and image would cut from scene to scene. In 1962 Jordan recorded the music, filmed the collages, and edited the resulting film. Sometime before *Heavy Water,* Jess sent Jordan a number of collaged text pieces that he thought Jordan could use as intertitles in a film. Jordan attempted to make a live film that would feature the collages, but it was only in 1980 that he shot *Finds of the Fortnight,* in which cut-out animation alternates frame by frame with Jess's text collages so that the two artists' work is literally interwoven, creating a flickering or strobe effect. This laborious technique results in an exquisite metaphor for appropriation, collage, and collaboration: the attempt to transform disparate material into a new whole, as the cut and the suture initiate their own alchemy.

—Tara McDowell

1 Lawrence Jordan, conversation with Tara McDowell, March 21, 2011.
2 Lisa Jarnot, *Robert Duncan: The Ambassador from Venus* (Berkeley: University of California Press, 2012), 122.
3 Rebecca Solnit, *Secret Exhibition: Six California Artists of the Cold War Era* (San Francisco: City Lights Books, 1990), 34. Jordan shot *Trumpit* in the Baker Street basement, and Brakhage made two films there: *In Between* and *Winter Shadow Garden.* Jess and Duncan make a brief appearance in Jordan's film *Circus Savage* (2009).
4 This list is compiled from P. Adams Sitney, "Moments of Illumination," *Artforum* 47 (April 2009): 164; and Michael Duncan, "Lawrence Jordan," in *Semina Culture: Wallace Berman and His Circle,* ed. Michael Duncan and Kristine McKenna, exh. cat. (New York and Santa Monica: D.A.P. / Distributed Art Publishers and the Santa Monica Museum of Art, 2005), 190–91.
5 Patricia Kavanaugh, "Interview with Lawrence Jordan," *Animatrix: A Journal of the UCLA Animation Workshop* 15 (2007): 32.

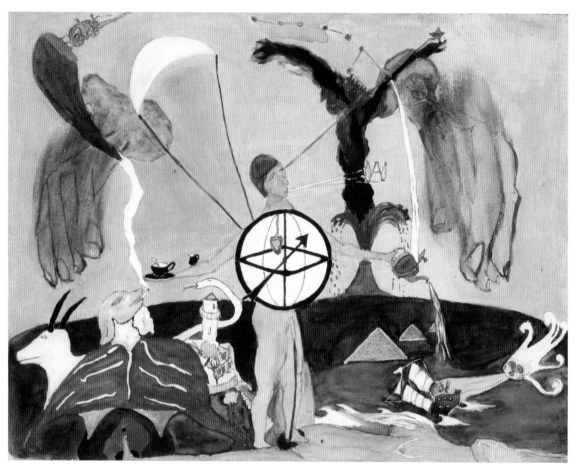

Lawrence Jordan, *From the One Proceeds the Other*, 1961
Watercolor on paper

Lawrence Jordan, *Hawk Haven*, 1994
Collage on paper

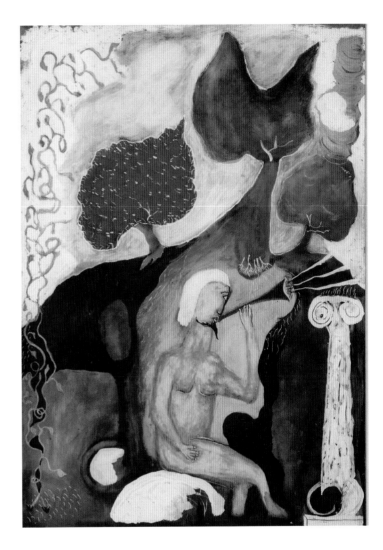

Lawrence Jordan, *Paradigm*, 1962
Watercolor on paper

Lawrence Jordan, *Entry Fissure*, 1962
Watercolor on paper

PATRICIA JORDAN

Photographer Patricia Jordan (1934–1988) made portraits of many of the major artists and poets of the Bay Area community, including Robert Duncan, Jess, Wallace and Shirley Berman, George and Louise Herms, Kirby Doyle, Joan Brown, Paul Beattie, Michael McClure, Keith Sanzenbach, and James Broughton. In a letter to Charles Olson, Robert Duncan referred to her as "a huntress with a camera."[1]

Born in Knoxville, Tennessee, as Patricia Topalian, she was the only child of Armenian parents who had emigrated during the Turkish genocide. When she was two years old, her parents moved to San Francisco, where her father worked as a waiter and her mother became a teacher. Her parents divorced in 1943. Patricia graduated from high school at age fifteen and moved out to her own apartment. She attended San Francisco State College, where she majored in theater and dance, taking classes irregularly from 1949 to 1959. Earning her living as a popular model, she posed for life-drawing classes at California School of Fine Arts and sat for many of the renowned figure artists of the time, including Joan Brown, Elmer Bischoff, Gordon Cook, and Richard Diebenkorn.

In the early 1950s she began taking photographs of her friends in the San Francisco art community, and over the course of the decade she shot hundreds of pictures. Kristine McKenna has stated that Patricia "printed her own photographs and often worked in sepia tone, which lent her images a muted, dreamy quality that becomes increasingly potent as the '50s recede further into the past. Many of her pictures have the slightly mannered self-consciousness of formal portraiture, and all of her work is heavily perfumed with the bohemian sensibility that pervaded San Francisco during the '50s."[2]

Patricia married Lawrence Jordan in 1960 and, after the birth of their daughter Lorna, they moved

Patricia Jordan, c. 1960

north of the city to Larkspur, not far from where Wallace Berman and his family were residing in a houseboat. Berman included a photograph of Patricia he'd taken shortly after the birth of her child in the seventh issue of his self-distributed journal *Semina*. Lawrence Jordan's short film, *Patricia Gives Birth to a Dream by the Doorway* (part of *Duo Concertantes*, 1964), featured a fixed photographic image of Patricia looking out on a tree-lined lake while animated woodcuts and etchings appear in the distance. During this period, Patricia contributed title-card drawings and set decorations for other films by her husband. In the early 1960s Lawrence traveled to New York to assist Joseph Cornell with his films, and Cornell corresponded with the entire family, sending Lorna collaged letters and requesting posed photographs of Patricia (in what he referred to as "the Cavalier costume," which to him evoked Joan of Arc).

Duncan and Jess were close friends of the Jordans, sometimes staying over with them when

visiting from Stinson Beach. They arranged these get-togethers in correspondence, often in decorated mailers featuring collages and cut-out photographs. In a letter to Duncan, Jess described his pleasure in visiting the Jordans, "buoyd on Patty's radiance & the baby's sheer loveliness."[3] In 1959, Jess and Duncan sent Patricia a handmade book for her birthday filled with forty-four pages of drawings, poems, and photographs. The book includes Case VI of Jess's paste-up *Tricky Cad,* as well as a manuscript text of Duncan's comic poem "The Ballad of Elfen Hayre," with Duncan's ink-drawn illustrations.[4]

Jordan made collages, most using cut-up Victorian and Old Master engravings. For *Golden Damsels Descending from the Clouds* (1960–1961) (p. 241), a mixed-media collage on fabric, she used found images of Byzantine religious icons, Pre-Raphaelite nudes, Egyptian hieroglyphs, Aztec gods, and Hindu deities, ornamenting the scroll-like expanse with embroidery, feathers, and five of her own photographs of Shirley Berman. The work celebrates the trans-historical, multidenominational presence of the goddess in culture. The scroll is bordered with calligraphic text taken from Song of Solomon 7:1, an erotic paean to female sensuousness ("How beautiful are thy feet in sandals, O prince's daughter").

In 1962 the Jordans moved to San Anselmo, twenty miles north of San Francisco. The blossoming of Jess and Duncan's careers in that period resulted in more complicated schedules and fewer visits between the two couples. In 1968 an important group of negatives and favorite photographic prints was stolen from Jordan's car and never recovered. That same year her works were included in the exhibition "Rolling Renaissance Photography: The Scene and Portraits 1945–1968" at the Light Sound Dimension Gallery in San Francisco. In the early 1970s, she exhibited her photographs at City Lights Bookstore, and in 1975 her work was featured in the exhibition "A Kind of Beatness: Photographs of a North Beach Era 1950–1965" at Focus Gallery.[5] Eighteen of her photographs were also included in the 1975 New York exhibition "San Francisco Renaissance: Photographs of the '50s and '60s."[6] By the mid-1970s, when her marriage ended, Jordan had stopped taking pictures entirely and had begun to channel her creative energies into the healing arts.

Of Jordan's later life, her daughter, Lorna Star, stated, "My mother taught dance and body movement on and off during the years I was growing up, and over a period of twenty years dance metamorphosed for her. She created a life and a work environment at home and she taught a movement class for elderly women. That, in turn, transitioned into bodywork, counseling, and massage. She was a very intuitive person and she became a mentor to many people."[7]

Jordan died of cancer at the age of fifty-four.

—Michael Duncan

1 Robert Duncan, letter to Charles Olson, January 21, 1960, Robert Duncan Collection, The Poetry Collection of the University Libraries, University at Buffalo, The State University of New York.

2 Kristine McKenna, "Patricia Jordan," in *Semina Culture: Wallace Berman and His Circle* (Santa Monica, CA: Santa Monica Museum of Art in association with DAP, 2005), 194.

3 Jess, letter to Robert Duncan, January 4, 1962, Robert Duncan Collection.

4 Patricia Jordan Papers, Archives of American Art, Smithsonian Institution.

5 Mark Green, ed., *'A Kind of Beatness': Photographs of a North Beach Era,* exh. cat. (San Francisco: Focus Gallery, 1975).

6 Merril Greene, ed., *San Francisco Renaissance: Photographs of the '50s and '60s,* exh. cat. (New York: Gotham Book Mart, 1975).

7 McKenna, conversation with Lorna Anthea Star Jordan, February 3, 2002, cited in McKenna, "Patricia Jordan."

Patricia Jordan, *Jess at Stinson Beach*, 1959
Photograph on hardboard

Patricia Jordan, *Robert Duncan Reading at Stinson Beach*, 1959
Photograph on hardboard

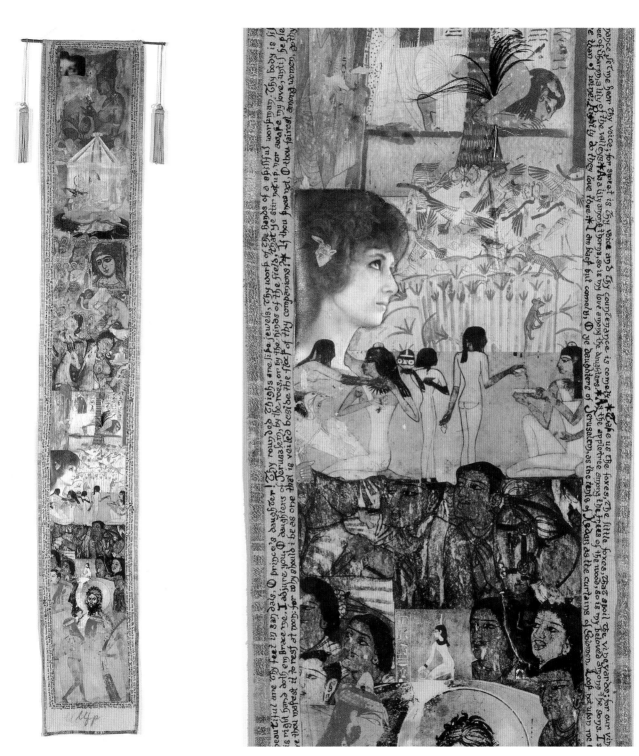

Patricia Jordan, *Golden Damsels Descending from the Clouds*, 1960–1961
Collage, embroidery, feathers, ink, and photographs on linen (detail at right)

Pauline Kael (1919–2001), the brilliant and original commentator on the art of film, wrote reviews in the *New Yorker* from 1968 to 1991. Her essays on movies and actors are incomparable for their insights, humor, and the sheer beauty of her writing. Kael and Robert Duncan enjoyed a warm, lively, and sometimes contentious friendship that began when they were college students and continued for over twenty years. They shared a total dedication to the craft and precision of writing, an amazing inner strength, and an integrity reflected in what they thought and did.

Born in Petaluma, California, Kael relocated with her family to San Francisco prior to the Depression. In 1936 she enrolled at the University of California, Berkeley, majoring in philosophy and English. Most likely through her work on the student magazine, the *Grizzly,* she met fellow student and budding poet Robert Duncan, with whom she conversed intensely about politics and other subjects. Duncan, having become bored with his courses in the English department and having fallen in love, left the university after a year and a half and moved first to Annapolis and then to New York City. Pauline, too, departed for New York in 1941, just shy of receiving her bachelor's degree.

In their spirited correspondence in these years, she and Duncan discussed Trotsky, pacifism, and their passion for Henry James, Melville, and Proust. In one letter to Kael, Duncan excitedly listed ten books he wanted her to read right away, including Nijinsky's *Diary,* Kafka's *Great Wall,* and Freud's *Civilization and Its Discontents,* adding (perhaps in the spirit of Nijinsky) that "I believe in God. Know God."[1] Having little patience with such idealism, she wrote him bluntly that he must not be swept away by such books and ideas.[2]

In 1946 Kael returned to the Bay Area and for a number of years struggled to make ends meet and

Pauline Kael with house murals by Jess, c. 1960

to support her daughter, Gina, who was born in 1948. While living in San Francisco she worked in a dry-cleaning establishment and as a freelance editor, wrote one-act plays, and taught violin. A few times she tried her hand at acting, appearing with Jess, for example, in a curtain-raiser preceding Gertrude Stein's *The Five Georges,* directed by Duncan at the King Ubu Gallery in 1953. Jess's 1955 painting *A Mile to the Busstop* (p. 43), done in Mallorca—perhaps from a photograph—shows Kael and her little girl walking hand in hand in a lush, green park.

In 1955, Kael went to work for Edward Landberg, who in 1951 had opened what became a two-screen art house called the Cinema Guild and Studio on Telegraph Avenue in Berkeley, just south of the university campus. Kael's imaginative, unexpected pairing of films, along with her booking of many unfamiliar European titles, soon attracted devoted and enthusiastic audiences. She designed and had printed a program guide featuring her lively and informative comments on the upcoming films. In the fall of 1956, Jess began helping at the theaters. He designed a logo for the brochures and, along with

the painter Harry Jacobus and Kael's daughter, Gina James, made movie posters for the display cases in front of the theaters. Sixteen of Jess's hand-lettered and painted posters have survived, and three are included in this exhibition: *The Importance of Being Earnest, Orpheus,* and *The Golden Coach* (p. 244). James has commented, "Jess put so much thought and care into whatever he did, even these posters. He basically made a new fresh alphabet for every movie, and each of his were done in the style of the film featured, even if he hadn't seen it. Mine were just simple cut-out letters, and Harry's were in Harry's own unique style."[3]

The Berkeley house Kael lived in during these formative years was a two-story brown shingle on Oregon Street. Tiffany and La Farge lamps (procurable then for very little in thrift shops and antique stores) lit the downstairs rooms, and art by Jess and David Young Allen, along with prints by Matisse and Picasso, lined the walls. Jacobus, who lived for a time behind the house, has written, "Her home in Berkeley was a Grand Central for people interested in the arts, sometimes fun and many times tedious. Pauline would put up with some really odious bores as she loved the debates, which of course she usually won."[4]

Also in 1956 Kael asked Jess to paint a series of murals in the upstairs rooms and hallway, which turned out to be his most jewel-like and ambitious mural project. He recalled that Pauline left the decoration entirely up to him and that he worked unremittingly on the rooms for three or four weeks.[5] The designs and scenes paid homage to Picasso, Braque, Klee, and Bonnard, as well as to medieval and Celtic art, which Jess had been exposed to during his previous year in Europe. The ceiling of the entrance hall had a sand painting pattern based on one in the Jean Renoir film *The River,* and the main wall in Gina's bedroom was an adaptation of Anna Magnani's skirt in Renoir's film *The Golden Coach.*[6] An upstairs wall showed a girl looking over an iron fence at pale green fields and a distant castle atop a mountain. Jess said he created this scene especially for Pauline's daughter, who assisted in its painting.[7]

The sitting or dressing room near the stairs once evoked the splendors of Braque and Picasso, and one fanciful wall in the style of Braque still remains in that room. Due to structural damage, the hallway ceiling that had pictured a giant white crane with yellow stars in a blue night sky has been painted over.

Although in the late 1950s Jess and Robert's friendship with Kael cooled due to their differing attitudes toward life and art (including movies), Kael was devoted to both of them and until her death treasured the paintings, oil crayons, and collages she had received from Jess in the 1950s. Kael's personal generosity is well known, and at different times it was shown toward Duncan and Jess; at one point she bought them an art glass hanging lamp with red cherries and green leaves, which they installed in their cottage at Stinson Beach and which Jess rendered in his *The Enamord Mage: Translation #6* (p. 16).[8]

—Christopher Wagstaff

1 Robert Duncan letters to Pauline Kael (1940–1946), 1940, The Bancroft Library, University of California, Berkeley.
2 Robert Duncan Papers, circa 1938–1969, Spring 1940, The Bancroft Library.
3 Author's conversation with Gina James, 2011.
4 Harry Jacobus, letter to the author describing his long relationship with Kael, 2011.
5 Author's conversation with Jess, 1991.
6 Pauline Kael's note to the author, 1991.
7 Author's conversation with Jess, 1991.
8 Author's conversation with Harry Jacobus, who accompanied Kael when she purchased the lamp. After Duncan's death in 1988, Kael wrote Jess a note of condolence, remarking, "I always thought Robert would go on forever, and maybe in some ways he will." Jess Papers, The Bancroft Library.

This page: Pauline Kael residence with
1956 murals by Jess
Photographs by Ben Blackwell

Facing page, clockwise from top left:

Jess, *Jean Renoir's "The Golden Coach,"* 1957
Collage and gouache on cardboard

Jess, *Oscar Wilde's "The Importance of Being
Earnest,"* 1957
Gouache on paper

Jess, flyer for Cinema Guild and Studio, c. 1956

Jess, *Jean Cocteau's "Orpheus,"* 1957
Collage and gouache on cardboard (two panels)

One of postwar art's most compelling figurative artists, R. B. (Ronald Brooks) Kitaj (1932–2007) used poetry and narrative as driving forces in his lyrical, intellectually engaged paintings, drawings, and prints. Intending to become a kind of scholar-painter, Kitaj set out to match in visual art his "intense passion for Pound and Joyce and Eliot and the complexity of so much modern poetry."[1] Raised by a single mother in Cleveland, Kitaj early on developed interests in literature, film, history, book collecting, and art. When his mother remarried and the family moved to Troy, New York, he took the name of his stepfather, Dr. Walter Kitaj, a Viennese emigré and research chemist. He attended art school at Cooper Union, where he began to read modern poetry in depth. To earn money during school he did stints as a merchant seaman, visiting Europe and South America; he was drafted into the US Army in 1954 and was stationed in France. After his service he enrolled under the GI Bill at the University of Oxford, where he fell under the spell of art historian Edgar Wind and became interested in contemporary philosophy.

After graduation, Kitaj settled in London where he studied at the Royal College of Art. As his painting career took off, he established himself with the city's stellar upcoming artistic and literary figures, most notably David Hockney and Richard Wollheim. Publisher Jonathan Williams introduced Kitaj to contemporary American poetry, which became a lasting enthusiasm. Kitaj's first solo exhibition was at Marlborough Fine Art, where he showed for the rest of his life. In 1965 his career was firmly established with a survey of seven years' work at the Los Angeles County Museum of Art. That same year he began a friendship with Robert Creeley; portrait drawings of Creeley and other literary friends became an ongoing series.

Robert Duncan and R. B. Kitaj, c. 1975

In 1967, Kitaj left London to spend a year teaching at the University of California, Berkeley. He met Robert Duncan and Jess, and they all became lifelong friends. Later that year, when Kitaj proposed an art trade, Jess wrote back enthusiastically, "I am so bowld over in the joy of your spirit affinity, I cannot express it."[2] In return for several of his prints, Kitaj received Jess's masterful painting *Ex. 7—Zodiacal Light: Translation #19* (1968). Kitaj helped promote his friend's work, trying to convince his gallery to take him on and even featuring Jess's Translation painting in one of his own shows.[3] In a catalogue essay for one of Jess's museum exhibitions, Kitaj wrote, "Jess has reinvented, in a properly transcendental sense, experience beyond its own ordinary limits, fantasies which may one day look like a particularly (Northern?) Californian brew."[4]

In 1977, when Duncan and Creeley were both visiting Kitaj in London, the artist painted the masterful double portrait *A Visit to London (Robert Creeley and Robert Duncan),* now in the collection of the Museo Thyssen-Bornemisza in Madrid. On trips

to Europe, Duncan used Kitaj's home in London as a base. In 1982 he spent several weeks with Kitaj in Paris working on a proposed monograph for Phaidon that was never realized. Kitaj's drawings of Duncan during this trip present him writing or reading, very much the sage. These works, along with five poems by Duncan, were published in a limited edition volume, *A Paris Visit* (New York: Grenfell Press, 1985). In a 1979 reminiscence, Kitaj described his admiration for Duncan:

> Duncan chooses to live some of the lives I would live. He gets them together in his texts in visions which shock me into recognition. I devour his sense of past, of heroism, his syntax, his wasp-talmudic take in an arcane myth-dredging tradition, the way his lines and life burn on his own townism . . . its late sunlight and westernamericaness, the expectation and surprise as so much value is given out of the mouths of libraries! Lines, poems, poetry, like coloured pictures, even drawing . . . in some of the possible quality of those pursuits . . . in their impurities, can arise, do arise in households, behind closed doors . . . out of the mouths of libraries.[5]

In his print *Star Betelgeuse Robert Duncan* (1968) (p. 249), titled after an orb whose brilliance exceeds that of the sun, Kitaj honored his poet friend, featuring two drawn portraits of him juxtaposed with pertinent images: a photo of Jess and a library; a photo of a rock in the shape of a primordial tool; and two illustrations from Gelett Burgess's *Goop* books (nonsense verse relished by Duncan and Jess). Kitaj made tribute prints for other contemporary poets, including Creeley, Charles Olson, Michael McClure, Ed Dorn, John Wieners, Kenneth Koch, and W. H. Auden. The collage *"Good God, Where is the King?"* (1964) (p. 249) exemplifies Kitaj's offbeat dark humor and penchant for historical arcana. Like one

of Jess's politically slanted paste-ups, the print draws on a mind-blowing range of sources, mordantly juxtaposed to reveal the nefarious underbelly of politics and war.

In 1969 Kitaj taught for a year at UCLA, where he became friends with Richard Diebenkorn and Lee Friedlander. Kitaj's personal life was fraught with tragedy, culminating in the death of his second wife, the artist Sandra Fisher, in 1994. The same year, negative critical response to his Tate Gallery retrospective led to a severe depression from which he never recovered. Living in Los Angeles in his final years, he committed suicide in 2007.

—Michael Duncan

1 Kitaj, quoted in Jerome Tarshis, "The 'fugitive passions' of R. B. Kitaj," *Art News* 75, no. 8 (October 1976), cited in Richard Morphet, "The Art of R. B. Kitaj: 'To Thine Own Self Be True'" in Morphet, ed., *R. B. Kitaj: A Retrospective* (London: Tate Gallery, 1994), 13.

2 Jess, letter to Kitaj, November 24, 1967, Kitaj Papers, Special Collections, University of California, Los Angeles.

3 *R.B. Kitaj: pictures from an exhibition held at the Kestner-Gesellschaft, Hannover and the Boymans Museum, Rotterdam,* exh. cat. (London: Marlborough Fine Art, 1970).

4 Kitaj, "Foreword," in *Jess: Paste-Ups (and Assemblies) 1951–1983,* ed. Michael Auping (Sarasota, FL: John and Mable Ringling Museum of Art, 1984), 9.

5 Kitaj, "[Untitled]," in *Robert Duncan: Scales of the Marvelous,* ed. Robert Bertholf and Ian Reid (New York: New Directions, 1979), 205–6.

A PARIS VISIT

Five Poems by

Robert Duncan

Drawings & Afterword

by R.B. Kitaj

The Grenfell Press

R. B. Kitaj, front cover and illustrations
for *A Paris Visit*, 1985

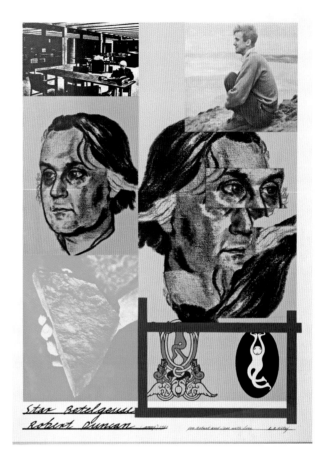

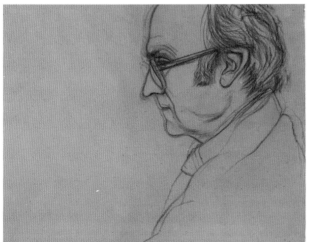

Clockwise from top left:

R. B. Kitaj, *"Good God, Where is the King?"*, 1964
Collage

R. B. Kitaj, *Star Betelgeuse Robert Duncan*, 1968
Lithograph

R. B. Kitaj, *Robert Duncan, Profile Left (light version)*, 1982
Charcoal pencil on paper

Although he died prematurely, William "Bill" McNeill (1930–1984) is still recalled as one of the most gifted painters among the circle of artists, poets, and writers who gathered around Jack Spicer at Gino and Carlo's bar and other North Beach meeting places in 1960s San Francisco.

McNeill was born to a well-to-do family in Pee Dee, North Carolina. After serving in the navy, he first pursued commercial art and design at the Art Center School in Los Angeles and then attended Black Mountain College, where he studied with Franz Kline and Joseph Fiore. Abruptly leaving Black Mountain in 1953 or 1954, he moved to New York, finding employment doing architectural renderings, especially interiors. Relocating to San Francisco in 1958, he connected with several Black Mountain alumni and spent time writing poetry.

Zen Buddhism was being introduced to the Bay Area at this time via books by Daisetz T. Suzuki and the talks and writings of Alan Watts, and this spiritual tradition immediately absorbed McNeill's interest. According to Joanne Kyger, his longtime friend, McNeill and his wife, Lou, began sitting in 1959 with Shunryu Suzuki at Soko-ji at 1881 Bush Street, the only Soto Japanese temple in the Bay Area. Late in 1960 McNeill and Bob Hense, another of Suzuki's first American students, flew to Japan to study at Rinso-in, Suzuki's home temple. Eventually they had their heads shaved, received robes, and were given the precepts in Japanese.[1] At this time McNeill studied the Japanese method of painting with broad, minimal, spontaneous strokes. Although this period of exploring Zen was essential to McNeill's development, in 1961 he realized he was temperamentally unsuited for such a disciplined path and flew back to San Francisco to again take up his life as an artist.

This was the period of the engaging and lively interchanges between painters and poets known

William McNeill, c. 1963
Photograph by Helen Adam

as the "San Francisco Renaissance," and although he was not immediately accepted by some of the poets, McNeill became an enthusiastic member of this community. Experimental filmmaking was an emerging part of this scene, and he spent several years working on both his own 16 mm films and those of others. In 1963 he served as Helen Adam's cameraman and editor for a black-and-white silent film she was making called *Daydream of Darkness,* based on her poem "Anaid Si Taerg (Great is Diana)." McNeill and Adam spent the summer of 1963 making trips to Big Sur and Golden Gate Park, shooting footage for which there was not always a script; the film seems to revolve around calls to the moon-goddess to come to life and purge the world of opposites.[2]

Although he actively painted during his post-Japan years, a defining moment occurred when a restaurateur friend brought McNeill an eight-panel, eight-foot-tall folding screen for him to paint. Paul Alexander has recalled, "Bill did a Japanese poppy field right out of Monet . . . no figures, just the poppies, the suggestion of plants, stems, grasses, and poppies. It was very beautiful and one was very impressed by that."[3] This screen was an impetus to McNeill to become even more dedicated to painting in various mediums. His most sensitive and delicate

works are the florals to which he returned again and again. Even in his many quickly executed portraits, daffodils or other flowers are sometimes present and in front of the figure, playing a central rather than a decorative role. Robert Duncan had a high opinion of McNeill's light touch and intuitiveness, and once on leaving his flat went back up the stairs and said, "McNeill, I want to tell you something. In order to be an artist a person has to be a little bit dumb."[4]

One of McNeill's most unusual projects consisted of one hundred watercolors of red poppies, one stapled into each copy of issue no. 7 of Stan Persky's pivotal mimeographed magazine *Open Space* in 1964. In issue no. 3, McNeill also did a flower rendering in gouache on gold leaf paper, a different version again pasted into each copy of the magazine.

Wanting to create larger and more complex works, McNeill began doing impressionistic likenesses in acrylic of poets who were living in San Francisco or nearby Bolinas, including Robert Creeley, Marilyn Hacker, Joanne Kyger, Ronald Johnson, ruth weiss, and Philip Whalen. Large and impressive, too, are imaginary portraits of people not usually paired, such as *Walt Whitman and Marilyn Monroe* and *Emily Dickinson and James Dean*. The one of *Gertrude Stein and Alice B. Toklas* was used as a cover for an LP record album of Mussorgsky's *Pictures at an Exhibition*. Probably the best rendering ever done of Jack Spicer is McNeill's small brown-ink drawing of the poet sitting in his favorite haunt at Aquatic Park. Spicer's eyes are closed or looking down, perhaps suggesting his listening to one of the "outside" voices he felt dictated his poems. Bill Brodecky Moore recalls McNeill once telling him that he tried to capture the interiorness of whatever he drew, adding, "When I do portraits, I do essences."[5]

In his personal life McNeill was charming and entertaining and, according to Moore, he could form an instant and intimate connection with many people upon first meeting them. Although his work was not political, he took an active part in the Gay Liberation movement in the 1970s and had exhibitions at the Ambush and Stud bars and the Gay Community Center in San Francisco. He also showed his work to much positive response at the Buzz Gallery in Japantown in 1964 and later had a one-person show at the Transamerica Building, along with several home exhibits.

Although Bill McNeill was admired by the underground and outsider painters in San Francisco in the 1970s and 1980s, his color-saturated and exuberant work is still little known to the larger public as he was unsuccessful in placing his best work in commercial galleries and museums. His death from AIDS was a tragic loss to the art and poetry community in San Francisco and beyond.

—Christopher Wagstaff

William McNeill, *Aquatic Park (Jack Spicer)*, 1965
Felt-tip pen on paper

1 These and other details here are from written recollections provided by Ernesto Edwards, Joanne Kyger, and Bill Brodecky Moore in 2011.
2 Kristin Prevallet, ed., *A Helen Adam Reader* (Orono, ME: National Poetry Foundation, 2007), 44–45.
3 Christopher Wagstaff, ed., *Paul Alexander: On Black Mountain College and the San Francisco Scene* (Berkeley: Rose Books, 2010), 19.
4 Recollection of Bill Brodecky Moore, in an unpublished interview with the author, December 1, 1986.
5 Ibid.

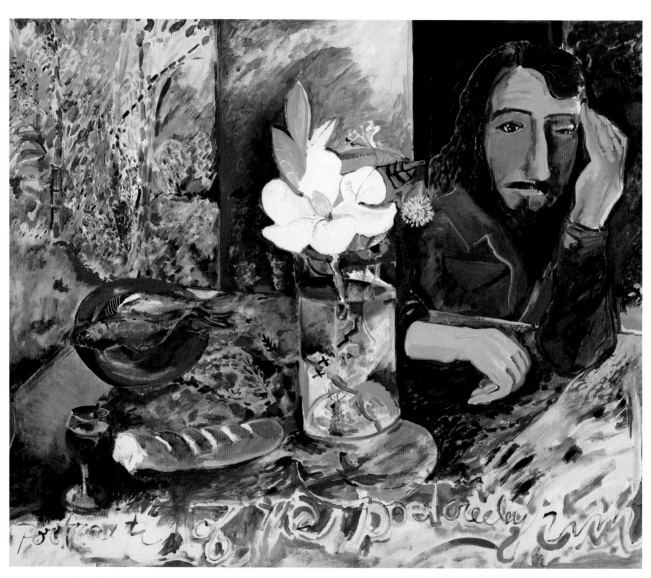

William McNeill, *Portrait of the Poet Creeley*, 1974
Acrylic on linen

William McNeill, *Poppies*, 1964
Watercolor on paper

William McNeill, *Daffodils with Man*, 1968
Opaque, crayon, and felt pen on paper

ELOISE TURNER MIXON

Eloise Turner Mixon (1922–1994) and her husband, Don Mixon, were students at Black Mountain College (BMC) when they met and became lifelong friends of Robert Duncan and Jess. Eloise's collage works were inspired by Jess's paste-ups, and two of them were part of Jess and Duncan's collection.

The daughter of a chicken rancher, Eloise Turner grew up near Wilkesboro, North Carolina. After high school she enlisted in the marines, serving as a combat correspondent. Afterward, she worked as a reporter for a Washington, DC, news bureau and in radio broadcasting and television promotion. During that time, she developed a strong interest in literature and decided to pursue creative writing. When she heard from her sister about BMC—the famous experimental school in her home state—she enrolled there on the GI Bill in what was to be the college's last year of operation: 1955. As a small-town Southern ex-marine she was somewhat of an anomaly at BMC. Her strong personality and feminist impulses were often at odds with what she perceived as the sexist attitudes of school leader Charles Olson.[1]

At BMC, Turner took classes from Olson and Robert Creeley but came into her own in a drama class taught by Wes Huss. In the class she fell in love with and soon married Don Mixon, an actor who had worked with Huss at Hedgerow Theatre, the prestigious summer repertory house in Media, Pennsylvania. She performed with Don in Huss's production of Robert Duncan's *The Poet's Masque,* and when Duncan came to BMC in 1956, the Mixons were immediately taken with the poet's energetic, direct approach to teaching and writing. They responded as well to Jess and to seeing the paintings he had brought with him from his stint with Duncan in Europe. Acting in Duncan's satirical play *Origins of Old Son*—an odd spoof of Olson—Eloise wore a "many-snake-festooned" Medusa mask designed by

Eloise Mixon at Stinson Beach, c. 1959
Photograph by Don Mixon

Jess.[2] Both Don and Eloise had large roles in the production of Duncan's new play, *Medea at Kolchis* (the poet John Wieners also had a small role). The two performances of the play were the last staged events at the college.

With the dissolution of the college, Huss convinced the drama students to move to San Francisco to continue as a troupe. A new production of *Medea* soon fell apart due to disputes about the casting of the major roles. Over the next few years, Eloise found jobs editing and writing for commercial magazines, while Don attended graduate school in social psychology. Their most idyllic times were spent living near Jess and Duncan in Stinson Beach. Eloise continued to write a string of unpublished novels while also finding a creative outlet in collage. In 1970 an exhibition of Eloise's collages was held at Gold Dust Gallery in Gold Hill, Nevada, near Reno, where Don was finishing his doctorate. Jess later purchased one of the works from the exhibition, *The Beanstalk* (1970) (p. 256), which features a spiral of images

from vintage children's books captioned with snippets of disjunctive text describing macabre and brutal incidents from fairy tales. The other Mixon work in Jess's collection, *The Phoenix* (1959) (p. 257) is a transfigured landscape that evokes the turbulence of his late large-scale paste-ups. The work's ominous Bosch-like array of birds and animals is presided over by its rising multicolored titular beast.

In the 1970s Eloise began to have health problems caused by severe bronchiectasis; the couple felt the need to find a more compatible climate than San Francisco. A job opportunity for Don in the psychology department of the University of Wollongong prompted a move to Australia in 1981. Eloise's steadfast correspondence from Australia helped sustain Jess emotionally after Duncan's death. Their letters compare notes on health and recent movies as well as mutual literary enthusiasms for Charles Williams, Armistead Maupin, and mystery novels by Joseph Hansen and Rex Stout. In his correspondence of the early 1980s, Jess began to seek Eloise's advice on his increasing memory loss. She suggested various sources of memory enhancement and subtly encouraged his reflections on the past. Both particularly relished moments from their idyllic period of living near each other in Stinson Beach. Jess's comment that Robert Duncan's drawings were as "brilliant as butterflies alight on the walls" prompted Eloise's reminiscence:

Never will I lose the breathtaking wonder of a Stinson Beach walk with the dog when we lived at the Canyon house. I crossed the stream at the back of the house, turned left as usual to approach the forest that lay between us and the Stinson–Bolinas highway. I think in that very familiar patch of pines and other trees, suddenly, hundreds and hundreds of Monarch butterflies. Truly nature had left no vacuum. Each selected tree had its veil of orange and black wings with shivers, it seemed, as the veil preened showing off beauty, beauty passive, beauty testing, beauty uncannily at rest. Later, when I learned that Monterey had the larger grove and was celebrated in *National Geographic,* I had no envy. Mine might be a mere stop for Monarchs on the flight south, but mine was mine own. A magic in that patch of piney grove.[3]

After her death, Jess wrote Don:

And Eloise was so immediate to me, both loved & admired. How selfishly I'm dismayd that an Eloise letter, intense & vivid, will no more be in my mail basket. She heroically wrote 4 or 5 letters to my one! I treasure them. Her indomitable spirit is great inspiration to me. I know it will take slow passage of time to dispel your pain. But you know, she's there with you as Robert is here with me - both there/here and everywhere in spirit. & her writing WILL be discovered![4]

—Michael Duncan

1 Don Mixon, telephone conversation with the author, July 16, 2012.
2 Eloise Mixon, *Robert Duncan's Medea at Black Mountain,* unpublished manuscript, Jess Papers, The Bancroft Library, University of California, Berkeley.
3 Eloise Mixon, letter to Jess, August 29, 1992, Jess Papers.
4 Jess, letter to Don Mixon, April 10, 1994, Don Mixon archive, Woollarra, NSW, Australia.

Eloise Mixon, *The Beanstalk*, 1970
Collage on paper

Eloise Mixon, *The Phoenix*, 1959
Collage on paper

Although virtually unrecognized today, Philip Roeber (1913–1995) was one of the most accomplished painters to come out of the West Coast abstract expressionist movement. The son of sharecroppers who worked in rural Colorado and the Pacific Northwest, Roeber as a child developed against all odds an interest in literature and poetry. His family's peripatetic life added to his sense of being an outsider or misfit from an early age. Working odd jobs after graduating from high school, he acted on a friend's suggestion to move to Seattle. There he won a scholarship to the Cornish School, a college specializing in visual and performing arts. When the school temporarily closed during the Depression, Roeber continued to work with local dance and theater groups and familiarized himself with regional museum collections. He became acquainted with the Seattle intelligentsia, including Morris Graves, Malcolm Roberts, John Cage, and Merce Cunningham. Interested also in writing, he contributed poems to small magazines and began a novel before being drafted into the navy during World War II.

After the war, Roeber settled in San Francisco, where he enrolled on the GI Bill at the California School of Fine Arts. Of studying there from 1948 to 1952, he later stated, "The encouragement by Still, Corbett, Spohn, Diebenkorn, Bischoff, Park, Calcagno, etc., and various other students, gave me the necessary confidence to think of myself as a visual artist."[1] Never having painted seriously before, Roeber immediately began working abstractly in the mode of his teachers and fellow students. "I felt absolutely free to do exactly what I wanted to do. I didn't try to do what at the time I couldn't do," he recalled. "The one thing I remember most is that I constantly wanted everything to look much rougher than it looked in the paintings of the students around me."[2] At CSFA, he was friends with Lilly Fenichel and Jess. Jess and Robert

Philip Roeber, c. 1970

Duncan owned two of his paintings (both 1952 and in the exhibition) that exemplify Roeber's command of form. Using irregularly shaped blocks of color, he developed his own style of lyrical somber abstraction, somewhat akin in tone to Robert Motherwell. Susan Landauer characterized the work as "often dark and forbidding, inspired by the dream imagery of Blake, Shelley, and other romantic poets . . . Like Corbett, Roeber was capable of exceeding refinement without becoming precious or decorative."[3]

After leaving school, Roeber worked odd jobs for eight years, painting after hours. In 1953 Roeber had a solo exhibition at King Ubu Gallery, and the next year he edited an issue of Claire Mahl's journal *Artist's View* that was dedicated to his work and ideas. In his text for the issue, Roeber laid his probing self-doubts and passionate conviction to art-making on the table: "Instruction to myself (and to you, too, if you like): don't do it; don't put that paint on that canvas. That is don't do it *unless you are willing to destroy what they now call the world.*"[4]

Roeber achieved Bay Area respect with solo exhibitions at East West Gallery (1955–1957) and the prestigious Dilexi Gallery (1959). His work was included in Walter Hopps and Ed Kienholz's "Action I" show at Santa Monica Pier in 1955. In 1960, he received a grant from the Lannan Foundation to paint in Provincetown, where he created large-scale paintings. (Three of these from 1961 were bought by J. Patrick Lannan and are now in the collection of the Oakland Museum of California.) A grant from collector William Roth enabled him to move to New York in 1962, but he continued to spend summers in Provincetown and moved there permanently in 1968. Later collages from the 1970s are compositions of shredded and tattered papers, attuned to the poetry and patina of detritus. Motherwell allegedly called him "possibly the finest collagist in the country."

Despite the acclaim of fellow artists and a few patrons, Roeber never achieved commercial success and felt at odds with the commodification of art. As he stated late in life:

> I feel a sense of despair and anger at the so-called world of art today. Galleries and the connivance of dealers have made art a plaything . . . which has influenced me to stay out of all. What satisfaction I've found has come from working in isolation. Lately though, I've been thinking about this, and I'm beginning to realize that this attitude must affect my work, and damn it, that it must imply a note of finality.[5]

In a letter that same year to Lilly Fenichel, Roeber wrote of the difficult position of the artist in American society:

> You accept your role as a professional with a rather esoteric profession because you have none other, and because you have developed a certain habit of mind which dictates that you make pictures and you do, as best you can, ignore the hypocrisy, condone the patronage, put up with the silliness and make what you can out of it. I don't really know what I shall do—but I've already said that.

Fenichel recalls that in her last conversation with Roeber he scolded her for expecting loyalty from her art dealer or recognition from the art world. Roeber committed suicide at age eighty-two by jumping from a bridge near his home in Jonesport, Maine.

—Michael Duncan

1 Roeber, "Autobiographical Notes," in *Phil Roeber: A Retrospective Exhibition* (Provincetown, MA: Provincetown Art Association & Museum, 1981), n.p.
2 Mary Fuller McChesney, *A Period of Exploration: San Francisco 1945–1950* (Oakland, CA: Oakland Art Museum, 1973), 54.
3 Susan Landauer, *The San Francisco School of Abstract Expressionism* (Berkeley: University of California Press, 1996), 132.
4 Roeber, "Two Reflections on Painting," in *Artist's View*, no. 7 (1954), 4.
5 Roeber, "Autobiographical Notes," n.p.

Philip Roeber, *Self Portrait*, 1951
Ink on paper

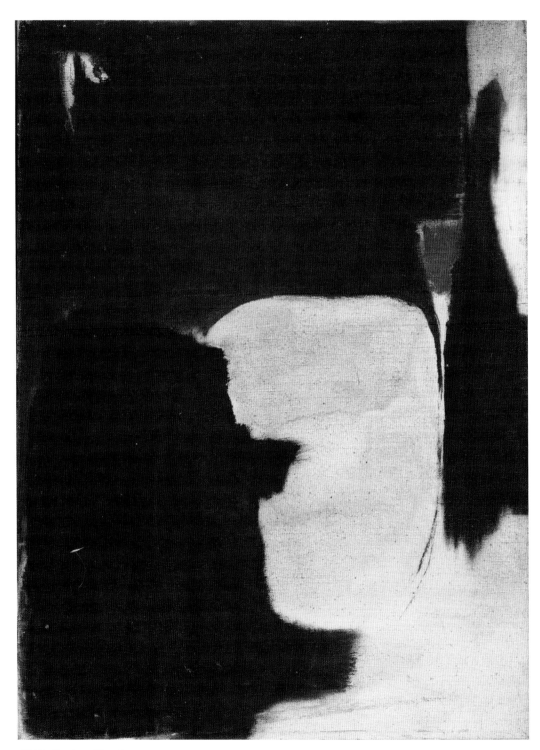

Philip Roeber, *No. 26, 1952*
Oil on canvas

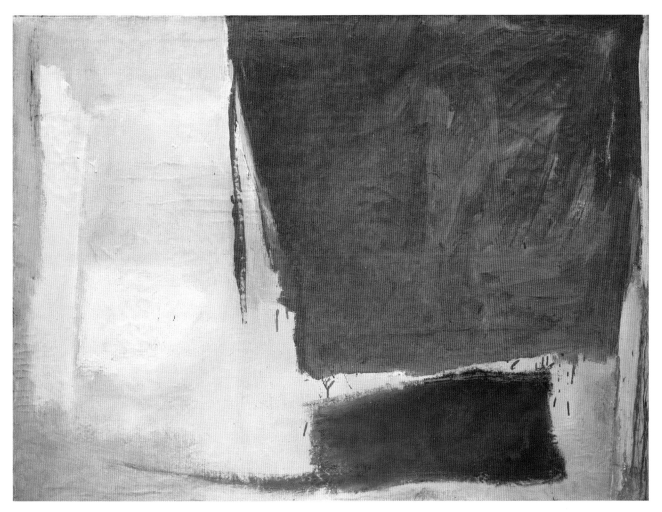

Philip Roeber, *Untitled,* 1952
Oil on canvas

Although known as one of America's most intriguing character actors, Robert Dean Stockwell (b. 1935) has long had an alternate career as a maker of lyrical and piquant collages and assemblages. Born in Hollywood, Stockwell was the son of actor parents who entered him into show business at an early age. He quickly became a child star, featured in important films such as George Sidney's *Anchors Aweigh* (1944), Elia Kazan's *Gentleman's Agreement* (1947), and Joseph Losey's *The Boy with the Green Hair* (1948). At age sixteen Stockwell had appeared in nineteen feature films and was aware that acting had denied him much of his childhood. Taking a hiatus for the next few years, he briefly attended the University of California, Berkeley, before leaving to travel around the country.

In 1955 he met Wallace Berman, who introduced him to an alternative world of art and poetry outside the confines of Hollywood. In an interview Stockwell stated, "My life began to shape itself after meeting Wallace, seeing his art and understanding what that art meant. Ever since then, my life has been a flow to art. Berman had a phrase, 'Art is Love is God.' That has been driving me throughout my life."[1] Berman introduced Stockwell to a West Coast community of poets, experimental filmmakers, and visual artists and encouraged him to make his own collages and poems. As Kristine McKenna has stated, Stockwell's early collages were "at turns romantic, apocalyptic, and droll. Images of celestial bodies, Greek statuary, gothic architecture, advertising, and photography clipped from old *Life* magazines ricochet across the picture plane in collages that initially appear to be random, but on closer examination resonate with a strange portentousness."[2]

Some of the most powerful works tap into an interest Stockwell shared with Berman in the Kabbalah. Employing the shapes of letters from the Hebrew

Robert Dean Stockwell, 1962
Photograph by Charles Brittin
© 2013 Charles Brittin Archive / Getty Research Institute / J. Paul Getty Research Center

alphabet, Stockwell evokes mystical and metaphysical forces. The two collages included in the exhibition both feature a form that seems an elaboration of the Hebrew letter *kaph,* whose pictograph was a symbol for the word "hand." Like Berman's repeated motive of the handheld transistor radio, Stockwell used the kaph symbol to represent a variety of ideas and cultural references. Here *Untitled* (*Mona Lisa*) (1960) (p. 264) is formed from cutout details of a photo of the cracked and textured surface of Leonardo da Vinci's famous portrait. Like a protective row of stolid columns, *Untitled (green)* (1959) (p. 265) presents five versions of the letter made from cutout sections of a photograph of green marble.

Wallace and Shirley Berman took Stockwell to Jess's studio, where, as he puts it, the work made a "powerful impact."[3] He purchased several pieces,

including *Tethys' Festival* (1961), an important painting that Jess regarded as being the prototype for the later Salvages series. Striking a friendship, Jess and Stockwell remained in contact through correspondence and visits. As a gift, Jess made the collage *IF (To D.)* (1962), honoring Stockwell in a mélange of mystical and phallic imagery including references to Apollo, David, Maria Callas, the Kabbalah, the Last Supper, the apocalypse, and Lawrence of Arabia. On one of his rare trips to Los Angeles, Jess stayed at Stockwell's house, and in 1966 Jess asked Berman and Stockwell to act as his agents in extricating works from Los Angeles art dealer Rolf Nelson.

Stockwell returned to acting in 1959 and has appeared in many important film and theater productions, including the Broadway production of *Compulsion*, a play and film loosely based on the notorious Leopold and Loeb murder case; Jack Cardiff's film adaptation of D. H. Lawrence's *Sons and Lovers*; and Sidney Lumet's critically acclaimed adaptation of the Eugene O'Neill play, *Long Day's Journey Into Night*. In 1964 Stockwell visited Taos, New Mexico, where he decided to settle, feeling a connection to its culture and landscape. Since the 1960s he has worked occasionally in television and regularly in independent films directed by friends such as Neil Young and the late Dennis Hopper. A starring role in Wim Wenders's *Paris, Texas* (1984) and an unforgettable cameo in David Lynch's *Blue Velvet* (1986) solidified his reputation with a younger audience. In 1988 he was nominated for an Oscar for his droll performance as a mob boss in Jonathan Demme's *Married to the Mob*.

During this time, Stockwell continued making visual work. One of his collages was featured on the cover of Berman's hand-printed journal *Semina* 8 (1963); another collage was featured on the cover of the 1977 Neil Young album *American Stars 'n Bars*. He shot several unreleased films in the late 1960s documenting George Herms making assemblages

in his studio. In 2003 Stockwell began work on a series of collages titled *The Spagyric Eye* that refer to alchemical changes centered around images of an abandoned house and a human eye. In 2004 he exhibited the completed cycle of forty works at the RB Ravens Gallery in Taos; the one-person show was accompanied by a catalogue with commentary by Dennis Hopper, Walter Hopps, and Ralph Gibson. In 2005 and 2006 Stockwell mounted two shows of collages and assemblages at Craig Krull Gallery in Santa Monica. Critic Leah Ollman stated that the magazine collages of the 2006 show "can pulse with wonder and dismay."[4] Along with George Herms, Stockwell today carries the torch of a generation of lyrical artists and poets who work outside the mainstream of the American art world.

—Michael Duncan

1 Hunter Drohojowska-Philp, "Solar Buzz," *Artnet Magazine,* November 29, 2006, www.artnet.com/magazineus/reviews/drohojowska-philp/drohojowska-philp11-29-06.asp.

2 Kristine McKenna, "Dean Stockwell," in *Semina Culture: Wallace Berman and His Circle,* ed. Michael Duncan and Kristine McKenna (Santa Monica, CA: Santa Monica Museum of Art, 2005), 262.

3 Stockwell, interview with Michael Duncan, September 21, 2012.

4 Leah Ollman, "A Culture Broken, Bereft," *Los Angeles Times,* November 17, 2006.

Robert Dean Stockwell, *Untitled (Mona Lisa)*, 1960
Collage on paper

Robert Dean Stockwell, *Untitled (green),* 1959
Collage on paper

Jess, 1965
Photograph by Fran Herndon

Appendix I
CONVERSATIONS WITH JESS

During visits in his last fifteen years, I would occasionally ask Jess questions about his life as well as about issues in his work that were puzzling. He didn't care for formal (or actually any) interviews and rarely gave them, but he said he didn't mind my queries and my scribbling notes on paper napkins at the dining table as we talked. He mentioned his childhood, his discovery of James Joyce, his meeting with Robert Duncan, his own earlier and later paintings, and the experimentally oriented King Ubu Gallery, which he briefly managed in 1952 and 1953 with the poet Robert Duncan and the painter Harry Jacobus. Below are excerpts from these conversations.

—Christopher Wagstaff

CW: What was your father like?
Jess: My dad was the commander of the American Legion for the whole state of California. This was before 1928. He was also the harbor manager for Long Beach, which was a pretty big job. He mortgaged the house for the 1932 campaign when he was running for a seat in the state legislature. When he lost the election, we had to move out of our house.

Before we left Long Beach and when I was six, I saw the illustrations in the Oz books and told my father I wanted to be an artist. He said, "Okay, there might be some money in it. You could do work like in the *Saturday Evening Post.*" I looked at Norman Rockwell there, however, and thought, "I don't ever want to be an artist!"

CW: When did you first encounter the work of James Joyce?
Jess: I turned on to James Joyce in 1943; it was somewhat easy reading after the Oz books. In the first six Oz books it is clear there are actual spirits involved here. There is an imagined reality which is complete.

There are spirits in the air, water, and earth. There is no argument that is involved. When there is argument, then the imagination is blocked. I read *Ulysses* when I was in the army in 1943, which led me to want to pick up *Finnegans Wake* immediately. I sent away and got one of the last of the limited signed copies that were available. At the same time I got the *Skeleton Key,*[1] which was helpful; when the *Key* didn't have the information for a particular passage, I made up my own and then would go on. This went over into 1946, when I went back to Cal Tech in Pasadena.

I had been drafted out of Cal Tech, and I hadn't fought it but gone along with it. Later, after the war, I took a job at what was called the Hanford Project in Richland, Washington, I think run by General Electric. After a year of that it got to me; my moral sense rebelled. I was thinking about painting, but I was such a coward and still wanted to have a side job which would support me while doing it. I decided to come to Cal [University of California, Berkeley] to get a master's degree in chemistry to enable me to go on with painting. But as soon as I

got in, I filed for a change of major to art, which was difficult to do on the GI Bill. After I was admitted, the guy at the admissions table, who happened to be a nonobjective painter, said, "You shouldn't be here but at the [California] School of Fine Arts in San Francisco. That's where everything is happening." I don't know what he thought of my portfolio, but he saw enough to make him think I was serious. I took the bus over to the School that day and enrolled, at the same time finding a room in a house on Russian Hill owned by a Mrs. Moscone.

CW: When was the first time you saw Robert Duncan?
Jess: I first saw him at an afternoon poetry reading in a room in Wheeler Hall on the Berkeley campus. This was one of the readings that got

banned during a controversial poetry festival. I was undone by the marvel of it. Robert read that afternoon, one of his first big poems. Landis Everson and one other person also read. When it came time for discussion, Jack Spicer commented that the end of Robert's "The Venice Poem" was meretricious. I remember thinking to myself, "I don't know who that person is, but I don't care for him." The room was filled.

I was just beginning some further graduate studies at Berkeley, where as I said I didn't stay long. Then I was in a public reading of Robert's "Halloween Masque" at the School of Fine Arts. We practiced it after hours, sitting around a table near an improvised stage. Robert might have come to see this play, but he *did* come to see another play I

Jess, 1956

was in, a Tennessee Williams one called *The Lady of Larkspur Lotion.* He said he fell in love with me in this play.

I first met him for real at Brock Brockway's, a wonderful painter I knew at the School; others were there for dinner, too, and Robert read his poetry to us. I enthused so much to Brock about Robert afterwards that Robert called me shortly after that. I even had a phone put in in the "Ghost House" where I was living so I could get his calls. I lived in one of the rooms in the old Spreckels Mansion at 1350 Franklin Street at the time.

CW: Did he buy any of your work in this early period?
Jess: The first painting Robert bought was from my first exhibit, which a fellow student arranged. A very good painter herself, Helvie Makela had made a scandal by including in a show at the San Francisco Museum of Art a male nude with genitals showing, which she had to cover with some fig leaves to make the museum happy. Helvie had opened a little gallery near the Broadway Tunnel, and that was where Robert saw my work in 1950. He went to the exhibit with me and bought a poster-paint work that was up [p. 53]. It was five dollars. That was before we were together, and I had hardly been an artist for a year at that point. However, there were enough paintings to fill a small room in the gallery. I showed paintings called *Still-bourne, Absurd Depths,* two Clyfford Still–like ones, and I think also *The Hero Reenters The Cave.*

CW: When did you start doing collages?
Jess: I first thought of doing collage when I visited Brockway's mother in Naples, near [Alamitos Bay] in Southern California, not far from where I grew up. We crossed over the bridge to Naples and then sat down to talk with Brock's mother. We mentioned our work at the School, and she said, "Look at the collage which I've just done." She had cut pictures of

flowers from magazines, and it was at that moment I saw collage for the first time. That was probably in 1950 or '51. I hadn't yet been exposed to Max Ernst or anyone else's work. Nobody at that time seemed to be doing story with collage.

CW: There is much story throughout the Romantic paintings, too.
Jess: In my Romantic works there are almost always landscapes in which you explore the unknown, of yourself or the world in which your self is. I always hope they will trigger the viewer into dreaming. Not only the Freudian dream which is a "little dream," but the big Dream, which is an actual other dimension. One feels more dis-ease in the "paste-ups," mainly because one is not familiar with the images and so much is packed in. I try to construct them so once learned they become a landscape in which you're happy to travel. Some people have told me they find the paste-ups in *Caesar's Gate* scary,[2] but they are not so to me. The scariness comes from not being able to deal with one's own daydream. The images came out of *Life* magazine, and so they were in everyone's minds then.

The images were from a series on the great religions of the world in the mid-1950s. I was drawing the sorts [part of tarot reading] from *Life* magazine instead of from the tarot. It was all pretty new to me, although I had started working with magazine images when we were living on Baker Street and Robert introduced me to Max Ernst. He bought a complete set of *Une semaine de bonté* in Berkeley, and it was a wonderful experience to have the whole set of Ernst images. I loved them, but it seemed to me that Victorian imagery would lend itself too easily to the dream work I wanted to do; I said, what if we could find the dreams within the photographic images we are bombarded with each day, wouldn't *that* be something? Of course, some of

the images cannot be recognized at all, and that is important too. These should make us think of what we don't comprehend every day, although science tells us differently.

CW: How did the Translations paintings get going?
Jess: I'd just finished a set of paintings called The Four Seasons, based on some of Hawthorne's stories, and we were feeling close to the garden and the landscape at Stinson Beach. I was gardening a lot. And I was painting fast in those days. That was why I began the Translations actually; the fluid shift of images in the more Romantic paintings were like colors which come quickly and go. I didn't know how to slow down. The whole impetus of the painting came from the painting itself; I wasn't doing it really. Of course, with the Translations [built up of many layers of paint], everything slowed down considerably. Sometime in 1959 at Stinson I did the drawings for the first four Translations. I didn't go on with them until we moved back to town [San Francisco]. I was never experimenting to get a style or make a personal statement. I was waiting for what was given to me or would appear. I completed *Ex. 1—Laying a Standard,* the first painting in the series, at Stinson Beach in 1959. And the last one of that series was done in 1972. The Salvages [a later series of Jess's works] are a melding of the Translations and the Romantic paintings.

CW: Could you help me with the images in the Don Quixote *painting?*
Jess: *Don Quixote's Dream of the Fair Dulcinea* [p. 72] was done while we lived on Baker Street in San Francisco. I was interested in the flow of a Romantic fairy-tale image into a close to nonobjective painting. The image at the right is a fountain *and* a unicorn. In the myth, the unicorn is attracted to a fair virgin, and this brings about his death. Yes, this

Quixote is different from Daumier's famous image of him. Daumier did not have a protective view of Don Quixote's silliness, but he also saw the tragedy of Quixote's view of the world. You might say my painting is Quixote's Romantic vision of the world. The present world is merely something to hang his dreams on; it doesn't function. In this period Robert and I read *Don Quixote* before we went to sleep, but we didn't get too far; Robert kept falling asleep. The same thing happened when we started reading Malory's *Morte d'Arthur* too; Robert would fall asleep after a few sentences, and I would have to explain to him the next day what had happened.

CW: Could you say a little about King Ubu?
Jess: At Ubu a fair amount sold but never enough for the expenses of the gallery; the prices were too low. [Philip] Roeber sold two or three, and he turned all the money over to us as a contribution to the gallery. We only took 10 percent commissions. The prices were so reasonable for what people were getting. Robert and I tried to buy a work from each show, and I asked him to buy something that was atypical of an artist. The shows lasted three weeks. No, we didn't have an overall plan. We showed people when there was reason to do so, and we worked out a schedule as we went along. Artists mostly hung their works themselves. We let them do it if they wanted. In the exhibit with Lyn [Brockway] and Harry [Jacobus], my works were up front. These were the Necrofacts, which set a strange tone. Lyn's paintings were free in spatial qualities, and Harry's were so elegant.

The Necrofacts were assemblies with real junk off the rubbish pile. Pieces were balanced and interlocked and jammed. I had about a half dozen of them there in a mock display case like you would see in a museum. One was an old dessert spoon which was used to dish up paint. Another was a wonderful old gilt frame, which had a drawing in it

on a piece of tissue for a toilet seat. It was true Ubu. There were also a few "assemblies," although I hadn't thought of calling works by that word then. A little later I did think of "assembly" before knowing the art term "assemblage."

Only one Necrofact exists that I know of. Someone came by when the show was over who was interested in having one of them, with a waffle iron, wire, and bulbs. I gave it to him as a gift, and he took it away very carefully. In the 1970s I was coming out of the Green Apple Bookstore [in San Francisco] one day, and a man came up to me and said, "Do you remember me?" I said, "No, who are you?" He said, "I got your *Moulting Phoenix* at the Ubu Gallery." I don't know what happened to that man. I wish I had taken his address.

CW: What was your visit to Black Mountain College like in 1956?

Jess: When Robert and I arrived at Black Mountain, I attended a couple of classes, but they didn't interest me much. I remember giving a slide lecture of my work, which I don't think made an impression on anyone. The audience was polite and cool. What people really liked was Robert's [farce] "Tales of Old Son," for which I did a backdrop. It was a fun production. [When Robert later did his play *Medea at Kolchis* there] he was furious that Wes Huss, the director, was a quietist and wouldn't allow blood to be shown on the stage, which occurs at the end of the play.

CW: Why do you think there was negativity shown towards Robert by some of the painters and poets around Jack Spicer?

Jess: The Spicer people were so trained by Spicer to spot pretension and expose it that they tended to see Robert as pretentious. Of course, Robert *believed* in "pretension" and pretending, and was himself over-extending himself in many directions all the time. Yes, this is the only way that certain people can get their work done. And that kind of pretension has been a part of art forever! Another important word for Robert was "drive," which you know he valued highly. Doing a thing makes it come about and the shaping of that drive is the art of it.

1 Joseph Campbell and Henry Morton Robinson, *A Skeleton Key to Finnegans Wake* (New York: Harcourt, Brace and Co., 1944).
2 Robert Duncan, *Caesar's Gate* (Palma de Mallorca: Divers Press, 1955; reprint with additional poems and paste-ups, Berkeley: Sand Dollar, 1972).

Appendix II
PHOTO ALBUM

Pauline Kael with Harry Jacobus in Kael's home, Berkeley, c. 1962

Page from Helen Adam floral scrapbook, c. 1955 (clockwise from top left: Robert Duncan, Tom Field, Pat Adam, Jess, and James Broughton; Robert Duncan; Harry Jacobus with unidentified man and Madeline Gleason; Jess and unidentified man; Helen Adam and cat; unidentified man and Jess)

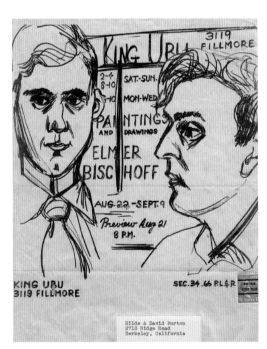

Flyer for King Ubu exhibition of work by Elmer Bischoff (drawing by Bischoff), 1953

Nemi Frost with her painting and friends at Buzz Gallery (left to right: Ernesto Edwards, Bill Brodecky Moore, Paul Alexander, Joanne Kyger, and Jack Boyce), 1964. Photograph by Jim Hatch

Clockwise from top left:

Jess and Norris Embry, 1952

Robert Duncan, 1963
Photograph by Helen Adam

Flyer for Philip Roeber exhibition at King
Ubu Gallery, 1953, design by Roeber

Jess's decorations in Pauline Kael's
Oregon Street home, Berkeley, c. 1960

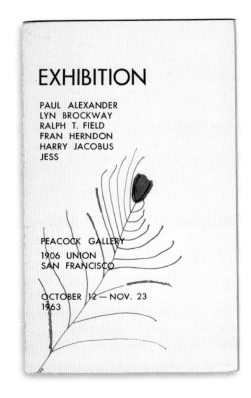

Clockwise from top left:

Lilly Fenichel in her apartment with paintings by Hassel Smith and Edward Corbett, c. 1955

Exhibition catalogue for group show at Peacock Gallery, San Francisco, 1963

Edward Sanders, Robert Creeley, and Robert Duncan (left to right), c. 1965

Jess and cat with Miriam Hoffman sculpture, c. 1958

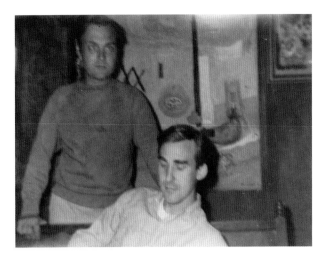

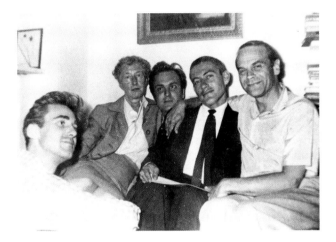

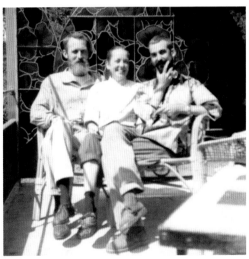

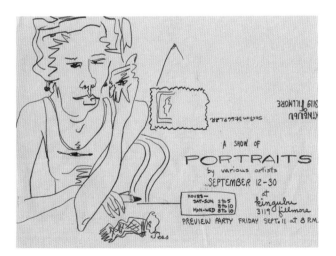

Clockwise from top left:

Robert Duncan and James Broughton, Stinson Beach, c. 1960
Photograph by Helen Adam

Robert Duncan and Jess with Virginia Admiral painting, c. 1952

Don Mixon, Eloise Mixon, and Jess at Stinson Beach, c. 1959

Flyer for King Ubu group show of portraits, 1953
Illustration by Jess

The Maidens and Their Sympathizers (left to right: Jess, Madeline
Gleason, Robert Duncan, Robin Blaser, James Broughton), c. 1960

```
She asked me a riddle
When the sun was rolling low.
She asked me a riddle
Three thousand years ago.

Her riddle I've pondered.
I've never solved it yet.
Far and wide have I wandered,
But she does  not forget.
```

Clockwise from top left:

Helen Adam, c. 1958
Photograph by Helen Adam

Helen Adam, "She asked me a riddle . . . ," c. 1957
Poem with photograph of Jess

Robert Duncan and Jess at home, c. 1975

Wallace Berman and Robert Duncan, c. 1969

EXHIBITION CHECKLIST

Helen Adam

Benign Mage, Divine Bear, c. 1957–1959
Collage, 12½ x 20 in.
Private collection

Bonnie Charlie's Gone Awa, c. 1957–1959
Collage, 12¼ x 10⅛ in.
The Poetry Collection of the University
 Libraries, University at Buffalo, The State
 University of New York

I Blame Mother, c. 1957–1959
Collage, 15⅛ x 11 in.
The Poetry Collection of the University
 Libraries, University at Buffalo, The State
 University of New York

Perhaps No One Will Notice Them,
 c. 1957–1959
Collage, 15¼ x 10¾ in.
The Poetry Collection of the University
 Libraries, University at Buffalo, The State
 University of New York

Where are the Snows, c. 1957–1959
Collage, 16¾ x 13¾ in.
The Poetry Collection of the University
 Libraries, University at Buffalo, The State
 University of New York

Virginia Admiral

Blue Composition, 1943–1944
Oil and collage on canvas, 40 x 30 in.
Collection of Robert De Niro Jr.

The Red Table, 1944
Oil on canvas, 44 x 38 in.
Collection of Anne and Robert J.
 Bertholf, Austin, TX

Paul Alexander

Death of Patroclus, 1963
Oil on canvas, 36 x 47½ in.
Collection of Fran Herndon, San Francisco

Eakins as Pan, 1974
Oil on board, 19 x 16 in.
Collection of Ernesto Edwards,
 Salt Lake City, UT

Japanese Iris, 1981
Oil on canvas, 33 x 27½ in.
Collection of René Viargues, Davis, CA

Wallace Berman

Mailers to Robert Duncan and Jess
 (four cards), c. 1962
Ink and collage on cards, various sizes
Collection of Philip Aarons and Shelley Fox
 Aarons, New York

Untitled (Spider), c. 1964–1976
Twenty-five-image Verifax collage,
 33½ x 30½ in.
Courtesy of the collection of Tosh Berman
 and Michael Kohn Gallery, Los Angeles

Untitled 112 (Ezra Pound), c. 1964–1976
Single negative photographic image,
 6½ x 6½ in.
Courtesy of Wallace Berman Estate and
 Michael Kohn Gallery, Los Angeles

Ronald Bladen

Untitled (Blue Forms), 1953
Oil on canvas, 32 x 44½ in.
Private collection

Connie's Painting, c. 1957–1958
Oil on canvas, 38 x 38½ in.
Courtesy of Loretta Howard Gallery,
 New York

Robin Blaser

Inside, 1957
Collage, 14 x 24½ in.
The Jess Collins Trust

Triptych, 1960
Collage, 14 x 24½ in.
Collection of Anne and Robert J.
 Bertholf, Austin, TX

Jack Boyce

Untitled (hanging scroll), 1968
Opaque on paper mounted on cloth,
 102 x 60 in.
Private collection

Lyn Brockway

Breakfast in a Paris Lodging, 1951
Oil on muslin, 45 x 31 in.
Collection of Anne and Robert J.
 Bertholf, Austin, TX

Aunt at Solitaire, 1953
Oil on canvas, 46½ x 46½ in.
Collection of Anne and Robert J.
 Bertholf, Austin, TX

Wild Flowers, 1962
Oil crayon on board, 31 x 37 in.
Private collection

James Broughton

Jess, flyer for James Broughton reading,
 1951
Collage with ink and paper, 7¾ x 5 in.
The Jess Collins Trust

The Pleasure Garden, 1953
Film transferred to DVD, 38 minutes
Courtesy of the James Broughton Estate

Un Jeu d'Été pour Robert et Jess, c. 1957
Collage, 7 x 9¼ in.
The Poetry Collection of the University
 Libraries, University at Buffalo, The State
 University of New York

Edward Corbett

Untitled, 1950
Charcoal and pastel on drafting paper,
 36 x 24 in.
Collection of Harry W. and Mary Margaret
 Anderson, Menlo Park, CA

Untitled, 1950
Oil on canvas, 48 x 44³⁄₁₆ in.
The Buck Collection, Laguna Beach, CA

Robert Duncan

Self Portrait with Shadow, 1946
Wax crayon on paper, 18½ x 15 in.
The Poetry Collection of the University
 Libraries, University at Buffalo, The State
 University of New York

Homage to Jack Spicer, 1947
Wax crayon on paper, 9½ x 12½ in.
Collection of David Farwell and the late
 Robin Blaser, Vancouver, BC

Untitled, 1947
Wax crayon on paper, 29 x 23 in.
The Poetry Collection of the University
 Libraries, University at Buffalo, The State
 University of New York

A Winter Sun Yet Dark, 1950
Wax crayon and gold paint on paper,
 18 x 14¾ in.
Private collection

Fragments of a Disorderd Devotion (San Francisco: privately printed, 1952)
Book with cover hand-decorated in wax crayon and ink, No. 6 of approximately 50 copies
Private collection

Fragments of a Disorderd Devotion (*Robert Duncan Poems 1952 for Jess*), 1952
Handmade book with illustrations
The Poetry Collection of the University Libraries, University at Buffalo, The State University of New York

"A Book of Exquisite Corpses," 1952–1953 (with Harry Jacobus and Jess)
Book of drawings; pencil, ink, and crayon on paper, 11½ x 17 in.
Collection of The Bancroft Library, University of California, Berkeley

Wallpaper Design, 1952–1954
Wax crayon on paper, mounted on canvas, 57 x 48 in.
Private collection

Dancing Salamanders, c. 1953
Wax and oil crayon on paper, 12 x 10 in.
Collection of Lawrence Jordan, Petaluma, CA

Announcement for *The Five Georges,* 1953
Flyer, 3 x 5 in.
Private collection

The Artist's View, no. 5 (Tiburon: Painters Poets Sculptors, 1953)
Private collection

Faust Foutu, 1953
Wax crayon with collage on butcher paper, 40 x 24 in.
Private collection

George III, 1953
Wax crayon on brown butcher paper, 93 x 48 in.
One of five panels for a production of Gertrude Stein's *The Five Georges,* King Ubu Gallery, November 5, 1953
The Jess Collins Trust

Odalisque, c. 1953–1954
Wax crayon on paper, 23 x 19 in.
Private collection

Caesar's Gate (Palma de Mallorca: Divers Press, 1955) (with Jess)
Poems by Robert Duncan; front cover and collages by Jess, two copies of special edition with original collages: Helen Adam's copy (#1), *Shadows of the Smoke*; Jess's copy (#b), *Source Magic*

The Poetry Collection of the University Libraries, University at Buffalo, The State University of New York

Untitled (Greek god), c. 1955–1956
Wax crayon on paper, 24 x 19 in.
The Jess Collins Trust

Program for *Medea* (Black Mountain College production), 1956
Private collection

The Return: A Ballad (for Helen Adam), 1957
Handmade book with wax crayon drawings
The Poetry Collection of the University Libraries, University at Buffalo, The State University of New York

Robert Duncan: A Selection of 65 Drawings, 1970
Original version of Black Sparrow Press drawings portfolio (loose-leaf), ink and pencil on paper, 8 x 6 in.
Private collection

Richard O. Moore (director), *The Originals: The Writer in America—Robert Duncan,* 1978
Video transferred to DVD, 30 minutes
Courtesy of the director & WNET

Christopher Wagstaff and David Fratto, *The Household of Robert Duncan & Jess: An Intimate Portrait of a Legendary Home,* 2006
DVD, 20 minutes
Courtesy of Christopher Wagstaff

Ernesto Edwards
Putting on the Eyes, 1963
Collage, 15 x 13 in.
The Jess Collins Trust

Thoughts Have Wings, 1966
Collage, 25 x 13½ in.
Collection of the artist

At the Bijou, 1968
Collage, 13 x 29 in.
Collection of the artist

Vanishing Men, 1968
Collage, six panels, each panel 8 x 6 in.
Collection of the artist

Norris Embry
Untitled (man and woman), c. 1950–1953
Poster paint on torn paper, 8½ x 11 in.
The Jess Collins Trust

Feeding the Cat, 1951
Monoprint, 11¾ x 8¼ in.
The Jess Collins Trust

Untitled (woman sitting at table), 1951
Oil crayon on paper, 11 x 8½ in.
The Jess Collins Trust

Untitled (garden), 1954
Oil crayon on paper, 15 x 18 in.
The Jess Collins Trust

Lilly Fenichel
No. 15, 1951
Oil on canvas, 40 x 48 in.
Private collection

Untitled, 1951
Oil on canvas, 46 x 62 in.
Collection of Anne and Robert J. Bertholf, Austin, TX

Tom Field
Portrait of Robert Duncan, 1956
Pencil on paper, 17½ x 22½ in.
The Jess Collins Trust

Cluttered Roof, 1959
Oil on canvas, 58 x 60 in.
Private collection

Kerouac Painting, 1960
Oil on canvas, 75 x 72 in.
Collection of Morris and Helen Belkin Art Gallery, University of British Columbia, Vancouver

Llyn Foulkes
This Painting Is Dedicated to Jess, 1966
Oil on canvas, 36¾ x 39⅜ x 2¼ in.
The Buck Collection, Laguna Beach, CA

Nemi Frost
The Mad Hatter's Tea-Party, Starring Dora Dull and Tom Field, 1960
Oil on canvas, 39 x 29¼ in.
Collection of Glenn Todd, San Francisco

Aunt and Joss (Whippet), c. 1961
Oil on canvas and mixed media, 50 x 31¾ in.
Collection of the artist

Madeline Gleason
Untitled (Carnival), c. 1948
Oil and gouache on board, 14½ x 19½ in.
Private collection

Theatre, 1950
Gouache on paper, 15 x 20 in.
The Jess Collins Trust

Untitled (Figures in Desert), c. 1965
Oil on board, 28 x 24 in.
Private collection

George Herms

The Zodiac Behind Glass: Box #5 Leo, 1965
Mixed media, 25 x 25 x 4 in.
Collection of Margaret Nielsen, Las Vegas,
 NV

Servant of Holy Beauty Giving Thanks, 1968
Collage, 28 x 18 in.
The Poetry Collection of the University
 Libraries, University at Buffalo, The State
 University of New York

Donuts for Duncan, 1989
Mixed media, 62 x 40 x 24 in.
Collection of Iris & B. Gerald Cantor
 Center for Visual Art at Stanford
 University, Gift of the Robert & Ruth
 Halperin Foundation, 2000.28

Fran Herndon

Collage for Jimmy Brown, c. 1960
Collage on board, 30 x 24 in.
Collection of the artist

Jack Spicer and His Radio, 1960
Oil on canvas, 23 x 28 in.
Collection of the artist

Opening Day, 1961
Oil on canvas, 56 x 52½ in.
Private collection

White Angel, 1962
Collage on Masonite, 25 x 25 in.
Kadist Art Foundation

Fran Herndon at Buzz, 1965
Silkscreen exhibition poster, 21½ x 18 in.
Collection of the artist

Miriam Hoffman

Head, 1950s (Sacramento only)
Cast concrete, 52½ x 27 x 35 in.
Collection of Crocker Art Museum,
 Sacramento, CA

Male Figure, c. 1952
Ceramic, 20 x 7 x 3 in.
Collection of Fran Herndon, San Francisco

Goblet, 1952
Glazed ceramic, 6 x 4 x 4 in.
Collection of Sandra B. and Stephen D.
 Burton, Berkeley

Irene, 1952
Fired ceramic, 16½ x 10 x 8½ in.
Collection of Karin McPhail, Berkeley

Goddess, 1953
Mixed media, 22½ x 32 x 10 in.
Collection of Crocker Art Museum,
 Sacramento, CA

Harry Jacobus

*Robert Duncan, Lyn Brown, and Miriam
 Hoffman Playing Strip Poker,* c. 1952
Ink on paper, 13¾ x 7½ in.
The Jess Collins Trust

Flyer for "Large Scale Drawings" exhibition
 at King Ubu Gallery, 1952
8 x 11½ in.
Private collection

Ennui, 1962
Oil pastel on board, 48 x 31 in.
Collection of Karin McPhail, Berkeley

Last Greek Painting, 1972
Oil pastel on paper mounted on canvas,
 38 x 53 in.
Collection of Karin McPhail, Berkeley

Untitled (flowers), c. 1978
Oil pastel on paper, 30 x 27 in.
Private collection

Unsettled, 1985
Acrylic on canvas, 54 x 48 in.
Collection of Barbara O'Brien Wagstaff,
 Kensington, CA

Jess

To Corbett, 1951
Oil on canvas, 46 x 36 in.
Courtesy of Odyssia Gallery, New York

*Now Roll Over And Play Dead: imaginary
 portraits #2: self-,* 1952
Oil on canvas, 46½ x 40 in.
Courtesy of Odyssia Gallery, New York

Secret Compartments, 1952
Oil on canvas, 44 x 36 in.
The Jess Collins Trust

Unkingd by Affection?, c. 1953 (with Robert
 Duncan)
Ink on paper, 13 x 10½ in.
The Jess Collins Trust

The Artist's View, no. 8 (Tiburon: Painters
 Poets Sculptors, 1954)
Private collection

*Don Quixote's Dream of the Fair
 Dulcinea,* 1954
Oil on canvas, 40 x 52 in.
Collection of Sandra B. and Stephen D.
 Burton, Berkeley

Feignting Spell, 1954
Oil on canvas, 42 x 48 in.
Collection of Crocker Art Museum,
 Sacramento, CA

*The Seven Deadly Virtues of Contemporary
 Art,* 1954
Crayon on board in standing frame, 5 x 7 in.
The Jess Collins Trust

A Thin Veneer of Civility (Self-Portrait), 1954
Oil wash on canvas, 94 x 24 in.
The Jess Collins Trust

The Visitation (I), 1954
Oil on canvas, 20 x 16 in.
Collection of David Farwell and the late
 Robin Blaser, Vancouver, BC

Song of the Borderguard, c. 1955 (with
 Robert Duncan)
Ink on paper, 12 x 10 in.
The Jess Collins Trust

A Mile to the Busstop, 1955
Oil on canvas, 28 x 42 in.
The Poetry Collection of the University
 Libraries, University at Buffalo, The State
 University of New York

One Way, 1955
Collage, 20 x 15 in.
The Buck Collection, Laguna Beach, CA

*Robert Bee Rose: imaginary portraits #16:
 Robert Duncan,* 1955
Oil on canvas, 46 x 24 in.
Collection of Sandra B. and Stephen D.
 Burton, Berkeley

Section Through Hairy Skin, c. 1956
Collage, 28 x 29 in.
Collection of David Farwell and the late
 Robin Blaser, Vancouver, BC

Untitled (Eros), c. 1956
Collage, 18⅞ x 27⅛ in.
Collection of Morris and Helen Belkin Art
 Gallery, University of British Columbia,
 Vancouver

Untitled collage for *Robert Duncan Reading*
 record album, 1957
Collaged cover for record album, 17 x 17 in.
Collection of David Farwell and the late
 Robin Blaser, Vancouver, BC

The One Central Spot of Red, 1958
Oil on canvas, 38 x 40 in.
Collection of David Farwell and the late
 Robin Blaser, Vancouver, BC

Qui Auget Scientiam Auget Dolorem, 1959
Wax crayon on paper, 8 x 6 in.
Collection of Roger and Nancy Boas, San
 Francisco

Selfsketch, 1959
Oil on canvas, 7½ x 5½ in.
Private collection

Untitled (Man under tree), c. 1960
Ink on paper, 11 x 8½ in.
Private collection

The Opening of the Field, 1960
Ink drawing with collage, 16 x 10½ in.
The Jess Collins Trust

Illustrations for Helen Adam's *San
 Francisco's Burning* (Oannes: Berkeley,
 1963), c. 1961–1963
Ink on paper, 19¼ x 14¾ in.
The Poetry Collection of the University
 Libraries, University at Buffalo, The State
 University of New York

The Chariot: Tarot VII, 1962
Collage, 51 x 33 in.
Collection of Dr. John Hallmark Neff,
 Winston-Salem, NC

Untitled (IF, To D.), 1962
Collage, 18 x 29 in.
Private collection

"The Horns of Artemis," c. 1962–1964 (with
 Robert Duncan)
Ink on paper, 20½ x 10 in.
Collection of the family of Barbara Joseph

Illustration for *"An Imaginary War Elegy,"*
 c. 1962–1964 (with Robert Duncan)
Ink on paper, 13 x 10½ in.
Collection of Sandra B. and Stephen D.
 Burton, Berkeley

Montana Xibalba: Translation #2, 1963
 (Sacramento and New York only)
Oil on canvas mounted on wood, 30 x 33 in.
Collection of The Modern Art Museum
 of Fort Worth, Museum Purchase, The
 Friends of Art Endowment Fund

Moonset at Sunrise, 1963
Oil on canvas, 30 x 24 in.
Courtesy Tibor de Nagy Gallery, New York

The Enamord Mage: Translation #6, 1965
Oil on canvas over wood, 24½ x 30 in.
Collection of The M. H. de Young
 Memorial Museum, Fine Arts Museums
 of San Francisco

In Praise of Sir Edward: Translation #7, 1965
Oil on canvas mounted on wood, 28 x 18 in.
Collection of the family of Barbara Joseph

"Rintrah Roars . . .": Salvages VI, 1965/1981
Oil on canvas, 16 x 22 in.
Collection of Grand Rapids Art Museum,
 Grand Rapids, MI, Museum Purchase,
 1982.1.21

Signd and Resignd: Salvages VII, 1965/1987
 (Sacramento and New York only)
Oil on canvas, 16 x 20 in.
Collection of San Francisco Museum of
 Modern Art

*The Napoleonic Geometry of Art—Given: The
 Pentagon in the Square; Demonstrate: The
 Hyperbolic Swastika,* 1968
Collage and diverse materials, 43 x 37½ in.
Collection of Francis H. Williams,
 Wellesley, MA

Lovers III: Erotic Triptych, 1969
Wax crayon on paper, mounted in cabinet,
 8½ x 11 in. closed
The Jess Collins Trust

A Mask for All Souls, 1969/1992
Paper collage, stuffed bird mounted on
 vintage photograph attached to cap,
 24 x 19 x 6 in.
Private collection

*Robert Duncan Readings at LeConte
 Auditorium,* 1970 (Sacramento only)
Collage, 30¼ x 38¼ in.
Collection of Berkeley Art Museum and
 Pacific Film Archive, Berkeley; gift of the
 artist

Paste-Ups by Jess, 1971
Collage, 22 x 28 in.
Courtesy of Odyssia Gallery, New York

Sent On The VIIth Wave, 1979
Collage and mixed media, 39 x 33 in.
The Buck Collection, Laguna Beach, CA

"Danger Don't Advance," Salvages IX
 (last painting), c. 1995
Oil on canvas, 44 x 18¾ in.
The Jess Collins Trust

Lawrence Jordan
*Heavy Water, or The 40 & 1 Nights, or Jess's
 Didactic Nickelodeon,* 1955–1962 (with
 Jess)
Short film (5:19); collage images by Jess
16 mm film transferred to DVD
Collection of Lawrence Jordan, Petaluma,
 CA

Jess, *Intertitles for Finds of the
 Fortnight,* 1960
Thirty-five collages on paper used in
 Lawrence Jordan film, each approx.
 6 x 8 in.
Collection of Lawrence Jordan, Petaluma, CA

From the One Proceeds the Other, 1961
Watercolor on paper, 11 x 13 in.
Collection of the artist

Entry Fissure, 1962
Watercolor on paper, 13 x 11½ in.
Collection of Susan Steel, Berkeley

Paradigm, 1962
Watercolor on paper, 18 x 14 in.
Collection of the artist

Finds of the Fortnight, 1980
Short film (8:15); intertitles by Jess
16 mm film transferred to DVD
Collection of Lawrence Jordan, Petaluma,
 CA

Hawk Haven, 1994
Collage on paper, 15 x 32 in.
Collection of the artist

Patricia Jordan
Jess at Stinson Beach, 1959
Photograph on hardboard, 15¾ x 15¾ in.
Collection of Lorna Anthea Star Jordan

*Robert Duncan Reading at Stinson
 Beach,* 1959
Photograph on hardboard, 15¾ x 16 in.
Collection of Lorna Anthea Star Jordan

Robert Duncan, c. 1960
Photograph, 10½ x 10¼ in.
Collection of Kenneth Irby, Lawrence, KS

Golden Damsels Descending from the Clouds,
 1960–1961
Collage, embroidery, feathers, ink, and
 photographs on linen, 67 x 14½ in.
Collection of Lorna Anthea Star Jordan

Pauline Kael
Jess, flyer for Cinema Guild and Studio, c. 1956
Private collection

Jess, *Jean Cocteau's "Orpheus,"* 1957
Poster for Cinema Guild and Studio
Collage and gouache on cardboard (two panels), 23¾ x 21 in.
Private collection

Jess, *Jean Renoir's "The Golden Coach,"* 1957
Poster for Cinema Guild and Studio
Collage and gouache on cardboard, 28¼ x 15 in.
Private collection

Jess, *Oscar Wilde's "The Importance of Being Earnest,"* 1957
Poster for Cinema Guild and Studio
Gouache on paper, 20¾ x 13½ in.
Private collection

R. B. Kitaj
"Good God, Where is the King?", 1964
Collage, 36 x 23 in.
Collection of Anne and Robert J. Bertholf, Austin, TX

Star Betelgeuse Robert Duncan, 1968
Lithograph, 30 x 22 in.
Private collection

Robert Duncan, Profile Left (light version), 1982
Charcoal pencil on paper, 15½ x 22¼ in.
Collection of San Francisco Museum of Modern Art

A Paris Visit (New York: Grenfell Press, 1985), front cover and illustrations by R. B. Kitaj
Private collection

Denise Levertov
"The bear in the wicked tasman tree," 1956
Ink on paper, 5 x 4 in.
The Jess Collins Trust

Jess, cover illustration for *5 Poems by Denise Levertov,* 1956
Ink on paper, 8½ x 6½ in.
The Jess Collins Trust

Michael McClure
Snake Eagle, 1956
House paint on canvas, 88 x 44 in.
Collection of Joanna Kaera McClure, San Francisco

Jess, title and end page for the book *The Boobus and the Bunnyduck* by Michael McClure, 1957
Crayon, ink, and watercolor on paper, each 20 x 18 in.
The Jess Collins Trust

William McNeill
Poppies, 1964
Watercolor on paper, 20 x 13 in.
The Jess Collins Trust

Aquatic Park (Jack Spicer), 1965
Felt-tip pen on paper, 15 x 18 in.
Collection of Fran Herndon, San Francisco

Daffodils with Man, 1968
Opaque, crayon, and felt pen on paper, 11 x 8¼ in.
The Jess Collins Trust

Portrait of the Poet Creeley, 1974
Acrylic on linen, 5 x 6 ft.
Collection of Ernesto Edwards, Salt Lake City, UT; Promised gift to Nora Eccles Harrison Museum of Art, Logan, UT

Eloise Mixon
The Phoenix, 1959
Collage on paper, 32½ x 42 in.
Private collection

The Beanstalk, 1970
Collage on paper, 30 x 24 in.
Collection of Anne and Robert J. Bertholf, Austin, TX

Charles Olson
The Maximus Poems, 1953
Typescript with notes; copy of Jonathan Williams
The Poetry Collection of the University Libraries, University at Buffalo, The State University of New York

"Bud, pink enclosing" (for Jess), 1956
Card with typed poem, 7 x 9 in.
The Poetry Collection of the University Libraries, University at Buffalo, The State University of New York

"A Litan, for Duncan in January," 1958
Typed postcard, 3¼ x 5½ in.
Private collection

Philip Roeber
Self Portrait, 1951
Ink on paper, 11 x 8 in.
The Jess Collins Trust

No. 26, 1952
Oil on canvas, 22 x 16 in.
Private collection

Untitled, 1952
Oil on canvas, 36 x 48 in.
Private collection

Exhibition flyer for King Ubu Gallery, 1953
9 x 13½ in.
Private collection

The Artist's View, no. 7 (Tiburon: Painters Poets Sculptors, 1954)
Private collection

Jack Spicer
Heavenly City Earthly City, 1947
Pencil on torn paper, 4 x 3½ in.
The Jess Collins Trust

Untitled, 1957
Pastel on cardboard, 7½ x 15 in.
Private collection

Billy the Kid, 1959 (with Robert Duncan) (Sacramento only)
Collage on cardboard, 14 x 8 in.
Collection of The Bancroft Library, University of California, Berkeley

The Heads of the Town up to the Aether (San Francisco: Auerhahn Society, 1962)
Edition with original crayon drawing by Spicer
The Poetry Collection of the University Libraries, University at Buffalo, The State University of New York

Robert Dean Stockwell
Untitled (green), 1959
Collage on paper, 9 x 24 in.
Private collection

Untitled (Mona Lisa), 1960
Collage on paper, 8 x 10 in.
Private collection

LENDERS TO THE EXHIBITION

Philip Aarons and Shelley Fox Aarons
Altman Siegel Gallery, San Francisco
Harry W. and Mary Margaret Anderson
Tosh Berman
Estate of Wallace Berman
Anne and Robert J. Bertholf
Roger and Nancy Boas
Estate of James Broughton
The Buck Collection, Laguna Beach, CA
Sandra B. and Stephen D. Burton
Crocker Art Museum, Sacramento, CA
Robert De Niro Jr.
Ernesto Edwards
David Farwell and the late Robin Blaser
Fine Arts Museums of San Francisco
Nemi Frost
Grand Rapids Art Museum,
 Grand Rapids, MI
George Herms
Fran Herndon
Kenneth Irby
Iris and B. Gerald Cantor Center for
 Visual Art, Stanford University
The Jess Collins Trust
Lawrence Jordan
Lorna Anthea Star Jordan
The Family of Barbara Joseph

Kadist Art Foundation
Loretta Howard Gallery, New York
Joanna Kaera McClure
Karin McPhail
Michael Kohn Gallery, Los Angeles
Modern Art Museum of Fort Worth, TX
Richard O. Moore and WNET
Morris and Helen Belken Art Gallery, University of
 British Columbia, Vancouver
Dr. John Hallmark Neff
Margaret Nielsen
The Poetry Collection of the University Librarics,
 University at Buffalo,
 The State University of New York
San Francisco Museum of Modern Art
Odyssia Skouras, Odyssia Gallery, New York
Susan Steel
Robert Dean Stockwell
Tibor de Nagy Gallery, New York
Glenn Todd
University of California, Berkeley Art Museum &
 Pacific Film Archive
University of California, Berkeley, The Bancroft
 Library
René Viargues
Barbara O'Brien Wagstaff
Francis H. Williams

INDEX

About the Authors

MICHAEL DUNCAN is an independent curator and a corresponding editor of *Art in America*. Among the many exhibitions he has organized of modern and contemporary art are surveys of Pavel Tchelitchew, Florine Stettheimer, Lorser Feitelson, Richard Pettibone, Alberto Burri, Sister Corita Kent, Kim MacConnel, and contemporary Los Angeles art. His books include *L.A Raw: Abject Expressionism in Los Angeles 1945–1980* and *O! Tricky Cad and Other Jessoterica*.

WILLIAM BREAZEALE is the curator for European art at the Crocker Art Museum and holds a PhD from the University of Maryland. A recipient of the Margaret M. Mainwaring Curatorial Fellowship for Prints, Drawings, and Photographs at the Philadelphia Museum of Art, he has long experience in a variety of works on paper including Californian and American prints. In addition to the exhibitions "The Language of the Nude: Four Centuries of Drawing the Human Body" and "A Pioneering Collection: Master Drawings from the Crocker Art Museum," he has organized a number of exhibitions dealing with paintings and prints.

CHRISTOPHER WAGSTAFF first saw Jess's work at the Rolf Nelson Gallery on La Cienega Boulevard in Los Angeles, and as a teenager he heard Robert Duncan's voice for the first time on an LP in a listening booth at Music City in Hollywood. He taught literature for some years at the University of California at Davis and at Berkeley, and more recently he has been an editor and independent art curator. He edited *Robert Duncan: Drawings and Decorated Books* (1992); *A Sacred Quest: The Life and Writings of Mary Butts* (1995); and *A Poet's Mind: Collected Interviews with Robert Duncan, 1960–1985* (2012).

JAMES MAYNARD, PhD, is associate curator of The Poetry Collection of the University Libraries, University at Buffalo, State University of New York, which houses the largest collection of Duncan's papers in its Robert Duncan Collection. He co-edited the single-volume publication of Duncan's *Ground Work: Before the War/In the Dark* (New Directions, 2006), edited *(Re:)Working the Ground: Essays on the Late Writings of Robert Duncan* (Palgrave Macmillan, 2011), and is currently editing a collection of Duncan's essays and other prose for the University of California Press's Collected Writings of Robert Duncan series.